THE
DOWNTOWN
POP
UNDERGROUND

THE DOWNTOWN POP UNDERGROUND

New York City and the literary punks, renegade artists, DIY filmmakers, mad playwrights, and rock 'n' roll glitter queens who revolutionized culture

KEMBREW McLEOD

ABRAMS PRESS, NEW YORK

CONTENTS

Part Three: The Twisted Road to Punk (1970–1976)

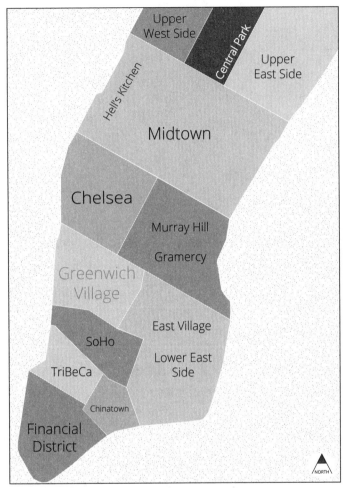

MAPS DESIGNED BY AHNNA NANOSKI

List of Maps

Introduction

The 1960s and 1970s produced seismic shifts in American popular culture that can now be felt on a global scale. One major epicenter was downtown New York City, where the inhabitants of a roughly one-square-mile area of Lower Manhattan changed the way we think about music, art, performance, and human sexuality. These events were set in motion by a tight-knit creative community that made sparks fly as they brushed against each other. Expressing themselves without much thought about career development or sound business plans, they did it collectively in the spirit of fun and adventure.

The escapades of these experimental musicians, writers, activists, dancers, film- and video-makers, theatrical performers, and visual artists were set against a backdrop of social decay. New York's economy was decimated by a wave of white flight to the suburbs, starting in the 1950s, and its old industrial base also declined as manufacturers abandoned the city's crowded factory lofts and inadequate transportation systems, favoring the West Coast's tax breaks and better infrastructure.[1] Postwar optimism gave way to rot in many downtown neighborhoods, which were disproportionately affected by deindustrialization. By the early 1970s, New York was in the midst of one of its most violent periods, with 1,691 murders and over 20,000 assaults in 1972 alone.[2]

The rise in poverty and crime was devastating for those who remained, but at the same time the downtown became a magnet for artists and other outsiders. Together, they escaped into music, art, film, theater, and other fantastical worlds—their creativity enabled by inexpensive rents that lifted the burden of securing steady employment. "It was much, much cheaper," recalled underground filmmaker and *Village Voice* critic Jonas Mekas, a Lithuanian immigrant who came to America after World War II. "Between '53 and '57, I lived downtown on 95 Orchard Street," he said, "and I paid fourteen dollars and ninety-five cents a month, for one floor. That was how cheap it was. During the same period, the same space uptown would be maybe seventy-five dollars, which made a big difference."

Andy Warhol's longtime residence on East Seventy-Fifth Street, in the tonier Upper East Side, stood in sharp contrast to the decrepit downtown environs where he socialized. Manhattan's midtown, sandwiched between these two zones, was the nation's center of cultural power in the decades after World War II. Along with the Broadway theater district, it hosted all three national radio and television broadcasting networks (CBS, NBC, and ABC), as well as major book, newspaper, and magazine publishers. They presented images of Eisenhower-era idealism and a conformist culture—skin-deep representations that would soon be punctured by this book's protagonists.

The peak period of mass media's influence coincided with an explosion of localized independent media. This was enabled by several technological break-throughs: audiocassette recorders, portable movie and video cameras, and public access cable television. The older medium of print also felt a jolt thanks to the mimeograph machine, a relatively cheap duplicator that was later supplanted by photocopiers and home printers. Mimeo made possible the instant publication of zines that writers distributed in the streets and at indie bookstores, underground cinemas, and do-it-yourself (DIY) performance spaces. Alternative newspapers such as the *Village Voice* and *East Village Other* also fostered community connections and encouraged new forms of expression to flourish, as did the free-form New York City radio station WBAI.

The fact that midtown and downtown were just a few subway stops away from each other sparked a dialogue. Unlike other avant-garde scenes that existed outside New York City, the downtown area's close proximity to the nation's media capital helped circulate cutting-edge ideas and innovations. Underground culture and popular culture have traditionally been viewed as diametrically opposed to each other, but the boundaries dividing the two are often blurry. Rather than living in different universes, they developed a mutually constitutive relationship that was transformative—a point underscored by this book's title.

The Downtown Pop Underground examines the intersecting lives of those who played major roles in the downtown arts scenes, creating a whole that was far greater than the sum of its parts. By surveying the social networks they were a part of, we can get a clearer view of how these artists worked across mediums and collaborated with their neighbors.

As a key connector figure, Andy Warhol circulated not only through uptown art circles, but also within the underground film, poetry, theater, and music scenes.

He is joined here by an ensemble cast of seven other main characters: H. M. Koutoukas, an outré playwright with a kaleidoscopic way with words; bohemian dancer Shirley Clarke, who evolved into a headstrong indie filmmaker and early video pioneer; Patti Smith, a punk-poet with roots in the underground theater movement known as Off-Off-Broadway; the trashy bleach-blonde Debbie Harry, who imploded the boundaries between pop and punk; Ed Sanders, a mimeo publisher, potty-mouthed poet, and frontman of the Fugs; DIY theater impresario Ellen Stewart, who cultivated an extended family of theater folks; and Hibiscus, the gender-fluid performer and founder of the psychedelic drag troupes the Cockettes and Angels of Light.

These interconnected individuals were nodes within a circuit that linked them to national and international mass-media outlets. Jacked into a system that amplified the downtown underground's subversive signals, their whispered messages could eventually be heard loud and clear. Of course, dozens of other downtown figures also broke new ground and had widespread influence—far more than could be catalogued in a ten-volume magnum opus, let alone this one book. A comprehensive history of this milieu is a fool's errand, so I accepted some constraints.

While sorting through stacks of archival research and over a million transcribed words from my interviews, I gravitated to those individuals who straddled multiple mediums and art forms. This book's primary themes—experimentation, hybridity, and border-crossing—are embodied by Warhol, Koutoukas, Clarke, Smith, Harry, Sanders, Stewart, and Hibiscus. My focus on these eight people and their social networks limited *The Downtown Pop Underground*'s scope, but trading encyclopedic expansiveness for a comprehensible narrative has advantages. A close attention to detail provides nuance that other histories sometimes bury in generalities—and when viewed collectively, these personal experiences shed light on more universal dynamics that drive culture, creativity, and connectivity.

This book is organized into three parts, beginning in the late 1950s with Off-Off-Broadway and concluding in the mid-1970s during the rise of punk rock. Along the way, it ricochets back and forth between Pop Art, pop music, avant-garde rock, contemporary dance, Happenings, alternative newspapers, underground film, public access television, gay liberation, antiwar activism, street poetry, urban planning, and even early reality television—all of which are intertwined in one way or the other. Part One ("Setting the Scenes") shows how downtown artists crossed paths and fed off each other, while Part Two ("Action!") is full of the sort of conflict that marked the Vietnam War and Civil Rights eras. In Part

Three ("The Twisted Road to Punk"), that vortex of energy was channeled into a new scene that included many familiar faces from earlier in the book.

The Downtown Pop Underground tracks the movement of these starring and supporting players through time, and also through space. The first chapter opens during the late 1950s in Greenwich Village, a place that attracted oddballs looking for a place to fit in—whether they were peace freaks, artists, homosexuals, or all of the above. That neighborhood has a long bohemian history that stretches back at least to the nineteenth century, and by the 1940s and 1950s it was home to several notable Beat writers, jazz musicians, and visual artists. The West Village, particularly Christopher Street and Sheridan Square, created spaces for gay men to openly experiment and develop new sexual identities.

This was certainly true of the pioneering Off-Off-Broadway theater venue Caffe Cino—located on Cornelia, a one-block-long street that terminates to the north at West Fourth Street. One block to the right of that intersection is Washington Square Park, a central gathering spot for New York's folk and Beat scenes in the late 1950s and early 1960s. The area surrounding the park was filled with coffee-houses, particularly on MacDougal Street, a staging ground that launched Bob Dylan into the pop culture stratosphere and provided a home for more unorthodox folk artists like the Holy Modal Rounders.

On the south side of Washington Square is Judson Memorial Church, less than a five-minute walk from the Cino. It mixed radical art, politics, and performance by hosting experimental music composer and theorist John Cage, choreographer Merce Cunningham, painter Robert Rauschenberg, and so many others. These artists used the church's space to expand the possibilities of mixed media, chance strategies, and nonlinear narrative—all of which dramatically altered the direction of twentieth-century dance, theater, visual art, and musical composition. Judson, along with Caffe Cino and Café La MaMa, also welcomed a large theatrical family that included George Harris III, later known as Hibiscus.

The dividing line between downtown and the rest of Manhattan is Fourteenth Street, where the Living Theatre was housed in an old four-story department store building on the corner of Sixth Avenue, ten blocks north of Judson. Shirley Clarke adapted her first feature film, 1961's *The Connection*, from the Living Theatre's 1959 production of that play, which was a downtown hit. In 1965, Clarke began living and working at the Chelsea Hotel—about nine blocks north of the Living Theatre, on West Twenty-Third Street and Seventh Avenue. A kind of downtown annex, this residential hotel housed many artists and bohemians through the years: poet Allen Ginsberg, philosopher Simone de Beauvoir, singer Janis Joplin, couturier Charles

James, and playwrights Arthur Miller, Tennessee Williams, and Sam Shepard, to name but a few of the dozens of prominent figures who lived there at one time.

Patti Smith also spent time in the Chelsea after moving to New York in 1967, not long after fellow Jersey girl and future Blondie singer Debbie Harry settled on the Lower East Side. Much of the pop music Harry and Smith listened to as adolescents was a product of record companies and song publishers that were located in the midtown area. The music industry was concentrated around the Brill Building at 1619 Broadway, which was packed with songwriters who pitched their musical products to hit-seeking record labels. Midtown was also Manhattan's primary entertainment district, where popular and highbrow fare could be enjoyed in Broadway theaters, Radio City Music Hall, and Carnegie Hall. Additionally, the area had several large movie palaces, such as the Bryant Theatre on Forty-Second Street.

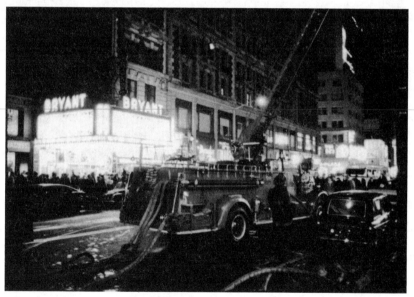

Bryant Theatre in midtown Manhattan
© SYEUS MOTTEL

Midtown was home to the original location of Warhol's studio, the Factory, which was known for its silver spray-painted decor, electric atmosphere, and eclectic cross-pollination of people and scenes. The studio's name was inspired by the artist's assembly line–like production of silkscreened prints and, a bit later, underground films and music. Unlike many critics of mass culture during that time, Warhol didn't draw distinctions between the downtown's "purer" kinds of artistic expression and the "commercial" products pumped out of these midtown

office buildings. This flattening of cultural distinctions helped usher in a new postmodern aesthetic.

Warhol lived uptown and worked in midtown, but his heart was very much tied to the downtown's arts scenes. In 1967, he moved the Factory to 33 Union Square, between East Seventeenth and Eighteenth Streets in Manhattan. Across Union Square Park was a restaurant and bar named Max's Kansas City, one of Warhol's regular haunts even before the move. Max's became a key destination where radical politics, painting, poetry, rock 'n' roll, and Off-Off-Broadway theater crossed paths, and the downtown's center of gravity continued shifting eastward as the 1960s progressed.

People moved away from Greenwich Village to the much cheaper Lower East Side, which nurtured everything from avant-garde poetry to the radical Puerto Rican nationalist organization the Young Lords. It was also where poet and indie mimeo publisher Ed Sanders opened his Peace Eye Bookstore, where he used to crank out printed matter on his mimeo machine and rehearse with his irreverent underground rock band the Fugs. Peace Eye was located between Avenues B and C, on East Tenth Street, in what was later known as Alphabet City—where the cost of living was lower, but life was harder. By the mid-1960s, parts of the Lower East Side were renamed the East Village by developers hoping to rebrand the neighborhood's sketchy image, but the streets could still be dangerous.

Ellen Stewart's Café La MaMa was located in the East Village and, like Caffe Cino, was among the first to uproot theater from its midtown home. With seemingly unlimited energy, she charmed the Ford Foundation and shook other money trees to sustain her growing theatrical empire. Stewart was an exemplar of self-invention, a black woman with zero theater experience whose distinctive accent was somewhere between truth and put-on, depending on who she was speaking to. La MaMa cultivated innovative performative styles that eventually injected new life into Broadway theater, as when its star director Tom O'Horgan turned *Hair* into a pop culture phenomenon in 1968.

A short walk from La MaMa's East Fourth Street location was the Mercer Arts Center, where underground theater, glam rock, video art, and performance art briefly intersected in the early 1970s. After part of the building collapsed in 1973, the music scene that developed at Mercer's shifted to Club 82, a basement disco and proto-punk venue located on East Fourth Street, right next to La MaMa. Just around the corner was CBGB, a large bar at 315 Bowery where many of the scene's key players finally put down roots.

Punk absorbed energy from Off-Off-Broadway, which had been one of the

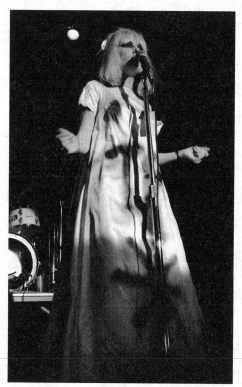

Debbie Harry in spray-painted wedding dress
© LISA JANE PERSKY

downtown's primal cultural forces since the late 1950s. Underground theater broke down the barriers between performer and audience with provocative low-budget shows in DIY venues, activities that later became associated with punk. In addition to sharing several social connections, punk and Off-Off-Broadway theater made magic by appropriating found materials and makeshift spaces—much like Andy Warhol's silkscreened prints and indie films, Ed Sanders's mimeo publications, Shirley Clarke's film and video experiments, Debbie Harry's trashy camp pastiches, Patti Smith's independently released musical debut, Ellen Stewart's basement theater, H. M. Koutoukas's paper cup telephone props, and Hibiscus's glittering homemade productions staged by his loving family.

Collectively, they blurred several entrenched dichotomies: art and commerce, high and low culture, corporate and independent media, center and margin. The residents of Lower Manhattan may have been subterranean, but their position deep inside America's media capital enabled them to reshape the larger culture by causing the underground to go pop.

PART ONE

SETTING
THE SCENES

1958 – 1967

CHAPTER 1

Harry Koutoukas Arrives in the Village

Haralambos Monroe "Harry" Koutoukas took a bus from his home in upstate New York to Greenwich Village just as the 1950s came to a close, in search of adventure. "When Koutoukas hit town, he was an Adonis, a Greek youth with abundant energy, personality, and natural wit. He was able to express himself in the vernacular of downtown—being free," said Agosto Machado, a Chinese-Spanish Christopher Street queen and *Zelig*-like figure who witnessed the rise of the underground theater and film movements, the 1960s counterculture, gay liberation, and punk rock. Even in the Village, which was bursting with theatrical flourishes, this Greek American cut a striking figure. Entering a coffeehouse, Koutoukas might come swooshing in the door with a large swath of fabric flowing behind him—all while holding a cigarette high, for dramatic effect.

"It was sort of grand," Machado said, "but it wasn't a pretentious-grand. It was a *fun*-grand."

"Harry dressed extravagantly," added playwright and *Village Voice* theater critic Michael Smith. "He had a kind of flamboyant Greek personality, and was very funny. He would make fun of you, and he would make fun of himself. His plays were extremely fanciful." This provocateur, poet, and playwright had a knack for wordplay that spilled over into the titles of his "camps" (Koutoukas's preferred term for plays), such as the following:

All Day for a Dollar, or Crumpled Christmas
Awful People Are Coming Over So We Must Be Pretending to Be Hard
 at Work and Hope They Will Go Away
Feathers Are for Ramming, or Tell Me Tender Tales
The Man Who Shot His Washing Machine
Medea, or Maybe the Stars May Understand, or Veiled Strangeness
 (a Ritualistic Camp)
Pope Joan, or A Soul to Tweak (a Divine Camp)

Theory for the Application of Rainbows
Tidy Passions, or Kill, Kaleidoscope, Kill (an Epic Camp)
Too Late for Yogurt
Turtles Don't Dream, or Happy Birthday, Jesus

Harry's first play, *With Creatures Make My Way*, was about a semi-human fig-ure that lived in the New York sewers along with rats, baby alligators, and "little tweekies," and who longed to be reunited with his love—a lobster. The show's subterranean setting was a metaphor for the underground culture Harry helped shape in Greenwich Village and its surrounding downtown neighborhoods.[1]

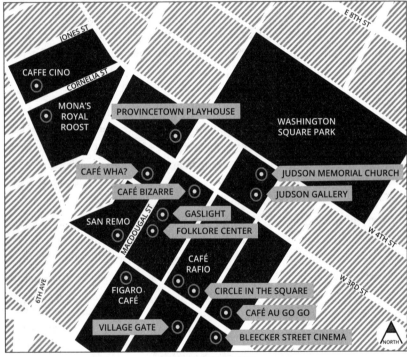

GREENWICH VILLAGE

Playwright Robert Heide first met Koutoukas around 1959, when both young men followed bohemian paths that had been blazed by the Beats. "I met up with Harry several times on MacDougal Street, in the coffee shops," Heide said, "where he would be carrying a copy of Jean-Paul Sartre's *Being and Nothingness*, and I would as well. So we began talking existentialism." When he first crossed paths with Koutoukas, Heide thought he was a lesbian with a 1950s-style DA haircut.

He was very petite at the time, though Harry's waistline expanded along with his corpus of plays (he wrote dozens upon dozens throughout his life).

They'd congregate at Lenny's Hideaway, a Greenwich Village cellar gay bar that was an important node in the downtown's overlapping social networks. Heide met playwright Edward Albee there, and the two eventually became close. "Edward and I would take long walks," he said. "We would say nothing. Later he told me that there were characters running around in his head that he was thinking about. We would drink at Lenny's Hideaway 'til four in the morning, then maybe we'd go back to his place, like in *Who's Afraid of Virginia Woolf?*" Wandering around downtown late at night, the couple sometimes stopped by Bigelow Drugs on Sixth Avenue, between West Eighth and Ninth Streets, to have a black-and-white ice cream soda with seltzer.

The streets were much quieter in Greenwich Village, compared to the bustle of today, and it felt as though everyone knew each other. "You would run into people that you knew," Heide recalled. "I'd run into Sam Shepard at a coffee shop. You could have a hamburger and apple pie and coffee for ninety-five cents. You have to remember, everybody's rent was low, like that song 'Bleecker Street,' by Simon and Garfunkel, that goes, 'Thirty dollars pays your rent on Bleecker Street.' Ha! *Thirty dollars!*" Even though they lived in a big city, it felt like a small town. This self-contained metropolis even had its own directory, *Greenwich Village Blue Book*, which was published from 1961 to 1968 and contained listings for stores, doctors, churches, theaters, and other establishments in the area.

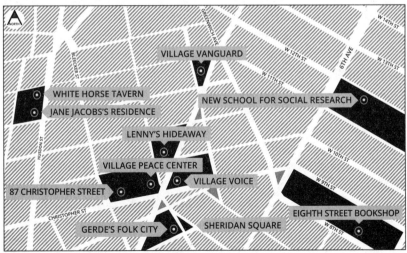

WEST VILLAGE

By the early 1960s, Heide rented an apartment at 84 Christopher Street, which was crawling with artists. "Upstairs from me lived Dick Higgins, who was involved with the Fluxus movement and Happenings," he recalled. "The actress Sally Kirkland lived in the building. She was studying at the Actors Studio. Zal Yanovsky of the Lovin' Spoonful was my downstairs neighbor, and his band was performing at a place called the Nite Owl, where the Mamas and the Papas played when they were in town."

Lisa Jane Persky entered Harry Koutoukas's life in 1965, when she was about ten years old and her family moved into 87 Christopher Street. This nineteenth-century tenement apartment building was a microcosm of the neighborhood, hosting everyone from the playwright Persky and Yoko Ono to a mother-daughter pair who were always standing at the building's entrance. Rosie was a diminutive older lady, and her daughter Ernestine was in her forties or fifties. "Harry is not a homosexual," Rosie would insist. "He is *refined*."

"The thing about the Village that I really miss now," Persky said, "there were lots and lots of old ladies in the doorways, just enjoying the night air and hanging out." In these small residential buildings, neighbors passed each other returning with groceries or coming home from work (if they had jobs, which wasn't true of Koutoukas). People were coming and going at all times of the day and night, and they inevitably stopped and talked to each other. The surrounding streets were also a mixture of old and new worlds, where openly gay street queens crossed paths with those from more traditionally conservative immigrant backgrounds.

Within spitting distance of 87 Christopher was Jimmy the Fence, who ran a barber shop that sold items of questionable origin, along with a fancy dress shop, a grocery store, a butcher, and an old-fashioned Jewish department store. Like many city kids in those days, Lisa had a lot of unsupervised time, and she used to wander the streets, exploring various shops. "I'd just go in and started talking to people about what they were selling. There were these two women who ran this bakery called Miss Douglas Bakery. Were they girlfriends or were they sisters? What was going on there?"

Persky also couldn't help but notice that Christopher Street was a place where many gay men congregated, including Koutoukas. "I remember thinking that Harry was so exotic, because he dressed in a really flamboyant way," she said, "but to me it was just fashionable and lavish. He had really cool clothes and other stuff. He had a very fanciful way about him that was, to a kid, so attractive—because it was totally genuine, not false." She recalled that everything was theater to Harry, including the exaggerated way he carried himself while swooping to pick up a bag

of groceries, or rounding a corner. He once described these fluid movements to Lisa's mother as being "like the inside of a washing machine."

Koutoukas likely picked up this flair for the dramatic while growing up outside of Binghamton, New York, in the "Magic City" of Endicott. His family ran a restaurant and entertainment establishment that booked "female impersonators," though he was forbidden to see those shows when he was an adolescent. Undeterred, Koutoukas snuck in to see the outlandish performers (who were a bit taller than ordinary women, with large hands and an exaggerated sense of femininity).

This planted a seed in Harry's mind that a weirder world was within his reach, and through magazines and movies he discovered Greenwich Village. *Ahh*, Koutoukas thought, *now there's a place I'd like to go.* "By the time Koutoukas came to the Village," recalled Agosto Machado, "things were shifting. There was a ferment of sexual revolution, the beginnings of a youthquake."

Harry Koutoukas was one of many men and women who gravitated from other cities and countries to the Village, a catch-all term that included Greenwich Village, the East Village, and other surrounding neighborhoods. Soon after arriving, he befriended a gay coffeehouse proprietor named Joe Cino, who helped spark the underground theater revolution known as Off-Off-Broadway. "Caffe Cino encouraged creativity and no barriers," Machado said. "You'd just say you're a playwright, and then you would put on a play."

This storefront theater was located on Cornelia Street, a block-long side street that connects Bleecker with West Fourth Street and got little foot traffic. Cornelia was one of those charming little Village roads near Washington Square Park that could have easily appeared on *Freewheelin' Bob Dylan* (that iconic album cover was shot on Jones Street, just one block to the north). Coffeehouses proliferated in Greenwich Village because the area had plenty of empty commercial spaces; these establishments were much cheaper to run than bars, which required the proper city licenses and Mafia protection rackets.

Caffe Cino had six or eight little tables with wire-back chairs that were complemented by a hodgepodge of other furniture found in the street. Its stage was usually set in the center, among the tables, though this arrangement often changed from show to show. In the back of the Cino, to the left, was a counter with an espresso machine and a hallway that led to a tiny dressing room and a toilet. During its early days, the place was lit by Chinese lanterns and other little lights, though Caffe Cino grew more cluttered as time went on.

Joe Cino opened it after giving up on his dream of being a dancer, for he was too heavyset to make it in the dance world. "Joe wore sweatshirts on the street, like

dancers did," recalled Robert Patrick, another Cino regular-turned-playwright who entered the fold in 1961. "He wore them backwards for the high neck. He was an affected faggot before it was fashionable." He could be found behind the espresso machine—which served some of the best coffee in town—surrounded by photos of James Dean, Jean Harlow, Marilyn Monroe, and other movie stars. Joe didn't bother reading scripts; he read people's faces instead, or asked them their astrological sign.

"The Cino was one of a number of little coffeehouses and alternative spaces," said Michael Smith, "and I liked that it was so intimate. There was no proscenium. You were not separated from the play by some kind of frame. It was happening in the room with you. It was a very free atmosphere. Joe Cino was very supportive and just encouraged people to be themselves and be free. It's quite unique that way, and I've never really been in another theater that was quite as supportive."

Caffe Cino became an alternative to Off-Broadway, which emerged in response to the conservatism of Broadway—whose producers, even then, were loath to take risks and instead relied on revivals of established hit shows that could guarantee a return on their investments. Off-Broadway shifted American theater from its midtown Manhattan roots after venues such as Cherry Lane Theatre drew audiences further downtown. This new theater movement created a low-budget style that offered artistic freedom, but by the end of the 1950s Off-Broadway's budgets rose and its theaters followed the same cautious logic of Broadway producers.

The time was ripe for Off-Off-Broadway. "There was no way to get a show on Broadway," said Michael Smith. "At that point in time it cost a lot of money to put a show on Off-Broadway. You would have to go raising money, and a lot of the budgets at that point were $20,000. That was a lot of money." Instead, Caffe Cino staged shows for a few dollars or for nothing (when Smith staged his first play there, he dragged his own bed down Cornelia Street to be used as part of the set). Off-Off-Broadway locales were akin to the barebones venues where punk rock developed in the mid-1970s—introducing the idea that one could simply do it yourself, without waiting for funding or the approval of cultural gatekeepers.

"Arrogant peacocks like Harry Koutoukas were a product of the Off-Off Broadway milieu," recalled Robert Patrick. "Since nobody was making any money and hardly ever getting reviewed at that time, it was the first time in history that theater became this totally self-expressive art form. A playwright could produce whatever they wanted." Koutoukas was free to craft his playful, poetic

wordplay and unconventional scenarios that never could have made their way to Off-Broadway, much less Broadway, and he immediately attached himself to Joe Cino.

"Harry just worshiped Joe," Patrick said. "Most of my Cino memories of Harry are him at Joe's side, or talking to Joe by the counter, or at a table with him." The café owner sometimes spoke in a very high-cultured purr, though he also employed a pseudo-Italian language that was kind of campy—like, "*Mamma mia!* Here's another group of lost boys!" He liked eccentric people with wild personas and wanted to create an open atmosphere that was like an ongoing party, blasting Maria Callas and other opera divas at top volume on the phonograph. Joe loved the 1940s pop singer Kate Smith, and sometimes wrapped himself in the American flag—occasionally completely naked—while playing the famed contralto's rendition of "God Bless America" at top volume, just standing there.

Cino's appetite for a good time was equaled by his warmth and generosity. If one of his starving young artists was actually starving, he would offer them bread or pastries, even when he couldn't pay rent himself. His café offered a warm refuge for the poor, tired, huddled gay masses who increasingly congregated in the Village—like a young Agosto Machado, who met Joe in 1959. "I was on Cornelia Street, around Bleecker," he recalled, "and it was still heavily an Italian neighborhood, and there were these young men who were so attractive, carrying things like panels of wood. I thought I was being discreet, but I just got overwhelmed by their handsomeness and I followed them as they went up Cornelia Street."

When this group of men walked through Caffe Cino's doorway, Agosto peered in. "May I help you?" Joe asked. "Oh no," he replied, "I was just wandering about the neighborhood." The friendly coffee shop owner ushered him in. "This is a café, and you're welcome here. We don't sell alcohol. We sometimes have poetry readings and little presentations. There's hot cider, or espresso, or some cookies."

Machado came from other parts of the city, though several other villagers came from much farther away—like Robert Patrick, another bohemian immigrant who was drawn to the Cino. After working a dishwashing job at a summer stock theater in Maine in 1961, he made a stopover in Greenwich Village on his way back home to Santa Fe, New Mexico, on a Greyhound bus. As he walked down West Fourth Street, Patrick saw a young long-haired man with jewelry around his neck who was clearly not wearing underwear.

"His name was Johnny Dodd," he said of Caffe Cino's genius lighting technician. "So I followed what I call the 'other brick road' down to Sheridan Square. I followed him a couple of blocks and he looked over his shoulder at me and turned

the corner." Patrick continued down Cornelia Street, which had a little art gallery and bookstore, then followed Dodd into the Cino—which was dark and smelly. Actor Neil Flanagan and director Andy Milligan were in the midst of rehearsing a show, so the newcomer sat down, watched, and basically never left Caffe Cino until it shut down in 1968.

"We were raised in an America that hated art, sex, and intellect," Patrick recalled, "and sex was not the worst offense." He was beaten up in grade school, junior high school, and high school not for being gay—which he was—but for carrying too many books. "Once we all left the small town to hit the big city, we were ready to explode. There were people at the Cino who were versed in every aspect of history, arts, science. Nobody beat you up for it there." Patrick surrounded himself with creative, forward-looking people who were smart, friendly, and supportive. "Most of us had never been part of a group where we came from, so it was rather intoxicating to be in one."

Sitting around having coffee, they shared their frustrations and aspirations with each other, so it wasn't much of a stretch for them to say, "Hey, let's act this out—let's put on a show!" Every night at Caffe Cino, Joe walked from the espresso machine to his makeshift stage, rang chimes, and announced, "Welcome ladies and gentlemen, it's magic time!" When the lights went down, a different reality materialized: "It was the magic and ingenuity of Off-Off-Broadway," Machado said. "You had to suspend belief, because you wanted to, and you're enjoying it. If you didn't have money, you used your ingenuity. It was so magical, so special. It was a playhouse for yourself and the selective group of people who were seeing this."

"Do what you have to do," said Joe Cino, who gave this small group of outsiders a literal stage to act out new ways of presenting themselves in public. Together, they transformed social life by performing openly gay identities in ways that had been suppressed elsewhere in the country. "All the gay guys bought muscle magazines like *Young Physique*," Patrick recalled. "At one point, I dared bring in a photo of one of the most popular models, a blond in just the tiniest white bikini. I tacked it on the wall, which is like saying, '*Yes!* We're gay.' But we were actually worried if I could legally put a picture of a young man in a bathing suit on a wall."

Over time, this motley crew grew more confident and confrontational, such as when Patrick and his fellow Cino playwright William Hoffman were attacked in the neighborhood by a group of teenage boys. Patrick and Hoffman turned the

tables on the homophobes by breaking off a car antenna and chased them through the streets with it. "I would have killed them," Hoffman said, vividly recalling this pre-Stonewall memory a half century later. "It was very empowering."

F. Story Talbot, who had an apartment on Cornelia Street, was one of the token straight guys who hung around the Cino in its early days. "All the guys down there who worked there were making semi-passes at me," he said, "and we would laugh about it." Talbot began going to Caffe Cino in 1959, when Joe was starting to program one-act plays. When he approached Cino about doing a musical, Talbot instantly got a date for the show. *Herrengasse* was a tragic comedy about a German whorehouse, written under the heavy influence of Kurt Weill and Bertolt Brecht (a reviewer referred to it as a "one-penny opera").

At the time when Talbot lived on Cornelia, it was still a quiet street just far enough away from the bustling coffeehouses of MacDougal Street. One would often see women in upstairs apartments with pillows on the windowsill, leaning out over the street for hours. "They'd just converse with people down below and then watch the scene," Talbot said. "Sometimes you wouldn't notice they were there, but they were there—like a Greek chorus." Whether they were hanging out on stoops or leaning from their windows, many women in the Village kept an eye on the street, serving as an informal neighborhood watch. When Joe first poked around the storefront that became Caffe Cino, interested in renting it, someone on the fire escape yelled down, "Wha'dya want?" It turned out to be the building's landlady, who asked Cino if he was Sicilian. "Yeah," he said, so she just threw him the keys. (Joe would place his rent money—often in coins—in an envelope, then wrap it in a scarf, and toss it up to her through the fire escape.)

There were few businesses on Cornelia: a bar across from the Cino, a bookstore, an art gallery, and a couple of small shops, including the original Murray's Cheese Shop. The gallery was run by a creepy artist and pedophile named Frank Thompson, who sold paintings of nude boys with huge penises. Talbot lived next door to Thompson, and on the other side of his apartment was Mona's Royal Roost—a quintessentially quaint Greenwich Village cocktail bar run by two older women. On the Bleecker Street corner was a butcher shop with rabbits hanging in the window, and down Cornelia Street an Italian bakery named Zampieri infused the street with the smell of bread.

Around the other corner, on Cornelia and Fourth Street, was a dress shop with a fancy mannequin in front where movie stars sometimes shopped. It was run by Andy Milligan, a designer who also directed some of the earliest shows

at Caffe Cino. He later went on to make trashy low-budget movies such as *The Ghastly Ones, Vapors, Seeds of Sin, The Body Beneath, The Man with Two Heads,* and *Torture Dungeon.*

"Andy was an S&M motorcycle freak, but a good director," said playwright Paul Foster, who was connected to another Off-Off-Broadway theater, Café La MaMa. "He was outrageous. He would say anything and do anything, which was exciting because it was new. Andy was quite a character." Robert Patrick added, "Andy Milligan was a dress designer and into S&M, as pretty boys learned when they first hit the Cino." He staged a homoerotic dance during his production of Jean Genet's *Deathwatch* at the Cino, and Milligan's version of Genet's *The Maids* had a lesbian sex scene that was sizzling for its time.

For extra money, Joe Cino sometimes tried to capitalize on the Village's reputation by organizing groups of tourists to watch a "beatnik session." Talbot recalled sitting outside his Cornelia Street apartment one day with another straight-but-not-square friend, Milton Wyatt, when a tourist bus pulled up. "Milton said to me, 'Oh, here comes the bus! Quick! Kiss me!' So we put on our little performance for them."

Greenwich Village was filled with eccentrics and bohemians, but it was also where many families and kids resided, such as Lisa Jane Persky. "This place had a certain history in it," she said. "It called to people who wanted to feel comfortable being different." When Persky's parents first moved to the Village in 1962, they stayed in a nearby apartment building off Sheridan Square. One of the first sights she saw while looking outside her bedroom window was Bob Dylan, who was sporting the same coat he wore on his first album cover.

Bibbe Hansen was another kid who grew up in the Village—living at 609 East Sixth Street, between Avenues C and D, and on Great Jones Street. Her junior high school was in Greenwich Village, where her teachers imbued students with a utopian outlook. "One of the things to really get about these times is how incredibly optimistic we were, how incredibly blessed we felt," Hansen recalled. "We conquered childhood diseases and diphtheria and smallpox and polio, and we were conquering the civil rights injustices."

It felt like so many evils were being eradicated, and they were inheriting a new world in which the seeds of social justice were finally bearing fruit. "When I was little, going to P.S. 41 in second and third grade," Persky added, "it was hammered into us that we were in a melting pot. So I thought by the time I'm an adult, there

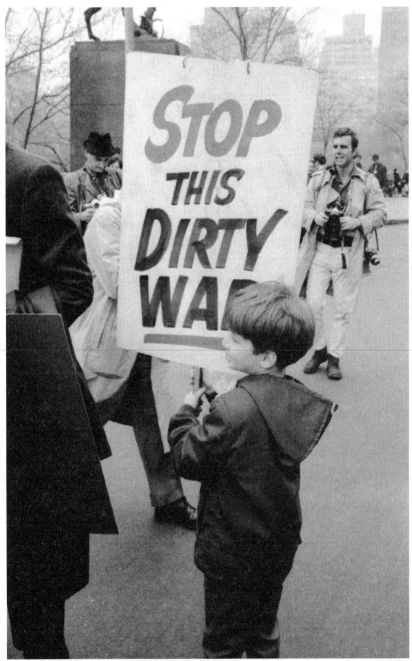

Antiwar demonstration, April 15, 1967
© SYEUS MOTTEL

will be so much interracial marriage that we'd all just be one color." It was common to see interracial couples in the neighborhood, along with other sights that would have scandalized people in other parts of the country.

The peace movement thrived in the Village, and Hansen's school chums were the son and daughter of poet and activist Grace Paley. One day in 1963, she tagged along with them to an early protest against the Vietnam War while conservative Italian Americans threw tomatoes and shouted epithets at them. (As the 1960s wore on, New York City became a hotbed of antiwar activism.) The poet and activist Ed Sanders also joined Paley when they renovated a storefront on West Third Street, between Bleecker Street and Sixth Avenue, which became the Greenwich Village Peace Center. "Meeting Grace Paley and Bob Nichols was a big inspiration," recalled Sanders, who had recently relocated from his Missouri hometown before gaining notoriety as the frontman of the Fugs and the publisher of *Fuck You/A Magazine of the Arts.*[2]

In addition to biological families, Greenwich Village offered informal kinship systems that welcomed people like Agosto Machado. He arrived there in the late fifties after growing up in some rough New York neighborhoods, such as Hell's Kitchen, where he heard schoolyard taunts like "Ooh, you're so queer you should go to Greenwich Village." "People came from different parts of the city to express yourself in the Village," Machado said. "I didn't really feel I was part of the majority culture, which is why so many people who were trying to find themselves gravitated there."

Just being gay made one a criminal and an outsider. In the early 1960s, a man still could be arrested for wearing women's clothes in public, so Machado and his friends would carry their drag finery in shopping bags and then change once they hit a critical mass. After the sun went down, they promenaded up and down the street—sometimes gathering by Gay Street, which intersected Christopher. "Honey, where are we? *Gay Street!*" they'd all shout. It was safety in numbers. "The queens, all the way down Sheridan Square, would have an audience," Machado said, "people walking by, people on the stoop. And as the evening wore on, they got a little louder and grander—showing their new fabric they got, or a new wig. It was a street society, and you could walk around and feel that your community would protect you."

The street scene on Christopher functioned like an extended family for those who had been rejected by their own relatives, an embracing place where social networks formed. "There was no internet," Machado said, "so how do you find out what's happening? You go out on the street and you can hang out in Sheridan

Square, Washington Square Park, and you'd find out more or less what people were doing." He likened it to street theater, with different people making an entrance—"Hi, *girl!* What are you *doing?*"—and putting on a show.

Roller-Arena-Skates (also known as Rolla-Reena Skeets) glided around on cobblestone streets while wearing a soiled dress and holding a wand, looking like a shabby Glinda the Good Witch. Another street character named Bambi cruised Christopher Street with his little dog, day and night, until some queens found him frozen to death one winter evening. That night, Lisa Jane Persky huddled on the stoop with her neighbors Rosie and Ernestine as they watched the cops zip Bambi into the body bag. The next day, he was back in his spot sitting on the stoop across the street; it turned out Bambi had awakened in the morgue. "I don't know who was more scared," he told Lisa, "me or the guy who heard me scream."

Machado fondly remembered the vibrancy of Sheridan Square and Christopher Street, where people socialized and made connections. "Oh, I'm going to sing in the chorus at the Judson Church," someone might tell him, "and why don't you join?" Agosto added, "There was the Judson Church circle merging dance and Happenings, and Caffe Cino and La MaMa, plus other alternative groups, plus street theater. They were just hanging out, and you expressed yourself on the street, developed your own persona, and then figured out your own place in that world. You could reinvent yourself."

CHAPTER 2

Shirley Clarke's Downtown Connections

Shirley Clarke's journey from modern dance to independent film and experimental video embodies the downtown's boundary-blurring. Like all the main characters introduced in these early chapters, she straddled many scenes and faced even more obstacles. While the gay men at Caffe Cino were subject to routine homophobia outside their little theater's walls, Clarke dealt with rampant sexism that left her emotionally bruised but defiant, as did her home life. Her father was a difficult man who wanted a son to take on the family business, but he instead had three daughters. Worse still in his mind, he was saddled with *artistic* daughters: Shirley became a dancer, and her sister Elaine Dundy took up writing and authored the bestselling 1958 novel *The Dud Avocado*.

"Shirley argued with Daddy, pitted herself against him, knowing full well the denunciations and derisive mockeries she was subjecting herself to," Dundy wrote in her memoir, *Life Itself*. "It made dinner a different kind of hell, but she stood her ground. Nevertheless, I know his constant disapproval took its toll on her. She was wounded by him in a way that would last for the rest of her life and lead her to seek more and more dangerous ways of rebelling against him."[1]

At least Shirley's class position allowed her some comfort; her grandfather had invented and patented an industrial screw that made the family millions. Clarke used the money as a cushion at times, but she spent much of her life trying to escape the bourgeois trappings of her upbringing. Before she dove into the world of downtown bohemia in the 1960s, she lived a respectable middle-class life married to Bert Clarke, a successful art book designer. She had married Bert in 1942 and settled in an uptown brownstone not far from where Andy Warhol lived, then gave birth to her daughter Wendy in 1944.

"My mom started off as a dancer," Wendy Clarke said. "In the beginning, when she was in high school, she wanted to do something that nobody else in her class did. So it was dance." Dundy noted that her sister's clothing and hair resembled those of modern dance's charismatic leader, Martha Graham. Shirley would

swoop down to pick up a book without wasting a movement, and she retained this attention to motion throughout her filmmaking career—which began when she rediscovered an old wedding present: a home movie camera.

Shirley Clarke's early films were multimedia experiments that explored how dance movements worked in dialogue with camera movements and edits. Her first short film—*Dance in the Sun*, a collaboration with choreographer and dancer Daniel Nagrin—effortlessly melded the expressive worlds of cinema and dance. "She would have a gesture that Daniel was making with his arms onstage in the rehearsal hall in New York," Wendy said, "and there would be a cut to the completion of that gesture that was shot on the beach. When she got into film, she was a really good networker, and people came over all the time. Jonas Mekas and other people came over for dinner and they would all show each other the films that they were working on."

Mekas and Clarke were classmates in 1950 at City College of New York, where she studied film with Dadaist Hans Richter. Mekas and Clarke stayed in touch and eventually formed the New American Cinema Group in 1960, along with other likeminded filmmakers. This group advocated for a low-budget, more personal and auteurist approach to cinema; their manifesto stated: "We don't want false, polished, slick films—we prefer them rough, unpolished but alive."[2]

By 1962, Mekas began hosting Film-Makers' Cooperative screenings at his loft at 414 Park Avenue South, between Twenty-Eighth and Twenty-Ninth Streets. "A normal evening at the Film-Makers' Cooperative," Mekas recalled, "you could see Allen Ginsberg, you could see Robert Frank, you could see Larry Rivers, you could see Bob Kaufman or Jack Smith—all the filmmakers, painters, or musicians. It was a mix, and not as separated as today. They were very close, they were using each other."

Mekas's loft was the office of the Film-Makers' Cooperative, a space lined with shelves of films and an old Moviola film-editing machine that Jonas slept under to save space. "It was also the office of *Film Culture* magazine," he recalled, "and then we built a space with a screen that was good enough for twenty people or so. Every evening, filmmakers used to bring their own films and friends to check what they did just a few days ago. It was very, very active. The low-budget or no-budget filmmakers stuck together because they had nothing to lose and nowhere to go. Nobody wanted to distribute our films, but here we had our own distribution center. The rule was, no film was rejected. The film, good or bad, is your ticket."

Shirley Clarke made a variety of experimental shorts before her first feature-length film in 1961, *The Connection*, adapted from Jack Gelber's play, which had been a hit for the Living Theatre in 1959. Founded by Judith Malina and Julian Beck in 1947, the Living Theatre was at the forefront of the 1950s Off-Broadway and 1960s Off-Off-Broadway movements. "New York theater at the time was just glittery entertainment—very, very glamorous and all that," recalled *Village Voice* theater critic Michael Smith. "So the Living Theatre was very much an alternative to that, completely going against the mainstream culture."

Before future *Voice* rock critic Richard Goldstein joined the paper in 1966, he saw Off-Broadway shows like Eugene O'Neill's *The Iceman Cometh*, Edward Albee's *The Zoo Story*, and Samuel Beckett's *Krapp's Last Tape*. "But my favorite company was the Living Theatre, and the reason I liked them was that they were really ragged," Goldstein said. "There was no class pretension about them. I also liked it because, unlike the other stuff that I saw, their work was very physical and sexual. There would be nudity almost always. I was always starved for physicality, so I really responded to it."

Off-Off-Broadway director Larry Kornfeld honed his skills at the Living Theatre before directing dozens of shows at the Judson Poets' Theatre throughout the 1960s. "Judith Malina, Julian Beck, and I hit it off right from the beginning because we saw eye to eye about aesthetics," he said. "We were breaking away from commercialism in New York theater and were influenced by Brecht, the Berliner Ensemble, and the new movements in avant-garde theater."

Since its founding, the Living Theatre remained itinerant. After its West Ninety-Ninth Street location was closed, Kornfeld joined Malina and Beck when they were preparing to open their final location on West Fourteenth Street, on the northern edge of Greenwich Village (where *The Connection* debuted). The Living Theatre was also part of the broader antiwar and civil rights struggles during this time. "We marched on the White House in the fifties to ban the bomb," Kornfeld said. "So that kind of political reaction to the status quo fell in line with the artistic reactions—you can't separate them. It all fit together by the end of the fifties into the sixties, when there was the beginnings of an anti-bomb, anti-war, anti-middlebrow movement."

"My experience at the Living Theatre was a five-year period in which every day I was stage managing, directing, acting, learning—soaking it all in," he added. "And also being part of the many artists, dancers, and people who came to the Living Theatre—like John Cage, Merce Cunningham, and so many others." Experimental music composer Cage is perhaps best known for *4′33″*, a

"composition" that instructed musicians to sit in silence for exactly four minutes and thirty-three seconds. It was a kind of art prank that also expanded the sonic possibilities of music-making by integrating ambient and environmental sounds into the performance.

"Pretty soon you begin to hear chairs creaking, people coughing, rustling of clothes, then giggles," said Cage's future collaborator David Tudor, who attended the second performance at Carnegie Recital Hall. "Then I began to hear the elevator in the building. Then the air conditioning going through the ducts." Eventually, as Tudor recalled, the audience began to realize, *Oh. We get it. Ain't no such thing as silence. If you just listen, you'll hear a lot.*[3]

4'33" represented a clean break from the past. Painting, dance, theater, literature, and music were moving away from romanticism, realism, and sequential narrative into more abstract forms throughout the 1950s. "Almost everybody got tired of the old kind of plots, old kinds of choreographies, that they had seen again and again—the same," Jonas Mekas said. "Times were changing, new sensibilities. A new generation looks at everything differently."

Cage and his longtime partner, choreographer and dancer Merce Cunningham, were closely involved in the overlapping downtown arts scenes. The two rented a studio on the third floor of the Living Theatre, which accelerated the cross-fertilization of scenes. It wasn't unusual for Cage to compose a musical piece for a Cunningham dance performance, with set pieces designed by their painter friend Robert Rauschenberg. "They became immersed with that world—the New York school of painters, the San Remo bar, the Cedar Tavern," Kornfeld said. "We'd go from our living rooms to the theater, from theater to bar. It was a triangle."

The Living Theatre's Monday Night Series, held during the acting company's night off, hosted many kinds of artists: musicians John Herbert McDowell and Bob Dylan, painters Robert Rauschenberg and Andy Warhol, poets Diane di Prima and Frank O'Hara, dancers James Waring and Freddie Herko. In his memoir *Fug You*, Ed Sanders recalled that the Living Theatre "was an important place in my personal world. I had heard historic poetry readings there; I had first seen Bob Dylan perform as part of the General Strike for Peace in February '62 . . . [and] I had typed the stencils for the recent issue of *Fuck You/A Magazine of the Arts*."[4] It was this latter endeavor—his infamous mimeographed poetry zine, *Fuck You*—that established Sanders as a ubiquitous downtown presence.

When the Living Theatre staged Paul Goodman's *The Cave*, the group was fully prepared to go to jail. One scene contained three uses of the word *fuck*—something that was unheard-of—but these ahead-of-their-time punks staged it anyway.

Fittingly, one of the Living Theatre's workers, Peter Crowley, spent time there well over a decade before he began booking the Ramones, Blondie, and other punk bands at Max's Kansas City. In both venues, he witnessed the dissolution of barriers that separated audiences from performers.

After running away at the age of seventeen to join the circus (literally: Crowley worked for Clyde Beatty–Cole Bros. as a sideshow laborer), he moved to New York in 1959 and got involved with the Committee for Non-Violent Action. Crowley met Malina and Beck at a demonstration and began working in the theater's lobby and bookshop, taking acting classes on the side. "The Living Theatre's involvement with the peace movement was an attraction, and the plays themselves were fascinating," he said. "They did *The Connection* and *The Brig*, those are the two famous ones."

The theater's jack-of-all-trade's Larry Kornfeld was given Jack Gelber's script for *The Connection* and immediately fell for it, so he brought it to Malina. She directed the play, which centered on a group of men waiting for their drug connection named Cowboy (played by Carl Lee, who became Shirley Clarke's longtime companion). "*The Connection* broke down the wall between the audience and the actors," Crowley recalled. "The realism of it was pretty radical at the time. They had junkies playing junkies. I mean, not that every actor there was a junkie, but some were. And then a real jazz band was part of the show."

The Connection was framed as a play within a play. A man who introduced himself as the show's producer told the audience that he brought in actual heroin addicts to improvise on the playwright's themes for a documentary they were shooting. In exchange for their cooperation, he explained, the men were promised a fix. The show's first act consisted of the junkies waiting for the heroin, and during *The Connection*'s intermission the performers wandered into the crowd and bummed change. "It had the actors, still in character, haranguing the spectators for money during the intermission so convincingly that they left profound doubts in the audience as to whether or not they were the real thing," Elaine Dundy recalled. "It was, to use a word just gaining favor, a Happening."[5]

The Brig, the other show Crowley mentioned, was a devastating play by Kenneth Brown about the brutality of army prisons. It was poorly received within power circles, which may have led to the Living Theatre's West Fourteenth Street location being closed by the government. "*The Brig* was an incredibly powerful play," Kornfeld recalled, "and Judith did an absolutely powerful production. It seemed to all of us, and to many people, that there was a political reason why the Living Theatre had been shut down."

Malina and Beck were behind on their taxes and had already made a payment arrangement with the IRS, but in 1963, after *The Brig* opened, federal authorities padlocked its doors. "People climbed into the theater," Kornfeld said, "and the actors were out the windows yelling." After temporarily "liberating" the theater, the Living Theatre did one final unauthorized performance before the company exiled themselves to Europe for the better part of the decade. This also marked the start of the city government's war on venues that catered to the underground, which shuttered many a gay bar, coffeehouse, and Off-Off-Broadway theater in an attempt to clean up New York's image before the 1964 New York World's Fair.

In 1959, Shirley Clarke asked her sister Elaine Dundy if she could recommend a short story or play to adapt as her first feature-length film. "I didn't even have to think," Dundy said. "Something that would suit her right down to the depths of her avant-garde soul was the Off-Broadway play *The Connection*."[6] After Shirley optioned the film rights, she and playwright Jack Gelber collaborated on the screenplay, which incorporated the presence of cinema verité documentary film-makers into the plot. "Shirley was like a rushing river," Gelber recalled. "Warm, quick, garrulous, laughing at the slightest provocation, she seemed ready to jump at any new experience out there."[7]

Bursting with energy and determination, Shirley shot the film over the course of nineteen days in a bare loft that doubled as a set. "They brought in a piano for Freddie Redd and his band," said *The Connection*'s film editor Patricia Jaffe. "The windows were real and the walls were real, and then they brought in some furniture and a lightbulb, but that was about it." Jaffe was ideal for this project because she had already worked with documentary legends Richard Leacock, D. A. Pennebaker, and the Maysles brothers, and understood what Clarke was attempting to do.

"Shirley was influenced by what we were all doing then," Jaffe said, "which was making cinema verité films. She also did some handheld shooting while we were working, so that was unusual for a woman, to be handling a camera." Clarke's film subtly critiqued the assumptions that underpinned cinema verité by showing how documentary filmmakers often unintentionally influenced onscreen action with their very presence. (She further explored this theme in her two subsequent feature films, 1963's *The Cool World* and 1967's *Portrait of Jason*.)

Clarke's dance career also shaped *The Connection*; it was shot in carefully choreographed long takes and deftly edited together by the two women. Jaffe

Shirley Clarke on location in Harlem while filming *The Cool World*
COURTESY THE WISCONSIN CENTER FOR FILM AND THEATER RESEARCH

recalled how Clarke came to the editing room smoking a cigar while dressed in pants and a jockey cap. "I was eight months pregnant at the time, and we had a cutting room at 1600 Broadway," she said. "People used to open the door just to look at the two of us. We were such an unusual pair."

The New York State Film Agency labeled the film obscene, based on the use of the word *shit* as slang for heroin (as well as the brief appearance of a nude picture of a woman on the set). The D. W. Griffith Theatre, hoping to make a name for itself as an art cinema, screened it on October 5, 1962, and was promptly busted

by the police. Although it couldn't be shown in commercial theaters, the progressive Judson Church held a private screening. "Both performances were packed," Judson pastor Howard Moody recalled. "We didn't know whether the district attorney's office would try to shut it down, but no one appeared."[8]

Before it was banned in New York, *The Connection* became a massive critical hit at the 1961 Cannes Film Festival—an artistic triumph that coincided with the end of Shirley's marriage to Bert Clarke. "At Cannes Shirley's hour had come," Elaine Dundy recalled. "She was heroine of the Beats, the Queen of Cool. And she had found her Prince Charming. She and the young black actor, Carl Lee, who played Cowboy, the Connection himself, had fallen in love. She would later tell me he was the only thing that mattered to her in the world, the great love she had been waiting for all her life."[9]

In November 1962, the New York Court of Appeals lifted the ban on *The Connection*, though by this point Clarke had moved on to her next feature. *The Cool World*, released in 1963, was also shot using handheld cameras and high-contrast film stock in a cinema verité style. It was based on Warren Miller's best-selling novel about Harlem teens and was shot on location with nonprofessional actors, further giving the film a gritty realism. "It was Carl who gave her the entry into this world," Dundy recalled, "where he was a man of substance, a respected presence in the cool black underworld. Without his endorsement of her, Shirley would not have had access to record it so intimately."[10]

Wendy Clarke, who helped her mother through all the stages of the production, recalled that it was the first feature film shot in Harlem using inexperienced actors and ordinary people. "Over two thousand folks auditioned for *The Cool World*, and I got the role," said Hampton Clanton, who was cast as the lead—Duke, a fifteen-year-old gang member. "I never acted before, so there was a lot of things I never did, like look at a script." He grew up in the projects, though Clanton himself was nothing like the character he portrayed. His parents raised seven kids who went to church every Sunday and stayed out of trouble. "But I grew up on the Lower East Side, where all of that was around me," he said. "The gangs were prevalent, man."

Clanton had been employed as a summer youth worker at St. Augustine's Church when Carl Lee came by scouting for young actors and encouraged him to audition. When Clarke asked the aspiring actors to improvise a gang scene during auditions, everybody was quiet until Hampton shouted from the back, "Get that motherfucker!" They all started fighting, and she said, "Bring that kid over here." Clarke and Lee sat Clanton down and gave him a script, which he had

difficulty reading because he had never seen one before—though that didn't stop the fourteen-year-old from landing the role (he has since appeared in dozens of films, as Rony Clanton).

Over a half century later, Clanton vividly remembers the production. "Shirley was very focused, very creative," he said. "We're talking about 1962, right? Because

Shirley Clarke directs cameraman in DIY wheelchair dolly
COURTESY THE WISCONSIN CENTER FOR FILM AND THEATER RESEARCH

of Shirley, I was one of the first cats that walked around with an Afro back then, in 1962, because of working on this movie. Duke was one of the first cats who was wearing it natural, which was the way Shirley wanted it. That's how innovative this film was."

The Cool World begins with speech by a black nationalist street preacher in Harlem and then follows youths over the course of a day—intimately portraying blackness in ways that Hollywood still has not caught up with. In contrast to mainstream films about blacks that were narrated from a white perspective, such as *To Kill a Mockingbird*, it was presented entirely from an African American point of view.[11] "Shirley was a genius," Clanton observed. "She worked hard, man." Clarke not only broke new narrative ground, she pioneered a new visual style by having cinematographer Baird Bryant carry a bulky 35-mm camera during the whole shoot. "That was unheard-of at that time," Clanton said. "Shirley took a clothesline and dollied the camera, going back and forth. When I look back at her creative genius as a filmmaker, I'm amazed."

While *The Connection* and *The Cool World* featured African American actors, the downtown visual art, film, dance, and literary scenes were dominated by white artists. "Clearly, some of the reasons for that relative absence have to do with limited access and training opportunities available to African Americans before the Civil Rights years," dance historian and critic Sally Banes noted. "That is, many black artists may not have had a taste for the kind of iconoclast activity—the product of some measure of educational privilege—in which the white artists reveled."[12] The avant-garde was seen as too marginal for many black artists, who aspired to have more mainstream success, while others chose to distance themselves for political reasons. LeRoi Jones, for instance, walked away from the downtown scene by embracing black cultural nationalism, resettling in Harlem, and changing his name to Amiri Baraka.

Before he made that move, though, Jones was drawn in by the Village's mysterious charms, which liberated him from the constraints of American society. When he arrived there in the late 1950s, he recalled, "I was struck by the ambience of the place. People in strange clothes. One dude I saw on the streets then dressed up like a specter from the Middle Ages, like some jongleur wandering through the streets, complete with bells and all. I wondered then, what wild shit lurks behind this creature's eyes?"[13] The downtown was no utopia, but it was still a relatively open place where many races intermingled—at least compared to the rest of the country, which was still in the throes of Jim Crow segregation.

CHAPTER 3

Andy Warhol Goes Pop

Growing up during the Depression in a working-class immigrant family near Pittsburgh, Andy Warhol spent much of his early life on the outside looking in. The seductive world of consumer goods remained out of his reach as a child, and as an adult he found himself shut out of the fine art world because of his advertising background. Andy's first published drawing was, appropriately enough, an image of five shoes going up a "ladder of success," published in the summer 1949 issue of *Glamour*.[1] By the 1950s, Warhol had established himself as a successful commercial illustrator—a profession that clashed with prevailing notions of what it meant to be a "real" artist.

Abstract Expressionism, which was exemplified by hard-drinking macho painters like Jackson Pollock, dominated America's postwar painting world. Its frenetic, expressive style was celebrated by American and European critics as the authentic, spontaneous eruption of the human spirit—an antidote to the deadening standardization of popular culture that Andy grew up with and admired. If Pollack's drip paintings communicated a wild emotional intensity, Warhol's silkscreened prints were deliberately flat and deadpan, the antithesis of the Abstract Expressionist aesthetic.

As was often the case throughout his career, Andy was more a popularizer than a pioneer. By the late 1950s and early 1960s, Jasper Johns and his boyfriend Robert Rauschenberg were already pushing back on the art world's informal ban on real-world objects by painting familiar things like flags, targets, and maps. They made their work under the influence of their friend John Cage, who encouraged others to incorporate chance methods and mundane materials from mass culture into their work. During this time, Sally Banes noted, artists turned their attention to everyday life: "It had become a symbol of egalitarianism, and it was the standard stuff of avant-garde artworks and performances."[2]

Downtown artists not only reoriented the taken-for-granted sensibilities of the New York art world, they also shifted its center of gravity away from the

established uptown galleries—much as Off-Off-Broadway did. Over the course of the 1960s, several important galleries opened in Greenwich Village and, a bit later, in what became known as SoHo.

By 1962, the term *Pop Art* was being applied to work produced by the likes of Claes Oldenburg, Roy Lichtenstein, and its poster man-child, Warhol. Pop Art's buzzy, glowing sheen fit the cultural mood of the day, when the consumer economy exploded with color and abundance. This public interest intensified after Warhol's first solo show at the Stable Gallery in November 1962, which featured his silkscreened Marilyn Monroe portraits, Coca-Cola bottles, and other works that became iconic. Metropolitan Museum of Art curator Henry Geldzahler threw a party the night of the opening, attracting art world heavy hitters and popular writers such as Susan Sontag and Norman Mailer. Ivan Karp, who later founded one of SoHo's first galleries, was the event's DJ. He played the Shirelles, the Crystals, and other Brill Building pop hits, while Jasper Johns did the twist.

Pop Art ran counter to the serious sensibilities of Ab-Ex painters, who treated commercial culture with contempt and thought Warhol's work was vapid and commercial (he was happy to be guilty as charged). "I think Andy Warhol comes out of exhaustion," said Judson Poets' Theatre director Larry Kornfeld. "The Abstract Expressionists work is based on energy, the output of energy, and Warhol was a depletion of energy to a point where it's quite fascinating. Andy's work is basically despairing, and the Abstract Expressionists are very joyous."

"My personal impression was that Andy was of a different world," Kornfeld added. "Andy was just somebody on the scene who did his thing. My friends were almost all Abstract Expressionists—Franz Kline, Willem de Kooning, Robert Rauschenberg—and I never considered Warhol of their quality, though it was quite clear he was being very successful in doing everything in a way that made himself successful. So there's two ways you can look at that kind of work. You can be very judgmental and put them down or you can just accept them for who they are. I think a lot of people resented his success."

For some of the chest-beating, chin-massaging painters whose work was quickly being supplanted by Pop Art's new guard, Warhol's persona was too fey to be taken seriously. (This was another criticism Warhol never bothered to counter.) The disdain many felt for Warhol wasn't necessarily driven by homophobia; it was more a clash of sensibilities. "The Abstract Expressionists tended to be heterosexual, but the great champion of the Abstract Expressionist movement was Frank O'Hara, who was gay and somewhat swishy," Kornfeld said. "The Abstract Expressionists had nothing against gay people. I think the painters of

that period were very, very serious—heavy drinkers, serious, sexual—and Warhol was basically a-sensual and asexual."

Andy Warhol circulated among the artists, poets, theater people, and gay crowds that populated Greenwich Village bars such as Lenny's Hideaway, the San Remo, and the White Horse—which were central nodes in social networks that connected artists who worked in different mediums. Playwright Robert Heide first encountered Warhol around 1960 at a place named Aldo's on Bleecker Street, a relatively upscale gay restaurant with white table cloths. "That's where I met Andy," Heide said, "but I didn't really connect with Andy until a little later, though I would see Andy now and then in different situations."

In the late 1950s, Heide began coming to the Village from his parents' house in New Jersey, hanging out in the Gaslight on MacDougal Street and other coffeehouses. Before it became known for hosting Bob Dylan performances in the early 1960s, the Gaslight was a haven for Beat writers. "One night there was Allen Ginsberg, Jack Kerouac, Gregory Corso, Jack Micheline, Ted Joans, Taylor Mead—all these people," he recalled. "So I was the middle of this crazy scene." Heide permanently settled in Greenwich Village, and by 1965 he began working with Warhol on screenplays for some of his early films.

Along with Lenny's Hideaway on West Tenth Street and Seventh Avenue, the San Remo was another regular stop on the downtown circuit—a traditional village tavern with pressed-tin ceilings and wooden walls that was further south, on MacDougal Street and Bleecker. There, playwrights Harry Koutoukas and Tom Eyen rubbed shoulders with eccentric characters like Ian Orlando MacBeth, who spoke in iambic pentameter, dressed in Shakespearean garb, and sometimes wore a live parrot on his shoulder. (He also dyed his beard pink.) MacBeth and others favored a drink called the Clinker, a powerful apricot brandy concoction served in a brass cup. "People would wind up on the floor drinking these things," Heide recalled. "They were really powerful."

Koutoukas appropriated MacBeth's affectation and began wearing a stuffed parrot on his own shoulder. The bird perched on his black cape was as much tongue in cheek as it was a genuine attempt to cultivate himself as a memorable Village character. "Harry created this persona with his colorful clothing and dramatic flourishes," Heide recalled, "and Andy Warhol as well. Andy created a whole persona that was kind of the opposite of Harry's: affectless." Whereas Koutoukas dramatically waltzed into the San Remo—with a cigarette held high, wearing his cape and stuffed parrot—Warhol was more likely to be barely seen and not heard, quietly sitting at a table, observing.

Kornfeld and his friends usually started out at the Cedar Tavern in the evening and then headed over to the San Remo. "It was wilder," he added. "San Remo was more outré. Usually, there would be a lot of chatter and then there'd be a crash. Something would drop and break, or someone would fall off their stool, and you would sort of know that the night was going to get wild. We all gathered at the San Remo and the Cedar Tavern, people from all those theaters—the Living Theatre, the Judson Poets' Theatre, the other Off-Off-Broadway theatres like St. Mark's Church, all of them. We all knew each other. We all knew the Abstract Expressionist painters, and the poets, and the musicians. So it was a social, cultural, artistic camaraderie."

Through these social scenes, Heide got to know some Warhol associates, like Billy Name (born William Linich). "I immediately was attracted to Billy," Heide said. "He had a terrific aura, and was very good-looking, wearing tight black dungarees and a white shirt. So we carried on." Billy ended up living at Warhol's Factory studio, working as its unofficial custodian when it opened in 1964 until the end of the decade. Before meeting Warhol, he was already embedded in a variety of downtown scenes: experimental dance, Off-Off-Broadway, and the subterranean world of the Mole People, a group of gay speed fiends also known as A-heads (*A* as in *amphetamine*).

Billy Name learned lighting design in underground theater and apprenticed under Nick Cernovich, who was part of the Black Mountain College group that also included John Cage (dozens of experimental artists passed through that influential North Carolina school). Billy lit shows at Judson Church and the Living Theatre, as well as the New York Poets Theatre. The latter venue was founded by dancers James Waring and Freddie Herko, along with poets LeRoi Jones, Diane di Prima, and her then-husband, Alan Marlowe. In typical downtown fashion, the New York Poets Theatre was run by people with no theatrical experience.

Warhol's connection to the underground poetry world intensified when Gerard Malanga, a poet who also had a background in commercial printing, became his primary printing assistant in the summer of 1963. The two began working together in an uptown studio near Warhol's brownstone home until the artist needed a larger studio, leading to his acquisition of a space in a midtown industrial building that became the Factory. By this point, Warhol had shifted from creating paintings with brushes—as he did with his famous Campbell's soup can series—to his mass production–inspired silkscreened prints.

By many accounts, Warhol was inspired by the amateur techniques used to make the experimental films, mimeographed poetry zines, and Off-Off-Broadway

theatrical productions he was taking in. He then applied this DIY approach to his own messily printed silkscreens. "The spirit of the aleatory, that is, of John Cage's chance operations, which Cage featured in his compositions, came into play in these early silkscreens, when talent overwhelmed technique," recalled Ed Sanders. "I was friends at the time with Warhol's assistant, poet Gerard Malanga, who told me about some of the casual and accidental silkscreen results."[3]

Billy Name's Lower East Side apartment was filled with shiny aluminum foil and other metallic surfaces that he carefully lit to create a degenerate space-age look. The interior of his apartment can be seen in Warhol's 1963 silent film series, *Haircut*, which features Billy giving poet John Daley a haircut as James Waring and Freddie Herko watched. "Andy didn't just see a guy's place and think, 'That's really cool—he's got foil all over the place,'" Name recalled. "He saw that I had done an installation."[4] Warhol asked his new employee to decorate the studio, and during the first three months of 1964 Name transformed a rather dour workspace into the embodiment of a "living art form" by covering its walls and ceiling in foil, bits of broken glass, and silver Krylon spray paint.[5]

Name's mentor Nick Cernovich worked at the time in a Zen bookstore, another big influence. Buddhism was all the rage among downtown artists such as Ray Johnson, and Warhol surely absorbed Zen's penchant for repetition in his own silkscreen prints. "You can't really understand Andy Warhol or any of these people—John Cage or any of them—without understanding Zen," said Bibbe Hansen. "All these people who were interconnected were going to Zen classes, and even people who weren't regularly practicing, like my dad, Al Hansen, would drop in once in a while."

Zen practices informed John Cage's *Untitled Event*, a proto-Happening produced in the summer of 1952 at Black Mountain College. Standing on a stepladder and wearing a suit and tie, Cage read passages on "the relation of music to Zen Buddhism" as David Tudor played a "treated" piano and Merce Cunningham danced through the aisles. The space was also decorated with Robert Rauschenberg's provocative *White Paintings* (in a Zen-like gesture, the canvases were completely painted white). "Rather than being predetermined," art historian Judith F. Rodenbeck wrote, "the interactions of any given set of actions with any other was the result of aleatory juxtaposition of performances as perceived by an audience at a particular moment, creating a temporal collision. Thus anything that happened, according to Cage, 'happened in the observer himself.'"[6]

Existentialism was also in full bloom. "*Being and Time*, by Heidegger, *Being and Nothingness*—that's what we were reading," Heide recalled. "Andy was into that

as well, and Ray Johnson particularly embodied that in many ways, and Harry Koutoukas dabbled in it as well. Billy was essentially very sweet and a little naive, and when he got into the Buddhism thing, he was very heavy into that. That's where Andy became fascinated with Billy, because Andy was always learning something from somebody."

Bibbe Hansen, who described herself as thirteen going on thirty-eight, found a home at the Factory, along with two of her favorite Lower East Side neighbors. "There was nobody in the world who was ever handsomer to my way of thinking than Freddie Herko," she said. "Billy Name did lights at Judson Church, but he was also this guy who lived a block and a half away, and Freddie was sometimes there. And at the same time, my mother's an amphetamine addict, and she's running with the whole A-Head scene on the Lower East Side, which is a particularly demented group of folks."

The Factory began as a private world occupied mostly by Name, Malanga, and Warhol—a place to get work done, an artistic factory with a seemingly passive Warhol at the center. "I think Andy was very into a kind of dumb Marilyn Monroe thing," Heide observed. "He wore the wig, and it was almost like the wig is holding in his brain somehow. Sometimes you'd see the little black wire—he didn't bother to cover it up too much."

"What'll we do today, Billy?"

"Oh, let's do the cow wallpaper."

"Okay, that sounds like a good idea."

The Factory was eventually populated by Billy's speed-freak friends, such as Ondine (born Robert Olivo) and Herko, and then the uptown's upper classes came down to slum there. Into this swinging scene stepped Baby Jane Holzer—Warhol's first "girl of the year"—followed in 1965 by Edie Sedgwick, who was virtually inseparable from Warhol until early 1966. They looked like androgynous doppelgängers, especially after she dyed her hair silver. "I always wanted to do a movie of a whole day in Edie's life," Warhol later said, anticipating the reality television aesthetic. "What I liked was chunks of time all together, every real moment."[7]

Sedgwick was the star of *Chelsea Girls* and appeared in other Warhol films—*Poor Little Rich Girl, Restaurant, Face, Afternoon, Kitchen, Beauty No. 2,* and *Lupe*—before meeting a tragic end. "Edie took a lot of drugs," said Bibbe Hansen, who costarred with Sedgwick in the feature-length Warhol film *Prison*. "Andy didn't give them to her. She would have done drugs wherever. I gave her drugs. I had drugs. My mother's boyfriend robbed a pharmacy, and I had a giant jar of speed and I was dealing all over the place. She knew Andy Warhol for a little

Edie Sedgwick and Bibbe Hansen on the set of Andy Warhol's *Prison*, 1965
COURTESY THE BILLY NAME ESTATE AND DAGON JAMES / © BILLY NAME

over a year, and it was one of the most magical times of her life, and it made her immortal, it captured her."

By the mid-1960s, Heide was going back and forth between Caffe Cino and the Factory, whose social scenes often overlapped. "There was a point when I was running a lot with Andy and Edie," he said. "Edie really had this incredible

THE DOWNTOWN POP UNDERGROUND

charisma and aura when I met her. I was riding around town with her in a limousine, and we'd go to Ginger Man and have Bloody Marys. We'd wind up out on the town. We would go to a Salvador Dalí opening, or wind up at the Rockefellers' big cement house that looked like a bank, and then there were the Factory parties. There was a big celebrity party one time with Elizabeth Taylor and Tennessee Williams. It was a real scene."

"Later on I got scared of the drugs," Heide added. "I just knew I might jump out a window or something like that if I went too far." By this point the Factory had become a magnet for drug dealers, art dealers, artsy Harvard students, Greenwich Village bohemians, dancers, poets, musicians, and every imaginable type in between. "So you had drag queens and queers," Hansen said, "children, street hustlers, rough trade, dropouts, runaways, drug dealers, psychiatric basket cases, and society bad girls. It was very much like the Greenwich Village that I came from."

Before becoming a Factory regular, Taylor Mead was already a star of underground film after his appearance in *The Flower Thief*, a 1960 film by Ron Rice. The actor, activist, and scenester Jim Fouratt fondly remembered Mead as an early performance artist whose head-scratching routines could be seen in a variety of downtown venues. During one show, he sat on a swing while wearing red long johns attached to several Campbell's soup cans. "He was doing this sort of burlesque," Fouratt said, "throwing the cans to the ground, while swinging." Taylor also read poems at the San Remo with lines like, "There's a lesbian in the harbor that has been carrying a torch for someone for a hundred years" and "Give me your tired, your poor, your huddled masses. And let me blow them."

Mead was typical of the people who surrounded Warhol, because he was given an inheritance to keep him away from his hometown. The money gave Taylor the kind of privilege that Sedgwick also enjoyed—that is, as Fouratt noted, "until Edie ran out of money, because Andy always made her pick up the check. And she always graciously picked up the check." Money was a constant source of tension at the Factory, causing Mead and many others to eventually fall out with Warhol.

On June 3, 1968, an unhinged radical and aspiring playwright named Valerie Solanas entered the Factory and shot Warhol in the chest multiple times, nearly killing him. ("Taylor told me once that if Valerie hadn't done it," Heide recalled, "he would have.") Much to Warhol's chagrin, he was upstaged a couple days later by the assassination of Robert F. Kennedy—just two months after Martin Luther King Jr. was murdered. These shootings were a symptom of the wider chaos that was spreading through America at the time, along with trouble that was brewing in many parts of downtown.

CHAPTER 4

Debbie Harry, Patti Smith, and the Pop Generation

Debbie Harry grew up in the small idyllic town of Hawthorne, New Jersey, where her parents ran a gift shop and life was dull. "I hated suburbia," Harry said, "and I always dreamt of having a bohemian life in New York." At first she found her escape through music, listening to pop songs from an early age, though she didn't collect records herself. "A friend of mine had a great record collection, and I listened to whatever was on radio," she said. "I was always changing channels and searching around." Harry and her friends watched *American Bandstand* to learn dances like the Hully Gully, the Swim, the Twist, and the Watusi to show off at their school dances. "We also did a lot of slow dancing," she said, "a lot of grinding, which was always fun, very passionate dancing."

Patti Smith was another New Jersey native who grew up on rock 'n' roll. The flamboyantly queer rhythm and blues pioneer Little Richard first rocked her world, introducing the young tomboy to androgyny. Later, in Patti's teen years, Edie Sedgwick made a similar impression with her boylike stick figure. Recalling the time she first saw Sedgwick in *Vogue* magazine during the mid-1960s, Smith described her as looking like a thin man in black leotards.[1] "That's it. It represented everything to me," she recalled, "radiating intelligence, speed, being connected with the moment."[2] Smith saw Sedgwick in person during the fall of 1965, when she accompanied Andy Warhol to the opening of his first retrospective at the Institute of Contemporary Art at the University of Pennsylvania. "Edie Sedgwick with the blonde hair and dark eyebrows," Patti recalled, "she didn't mess around. She was really something."[3]

Lenny Kaye, Patti Smith's longtime musical collaborator, was also bitten by the rock 'n' roll bug at an early age. Born in Washington Heights in upper Manhattan, he moved around with his parents to the boroughs of Queens and Brooklyn before settling in North Brunswick, New Jersey, as a teen. "Growing up in New York," Kaye said, "most of the music that came to me was seeing the older kids sing doo-wop on the corner, but of course you're also very close to the cultural

centers of Greenwich Village. Even though I was too young to go there, you felt part of the cultural crosstalk in the city."

Most doo-wop groups around the New York area were basically street bands—young men who sang on corners and in school talent shows and recreation centers. "I hoped that I would be a high tenor in a doo-wop group, and that's what singing on the corner is about," Kaye said. "But it was mostly for fun and we weren't very serious about it." This was also true of future Ramones frontman Joey Ramone (born Jeffrey Hyman) and his little brother Mickey Leigh (Mitchel Lee Hyman), who as kids heard the sounds of doo-wop street singers creeping into their bedroom. Their window faced another building across the alley, which created an echo, so kids would congregate there to sing songs like "The Lion Sleeps Tonight" by the Tokens.

Pointing out the affinities between doo-wop and 1970s punk groups, Leigh said, "Those teenagers who were singing doo-wop in the street, you could say that was the first manifestation of DIY groups. They didn't really need anything. They just needed a bunch of guys, and they figured out who was going to sing which parts." Kaye also believes that the appeal of early doo-wop had to do with its accessibility. "If you weren't trained to be a classical musician, you could sing on the corner emulating the records that you heard on the radio," he said. "It was a sense that I think punk would also access—that you didn't have go through a conservatory to make the music."

As with many boys their age, the two brothers wanted to join a band when Beatlemania erupted in the mid-1960s. "By the time I was twelve," Leigh said, "I had a little guitar and a little amp and a microphone that I'd take around to like kids' birthday parties—playing Beatles songs and Dave Clark Five with friends." He continued to play in bands around Forest Hills, Queens, where he met two older teens who, with his older brother, later cofounded the Ramones.

Before John Cummings and Tommy Erdelyi played guitar and drums as Johnny Ramone and Tommy Ramone, they performed in a 1960s garage band called the Tangerine Puppets. "Tommy was really nice, really intelligent. We were friends ever since that time," Leigh said. "John never really changed. Even back then, people said, 'Watch out for that guy. He gets a little nasty sometimes.' He was just kind of grouchy and barking to the rest of the other guys. But he was cool." Even when they were kids in Queens, the brothers felt the gravitational pull of Manhattan's downtown. Their father owned a small truck terminal around Spring Street, and they would take the F train and walk around the Village, taking in the scene.

Joey Ramone and Mickey Leigh weren't the only future punks exploring the area. As a young teenager, Debbie Harry began visiting Greenwich Village on her own in the early 1960s. "I would sort of sneak away," she said. "I was probably about thirteen. I would just get on a bus and walk around, just go into Manhattan and walk down to the Village. Of course nothing would be open during the day, but I would walk around and imagine what it was like and just look at the people, really. And then, run back home before anybody would know."

<p style="text-align:center">***</p>

Folk was also the music of the moment, and the best place to read about it was the *Village Voice*. Writers for that neighborhood paper had a connection to the downtown arts scenes that was far more intimate than, say, reporters from larger media organizations like the *New York Times*. Coverage from independent media outlets such as the *Voice*—and, later, the *East Village Other* and *SoHo Weekly News*—generated momentum and publicity for these scenes that allowed them to grow. It was a mutually constitutive relationship.

Michael Smith and Richard Goldstein (who became the *Voice*'s theater and rock critics) shaped their respective scenes through their writing, and the same was true of the paper's coverage of the folk phenomenon. The Bronx-born Goldstein first discovered the *Village Voice* in the late 1950s after listening to the independent Pacifica radio station, WBAI, which also cultivated the downtown's underground scenes. Reading the *Voice*, he learned about the folk music that was happening in coffeehouses and at Washington Square Park, and began taking the subway down there with friends. "The club that we went to the most was Gerde's Folk City in the Village, off MacDougal Street," Goldstein said. "Gerde's Folk City was one of the places that had these open mic events that we called hootenannies. That's where I saw Dylan first."

Playwright Robert Heide recalled, "At that time, in the early 1960s, everything was happening. If it wasn't in cafés doing poetry, it was Happenings, or early rock, and folk, and Bob Dylan." The Gaslight was another coffeehouse that Dylan frequented, a basement venue that could squeeze in about 125 people. The older Italians who lived on the upper floors complained about the noise that wafted up from below, and they retaliated by throwing things down the airshaft. "So instead of clapping, if people liked a performance they were supposed to snap their fingers," folk musician Dave Van Ronk explained. "Of course, along with solving the noise problem, that also had some beatnik cachet."[4]

Folk musician Peter Stampfel moved from the Midwest to New York in late 1959, just a few months before Dylan arrived in the city. They were each under the spell of 1952's *Anthology of American Folk Music*, a six-album set that was compiled by Harry Smith, another downtown dweller. By collecting folk, blues, and country songs from 1927 to 1932, the *Anthology* provided much of the source material for the folk music revivalists. "For almost the first time," Van Ronk recalled, "it gave us a sense of what traditional music in the United States was all about, from the source rather than from second- and third-hand interpreters. The *Anthology* has eighty-two cuts on it, and after a while we knew every word of every song."[5]

Stampfel recalled that there were two main schools of folk at the time: the traditionalists, who valued "authenticity," and the more polished performers who could be heard on the radio. "Each camp felt that the other was being apostate," he said. "It was the people who had heard the Harry Smith anthology and the people who hadn't heard the Harry Smith anthology, that was the dichotomy." In 1961, Stampfel was living on MacDougal Street and playing more traditional roots music at local coffeehouses. Three years later, in 1964, he founded the Holy Modal Rounders with Steve Weber, then expanded the lineup to include drummer and playwright Sam Shepard during the second half of the 1960s.

Between 1961 and 1964, MacDougal Street was crawling with coffeehouses that catered to the tourists who came downtown on weekends. Peter Crowley—who later booked Debbie Harry's and Patti Smith's bands at Max's Kansas City during the 1970s—ended up working at one of these tourist traps in 1963 after a stint at the Living Theatre. He was walking down MacDougal Street one day and saw a sign on a coffeehouse window that said Drag Wanted. Crowley inquired inside, wondering what in the world that sign meant, and was told, "Oh, we need some-body to stand outside and drag the tourists in."

"Well, *I* could do that," he said, so the manager hired him on the spot. There Crowley was, hustling tourists in front of the Why Not Café, across the street from the more famous Café Wha. "The coffeehouses were fake, where you would just drag the tourists in with the sales pitch, almost like a carnival," he said. "The opposite was done by the manager of the Café Rafio, who would stand out in front. He looked like a Viking with really long red hair and long red beard. He dressed all in black and would glower at the tourists. So having gone past all these places that tried to drag them in, tourists would see this guy standing at the doorway, giving them dirty looks, and they'd say to each other, 'Oh, this must be the *real* place,' and they would go in there."

For the largely Italian American residents who lived on MacDougal Street and the surrounding neighborhood, the influx of young people was a noisy nuisance. "The Italians were trying to drive the coffee shops on the MacDougal Street out of business because they had taken over the neighborhood and were driving them crazy," said Michael Smith. "The crowds, they ruined the neighborhood for the local Italian residents." Fellow *Voice* writer Richard Goldstein was one of those kids who flooded the area. "Washington Square became sort of the matrix of the folk scene," he said, "and that's why those clubs around the square started to play folk music."

MacDougal Street intersected with the park on its south side, creating a critical mass that included Wendy Clarke, the daughter of Shirley Clarke, who was another regular at Washington Square Park. "It was such a mixture of gay and straight and black and white," she said. "You talked to anybody and everybody, and there was a lot of hanging out on the street. I loved walking around the Village, barefoot."

Back when Debbie Harry began catching the bus from New Jersey to wander the streets of Greenwich Village, Chris Stein (her eventual boyfriend and Blondie cofounder) was taking the subway to hang out in the area. "I used to come in from Brooklyn a lot," said Stein, who would not meet Harry until 1973. "It was an interesting time, right after the Beatles came along. We used to play Washington Square, just hanging out there playing banjo and finger-picking stuff. We went to the clubs there to see groups, all that folk stuff."

Ed Sanders moved downtown to attend New York University, which surrounded Washington Square, one of his regular haunts. He would sit on the park's benches and set music to William Blake's poems "The Sick Rose," "Ah! Sun-Flower," and "How Sweet I Roam'd from Field to Field," songs that provided the kernel of identity for his group the Fugs. He formed that provocative noise-folk-rock band with Beat-era poet Tuli Kupferberg, then added the Rounders' Peter Stampfel and Steve Weber to the lineup.

When the city passed an ordinance banning musical performances in the park, the folk crowd pushed back hard. "There was the *New York Mirror* headline, 3,000 BEATNIKS RIOT IN VILLAGE, on the front page," recalled Goldstein. "That was for the right to sing in the square, and we won. So that became a huge gathering place, *huge*." Judson Memorial Church, which sat on the southern border of Washington Square, played a large role in lobbying the city to give folkies the freedom to sing. Judson pastor Howard Moody argued, "[W]hen the city attempts to put a roadway through Washington Square Park or stop folk-singing in the fountain or

tear down Verrazano Street houses—it is all the same—the absence of human and personal values at the heart of decision-making. These human values must be at the center of all our growing, planning, and policing this city. To keep alive these values, to awaken people when they are threatened, to give people the courage to fight for them—this is the task of the church."[6]

The folk crowd largely turned up their collective nose at rock 'n 'roll—which was seen as teenybopper music, unsophisticated and vapid—an opinion that was not shared by Peter Stampfel. "There were a fuck-ton of great pop songs then, because pop music started getting back on track in 1962," he said. "The Beatles came along in '62, Dylan's first record came out that year, so did the Rolling Stones' first album, the Four Seasons had their first hit, the Beach Boys, it was the heyday of girl groups—all this stuff happened within a twelve-month period. I stopped listening to pop radio in 1959 and I didn't start listening to pop radio until December of 1962, and I realized that most of the stuff on the radio was fucking great."

Much of what then dominated American radio was a product of a music business hub known as the Brill Building. It was an office building in midtown Manhattan located at 1619 Broadway, on Forty-Ninth Street and Broadway, that held the offices of several song publishers. The "Brill Building" more generally referred to a cluster of record companies and song publishing businesses found in buildings around the same area—such as 1697 Broadway and, a little to the south, 1650 Broadway. In between was the small Roulette Records building with a neon sign that said HOME OF THE HITS.

"The Brill Building was the musical epicenter of the New York music scene," said Richard Gottehrer, who wrote hits for pop stars and girl groups in the 1960s before producing Blondie's first two albums in the 1970s. This five-block area was an open marketplace where songwriters could pitch their tunes, hustling for a break. "Even as a kid, you could actually walk from office to office," he recalled. "Song publishers were always on the lookout for a song that they could then push on somebody else. You could build relationships with people who will be happy to see you again."

In the late 1950s, long before forming the Velvet Underground and entering the Factory fold, Lou Reed began playing rock 'n' roll in high school. At the age of fifteen he formed the Jades and in 1958 released a single, "So Blue"; then in 1962 released another poppy confection titled "Merry Go Round" under the name Lewis Reed. Both singles flopped, so Reed continued with his schooling at Syracuse University, where he met future Velvet Underground guitarist Sterling

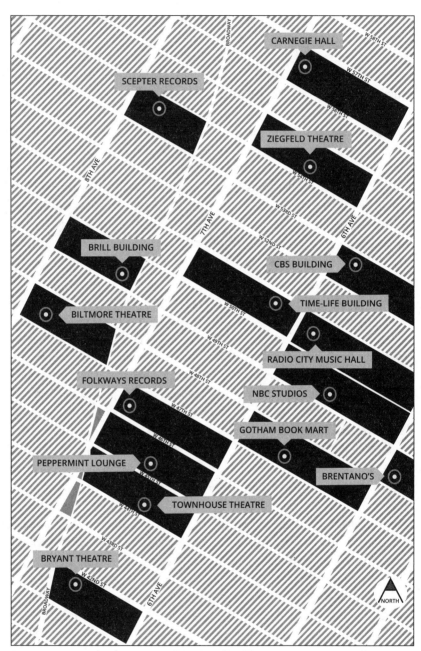

MIDTOWN MANHATTAN

THE DOWNTOWN POP UNDERGROUND

Morrison. While at Syracuse, he developed a love of experimental music forms like free jazz, but he never gave up on his pop craft.

Reed's first postcollege job began in 1964, working as a staff songwriter at Pickwick Records, a budget label that functioned as a low-rent Brill Building out in Queens. He was part of a group of four musicians who churned out knock-off pop records on a nine-to-five schedule, punching the clock and rocking out. "There were four of us literally locked in a room writing songs," he recalled. "They would say, 'Write ten California songs, ten Detroit songs,' then we'd go down into the studio for an hour or two and cut three or four albums really quickly."[7]

In 1966 Reed and his band recorded *The Velvet Underground & Nico* at the studios of Scepter Records, which was largely associated with the Shirelles and other girl groups. Eight years later, engineer Tom Moulton created the first twelve-inch extended dance remix in Scepter's studio, which became a crucial format for disco DJs. And when the disco movement was peaking in 1977, Studio 54 opened inside an old soundstage that originally broadcast hit television shows like *The $64,000 Question* and *Captain Kangaroo*. That former CBS television studio was located underneath Scepter Records at 254 West Fifty-Fourth Street—a building that produced an unlikely mix of girl group pop, left field rock, debauched disco, and children's television programming.

Back during the height of the Brill Building era, Richard Gottehrer formed a successful songwriting partnership with Bob Feldman and Jerry Goldstein, named FGG. "We became signed writers at April Blackwood Music, and they gave us a small office room in 1650 Broadway," he said. "We would sit around in a work environment with a piano in a small room and the publisher would come in and say, 'So-and-so is looking for a song for his next record.' And that's how you learned—you would try to write something that would suit them. We were constantly writing."

"For a lot of those songs, they made the song demo and cut the record in the same day," said producer Craig Leon, who worked alongside Gottehrer in the 1970s. "It was very much that quote-unquote 'punk' approach." This rapid-fire production style was used to create FGG's biggest hit, "My Boyfriend's Back," recorded by the Angels. "One day Bob Feldman came in, and he had been at his local candy store getting soda and cream," Gottehrer recalled. "Some girl came in and started screaming at a guy and literally said, 'My boyfriend's back and you're gonna be in trouble because he's gonna get you!'" They quickly wrote the song, and it was recorded and released within days.

Debbie Harry loved songs like "My Boyfriend's Back" when she was young, and learned a lot about singing from listening to them. "Their lyrical themes were a little bit different than sort of what I ended up with," she recalled. "They were all sort of a smitten and slightly abused from love, relationships. And I think my position was a little bit more sneering." One group she was drawn to was the Shangri-Las, a 1960s girl group from Queens who became punk favorites (they even reunited for a show at CBGB later in the 1970s). They sang gum-smacking odes to rebel boys, eschewing feminine clothes and copping some serious 'tude in their tunes—which often strayed into unladylike territory. "When I was a kid I thought the Shangri-Las were too commercial," Blondie's Chris Stein said, "but then later on it just clicked and I realized how awesome it was. I still think they're incredible."

When Beatlemania shook the city in 1964, its reverberations could be felt deep in the downtown underground. "Even those of us on the Lower East Side without a television set had to notice that something called the Beatles had come to town," Ed Sanders recalled. "New York DJs helped drum-beat the throng of 25,000 who shrieked hello to the group at JFK airport when the Fab Four arrived for *The Ed Sullivan Show* on CBS and two shows at Carnegie Hall."[8]

"It was the youth explosion," Bibbe Hansen said. "So whatever vestiges of the old, we were gonna just blow right away because there were just too many of us, and we were all fairly enlightened. With the Beatles and all these things, these cultural explosions absolutely captivated the world and put my generation at the forefront." The Beatles even inspired her to form a short-lived girl group, the Whippets—with Janet Kerouac (Jack Kerouac's daughter) and another friend, Charlotte Rosenthal—which released one single.

When Hansen became immersed in the Factory a year later, Warhol had been attending Ronettes and Shirelles concerts on weekends with art-world friends, and pop music constantly played on the studio's record player. They spun Top 40 singles as Sedgwick spent hours putting on makeup from her little blue Samsonite case, to the frustration of those around her. "On a typical day, Gerard Malanga would go pick up some silkscreens for Andy, and I'd go with him to the silkscreen makers," Hansen recalled. "They'd pick them up and bring them back and show them to Andy, and they'd do a little test run. Then Edie Sedgwick might come in, and the music might shift. We might dance. Chuck Wein and Edie would come in, and I might start dancing with Chuck, and then Edie would. And then maybe somebody would say, 'Oh, there's an opening at *da-da-da* tonight; let's go and eat at Voisin, and then go to the opening.' "

The Velvet Underground became part of the Factory scene around this time, though it was not the first time Warhol was involved with a rock 'n' roll group. In 1963, he played in a short-lived band named the Druds featuring himself on backing vocals, fellow Pop artist Jasper Johns providing lyrics, and sculptor Walter De Maria playing drums—along with other art scene luminaries. "Andy was very open to influences," noted Jonas Mekas, who played a role in Warhol's entry into the underground film world. "When the people from other arts with different ideas came into his circle of energy, he immediately embraced them. He was very flexible in moving into various directions and embracing new ideas."

CHAPTER 5

Ed Sanders Incites an Indie Media Revolution

Ed Sanders grew up in western Missouri, in the small farm town of Blue Springs. After briefly attending the University of Missouri, he hitchhiked to the East Coast in 1958 to attend New York University. "I soon was enmeshed in the culture of the Beats," Sanders recalled, "as found in Greenwich Village bookstores, in the poetry readings in coffeehouses on MacDougal Street, in New York City art and jazz, and in the milieu of pot and counterculture that was rising."[1] He also began volunteering at the *Catholic Worker*, a newspaper founded by activist Dorothy Day that was dedicated to social justice.

In 1962, the political poet decided to publish his irreverent mimeographed zine, *Fuck You/A Magazine of the Arts,* after a transformative experience viewing Jonas Mekas's film *Guns of the Trees,* which featured Sanders's literary hero Allen Ginsberg. The next day, in a fever of inspiration, he typed the first issue of *Fuck You* on a *Catholic Worker* typewriter using mimeograph stencils and colored paper that he "borrowed" from the newspaper. Day was furious when she found out, so Sanders then produced an issue of *Fuck You* using equipment found at the Living Theatre, a place where provocative aesthetics and left-wing politics aligned. "I went down to DC with the Living Theater to be a part of the Great March on Washington on August 28, 1963," Sanders said. "I brought along my Bell & Howell [movie camera], plus a satchel of the freshly published issue of my magazine."[2]

The Holy Modal Rounders' Peter Stampfel, who also joined Sanders in the Fugs, recalled that many Beat-era writers contributed to *Fuck You*. "The first inside page would be a rant by Sanders," Stampfel said, "like, 'Free Grass!' or 'Group Grope' or 'Total Assault on the Culture.' Basically, his rant was more interesting to me than the rest of the magazine." *Fuck You* consisted mostly of provocative poetry and experimental prose that often contained a healthy helping of expletives, such as Tuli Kupferberg's "Fuck Is God" and Carol Berge's "I Fucked a Bear and Found God," found in Volume 2, Issue 5. In another issue, Sanders mentioned that Stampfel's musical partner Steve Weber supposedly had a wild all-night sexual

romp with a gazelle in the Central Park Zoo. "Because I'm so gullible," Stampfel recalled, "I thought, 'Oh my God, that is *so cool.*'"

For the *Village Voice*'s Richard Goldstein, Sanders embodied the spirit of the underground. "What I really loved about *Fuck You*," Goldstein said, "was that each copy supposedly had a genuine drop of the editor's sperm on the cover." Sanders met many interesting and prominent people during this time, but nothing compared to the thrill of befriending Allen Ginsberg in 1964. "When I was first exploring New York City in 1958 and 1959," Sanders enthused, "I never thought in a cycle of centuries that I'd ever become friends with such a hero."[3]

He first met Ginsberg in front of Gem Spa, a newsstand located on St. Mark's Place that sold chocolate egg creams for a quarter. St. Mark's Place was a three-block street that terminated on its east side at Avenue A, in front of Tompkins Square Park, and to the west of Second Avenue it turned into East Eighth Street—a major throughway to Greenwich Village. Gem Spa was a popular hangout, where poet Ted Berrigan held court, smoking unfiltered Chesterfields while surrounded by younger poets such as Andrei Codrescu. "It was my first time staying in New York and I'm having a wonderful extraterrestrial floating experience," Codrescu recalled. "I saw Ted outside Gem Spa, and I just rushed him and said, 'Ted, I'm on acid!' And Ted just looked at me and he said, 'Yeah. I always wondered how it would feel to *kill* somebody on acid.' And I just thought it was the greatest, most wonderful thing to say. I just followed him around like a puppy for the rest of the day." (Berrigan also founded his own mimeographed zine, *C: A Journal of Poetry.*)

In late 1966, a seventeen-year-old named Richard Meyers arrived in New York, enthralled by the scrappy writers whose work appeared in those poetry zines. "The street poets I liked wanted to have fun and be direct and uninhibited, and their whole thing was mimeo," said Meyers, who later adopted the name Richard Hell and cofounded the early punk band Television. "It wasn't just that they were simply done cheaply and spontaneously. You could conceive of a book in the morning and have it at the East Side Bookstore on St. Mark's Place the next day." He added, "The mimeo magazines were also gorgeous objects. The people who were making them had really advanced ideas and high personal standards for making a book as effective in every area, including its design. The font was a typewriter, but they had great illustrations."

This nearly instantaneous form of printing strengthened the connections that had already formed through face-to-face encounters on the street, and it anticipated a mode of publishing later enabled by the Internet. "There's no question

that mimeo was a community-building tool, but we weren't thinking of it that way then," Codrescu said. "We were thinking of the fact that we could actually publish our works quickly because, if you sent it to any other magazine, it would take about a year to publish it and we weren't interested. The mimeos took one ink-stained day and three-hour street-corner distribution. Our poems were news and we had in mimeo the technology to make them news, but I'm not sure the Internet has the same kind of intimacy, even though it's instant. It doesn't have the touch of the flesh and ink on the hands."

Mimeo publications circulated among an interconnected group of artists working in a variety of mediums. The mailing list for Diane di Prima and LeRoi Jones's semi-monthly newsletter *The Floating Bear* was a who's who of the underground poetry, film, visual art, and Off-Off-Broadway worlds, which facilitated artistic and personal exchanges between these audiences on the page as well as in person. The only way to get a copy of their stapled poetry zine was to know someone who worked on it, and Andy Warhol's name was likely added to the mailing list through his association with printing assistant and poet Gerard Malanga. Soon

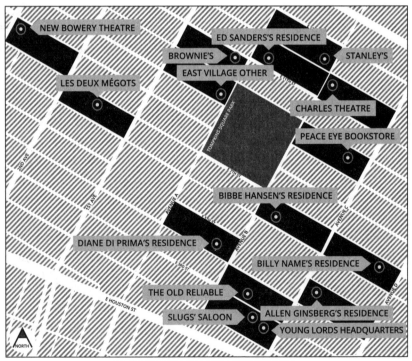

EAST VILLAGE AND THE LOWER EAST SIDE

THE DOWNTOWN POP UNDERGROUND

after the artist received an issue of *The Floating Bear* that described one of the "haircut parties" held in Billy Linich's glimmering Lower East Side apartment, Andy began shooting his *Haircut* movies.[4] Linich performed typing and collating tasks for *The Floating Bear* until he had a falling-out with di Prima, so he shifted allegiances to Warhol's Factory scene and became known as Billy Name.

Ted Berrigan got to know Ed Sanders through these mimeo zines, which anticipated the kinds of back and forth that occur on today's social media platforms. They often contained gossip and announcements about what was going on downtown, which was another way Warhol and others kept their ear to the ground. They also shared images via mimeo publications, like the time Warhol provided Sanders with the cover for an issue of *Fuck You* (a black-and-white frame from his 1964 movie *Couch*). Berrigan recalled, "There got to be groups, because there were a lot of people . . . because we had a magazine—that's how you get a group, I think, you start a magazine."[5]

The zines were distributed on the streets, via mail, and in select bookstores that served as important hubs in the downtown's social networks. "I worked part-time at the Eighth Street Bookshop," Codrescu said, "the greatest literary bookstore of all time." The downstairs room housed the traditional books with spines; poetry mimeos could be found in the store's second-floor room, which was dedicated to books from smaller publishers, such as Something Else Press. "The Eighth Street Bookshop was pivotal to a young poet in those days," Sanders recalled. "It was there I monitored little magazines such as *Yugen* and *Kulchur* and where I first purchased Allen Ginsberg's epochal *Kaddish and Other Poems*."[6]

Eighth Street bustled on the east and west sides of the Village, but the stretch between Fifth and Second Avenues seemed cursed. Odd-ball businesses—such as a French art store that employed both a classical painter and a modern painter, wearing berets—would open and then disappear, though the area came alive around the Eighth Street Bookshop. "It was really an anchor on that part of Eighth Street for a long time," Codrescu said. "Philip Roth shopped there, and Susan Sontag. It was my education. The employees saw everything these writers liked or took home, so we read everything that they were reading."

Another jewel in the downtown's literary crown was the Paperbook Gallery, on Sixth Avenue around the corner from the Eighth Street Bookshop. Cabaret performer and Off-Off-Broadway music composer Paul Serrato managed the Paperbook, which stayed open until midnight—a practice that encouraged people to socialize. "The area was like the Times Square of the Village," he said, "In those days, everybody hung out there, and Paperbook Gallery was the epicenter of all

the independent publishing." Frank O'Hara, Ted Joans, Diane di Prima, LeRoi Jones, and others came in to drop off their mimeographed publications, which were displayed on a series of shelves that looked like mail slots. "They didn't carry this stuff uptown," Serrato said. "The only place you could distribute it was Paperbook Gallery or Eighth Street Bookshop, or Peace Eye Bookstore."

Ed Sanders was a new father who needed a steady stream of income—publishing a mimeo literary magazine and fronting the Fugs certainly didn't pay the bills—and in 1964 he opened the Peace Eye Bookstore on 383 East Tenth Street. It served the East Village in much the same way Paperbook Gallery and Eighth Street Bookshop did Greenwich Village. "For the best mimeos and the hottest stuff, you went to Ed Sanders's bookstore, the Peace Eye," Codrescu recalled, "which was where he published *Fuck You*."

By this point Sanders was friends with Warhol, who was working on a popular new flower print series that anticipated the "flower power movement three years ahead of its time," as the Peace Eye proprietor recalled.[7] After Warhol agreed to print flower banners for the grand opening of his store, Sanders bought some colored cloths from one of the many fabric vendors on Orchard Street and carried them to the Factory. Warhol silkscreened red, yellow, and blue banners for the bookstore's walls—though Sanders certainly didn't treat them as precious works of art made by a famous artist. He used one banner as a rain cape, which he accidentally left at a deli, and ripped apart another onstage during a frenzied performance with the Fugs. The poet managed to hold on to only the red Warhol banner, which he and his wife later sold. "Not long ago I saw it in a Sotheby's auction listing," Sanders lamented, "where it sold for $250,000. That's why I say a Fugs show in which I tore up a Warhol banner cost me $250,000, and if I count the time I left the Warhol flower screen in the deli, that places my loss at $500K!"[8]

The store's grand opening attracted *Time* magazine reporters and even middlebrow celebrity author James Michener, who was dropped off in a limousine in his evening attire.[9] While the occasional famous figure might drop by, Codrescu described Peace Eye as a neighborhood bookstore for poets, activists, street riff-raff, travelers, visionaries, and crazies. "It was a scene," he said, "because Sanders's mimeograph machine was right in the middle of the store, and Abbie Hoffman hung out there a lot. It was a hanging-out place for various activists of the age."

When Peace Eye opened, the *Realist* publisher Paul Krassner was living and working nearby in a loft on Avenue A, between Sixth and Seventh Streets. On New Year's Eve 1967, Krassner, Hoffman, Sanders, and fellow activist Jim Fouratt helped cofound a political "organization" called the Youth International Party,

aka the Yippies. Two months earlier, they executed their infamous Pentagon levitation stunt during an antiwar rally in Washington, DC, for which Sanders used the Peace Eye's mimeo to print leaflets. "Mimeograph machines were used a lot in activism against the Vietnam War," Krassner recalled. "If there was a demonstration, people would get their hands messy with the mimeograph ink, and then pass them out."

In addition to DIY mimeo printing, the downtown's social networks thrived with the help of community and underground papers like the *Village Voice* and the *East Village Other*. Michael Smith joined the *Voice* in the early 1960s as a theater critic, when the paper was still struggling on a week-to-week basis to keep the lights on. It was more volunteer work than anything else, but Smith's passion for promoting underground theater kept him going. "I think the press did help shape the scene," Smith said, pointing to the *Voice*'s previous theater critic, Jerry Tallmer, who loved the Living Theatre. "They were kind of viewed as an eccentric sideshow to the uptown press, but to us they were central. I think that really had an effect. They needed to be taken seriously by somebody, and we were the only ones who did."

In New York, negative reviews had serious consequences for a show's bottom line, so producers and theaters tended to gravitate toward critic- and crowd-pleasers. For example, Sam Shepard's budding career as a playwright was nearly over before it began after mainstream papers panned his debut production. "I was ready to pack it in and go back to California," he said. "Then Michael Smith from the *Village Voice* came up with this rave review, and people started coming to see it."[10] Jonas Mekas also exerted a major influence on underground film through both his *Village Voice* film column and *Film Culture*, the magazine he published with his brother Adolfas Mekas.

Future filmmaker John Waters devoured Jonas Mekas's writings from afar. "When I was in high school," Waters said, "I would read Jonas Mekas's 'Movie Journal' column every week in the *Village Voice*. That was a huge, huge influence to me. Mekas's *Film Culture* magazine was my bible. He was my life saver. That's how I knew about everything when I was living in Baltimore." Media scholar Devon Powers argued that while much of the Village's print culture was rooted in its local community, "the *Village Voice* participated in the full-on broadcast of that space and its ways of being to all corners of the city (and eventually, the nation and the world)."[11]

The *Village Voice* and other independent publications such as *I. F. Stone's Weekly* debuted before the *Realist*, but Krassner's magazine had the biggest

impact on the 1960s literary landscape. It pioneered an envelope-pushing style that laid the groundwork for Tom Wolfe's "New Journalism," and its contributors included Ken Kesey, Kurt Vonnegut, Norman Mailer, Lenny Bruce, and Joseph Heller.[12] Television host Steve Allen was the *Realist*'s first subscriber and bought subscriptions for several people, including controversial comedian Lenny Bruce. *Mad* magazine art director John Francis Putnam wrote a regular column, called "Modest Proposals," starting in the first issue. "I had never heard of Jonathan Swift's 'A Modest Proposal' before that," Krassner said of the classic satirical essay that advocated eating babies as a solution to child poverty, "so it was an educational process for me."

The *Realist* and the Fugs sprang from the same countercultural hive mind—many Fugs songs, such as "Kill for Peace," were quite Swiftian—and the two troublemakers, Krassner and Sanders, became fast friends after meeting at an antiwar rally in Times Square. "Ed was a poet, but he also was very politically active," Krassner said. "The Fugs kind of split the difference between poetry and activism." As for the *Realist*, Krassner saw it as "a combination of satire and actual journalism. But I didn't want to label something as journalism or satire because I didn't want to deprive the readers learning for themselves which it was." The magazine had many taglines over the years, but the most apt was The Truth Is Silly Putty. "I started with 600 copies," Krassner said, "and then when it got up to a thousand, I said 'Wow.' Our peak circulation in 1967 was 100,000, plus pass-along copies and copies stolen from libraries."

WBAI's Bob Fass was another Yippie collaborator, and he used independent radio to broadcast his social and political critiques. Fass's free-form radio program, which aired from midnight to the early morning, was a prelude to the way many people use social media networks today. "It served a community purpose," Krassner recalled. "If there was some kind of event, people would call in to the radio station. They were like citizen journalists describing what was happening right then and there."

For example, Fass used his WBAI show to organize listeners after a citywide sanitation worker strike left piles of trash on the streets. "The first thing they did was clean up wealthier streets like Park Avenue, naturally," Fass said, "so we organized this 'Sweep-In'—where people came from all over to clean a block on the Lower East Side." Another time, Fass used his radio show to call for a "Fly-In" at JFK airport that drew thousands of people on one of the coldest nights of the year. "They sang and danced and gave out flowers and welcomed people as they

THE DOWNTOWN POP UNDERGROUND

were getting off the plane," Fass said. "There was nothing being sold, nothing but goodwill."

These street theater actions were partially rooted in Fass's own theater background. He appeared in Bertolt Brecht's *Threepenny Opera*, and performed in other Off-Broadway shows at the Circle in the Square and Cherry Lane Theatre during the late 1950s and early 1960s. "When I was in theater, I hung out with the people who were part of the art scene, and I would go to painters' bars," Fass recalled. "Actors' bars kind of bored me, but the painters' bars, there was excitement. I would also hang out in places like the Figaro. The coffeehouse scene and the music scene was beginning to erupt."

Between his theater background and Yippie activism, Fass stood at the intersection of the downtown arts scenes and radical left politics. Many of the early Happenings were not explicitly political, which was exactly what Fass and his collaborators hoped to change with an event they staged at the city's busiest crossroads: Grand Central Station. They brought several four-by-five-foot boxes containing helium-filled weather balloons, with a message attached to each, then marched around Grand Central's information booth and placed the massive boxes on the floor. "As the clock in the center hit 5:00 P.M.," Fass said, "we opened the boxes simultaneously and these enormous weather balloons flew up to the ceiling and hung there, with streamers on them that said WAR, PEACE, HATE, KILL, LOVE. Someone played a tape recorder that had the sound of screaming and bombs. Suddenly, it got really silent—in Grand Central Station at 5:00 P.M.! CBS filmed it and it made the news that night."

The nation's alternative media network was rapidly growing, with free-form FM radio stations such as WBAI and underground newspapers popping up throughout America (the *Berkeley Barb* and *Los Angeles Free Press* in California, Iowa City's *Middle Earth*, and many others). "Whether they lived in large cities, suburbs, or in the hinterland," media historian John McMillian noted, "young people forged connections to distant underground scenes through radical newspapers."[13] They helped spread the word about everything from peace rallies to a hoax rumor about smoking dried banana peels to get stoned (which continues to circulate to this day). A crazy idea hatched in a downtown loft could create a ripple effect across the country thanks to these indie media networks.

CHAPTER 6

Ellen Stewart Is La MaMa

"La MaMa" referred both to Ellen Stewart herself—a warm but tough-as-nails maternal figure—and the theater she founded. With no theatrical experience, she established Café La MaMa in a basement location in the East Village back in 1961, not long after Joe Cino had turned his coffeehouse into an Off-Off-Broadway theater. "Ellen Stewart *was* La MaMa," recalled Agosto Machado. "She gave care, attention, and nourishment for playwrights, directors, set designers, costumers, and others in her theater."

The details of Stewart's early history are hazy. The only facts she ever verified were that she was born in Chicago and lived for a while in Louisiana—likely where she picked up her strong Geechee dialect[1] and gave birth to her only son, Larry Hovell, 1943. After living for a while in Chicago, Ellen enrolled in New York's Traphagen School of Design, one of the few fashion schools that accepted African Americans in 1950.

Upon arriving at Grand Central Station, Stewart discovered that the apartment she was promised fell through, so she used the last of her savings on a Spanish Harlem hotel room. After a few days struggling to find a job, she lit a candle at St. Patrick's Cathedral and called on her faith to help her get back on her feet. As Ellen was leaving the church she noticed Saks Fifth Avenue across the street and, miraculously, was given an entry-level job working as a design assistant. It was like a plot ripped from a Hollywood film, and her long and winding story grew more cinematic and fantastical throughout the 1960s.

On Sundays, Stewart used her free time to explore the city on the subway, and she eventually stumbled upon a few blocks on the Lower East Side that were overflowing with fabrics sold by vendors. A Jewish merchant with "this little black thing on his head," as Stewart called it, approached her, looking to make a sale. Abraham Diamond soon realized she had no money, but he could tell she had a talent for design, so he took her under his wing and adopted Ellen as his "artistic daughter and designer."[2]

"Orchard Street is just a couple of blocks south of where La MaMa was," said playwright Paul Foster, who helped Stewart start Café La MaMa and stuck with her through the years. "That's where she met her buddy, Papa Diamond. He kept a pushcart in his window, to show everybody what he came from, because he was a peddler. He adored Ellen, and she adored him." Diamond provided Stewart with fabric, and she would take the subway back to Diamond's store every Sunday with a new outfit, when her "Papa" ushered her around Orchard Street, praising his "daughter's" designs.[3]

Back at Saks, where she worked from 1950 to 1958, customers saw Stewart in one of her self-designed outfits and thought she was a Balenciaga model. "Somebody finally noticed," recalled playwright Robert Patrick, "and she wound up with her own little boutique, Miss Ellie's Boutique at Saks." While at Saks, her foster brother Fred Lights wrote a musical, *The Vamp*, that debuted on Broadway in 1955 and starred Carol Channing as a farm girl turned film star. Unfortunately, Lights's script was heavily rewritten by the producers and became a $400,000 flop.[4] He bitterly left the theater world with no intention of returning, which is how Stewart arrived at the idea of opening a theater of her own.

Assuming that it was "like playing house," she planned to make money with freelance designing while simultaneously running her venue. Stewart hoped her theatrical babies (or "bibies," as the word was rendered by her unique accent) would have a place to gather and "write plays and all their friends would be in them and live happily ever after."[5] The idea of doing something she was passionate about was inspired by Papa Diamond, who told her, "Whatever you do for a living, always keep a pushcart—something you're doing because you love it, because it's good for people." Theater became Ellen's pushcart.

In September 1961, while living at 334 East Fifth Street, Stewart came across a sign that read BASEMENT FOR RENT. Hoping that 321 East Ninth Street would make a nice spot for a clothing boutique, she signed a lease and handed over her first fifty-five-dollar rent check. The basement space hadn't been used since the building was constructed decades earlier, so it required hours of trash removal and cleaning, and a floor was built atop the dirt using wood from salvaged orange crates. Stewart employed the help of a few friends, which is when Fred Lights mentioned that the space would make a nice theater.

Enter Paul Foster, stage left.

Foster grew up in a small Quaker town in New Jersey, then moved to New York City in 1954 to attend the NYU School of Law, but this artistic-minded man was not cut out to be an attorney. "I started to thrash around for a career that would

be good for me and I accidentally ran into Ellen Stewart," Foster said. "I had never known a black woman before. I grew up in a totally white environment, not even realizing it, and, well, she educated me in the current thinking. We hit it off right off the bat. She was just a wonderful creature. I admired Ellen so much. We became extremely good friends."

Foster mentioned to Ellen that he had written some plays but never had anything published because he was too busy going to college and law school. She told him, "If you'd help me build a stage, we'll put it on." He thought, *Well, why not?* "It was a kind of crazy idea. She was on unemployment at the time and had rented the basement space in the East Village, in a Ukrainian neighborhood." Neither Stewart nor Foster had any savings or a steady paycheck, but they were resourceful. "If somebody needed to make the coffee for the customers, I would make the coffee," Foster said. "If there was some woodwork to be done, I would get the nails and I would nail it together." To call it a shoestring budget would be generous.

"At that particular point, none of us had any jobs, so we had to make do. We went scrounging, looking for the sets and refuse that people would throw away. We would hit the sidewalks at nightfall and all of us would go trash picking," Foster continued. "Off-Off-Broadway was very transformative. You took pieces of cable and then swear it was a magic wand, and it became a magic wand!" As La MaMa's resident designer, Stewart costumed most of the early shows—often by picking up discarded fabric left on the street in the garment district on the West Side. (Living among the economic ravages caused by deindustrialization had some advantages.)

Stewart's new theater was a twenty-by-thirty-foot space with a ten-foot ceiling—little more than a room with a hall, toilet, fireplace, coffee bar, and stage. About thirty people could sit at the nine tables crammed into the space. "I would stand up on the street on the sidewalk and tried to lure in customers," Foster said. "We were willing slaves to the theater. And so we had a lot of work to do on no budget, and just two people. But we didn't know, because nobody told us that it could not be done, so we just did it. We had no expertise. We'd admit it, but we wouldn't shout it."

After nine months of renovations, the unnamed space opened on July 27, 1962. Its first production was *One Arm*, a Tennessee Williams story adapted by Andy Milligan, the intense dressmaker who also directed shows at Caffe Cino. He taught Stewart and Foster the basics: what was stage right and stage left, for instance, and everything about lighting—a lesson they learned one day when Milligan asked them if they had any gels, the industry term for lighting filters. It

was a simple question that confounded this unlikely theatrical couple, a beautiful black woman and gay white ex-lawyer.

"I looked at her and she looked at me," Foster recalled, "and I said, 'I don't know, sugar pot, you have any gels?' And Ellen said, '*Hmm*, let me look at my purse.' Of course, who would put lighting gels in a *purse*? Andy knew he had to take total charge, and he did. We used him like an open book, and he was a very good teacher." With no money to buy theater lights, Milligan taught them how to place an ordinary lightbulb in a large tomato can, painted black, and attach the gels with a rubber band.

One of their earliest productions, Harold Pinter's *The Room*, flouted all kinds of theatrical conventions—including getting permission from, and paying royalties to, the playwright. *The Room* was scheduled to open on October 31, 1962, just before its official New York debut at the much fancier Off-Broadway house, Cherry Lane Theatre. "Not knowing anything about theatre, we didn't know you had to have rights or anything," Stewart said. "You find a play, you just do it."[6] She quickly discovered this was not the case. The day before the opening, a finely dressed man approached Stewart in her theater and asked in a distinct British accent, "Where is this Mama woman?"

"Who wants to know?"

It turned out to be the playwright himself, Harold Pinter, who was accompanied by his agent. Stewart calmly explained that she had no money but hoped that she could produce all his plays—at which point the agent started yelling at them, threatening to sue. Pinter's agent declared that no one could produce his plays without her consent, but that only ruffled the playwright's feathers. "Since when can Harold Pinter not put on his own work?" he said. "My dear lady, I hereby give you permission to do *The Room* as many times as you like."[7] Foster recalled, "The agent looked like she had just swallowed a horse."

The neighborhood's Ukrainian residents were suspicious of their first black neighbor. "She was attractive, and they saw white young men going down to the basement, so they kept calling the police thinking that she was a prostitute," Agosto Machado said. "They were unaware that she was trying to start a theater, and that the young men were gay men who were helping her, so they harassed her and harassed her and harassed her." Nosy neighbors eventually called the health department to shut her down, but in a stroke of luck—one of dozens that kept La MaMa open over the years—the inspector had a history in theater and vaudeville.

Instead of issuing a summons, he helped her obtain a restaurant license to avoid further legal complications.[8]

Stewart's theater still had no name during the inspection, and she needed something for the restaurant license application. After one friend suggested "Mama," they decided to fancy-it-up by calling it "Café La MaMa." After satisfying the health inspector, Stewart focused on winning over her neighbors. "Ellen had a very wonderful way of putting people at ease," Foster said. "She baked cookies, and gave them cookies. She ingratiated herself, and pretty soon, they became friends and we got them into the theater. It was maybe the first one that they had ever seen in their lives." But Ellen's charm offensive did little to protect the theater against a constant stream of citations from city officials throughout the 1960s.

"There were city regulations that banned live entertainment," said Michael Smith, who dealt with the same problems when running Caffe Cino after Joe Cino died in 1967. Joe's Sicilian family connections helped protect him against harassment from city officials, and Smith recalled stories about how Cino's aunts ran a scheme that involved selling goods that "fell off the truck" at a loading dock. "There was sort of an outlaw mentality to the Cino that I liked," Smith said, "which was very refreshing." Robert Patrick confirmed that Joe knew how to deal with the police: "Once in a while, a cop would wander into the Cino and then go to the back with Joe and then come out sticking ten dollars in his pocket and zipping his fly. Draw your own conclusions."

"The city was continually sending inspectors," Smith added, "and I think Joe was paying off the inspectors and cops to leave him alone, but they really gave Ellen a hard time." In April 1963, the city's Buildings Department enforced a ban on theaters in the area and shut down Café La MaMa once again. Undaunted, Stewart moved her theater to a second-floor loft at 82 Second Avenue, and soon after was forced to move it farther down Second Avenue. Like a bureaucratic version of whack-a-mole, La MaMa then moved to St. Mark's Place, and finally to its longtime home on East Fourth Street.

Upset by what was happening to La MaMa and other venues, Ed Sanders used *Fuck You/A Magazine of the Arts* as a bully pulpit: "Shriek! Shriek! The Goon Squads are loose! We are motherfucking tired of the brickout of books, movies, theatre groups, dope freaks, Times Square gobble scenes, poetry readings, night club acts, etc. in New York. The Department of Licenses, the freaks in the various prosecutors' offices, the Nazis, the fascists, et al., have joined psychoses for a Goon Stomp."[9] Throughout the first half of the 1960s, Mayor Robert Wagner's

administration continued to ramp up the harassment, which finally began to ease after the election of Mayor John Lindsay in 1966.

La MaMa's 82 Second Street venue opened on June 28, 1963, with Eugène Ionesco's *The Bald Soprano*, but by October the theater literally went dark because no one could pay the electric bill. After quitting as a designer for a Brooklyn swimsuit factory, Stewart began working for the fashion label Victor Bijou to pay the bills. Selling instant coffee at La MaMa wasn't a big moneymaker, but that didn't stop the Buildings Department from charging her with profiting from the coffee sales, and the city padlocked La MaMa's doors once again in March 1964. Stewart was finally able to keep her new location open by giving away the coffee for free and turning the theater into a private club. "You paid one dollar dues," Robert Patrick said. "For that, you got to see all of that week's shows."

The new twenty-by-eighty-foot loft at 82 Second Street could seat seventy-four people, a big improvement from its original basement location, but it still needed a lot of work. Friends came to build a twenty-by-eight-foot stage, dressing rooms, and a coffee bar, and also installed a light board. They scavenged the streets for tables and old chairs, which furnished the new theater. "There were a lot of ways to get furniture in New York City," said actor Walter Michael Harris, whose family worked closely with Stewart. "People just put it out on the street, somebody liked it, and picked it up. That was the system. There were no two tables or chairs that were alike at La MaMa."

CHAPTER 7

Hibiscus and Family Grow Underground Roots

Before George Harris III transformed himself into Hibiscus and founded the gender-fluid theater troupe the Cockettes, he put on shows with his family in Clearwater, Florida. George—who was also called G3, along with other nicknames—was the oldest of six siblings: three girls and three boys, sort of an avant-garde *Brady Bunch*. In the early 1960s, the kids formed the El Dorado Players, a theatrical troupe that put on shows in the Harris family's cramped garage, where the backstage door led to the kitchen. They placed lawn chairs in their driveway and sometimes rented klieg lights to announce the latest premiere of their homemade shows.

"Hibiscus had real leadership qualities," said his youngest sister, Mary Lou Harris. "He came out of the womb as the grand marshal. He was just like the leader of the parade." She compared her brother's methods to a Hollywood studio system in the way that he conceived and cast his DIY theatrical productions, then put his family to work. George also got help from his mother, who wrote plays and music in college, and his father, a natural theatrical performer and drummer. "Just look at those Busby Berkeley movies, he was our idol," his mother, Ann Harris, said. "We all liked Busby Berkeley. I made sure they saw those thirties movies and things that I loved, like Fred Astaire. I would take them to the movies and show them what I liked."

From these beginnings to the very end of his life—Hibiscus was among the very first who succumbed to the AIDS epidemic, in 1982—his colorful productions were a product of, and collaboration with, a family that cultivated his offbeat aesthetic.

G3 was born in Bronxville, New York, along with his sister Jayne Anne and brother Walter Michael. The family wasn't involved in theater while in Bronxville, though their father, George, demonstrated a panache for drama. "Every Halloween, he would do elaborate makeup, elaborate scenes and stuff, and try to scare the kids as Frankenstein," said Jayne Anne, describing how Big George placed bolts in his neck and wore green makeup. "There was always a piano in the Bronxville

home, and Mom was always tinkering and making up songs," Walter added, "and Dad always had a set of drums, because that was his passion."

The Harris family ended up in Clearwater after the parents took a trip to Cape Cod and George proposed a move to Florida. "In those days," Ann noted, "whatever the husband said, that's what we're going to do, right?" She quickly discovered that she hated Florida, but life got better for Ann when the entire family started doing community theater. They became regulars at the Francis Wilson Playhouse, where both parents and children learned every aspect of theater: set building and prop making, dancing and singing, front of house and back of house.

When the family was living on El Dorado Avenue, eleven-year-old G3 hatched the idea to start a family theater troupe after learning that his mother had written two plays in college—*Bluebeard* and *The Sheep and the Cheapskate*—that had moldered in a trunk for years. *Bluebeard* was based on the classic story about the bloody nobleman, but in Ann's version the wives were turned into furniture, instead of being murdered by Bluebeard. *The Sheep and the Cheapskate* was a generation gap play that took place in the 1920s and dealt with new ideas about liberty, freedom, and self-expression—topics that grew more timely as the 1960s wore on.

"There were two ready-made little musicals that Mom had written," Walter said, "so we put them on in our garage on El Dorado Avenue." After that, George and his siblings began staging Broadway shows like *Camelot*. They didn't have a script for that musical, nor had they seen it, but the kids reconstructed the show based on the liner notes in the original cast recording. "For *Camelot*," Jayne Anne recalled, "my brothers put horse heads on the front of their bicycles and did jousting." Walter said, "We sprayed cardboard with silver paint to make armor. We came at each other on our bicycles and tried to knock each other down."

Little did the family know that what they were doing was exactly what was going on in the downtown's underground theater scene, a world the whole family would be immersed in by 1964. After staging a few of these DIY productions, they decided to dive into show business by moving to New York. (Ann had also been friends with many gay men, and her sixth sense told her that G3 wasn't straight, so she worried about raising him in a small southern town.) "I recall sitting around in a room, with Mom and Dad having discussed it," Walter said, "and they decided to put it to us kids, and they asked us what we thought." Mary Lou recalled, "We had those pivotal moments where somebody would say, 'It's time to jump.' We always did, and I feel like we always jumped to the right place."

In January 1962, Big George moved to the city ahead of the rest of the family to check out the situation. He got his Equity card right away with a play called *Wide*

Open Cage and, purely by chance, met Ellen Stewart. Still operating out of Café La MaMa's original location in the basement of 321 Ninth Street, she let George direct one of La MaMa's first productions, *The Collector*, on December 14, 1962. They became close, and she helped find the first apartment his family would move into—a cramped walkup apartment on First Avenue, just around the corner from La MaMa. "Thanks to Ellen," George said, "I had a place to live, current New York credits, and introductions to playwrights and producers."[1]

Before the entire family moved, he sent letters back home to Florida written on the back of Caffe Cino's ornate menus—which had cherub illustrations, gothic lettering, and exotic words like Espresso, Napoleon, Orange Blossom, and Ricotta. They looked like communications transmitted from another world, as Walter Harris recalled. The next person to move to New York was G3, in 1963. "My brother George came back and forth a few times," Jayne Anne said, "and then when I was eight, going on nine, I remember getting on the train with him, and it was a twenty-four-hour ride. We ended up in a car full of nuns who took us under their wing because we were in coach and they had little rooms."

G3 loved to costume Jayne Anne like a Barbie doll, so she was dressed to the nines after getting off the train at the old Penn Station on that hot August day. She wore white gloves, a straw purse, a little straw hat, and a tweed summer coat with big buttons. After G3 began getting commercial acting work, he showered her with miniskirts, go-go boots, and patent leather Mary Jane shoes.

By 1964, the rest of the family was in New York. Eloise Harris's first sight after arriving in the city was steam coming out of the sewers and a massive Camel cigarettes sign that blew smoke rings into the air. "Imagine taking your kids and moving to the Lower East Side with the idea that everybody is going to be actors, and then everybody just went ahead and did that," said Eloise. "No one was thinking, like, 'How are we going to make money?' There was no real plan." Ann Harris recalled that they just decided to do it. "I mean, with no knowledge of anything except suburban life," she said, "and this was the nitty-gritty city in the East Village."

During their adventures out and about, the kids followed their parents through the city streets like six little ducklings. They had to scale several flights of crooked steps to get to their first apartment, and the hallways were infused with the pungent cooking smells of their Eastern European neighbors. The tiny studio apartment was ill suited for a family of eight; it had what the landlord called a bedroom, but was really just a big closet where the parents slept, and the kids spread

out on the floor in sleeping bags. There was no bathtub, so the ever-resourceful Ann Harris filled a zinc washtub with water from the kitchen sink and bathed the kids in the middle of the living room.

The Harris family on the Lower East Side
© ANDREW SHERWOOD

Eventually, Ellen Stewart found them a larger loft apartment around the corner, right next door to Café La Mama, at 319 Ninth Street. Eloise and Mary Lou's sleeping loft was in the living room, with a white picket fence around it, and the girls would roller-skate through the long apartment. The kitchen had a piano that was constantly being used, along with a set of drums that Walter and Big George played. Ann made their thespian hub run like clockwork—walking the kids to school, shopping for groceries at the A&P, and on weekends dragging bags of clothes and costumes back from the laundromat as the kids jumped in the piles of warm fabric.

"Fortunately, we had ready-made theater friends in Ellen Stewart and Joe Cino," Walter said, "because Dad had already been doing shows in both of those places. Judson Poets' Theatre was another one. In those days, there was a Holy Trinity of Off-Off-Broadway: Caffe Cino, La MaMa, and Judson." Of the three, Stewart was most involved with the Harris family. After Café La MaMa moved

to its Second Avenue location, Stewart kept that East Ninth Street location as a rehearsal space and opened it up for the Harris family to use.

"Ellen was lovely," Ann effused. "There were some really beautiful people who really latched onto us and showed us the way, because we didn't know anything about what to do. You could go over to Judson or Caffe Cino and mount a show. Joe Cino didn't care what you did. He just gave you a date." Walter added, "I think we were a little bit of an anomaly at the Cino and at La MaMa, because we were so young. Here's this family with kids who were all involved in whatever these artists were up to, in these magic places."

Jayne Anne Harris serenading Lanford Wilson (seated) while David Starkweather, Soren Agenoux, and Arnold Horton (left to right) look on, in the 1967 Caffe Cino production of Claris Nelson's *The Clown* / © JAMES D. GOSSAGE

An Off-Off-Broadway director could cast a multitude of parts—a mom, a teenager, a boy, a girl—in one fell swoop. "If you needed a kid," recalled Robert Patrick, "you called the Harris family. We just took them for granted." Eloise got her Equity card at the age of nine performing in *Invitation to a Beheading* at Joseph

Papp's Public Theater, and Jayne Anne Harris could be seen serenading Lanford Wilson in a production of Claris Nelson's *The Clown* at Caffe Cino (she was cast as a boy). The roles kept coming, with the kids doing theater at night and going to school by day. The family queued for meals around the clock to maintain their varied production schedules, and Ann helped the kids with homework and ran lines with them.

Everyone in the family had agents, and the children might be sent out for two days in Central Park to do an industrial film or a public service announcement, while at the same time acting in experimental shows downtown. Jayne Anne, for example, appeared in the Macy's catalog at the same time she was performing in productions at Caffe Cino, La MaMa, and Judson Church. The family's commercial work essentially subsidized their more avant-garde endeavors. "The youngest George Harris was in Jeff Weiss's *A Funny Walk Home*," playwright Robert Heide recalled, "playing the boy that comes home and kills his whole family and goes crazy. It's a wild play. George was a golden boy."

When Ellen Stewart learned of the family's garage theater in Florida, she inaugurated a "Young Playwrights Series" at La MaMa. G3 and the rest of the kids mounted Ann Harris's *Bluebeard* and *The Sheep and the Cheapskate*, which they revived at La MaMa. "And there we were," said Walter, "not only doing the ones we did in Florida, which were two that Mom wrote in college, but Mom was also inspired to create some more shows—working with my brother George and me on the book and the music."

This started a family tradition of writing about whatever was going on in their lives. "Our *Macbeth* parody, titled *MacBee*, spoofed the *Mad Men* era of advertising," Walter said. "We all had some experience with this world, as we were constantly auditioning for TV commercials. We kids were all traipsing up and down Madison Avenue with our headshots and our portfolios, looking to find TV or commercial work, and so our show *MacBee* was about that." They enrolled in acting classes—learning Method acting and discovering how serious and ridiculous it could be—which inspired their satirical musical, *There Is Method in Their Madness*. It received a positive review from *Village Voice* theater critic Michael Smith, and the El Dorado Players continued to thrive on the La MaMa stage.

"Everything was one, the music and theater and art," Ann Harris recalled. "Everybody was interested in everybody then, and it was beautiful." When Ann was in her mid-40s, she appeared in the 1970 cult film *The Honeymoon Killers* with actress Shirley Stoler, and Harry Koutoukas also cast her in one of his eccentric

"camps." She could occasionally be found running around with Koutoukas and *Hair* creators Jim Rado and Gerome Ragni, having a blast on the streets of downtown New York.

"I think the Catholic Church was Mom's anchor into a magical idea of life," Walter said. "She had pretty strong, stringent Irish-Catholic roots in her childhood, and I think part of her fantasy life was really among the angels and with heaven—the idea of that sort of magical place." After the family moved to New York, they stopped going to church and entered Off-Off-Broadway's dingy temples. "Cino became the church," he said. "La MaMa took the place of that in our lives."

"Everyday life was just as interesting as the theater itself," Mary Lou observed. "You were Alice going down a rabbit hole every day. It was like being in a show in itself." The kids all had front-row seats for the rise of civil rights, gay rights, and women's rights just outside their Ninth Street windows. "The counterculture was one large theatrical Happening," Mary Lou added. "The hippie generation was rising and there would be riots emanating out of Tompkins Square Park." That park hosted its fair share of unrest, but it was also a place for neighborhood families. During the day, kids played on swings while adults read on benches, all while the sounds of an outdoor concert or protest rally reverberated in the background (it was at Tompkins Square where the New York chapter of the radical Young Lords Organization announced itself to the world on July 26, 1969).[2] However, it was still a rough neighborhood to grow up in.

"We went to New York City inner-city schools, which were terrifying," Jayne Anne said. "And then there was the Catholic school down the street, and we were terrified of them, because they were even tougher than the other kids were." The Harris children learned not to walk on certain blocks—like Thirteenth Street between First and Second Avenue, or Twelfth Street between First and A. They had to keep their wits about them, especially going into the area between Avenue A and Avenue D. "Apathy, Brutality, Chaos, and Despair," joked WBAI radio DJ Bob Fass. "Those were the streets." The stretch between Second Avenue and Avenue A was pretty tame, but they needed to be on their toes when passing through Avenues C and D, where there were drugs, muggings, and fights. This is where the Harris kids' acting training came in handy, because they could pretend they were just as tough as the ruffians around them.

"You've got to remember, we were coming out of the *West Side Story* era," Jayne Anne said, "so there were still gangs and things like that. Juxtaposed next to the theater that we were doing, it made for a very colorful existence." For instance, one time Jayne Anne had a part in a Caffe Cino production of *The Death of*

Tintagiles, and she had to rehearse at the director's apartment, which was on one of the streets she avoided at all costs. The director locked the ten-year-old in the bathroom so she could mentally prepare for the scene in which Tintagiles was imprisoned in a dungeon. Unfortunately, a junkie was crouched on the other side of the bathroom window, staring at her the whole time. "*AHHH!* Oh, my *GOD!* Let me *OUT!*" Jayne Anne screamed. "That's very good, dear. Let's try it again," the unknowing director said as she cried very real, non-Method tears.

Life in many parts of the Village could be scary. "People would break into your place for nothing," Lisa Jane Persky recalled, "for chump change. Speed freaks, they could be really menacing, and there's always the question about my mugging—whether it was somebody on speed." She was walking home one afternoon at rush hour when a man jumped out of a basement stairwell screaming, "I'll kill you! I'll kill you!" After he pummeled Persky's head with a heavy block of wood over thirty times, she stumbled toward her Christopher Street apartment, heavily bleeding from her head, until a neighbor helped her to the steps of St. John's Church. It was a serious head injury that put her in the hospital for two weeks, but she was resilient. "Lisa, I want to give you a little test," the doctor told her. "Can you name the oceans?" She named about three before asking, "Do seas count?" The doctor laughed and said, "You're gonna be all right."

New York's Lower East Side was populated by a mix of artists, performers, hippies, radicals, immigrant families, the working poor, and homeless people. "It was a wonderful neighborhood," said Ann Harris. "New York, years ago, had neighborhoods with elderly ladies looking out the window and kids playing stickball in the middle of the street, and each block was its own country."

The Harris family matriarch finally entered a new act of her life after finding herself among a like-minded tribe of experimental playwrights, directors, and actors. From her headquarters on East Ninth Street in the East Village, Ann began writing more songs and collaborating with her husband, children, and newfound extended family. "It must have been a relief for Mom after what must have seemed like a long exile in a desert—the years in Florida," Walter observed. "For Mom, I think it was just really quite liberating."

"I wish I could convey the fun and the work and the scariness of living in New York," Ann said. "When we first came up, there were lots of bums and drunks on the street. And then the hippies took over." Counterculture freaks hung out on St. Mark's Place, where the Harris kids might see their next-door neighbor running

across the tops of cars high on LSD. "The neighborhood was chock-full of people getting off of buses straight out of college," La MaMa's Paul Foster recalled, "or running away from Mommy and Daddy, and the suburbs."

One of these young immigrants was Romanian poet Andrei Codrescu. "I lived in the Lower East Side," he recalled, "where writers, artists, and musicians gathered to deal with the burning issues of their time: civil rights, women's rights, gay rights, and freedom in general." Codrescu used to eat fifty-cent bowls of brown rice and veggies at Dojo's, drop by the Free Store (run by the activist group the Diggers), and hang out in front of Gem Spa on St. Marks' Place, a three-block-long stretch filled with little record stores, hippie boutiques, and other assorted bohemian-friendly shops and bars, along with the odd Eastern European dance hall.

When the Holy Modal Rounders' Peter Stampfel arrived on the Lower East Side in 1959, the midwesterner was a bit leery of living in a slum. *Is it dangerous?* he wondered. *Is there trouble?* Yes, it could be a bit sketchy, but this was counterbalanced by the incredibly cheap rents. Bibbe Hansen—who lived at 609 East Sixth Street, between Avenues C and D—recalled that it was an extremely poor neighborhood. "It was more about poverty than anything else," she said. "There were artists living around where I was living, but mostly because we were poor. There are so many important people that were part of the everyday landscape that are now these monumental, awesome giants of alternative culture and experimental art."

Agosto Machado had always found the West Village to be a little expensive, so he mostly lived on the East Side. "Now, we're talking thirty-, forty-, fifty-, sixty-dollar-a-month apartments," Machado said. "That allowed a generation of people to come to New York City and spend, like, three-quarters of their time being an artist and a quarter of their time doing some sort of pickup day work to pay for your rent." By the mid-1960s, the social and economic dynamics in the neighborhood were shifting—as was the Lower East Side's name. "The landlords changed the name to the East Village so they could make a little more rent," recalled Peter Crowley. "That began in the early sixties, and by the mid to late sixties it was like a gold rush."

Richard Meyers was born in Lexington, Kentucky, and landed on the Lower East Side in late 1966; within a few years he had reinvented himself as Richard Hell. As a child, he and his mother had visited his grandmother in the West Village every three or four years, so he already had an impression of the city. "The West Village was—in terms of New York—deceptively quaint and peaceful and beautiful," Hell said. "It wasn't until I actually came here that I got exposed to Fourteenth Street

and Forty-Second Street and the East Village—the *real* New York, which is much more squalid than this isolated Village where my grandmother lived."

Each block had a different character, with Italian, Ukrainian, Polish, Russian, Chinese, African American, and Puerto Rican sections that were like little hamlets where everyone knew each other. Immigrant families and the working poor were packed in tenement buildings with four or five apartments per floor, living like sardines in a can. The Lower East Side also had a large Jewish population, and plenty of delis dotted the area. Second Avenue hosted disintegrating theaters that had been part of the early-twentieth-century Yiddish burlesque circuit, and a few street vendors peddling goods from pushcarts were the last remnants of that old world. Family fights would break out, and all kinds of accents filled the air—as did the scent of marijuana.

Stirred into the mix were artists like Ed Sanders, the Holy Modal Rounders' Peter Stampfel, and future punks Richard Hell and Debbie Harry. One could walk from the hippie-heavy area on St. Mark's Place to the Ukrainian National Home, where immigrants and their children held traditional Eastern European dances. "The Lower East Side was sort of a melting pot," recalled Debbie Harry, who moved there in the mid-1960s. "It wasn't like a hippie haven or NYU at that point. Everything was divided up into ethnic areas, and it was a little bit dangerous, actually—muggings, that sort of thing. My apartment was broken into a couple of times."

The Lower East Side's carnivalesque atmosphere grew edgier as one went farther east. "You just did not go east of Avenue A, which covers a lot of territory," Richard Hell said. "It was really ruthless, and the poverty was so extreme. That was really clear-cut, it was really nasty and hard. About half the time I lived in New York, I lived in those areas. You hoped to make a nice impression on the kid who ran the block because they would protect you, too." He added with a chuckle, "There was a fine line—it would mean they would only rob you every few months."

The parents of many young Jewish bohemians were shocked that they would want to live in this ghetto. *What are you thinking?* they'd ask. *Thank God we left!* Throughout the 1960s, the American economy expanded at an unprecedented rate, which made it possible for these artists to live on next to nothing and still survive. "It was a counterculture of abundance," *Village Voice* rock critic Richard Goldstein observed. "Everyone was affected by the prosperity. Even if they were very radical and against this prosperity, they benefited from it. That's why the East Village was able to exist, and it also explains why the older people were horrified by their children wanting to go back there."

CHAPTER 8
Preserving the Downtown Landscape for Artists

By the late 1950s, city government leaders had written off much of New York City's downtown as a "blighted" zone, and they targeted some now-iconic areas for demolition. Into the fray stepped a West Village writer named Jane Jacobs, who helped preserve sizeable swaths of the downtown landscape, allowing people to transform largely abandoned industrial areas into places to live and make art. Jacobs's first foray into activism began when she became aware of a plan hatched by the powerful city planner Robert Moses to put an expressway ramp through the middle of Washington Square Park. He was responsible for the hundreds of miles of expressways and bridges that linked New York City to the national interstate system, so Moses wouldn't think twice about running a multilane roadway through the center of that beloved park.

Jacobs joined the fight after 1956, when a coalition of Village groups formed to oppose Moses's plans, and she soon took a leadership role. "Jane Jacobs single-handedly saved the Village," Bibbe Hansen said. "She was an incredible community activist, and she prevented the bulldozers from plowing that place." Jacobs would go on to be a major thorn in Moses's side, eventually causing city officials to scuttle his proposal to build the Lower Manhattan Expressway, which would have run through SoHo, along Broome Street. The planned Washington Square roadway was designed to connect Fifth Avenue with that expressway, whose sole purpose was to speed the flow of traffic through Manhattan at the expense of the surrounding neighborhoods.

"The Fifth Avenue extension was a critical piece of Moses's larger vision for Greenwich Village," wrote journalist Anthony Flint, "one of a dozen areas in the city he had targeted for urban renewal—essentially wiping out sections of the old, cluttered neighborhood and putting in new, modern construction and wider streets."[1] When the battle to save Washington Square Park reached its peak in 1958, Jacobs used print media to her advantage. She wrote about architecture in

magazines and newspapers before authoring *The Death and Life of Great American Cities*, a book that revolutionized the field of urban planning.

"Jane and I both despised Moses as an ignorant, petty tyrant who used federal funds to finance his insane projects and seduce politicians, a familiar story," said Random House editor Jason Epstein, who commissioned the book. "He had been most destructive in poor neighborhoods whose residents were mostly passive." Moses's roadways had already shredded the social fabric in the South Bronx by cutting whole neighborhoods in half, and the same was true of the area where Lincoln Center now stands. "They cleared sixteen acres of what was a mixed-race community," said Agosto Machado, who had lived in that area. "The city was supposed to rehouse the people who were removed, but what they were offered was public housing in the outer boroughs."

Moses's typical strategy was to bulldoze a site in the early morning and confront residents with a fait accompli when they woke up. Fortunately, Jacobs had already learned an important tactic from a neighborhood group that successfully blocked Moses's attempt to expand a parking lot for the fancy Tavern on the Green restaurant. Mothers and small children arrived at midnight to block the bulldozers that came to raze the park an hour later. "This inspired the mothers of Greenwich Village to do the same," Epstein said, when Moses's bulldozers arrived at Washington Square Park to clear a path for a Fifth Avenue extension to Broome Street, his Waterloo.

Jacobs dispatched dozens of kids to collect petition signatures to save the park, and used them for sympathetic photo opportunities. "This was during the beatnik era," said her son Ned Jacobs, who was seven years old in the spring of 1958, "and my brother and I were outfitted with little sandwich boards that proclaimed Save the Square! That always got a laugh because people knew that 'squares' would never be an endangered species—even in the Village. These were also the dying days of McCarthyism. People were afraid—even in the Village—to sign petitions for fear they'd get on some list that would cost them their careers. But I would go up to them and ask, 'Will you help save our park?' Their hearts would melt, and they would sign."[2]

Jane organized these "Save the Square" protests from the living room of her family apartment at 555 Hudson Street, where she lived with her husband and three children. "I went to school with Ned Jacobs," Bibbe Hansen said, "and I actually dated him for a little while. Ned brought me home to lunch on Hudson Street. It was a block or so north of our junior high school, PS 3. I had a certain

social anxiety. I was utterly comfortable with thugs and criminals and street people, but in a house for lunch was very intimidating and difficult for me. She [Jane] was really being terribly nice—trying to be the good, enlightened mom—and was doing her best to make me feel welcome. But I was, frankly, intimidated."

Rather than solely relying on the *New York Times* and other mainstream newspapers, Jacobs also involved community newspapers like the *Village Voice* in this grassroots battle. Eventually, momentum on Robert Moses's plan ground to a halt, and after he failed in a last-ditch attempt to get his proposal rammed through at a Board of Estimate meeting, he sputtered, "There is nobody against this. Nobody, nobody, nobody but a bunch of, a bunch of mothers."[3] In 1961, Random House published Jacobs's *The Death and Life of Great American Cities*, which celebrated her fellow city dwellers' ability to navigate everyday life through the simple routines of walking to work, shopping at mom-and-pop stores, and watching the street scene from a stoop or apartment window.

"Arguing against modern planning strategies that favored tall towers surrounded by empty parks, wide streets built for auto traffic rather than pedestrians, and large-scale development by demolition and new construction," sociologist Sharon Zukin wrote, "Jacobs emphasized the authentic human contacts made possible by the city's old and unplanned messiness."[4] Not surprisingly, *Death and Life* was poorly received in professional city planning circles at the time, but Jacobs's argument ultimately won the day and created a paradigm shift in America and abroad.[5]

After losing the battle at Washington Square, Moses passive-aggressively turned his sights on Jacobs's Hudson Street home by targeting her West Village neighborhood as a "blighted" area. Her apartment became the center of activity in the fight against this scheme, though Jacobs and others could also be found making plans at the Lion's Head. This West Village coffee bar, which was also marked for demolition, was already a favorite haunt for journalists, and its owner, Leon Seidel, was on hand to provide newspapers with quote-worthy barbs. Meanwhile, Jacobs took journalists on walking tours of the neighborhood to demonstrate the folly of Moses, whose project was halted in its tracks.[6] Later, in the mid-1960s, she and a coalition of clergy, local business owners, artists, and others defeated Moses's Lower Manhattan Expressway plan, effectively ending his decades-long reign of power.

Throughout the 1960s, many bohemians moved away from Greenwich Village to an area that became known as SoHo (short for South of Houston, the street that

borders the Village, which lies to the north). The average cost of a Manhattan apartment in 1960 was $78 per month, whereas SoHo lofts in the 1960s ranged from $50 to $125 for quite large spaces—and the fact that the artists' studios also doubled as their homes lowered the overall costs even more. In addition to artist residences and galleries, these lofts were used to stage innovative performance-based art that ranged from experimental dance to the "loft jazz" scene.[7]

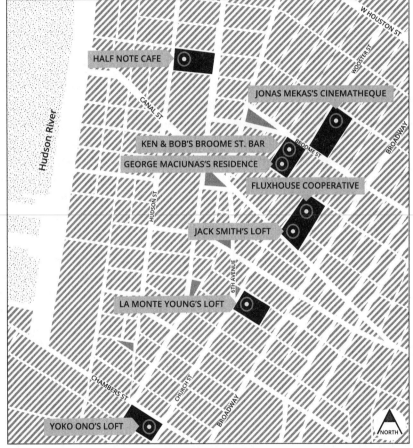

TRIBECA AND SOHO

Jane Jacobs's vision of a mixed-use downtown was the very thing that attracted so many outsiders, but SoHo would never have developed the way it did if Robert Moses had prevailed. His Lower Manhattan Expressway was set to cut a wide path across the borough, running east and west through Broome Street, in the heart of SoHo, which certainly would have stymied the neighborhood's economic

rebirth.[8] In late 1968, Paula Cooper opened the first SoHo art gallery at 96 Prince Street, and next came OK Harris Gallery at 465 West Broadway. A decade later, seventy-seven galleries had been drawn to the neighborhood, where many artists lived and created their works.[9] Its large, open lofts were supported by cast-iron columns that offered more spatial flexibility than the cramped tenement apartments on the Lower East Side—a plus for artists who created large-scale works or those who needed more room for performances.[10]

Multimedia artist Yoko Ono organized downtown Manhattan's first loft events, the Chambers Street Loft Series, in what is now called TriBeCa (the triangle below Canal Street). This area was her home base from the late 1950s until she moved in the mid-1960s into the same West Village building where Harry Koutoukas lived. Unlike more traditional venues that limited the length of individual pieces, Ono's series had no such limitations, which helped change the course of modern composition by opening up new possibilities that were free from temporal constraints.

The wide open spaces in Ono's industrial loft also created interesting spatial opportunities for the artists who participated in the Chambers Street Loft Series. John Cage and pianist David Tudor attended the first performance on a snowy day in December 1960—along with Dadaists Max Ernst and Marcel Duchamp, a kind of avant-garde passing of the torch. "I met John Cage towards the end of the fifties through Stefan Wolpe," Ono recalled. "What Cage gave me was confidence, that the direction I was going in was not crazy. It was accepted in the world called the avant-garde. . . . It was a great feeling to know that there was a whole school of artists and musicians who gathered in New York at the time, who were each in his or her own way revolutionary."[11]

This was an epiphany, for Ono had spent much of her life up to that point feeling as though she didn't belong. She studied philosophy at Gakushuin University in Tokyo and, later, composition at Sarah Lawrence College, but found both educational experiences constraining, so she forged her own path in downtown New York. At home and abroad, she was the perennial outsider, a walking study of dualities: She was born into a wealthy family, but World War II wiped out the family's fortune and turned her into a beggar; as an experimental artist, Ono's humor was misunderstood by her more serious contemporaries; and as a famous figure she became widely despised because, among other things, she was viewed as a groupie who broke up the Beatles after John Lennon fell in love with her.[12]

In the wake of her performance series, Ono became associated with Fluxus, an irreverent 1960s art movement whose informal leader was a German immigrant named George Maciunas (others, such as Bibbe Hansen's father, Al Hansen, were

THE DOWNTOWN POP UNDERGROUND

also deeply involved in the movement). "Fluxus was the furthermost experimental group of its time," Ono recalled. "Anyone doing experimental work was aware of us and took ideas from us and made them commercial. Their stuff was selling but ours was too far-out to sell."[13]

Al Hansen gets weird at a Happening
COURTESY THE AL HANSEN ARCHIVE

Preferring to work in a conceptual mode, Fluxus artists produced few physical works that could be sold within the established art market. Nevertheless, the people involved in Fluxus made a significant material impact in the way in which they reshaped SoHo. "The Fluxus artists changed the New York downtown," Jonas Mekas observed. "George Maciunas claimed that his one work of art is SoHo, transforming the downtown of New York." Maciunas, an old family friend of Mekas, was a force of nature who helped turn that neighborhood into an artists'

colony (one of his Fluxhouse Cooperative buildings, at 80 Wooster Street, was home to Mekas's Film-Makers' Cinematheque).

"If the Fluxus group took part in the trend toward environmental art," Sharon Zukin wrote, "then the changing factory district of SoHo was the environment that it both mined and mimed."[14] Maciunas and his friends weren't the first to occupy that former industrial area, but by renovating these old spaces—and fighting for the legal right to do so—they were the ones who established this practice on a wider scale.[15]

By the mid-1960s, Yoko Ono had collaborated with John Cage, Ornette Coleman, and other prominent composers and musicians, as well as important visual artists, dancers, and poets. She eventually moved on to more established venues such as Carnegie Recital Hall and London's Indica Gallery, but it wasn't always easy. "I feel that even in the avant-garde world, what I was doing was seen as a little bit out of line," she said. "They had their own set of rules, you know? 'You can't do that! You can't do certain things!' "

For Ono's *Cut Piece* in 1964, the audience was invited to cut off bits of her clothes until nothing remained. She sat onstage with her legs folded in a traditional Japanese pose of feminine submissiveness, embodying the kind of vulnerability women experienced in Asian and American societies. "That was a frightening experience," she recalled, "and a bit embarrassing. It was something that I insisted on—in the Zen tradition of doing the thing that is most embarrassing for you to do, and seeing what you come up with, and how you deal with it."[16]

Ono entered the underground film world in 1966 with *Bottoms*, a brazen but playfully cheeky work featuring several naked buttocks and no recognizable narrative. After she met John Lennon, they baffled audiences by crawling into a large sack and staying inside for long stretches of time. She called it "bagism."[17] Yoko's absurdist sensibility was also on display in her conceptual piece *Questionnaire, 1966 Spring*, which included lines such as "Happenings were first invented by Greek gods" and "The word 'manila envelope' comes from a deeply-rooted racial prejudice." Her *Do It Yourself Fluxfest Presents Yoko Ono and Dance Co.* instructed its audience to "Face the wall and imagine throughout the year banging your head against it: A) Slowly until the wall collapses B) Violently until your head is gone."[18]

After her union with Lennon, Ono kept one foot grounded in the mainstream and one in underground culture—in late 1971, for example, the couple appeared on the popular network TV program *The Dick Cavett Show* as well as at the Eighth Annual Avant Garde Festival of New York. They both mixed art and politics with

John Lennon, Yoko Ono, and Al Hansen at the Eighth Annual Avant-Garde Festival, 1971
COURTESY THE AL HANSEN ARCHIVE

a healthy sense of humor during events such as 1969's *Bed-In for Peace,* when the couple leveraged their celebrity status to spread an antiwar message. Lennon and Ono invited reporters to cover their weeklong stint in bed, but if media outlets wanted to cover this entertaining spectacle, they also had to broadcast the couple's political opinions as well.

This Happening was an extension of the work Ono had done for a decade, but many still thought of her as just a glorified Beatle groupie—despite the fact that Lennon and Ono met at *her* art opening. "I could have been killed because of my sense of humor," she said, chuckling. "I have to be very careful." Yoko was referring, in part, to the sorts of "ugly bitch" verbal assaults she endured after meeting Lennon. In the face of the racism, sexism, and pure unadulterated hatred, this trickster figure responded by laughing and screaming at the world.

Lisa Jane Persky's family bounced around several apartments downtown until, in 1965, she moved with her mother, stepfather, and three young siblings into 87 Christopher Street—a five-floor walkup tenement building where Harry Koutoukas lived for a half century. Located about four blocks south of Jane Jacobs's residence, it was one of those areas that may very well have been razed to make room for a large housing development if Robert Moses had had his way. Ono was

also living there with her husband, jazz musician Tony Cox (they met through their mutual friend La Monte Young, a composer she knew from staging the Chambers Street Loft Series).

On the evening the family was supposed to move in, Persky stood on the old hexagonal subway tile in the building's entrance, then walked up the stairs past the metal mailboxes. "We got there about 9:30," recalled Jane Holley Wilson, Lisa's mother, "but we couldn't get into apartment number ten, which we were supposed to move in to, so we knocked and Tony Cox came to the door." Cox served as the building's superintendent, along with Ono, who had recently given birth to their daughter, Kyoko. Because they were already living in the apartment Lisa's family had been promised, Tony put them downstairs, in apartment number one.

"I'll give you the key to your apartment," Cox said, "but first I want to show you my wife and kid." The eleven-year-old Persky followed her mother into the apartment, where she saw a pull-down bed with a woman lying facedown with black hair spread out across the white sheets. "It was quite a moment," Persky recalled, "the baby lying in the bed, and Yoko, black hair spread out. But I didn't know who Yoko Ono was. I certainly did not understand that as a kid, so I was like, 'Okay, we saw that. Can we get in our apartment now?'"

Poster for Yoko Ono's *Morning Piece*
COURTESY THE ARCHIVES OF LISA JANE PERSKY

It didn't take long for Persky to figure out that Ono wasn't a typical building superintendent. "Yoko was definitely doing Happenings and Fluxus art–type things," Persky said, recalling an event Ono held on the rooftop of their building,

Morning Piece. "She was always really interesting. I was fascinated by her. She gets the shit end of the stick a lot, but I think she is a miracle of womanhood." The busy artist sometimes dropped off Kyoko for Lisa and her mother to babysit, telling them she would be back by eleven o'clock that night—though occasionally Ono would return much later. "She would also wait for my mother to leave and then say, 'You take the baby,'" Persky said, "and it was just total nonsense. There were a lot of things about her that were interesting."

While living at 87 Christopher Street, Ono and Cox struggled a great deal in their marriage. "She and Tony had big fights," Jane Holley Wilson recalled. "It could get uncomfortable." The couple lived in the apartment next door to Harry Koutoukas, and Ono became good friends with him after having a terrible argument with Cox, who slammed the door and left. "Silence," Ono recalled. "Then I heard somebody knocking on my door very quietly. That was Harry. He invited me for tea at his apartment. He made tea, never mentioning what he obviously heard through the paper-thin wall. He was very considerate. I have never forgotten that afternoon—and how sweet Harry was."[19]

Koutoukas's apartment was small, dark, and cramped. There was just enough room for a sink and bathtub in the kitchen area, plus a little dining table, and behind that was a small area where the playwright slept. Actor James Hall, another resident of 87 Christopher, recalled, "All kinds of people went up to his apartment—Jim Rado and Gerry Ragni, who wrote *Hair*—all those guys. His apartment had dragons, creatures, all kinds of wild decorations." Koutoukas also made an impression on the young Persky. He dazzled her with his reality-bending stories, such as how his electricity was powered by albino cockroaches that ran on little spinning wheels in his bathtub. "It was like having a real poet in your midst," she said, "who completely grasped what was going on around him and turned it into something more beautiful, elegant, crazy, exaggerated."

Jane remembered Harry as a very warm person who made life in the building much more interesting, introducing her to his friends and bringing them by the apartment. "I don't think Harry ever had a regular job," she said. "He had some patrons, always, but he also always owed money." Ono helped Koutoukas from time to time throughout his life, and if bills came when he didn't have any money, he would stamp it DECEASED and mail it back—so he could spend what little he had producing his Off-Off-Broadway shows.

CHAPTER 9

Off-Off-Broadway Oddities

"I stepped into the new century my first day in New York when I stepped into Caffe Cino," playwright Robert Patrick said. "There was no question that I was in the most important place in the world. I know Harry Koutoukas felt like that. Whenever nothing else was booked, Joe Cino would say, 'Harry, you've got something?' and Harry would give him a title. Then Joe would put the title in the *Voice*." Though Koutoukas had been hanging around the Cino for a few years, his career as a playwright began in December 1964 with *Only a Countess May Dance When She's Crazy (an Historical Camp)*, which he wrote and directed at Caffe Cino.

Koutoukas's script notes stated that the play was "a tour-de-force for one actor, male or female," and the prop list reads like an ingredient list for making a surrealist bomb:

> Confetti or glitter
> Paper coffee cup on string (preset above table)
> "Tierra" (tiara made from globe with mushroom cloud)
> Lump of "shit" (colored Play-Doh)
> 2 life-size DayGlo skeletons
> Rubber hand on elastic band w/Velcro
> Jeweled hand mirror[1]

The script has the Countess shouting, "Bring me MY TIERRA—The one with the fewest jewels. . . . Oh there is no one to bring it—NO ONE TO BRING IT! NO ONE SHALL BRING IT OR CAN—I shall bring it unto myself! Even if I have to get it myself." When the Countess returns with her "tierra," she is interrupted by the ringing of a telephone, followed by the lowering of the paper cup on a string, which she answers. (When Koutoukas was asked why he couldn't just use a prop telephone, the playwright snapped, "In a *Koutoukas* production, it's *paper cups*.")

"Harry Koutoukas had the wickedest tongue in the world," recalled Cino regular Jim Fouratt. "He could drop a line like nobody I've ever known. He could cut you with his tongue, like a saber knife across your neck."

The playwright's version of the ancient Greek tragedy *Medea*, performed at Café La MaMa, seamlessly mixed pathos and farce in high Koutoukasian style. The production—retitled *Medea, or Maybe the Stars May Understand, or Veiled Strangeness (a Ritualistic Camp)*—was set in a laundromat, and the title character was a man in drag. During the show's final scenes, Medea blinds Creon by throwing bleach in his face and then kills her children by drowning them in a washing machine. The play had one foot planted firmly in contemporary camp culture and the other in ancient Greek theater. "Medea was played by Charles Stanley in a very dramatic style," Michael Smith recalled. "It was a pretty straightforward version of *Medea*, apart from its eccentric setting in the laundromat. Charles Stanley occasionally did drag, but it was a theatrical drag, not an 'I am a woman' drag."

When Stanley played Jean Harlow in another Koutoukas play, *Tidy Passions*, the Italian actor's black hair could be seen beneath his wig as he uttered lines such as, "Blond is the color of my true sex-goddess hair." In another scene—after Harlow was told she was holding up a production and was "late"—the diva snapped, "When I had my period, four hundred people didn't work!"[2] As Fouratt noted, "That line said a lot of different serious things and campy things. It's just star power—'Fuck you,' you know." Later in the show, Stanley launched into an extended monologue about the death of glamour, screaming and weeping: "Formulas gave forth formulas and glamour couldn't add or count, so it died at its first literacy test."

> When glamour died, did it go to heaven? . . .
> Why is why why?
> [Stands.]
> I'm a *stah* of the *cinemah*—to be seen—
> To be heard. All I can say—all that I know
> Is that glamour's dead.
> [Starts off. Turns to audience.]
> ANYBODY WANT TO FUCK A STAR?
> [Flashbulbs. Exits.][3]

Tidy Passions was first performed at Café La MaMa's 122 Second Avenue location, and its set resembled the inside of a kaleidoscope. "It is important that

the setting be made of remnants of glass, cellophane, etc.," Koutoukas's stage notes instructed. "It is vital that no part of the setting or costumes be bought; the designer of the costumes and sets must spin them of remnants and castaway items." At the start of the show, the Cobra Priest character utters a one-line homage to poet Allen Ginsberg's *Howl*, screaming, "I have seen the best cobras of my generation die mad—from lack of worship."

"ANCIENT TEMPLE MUSIC *UP*."

In the same play, Jacque Lynn Colton played a character who was described as having a razor blade for a vagina. At one point, Colton's character "threw up her preconceptions" as she leaned into the footlights and spat out beautiful blue, green, red, and gold glass baubles. The surreal chaos of Koutoukas's plays sometimes bled into real life. "There was one night when we did it," recalled Colton, "and the rumor was that Harry was despondent and he was going to commit suicide onstage. Everybody was terrified, but then he didn't, thank God." And during the Cino production of *The Death of Tintagiles*, Harry stirred up trouble as he sat by the stage wearing his cape with the fake parrot on his shoulder. "It was supposed to be a serious play," said cast member Jayne Anne Harris, "but, well, Harry was kind of a force of nature, even from the audience."

The trouble began when the lead actress pushed open a set door with her pinky, even though it was supposed to be heavy, which Koutoukas found endlessly amusing. "She was a Method actress, and she was a pain in the ass," Harris recalled. "If you *laugh* one more time, I will cut you," she declared, which only made Koutoukas laugh harder. "If you *laugh* one more time, *I WILL CUT YOU!*" she said again in a very dramatic Shakespearean voice, while holding a sword over her head. Koutoukas laughed again. Patrick, who was managing Caffe Cino that night, recalled that "she buried her sword in Harry's table and stormed out."

The Death of Tintagiles's run abruptly ended, so the café crowd quickly threw together a new show—a common occurrence at Caffe Cino, which had become known for staging plays based on comic books. This tradition began when someone suggested that they perform scenes from a *Wonder Woman* comic that was lying around the Cino. *Great idea*, Robert Patrick thought, so he sent someone out to buy extra copies of the comic at the corner store. "You're Steve Trevor," Patrick said, grabbing anyone who was available. "You're Woozy Winks. You're Etta Candy." Diana Prince—aka Wonder Woman—was played by Koutoukas (he eventually put the name "Diana Prince" on his mailbox at 87 Christopher Street).

"Within the hour," Patrick said, "we had *The Secret of Taboo Mountain*, the Cino's first comic book play. There were four comic book shows: *Wonder Woman*,

Snow White, Archie and His Friends, and a 'Classic Comics' version of *Faust.*" Koutoukas also appeared in *Snow White,* where friends and audience members were sometimes recruited minutes before a performance. Robert Shields, the actor who played Grumpy, recalled that the number of dwarves fluctuated from evening to evening. "One night we had something like eighteen to twenty dwarves running back and forth," he said. "Fred Willard did it one night. Whoever was there, they'd just say 'Okay, yeah, I'll do that.' So occasionally we had more dwarves than we had audience."

The shows at Caffe Cino were so intimate that occasionally, when drunk patrons had to use the bathroom, they might walk over a set piece during the performance. Actor Norman Marshall recalled that the Cino's dressing room was about the size of two phone booths put together, which created some memorable interactions with the audience—such as the one that happened during a 1967 show, *Vinyl.* When a naked performer attempted to put on his dance belt one night, someone accidentally bumped into him and he lost his balance. "He's got one foot on the floor and his other foot is tangled up in his dance belt," Marshall said. "He goes flying out through the curtain backwards, hopping on one foot, and his bare ass lands on a table of food."

The Cino and other Off-Off-Broadway venues carved out a place for gay men to explore ways of acting out openly queer identities, which eventually reshaped mainstream American culture. "Homosexuality," Michael Smith noted, "was unmentionable at the time." Robert Heide learned this lesson in 1961 when he wrote a play, *West of the Moon,* in which two men stood in a Christopher Street doorway seeking shelter from the rain. As the play unfolds, an older hustler takes advantage of a naive preacher's son who had just arrived in town. Establishment critics were repulsed, and a *Theatre Arts Magazine* reviewer said Heide "should break his typewriter over his hands." But Joe Cino liked it, and told Heide in his own eccentric way, "I want you to write a play just like *West of the Moon,* for two blond Nazi men."

The Bed featured two very attractive men in an existential time warp, drinking and drugging for three days. Joe Cino had no second thoughts about staging a show about two men in a bed, unlike Broadway producers of the time. "The Cino was very relaxed about people being gay," Smith said. "So it was no big deal there and no one judged you that way. It was an outsider place because these people had no other place to show their work. There were a lot of gay plays there early on, like Lanford Wilson's *The Madness of Lady Bright.*" That show was a heartbreaking little masterpiece, a Valentine to loneliness featuring an openly

gay main character—the first of many written by Wilson, who developed into a major American playwright and eventually won a Pulitzer Prize for Drama, among many other honors.

Lady Bright was a queen going crazy on a summer night, alternately talking on the phone and staring at the mirror, babbling: "You're not built like a faggot—necessarily. You're built like a disaster. But, whatever your dreams, there is just no possibility whatever of your even becoming, say, a lumberjack. You know?"[4] Wilson originally based the play's flamboyant character on Robert Patrick, but then the playwright met a true original named George Winslow, a ticket agent. "He was all hands and eyes," Patrick recalled, "and Lanford rewrote the play and caught George perfectly."

When Patrick began hanging out at Caffe Cino in 1961, he had no grand design to become a playwright. It was his friend Wilson who helped inspire him to begin writing *The Haunted Host*, a play that was set on Christopher Street and also featured an openly gay character.[5] "We went around to a diner called Joe's for lunch, and I reached for a napkin," he recalled. "I started writing *The Haunted Host*, but I would never have thought of writing the play if I hadn't already been part of the Cino."

When Patrick asked Joe Cino to put on the show, he just threw the script over his shoulder and into the garbage. "You don't want to be a playwright. Playwrights are terrible people," Cino said, motioning to his star scribes—Lanford Wilson, David Starkweather, and Tom Eyen. "Oh, all right," Patrick replied, dropping the issue. "Joe, you should do Bob's play," Wilson interjected. "He pulls his weight around here and you should do his little play." Cino said, "No. He'll thank me someday." Wilson then insisted, "If you don't do Bob's play, none of us will do plays here anymore." The other two playwrights looked at Wilson with raised eyebrows until Joe said, "Oh, all right, if it's going to be a palace revolution."

The Haunted Host was a hit, kicking off Patrick's wildly prolific career. The Cino production costarred William Hoffman, who was close friends with Patrick and was also Wilson's new boyfriend. "I ran away to the Village to be with them," said Hoffman, who had previously lived uptown. "The Cino was so welcoming to the gay side of me, so I didn't have to hide myself, and it was a wonderful feeling." He played the Guest in *The Haunted Host*, though he soon realized that acting wasn't for him because he was terrible at memorizing lines.

Hoffman was much better at writing scripts, the first of which began as a short story. "Lanford read it and said, 'By golly, your short story is a play!' So I set it as a play, *Good Night, I Love You*, and Joe Cino decided to do it." It revolved around

a telephone call between a gay man and his straight female friend. "It was like the television show *Will and Grace*," Hoffman said, "written thirty years before. It's identical."

Even though these playwrights included gay characters in their shows, they didn't think of themselves as making "gay theater." As Patrick put it, "It was more a question of *free* theater." After all, the Cino was also bursting with female playwrights such as Diane di Prima, Claris Nelson, and many others who were shaking up theatrical conventions. "There was every kind of person there," Hoffman said, "including very effeminate to not effeminate at all. I don't think you could pigeonhole it into one category or the other. The common denominator was that there were many gay men there, but there were also a lot of women and straight guys. It was a big mixture, and it was really way ahead of its time."

At the same time that these adventurous playwrights were presenting their work at Caffe Cino and Café La MaMa, an unlikely outlet opened its doors to Village artists of all kinds. "Judson Memorial Church was so pivotal to the foundation of downtown because they were so open to freedom of expression," said Agosto Machado. "They encouraged expression and let so many people in all the art movements do their thing. They took away the pews. They had Happenings. There was dance, movement, song. Gender preferences did not matter to the church." For example, Al Carmines, Judson's openly gay minister (who was also a musician), staged material that could've gotten him arrested for obscenity elsewhere.

In 1959, the Judson Gallery was founded in the church's basement at 239 Thompson Street, which displayed work by Pop and conceptual artists Robert Rauschenberg, Yoko Ono, Claes Oldenburg, and Red Grooms—and was home to several Happenings. The seeds of Happenings were planted in the early 1950s at Black Mountain College, when John Cage and his peers began developing mixed-media spectacles that emphasized live performance. Allan Kaprow, Dick Higgins, and Al Hansen were early Happenings innovators who attended Cage's influential, consciousness-raising class at the New School for Social Research in 1958.

"The everyday world is the most astonishing inspiration conceivable," Kaprow wrote. "A walk down Fourteenth Street is more amazing than any masterpiece of art."[6] He started out as a Jackson Pollock–inspired action painter, then began incorporating aluminum foil and other matter. Like many artists who became part of 1960s avant-garde art movements, Kaprow developed an expanded approach to painting, composition, poetry, and, eventually, performance.[7] As media scholar Fred Turner noted, "The lines between audience and performer, between art

and everyday life, between the ordinary object and the beautiful thing—Kaprow seemed to have blurred them all.[8]"

Kaprow's classmate Al Hansen also performed Happenings at Judson Gallery—such as his 1964 piece, *Oogadooga*—and in 1965 was the first to publish a book about the subject, *A Primer of Happenings and Time/Space Art*. However,

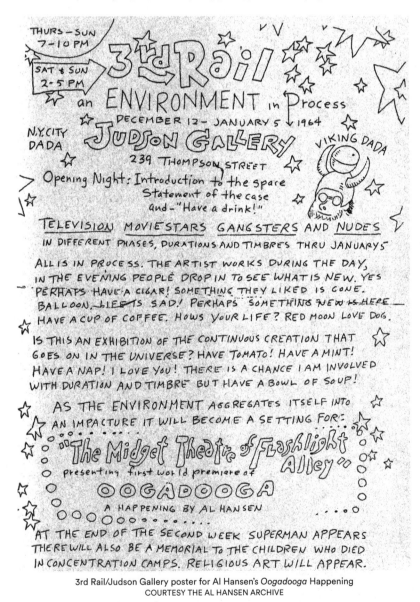

3rd Rail/Judson Gallery poster for Al Hansen's *Oogadooga* Happening
COURTESY THE AL HANSEN ARCHIVE

his idiosyncratic nature doomed any possibility of a "career" in art. Hansen's long, strange trip began when he served as a GI in post–World War II Germany, where he impulsively pushed a piano off the edge of a bombed-out building. He always considered that his first performance piece, and even reprised it as the *Yoko Ono Piano Drop* during his involvement in the Fluxus art movement. (Fluxus artists often named pieces after their friends, in a sort of intertextual social networking game.)

"Al Hansen was one of these crazy figures that marries all of these scenes together," said his daughter, Bibbe Hansen. "He's the connect-the-dots guy between the post–World War II beatnik to neo-Dada to Pop Art and Fluxus and Happenings and performance art and Intermedia." He was a roommate of Beat poet Gregory Corso, and when Bibbe was a young teen she lived in a Lower East Side apartment with Janet Kerouac, daughter of Jack Kerouac. Bibbe also tagged along with her father to see underground film screenings at Jonas Mekas's loft that were attended by Andy Warhol, with whom she would later collaborate on a couple of films (she also appeared in some of Mekas's films).

Al Hansen's 1962 *Hall Street Happening,* in which Bibbe performed when she was around ten, became infamous. It was held in the backyard of a place Al was renting with a friend in Brooklyn, on Hall Street, where people read poetry from behind bushes surrounded by large sheets of spray-painted plastic. "Larry Poons was in it, with the toilet seat around his neck," she recalled. "Two girls were making out on a deck chaise lounge thing, and I was given several assignments." Bibbe alternated between singing a rock 'n' roll song and smashing bottles in a box, while Cynthia Mailman was in a bikini on the porch roof dancing to a hit song, "The Stripper."

Unfortunately, Mailman ended up falling through a glass skylight during the performance. "We heard shrieking and screaming, and thought it was part of the Happening," Bibbe recalled. "The audience did not know that she was suffering and this was indeed a horrible thing, but my dad knew, and the ambulance and police were called immediately, but we went on with the Happening. So the cops were there, this guy was feeding them worms on a fork, and I'm circling the cops. Everybody kind of thinks it's all part of the Happening, and nobody had any clue."

Happenings were often unpredictable and provocative, like Carolee Schnee-mann's 1964 performance piece *Meat Joy*, which featured nude performers who played with paint, sausage, and raw chickens, and was presented at Judson Gallery. Two years after that gallery opened, Judson Poets' Theatre was founded

in 1961, and the Judson Dance Theater emerged the following year (its first concert featured the free jazz musician Cecil Taylor collaborating with dancer Freddie Herko).[9]

"The painters, the sculptors, the actors, the playwrights," director Larry Kornfeld said, "everybody at Judson were involved in exploring and extending mediums and the blending of them." Kornfeld—who saw himself as "a sculptor of space"—was deeply influenced by Merce Cunningham's and John Cage's spatial and temporal explorations. "Space was being explored by painters who were at the theater, people like Rauschenberg, who did sets for us. People were always at each other's shows, recitals, performances. They were drinking together, screwing together. There was a vast interchange of information and activity. It was a community, an anarchic community."

Kornfeld left the Living Theatre in 1961 to join Judson Poets' Theatre. He had been hanging out at the Cedar Tavern, one of his regular Village haunts, when poet Joel Oppenheimer approached him about directing his play at Judson. Oppenheimer had attended Black Mountain College in North Carolina during the early 1950s, crossing paths with Rauschenberg, Cage, and Cunningham. Back in New York, the Black Mountain group grew closer while spending time at the Living Theatre—where the interdisciplinary Monday Night Series was held and Cage and Cunningham also had a studio.

This environment inspired Oppenheimer to write a satirical play, *The Great American Desert*, which Kornfeld agreed to direct despite his concerns about censorship. (One character exclaims, "Damn this fuckin' desert anyhow. All this sweat over water, goddamn when I was a boy back home in Illinois they used to talk about the plains."[10]) Kornfeld told him, "Joel, it's a church. You've got 'fuck' all over the script, and 'fuck' is not even said in the theater these days." Oppenheimer assured him, "Oh, no. The church board read it, and they approved. They gave me their word that they will not interfere."

The church did not interfere, even though the play contained the type of language that caused Lenny Bruce to be arrested for obscenity three years later when the comedian performed his material just two blocks away at Café Au Go Go, in 1964. "We were very ethical, and inevitably broke the law," Kornfeld said. "There was a lot by cursing, nude performances, but nothing salacious—like Yvonne Rainer dancing with Bob Morris naked on stage at the church." Agosto Machado recalled that Judson strived to be inclusive of all ideas, art forms, and political beliefs. "They let antiwar speakers speak, and it was really quite marvelous," he

said. "Food for the hungry, on every human cause, the Judson community was trying to help humanity through their outreach."

Judson was deeply committed to supporting the arts community by providing them space to create. This openness expanded after they hired Al Carmines, who served as the associate minister for the arts at Judson. In addition to giving sermons and other ministerial duties, he wrote songs for plays that Judson produced—such as *Gorilla Queen*, a bawdy, campy, satirical riff on old B movies. This 1967 show featured two members of the Harris family: George Harris II (one of the few straight men in the show) and his son, a pre-Hibiscus George Harris III. "I met the Harris family at Judson," Machado recalled. "I feel very blessed to have met them. There was so much love with that family, and the parents were so nurturing."

Jayne Anne Harris appeared in the Judson production *Sing Ho for a Bear*, an adaptation of *Winnie-the-Pooh* with music by Al Carmines, and she also did a few Happenings there. "There was nudity," she said, "there were people running around, there was all kinds of stuff going on." One Happening involved a red team and a blue team that performed different dances to the Righteous Brothers song "You've Lost That Lovin' Feeling" as a man roller-skated by in a yellow dress. Walter Harris also performed in a Happening that was organized by director Tom O'Horgan. "The whole point of that Happening was to have what Tom called a kinetic sculpture," he said, "or human sculpture with music and other stuff." O'Horgan collected musical instruments from around the world, and he gave Walter some Tibetan chimes for him to play as he walked around in a funny hat; the two would later work together in the 1968 Broadway debut of *Hair*, which O'Horgan directed.

"Once we did an Easter sunrise morning Happening in Washington Square Park," Kornfeld recalled. "During the middle of it, Andy Warhol arrived and he drove into the park in a white limousine. He drove right into the center to upstage it, so we embraced it. It was all part of camping, making an entrance."

Happenings and other experimental performances had an impact on the plays that Kornfeld staged at Judson Poets' Theatre. Two of his biggest artistic breakthroughs were productions of *In Circles* and *What Happened*, both by Gertrude Stein, who Kornfeld cited as a major influence on the downtown scene. In its rejection of time-bound narratives, her groundbreaking writing anticipated the kind of approaches that later developed around Happenings. Stein developed a more spatially oriented approach that allowed audiences to contemplate all the

components at play—and to let them participate in meaning-making, rather than being passive spectators.[11]

What Happened wasn't a play in the traditional sense. It was more of a poem uttered by different unnamed characters, which posed several challenges for Kornfeld, though he embraced the nonlinear narrative and wordplay. This Judson Poets' Theatre production included five dancers and four actors—with Al Carmines onstage playing piano—and its use of the space and lighting was quite radical for the time. *What Happened* featured a protopsychedelic wash of light masterminded by Johnny Dodd, Caffe Cino's resident lighting genius, who also worked at Judson and other venues.

"The pews were taken out, folding chairs were put in, and so we played in every direction, in every corner, every possible way of using that space," Kornfeld said, describing the upstairs choir loft that overlooked Judson's open area of worship. "We sat audiences upstairs, they looked down, they sat downstairs, and looked up. Every kind of focus was explored—even two and three foci at the same time. It was an exploration of space." Bibbe Hansen still treasures her vivid memory of seeing *What Happened* as an adolescent. "It was absolutely, for me, a turning point culturally, artistically, because it was by nature very experimental and nonlinear," she said. "And yet it was lyrical and it was lovely and very winsome and captivating."

Hansen was even more surprised and delighted when the piano, which had remained in place throughout the performance, was swiftly moved from one end of the church to the other by the actors and dancers—all while Carmines continued playing. "At every performance from the first performance on," Kornfeld recalled, "audiences just stood up and cheered at that moment, because they had never seen a piano move like that."

It didn't simply move from point A to B; the piano itself seemed to *dance*. Carmines was a large man (not unlike the instrument he played), but both glided gracefully across the floor, twisting and turning with the most fluid of motions as the performers continued to sing. It may be hard to appreciate the jolt audiences felt back then, for it is now common for everyday objects to be incorporated into performances—thanks to the innovations developed by artists at Judson Church and other downtown venues. They inaugurated a paradigm shift by showing that even pianos, and not just human bodies, could be made to dance and occupy space in new ways.

CHAPTER 10

Underground Film's Bizarre Cast of Characters

Andy Warhol's dive into underground film commenced in early 1962 when he began attending screenings at the Film-Makers' Cooperative, then operating out of Jonas Mekas's loft. Warhol was one of fifteen or so people sitting on the floor, though he and Mekas didn't become acquainted until 1963. "That's where Andy Warhol began watching films and got the urge to make movies himself," Mekas recalled. "He was at the Film-Makers' Cooperative watching films and meeting his early stars: Mario Montez, Beverly Grant, Naomi Levine, Taylor Mead. He met them at the Film-Makers' Cooperative, and that's when he decided to make a film."

Mekas was already a major force behind the downtown's underground film movement, both as a filmmaker and as a critic who documented and promoted the scene. He also organized dozens of screenings, which attracted other like-minded artists and budding filmmakers, such as Jack Smith. The two first met in 1961 when Mekas was doing programming for the Charles Theatre, on Avenue B and Twelfth Street. "I hired Jack Smith as a ticket-taker," he said, "but I had to fire him two weeks later. He could not concentrate. But at the time I met him he was preparing to film, and a couple of months later he made *Flaming Creatures*."

Smith's highly influential underground film was shot on shoplifted black-and-white film stock, often overexposed to create a hazy white sheen. With its "disorienting framing and close-ups and lacking any real narrative continuity," art historian Branden Joseph noted, *"Flaming Creatures* was a concatenation of seemingly poor technical choices that added up to a hallucinatory new aesthetic vision."[1]

Flaming Creatures erupted with sexually ambiguous images of gay and trans performers, with quick cutaways to penises and breasts—all of which was less prurient than surreal. Smith loved trashy 1930s and 1940s Hollywood films, and his underground film's opening sequence appropriated the soundtrack of the 1944 Maria Montez film *Ali Baba and the Forty Thieves*. As one of Smith's characters applies lipstick, a faux ad in the background poses the question, "Is

there lipstick that doesn't come off when you suck cocks?" This gleeful assault on mainstream American values resulted in police raids and United States Supreme Court–backed censorship (the high court declined to hear an appeal, upholding the previous obscenity ruling).

"This movie will be called pornographic, degenerate, homosexual, trite, disgusting, etc.," Mekas wrote at the time in his "Movie Journal" column for the *Voice*. "It is all that and it is so much more than that."[2] Likewise, cultural critic Susan Sontag defended Smith's work in the *Nation* magazine, praising *Flaming Creatures* for "having, as its subject, the poetry of transvestitism." Sontag observed, "These are 'creatures,' flaming out in intersexual, polymorphous joy. The film is built out of a complex web of ambiguities and ambivalences, whose primary image is the confusion of male and female flesh."[3] By channeling his love of obsolete Hollywood celebrities like Maria Montez and other tacky consumer culture detritus, Smith charged them with new symbolic meaning. In so doing, he created a template for the queer, trashy camp styles that took root downtown and eventually permeated pop culture.

"I would go on the Greyhound bus and sneak away to New York," recalled film director John Waters, a devotee of Mekas's screenings. "I'd go to the Bridge Theatre. I went to the Film-Makers' Cooperative. I went to see the early Warhol movies, Jack Smith movies, all that stuff." Waters even attended New York University briefly, until he was expelled after being busted for marijuana possession. "But it wasn't really NYU's fault," he said. "I didn't go to class. I went to Times Square every day and saw movies. I stole books from their bookshop and sold them back the next day to make money. I took drugs. I probably should've been thrown out."

Warhol was inspired to make movies after seeing *Flaming Creatures*, which precipitated his shift away from visual art. In 1963, he bought a Bolex 16-mm camera with a newly introduced motor that made shooting simpler—one of the ways that new technologies shaped the development of the downtown's DIY scenes. (The massive amount of cheap 16-mm film stock left over from World War II also gave underground filmmakers access to this medium.)

While happily buzzing along on Obetrol, a diet pill often abused as a stimulant, Warhol began filming his boyfriend, poet John Giorno, as he slumbered at night. This resulted in the long silent film *Sleep*, which was composed of twenty-two different shots, some of which were looped and repeated several times.[4] Warhol also began working on a series of *Kiss* films, which included little more than scenesters such as Ed Sanders locking lips in semi-slow motion. "When he made his first films, *Kiss*, already I had almost fifteen years of cinema in me," Mekas

recalled. "I was publishing *Film Culture* magazine already for ten years, and writing. So I was very familiar, and I immediately saw that this is different—this is new, this is important. I was running at that time a filmmakers' showcase on Twenty-Seventh Street between Park Avenue and Lexington, and that's where I presented that series of *Kiss* films and premiered *Sleep* and his early silent films."

Sleep's experiments in time were also explored in the music of minimalist composer La Monte Young, who moved to the city in 1960 and became involved in Yoko Ono's Chambers Street Loft Series and the Fluxus art movement. Just as Warhol and other 1960s underground filmmakers expanded the temporal possibilities of film, Young and his collaborators did the same with music and sound—stretching out notes for hours at a time, creating elongated drones. Warhol, Smith, and Young were at the center of a swirling vortex of collaborative activity that touched many areas of downtown life and art. The *Flaming Creatures* soundtrack, for instance, was assembled by Tony Conrad, who performed in Young's group the Theatre of Eternal Music alongside Factory custodian Billy Name and future Velvet Underground member John Cale. Warhol also commissioned Young to produce droning sounds to accompany his silent films when they were screened at the 1967 New York Film Festival, and he worked with Jack Smith on several other projects.

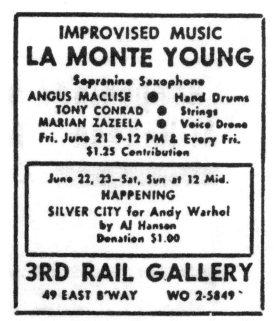

Advertisement for events at 3rd Rail Gallery

"Jack was a pure genius," said Smith's friend Agosto Machado, "a visionary artist who had the strength and determination to carry out his vision with almost no money. Jack talked about going to the Middle East to shoot, but since he couldn't afford to, he created that location in tenements or various places where he could create an illusion of that faraway place. You were in another dimension when you were with him because he didn't have a storyboard. He'd just set up and say, like, 'Oh, you're walking through the swamp, and there's a *mysterious creature* that's going to do this, that, and the other.'"

"Anyone who worked with Jack," Tony Conrad recalled, "knows what his direction was like: maddeningly unfocused, imprecise, and yet strongly imbued with ideas about the world of the project that it was necessary for all of us to inhabit."[5] At first Conrad didn't know what he was getting himself into when he helped Smith set up one Saturday to film *Flaming Creatures* on the roof of the defunct Windsor Theater, a tiny movie house on the Lower East Side. It took three hours for everyone to apply makeup and costumes, all while the drug intake spiked. *Something very weird is going on here,* Conrad thought as he and others began cross-dressing. *Geez. If my friends like La Monte could see me now, I would be so embarrassed, because this is like the weirdest shit.*[6]

"Jack also shot some of the scenes in Prospect Park, which wasn't as peopled or cleaned up during those years," Machado said. "You could walk through sections of slummy areas and do a shoot, if you just minded your own business and you did your thing." Playwright Ronald Tavel, who went on to write scenarios for Warhol's mid-1960s films, also worked on *Flaming Creatures*—dropping bits of plaster from a ladder onto the actors during the earthquake scene, among other tasks.

Flaming Creatures debuted in 1963 and was shown three times in early 1964 at the Gramercy Art Theatre without incident until the police issued a summons against the movie and the theater was forced to halt its screenings. The resourceful Mekas continued the screenings at the Bowery Theatre in the East Village, which was then hosting Diane di Prima's New York Poets Theatre company. On March 3, 1964, an undercover police officer in the audience arrested as many people as he could, including Mekas. "He watched the film," Mekas recalled, "and I knew, 'That's a cop, and he may arrest me.' I even had sandwiches in my pocket prepared already. Chicken sandwiches. I knew I might be arrested. They had seen an advertisement and the police just came in. They were waiting until the end of the film. No big fuss. I just spent a couple nights in jail."

Future gay rights activist Harvey Milk was another audience member who was thrown in the police wagon and taken to the Ninth Precinct house on East

Fifth Street.[7] Mekas was sentenced to sixty days in a prison workhouse in 1964, an unsettling irony for the survivor of a Nazi labor camp who came to America for the freedoms it offered. His sentence was eventually suspended, and fifty-one years later prosecuting attorney Gerald Harris reached out to Mekas. "I feel I owe you an apology," he wrote in a 2015 email. "Although my appreciation of free expression and aversion to censorship developed more fully as I matured, I should have sooner acted more courageously." The *New York Times* reported that Mekas replied immediately: "Your surprise generous apology accepted!"[8]

<center>***</center>

"Harry Koutoukas, Andy Warhol, and others would bow silently to Jack Smith," Agosto Machado recalled, "because he was such a pure artist." Warhol said that Smith was "the only person I would ever copy," adding, "I just think that he makes the best movies."[9] Having fallen under the spell of *Flaming Creatures*, Warhol turned his back on the visual art that made him famous and focused almost exclusively on making his DIY films. "Warhol had a particular anti-craftsman attitude," said Judson Poets' Theatre director Larry Kornfeld. "It was the idea that anyone can make art." In a 1965 news story about underground cinema, a befuddled *CBS News* correspondent inquired about this shift:

"Andy, why is it you're making these films?"

"Well, it's just easier to do than painting," Warhol deadpanned, hidden behind his sunglasses and platinum wig. "The camera has a motor and you just turn it on and you just walk away. It tapes all by itself."

"Is there anything special you're trying to say in these films?"

"Uh, no."[10]

Warhol had already embraced an amateur aesthetic when he created his sloppily printed silkscreen prints, an approach he brought to his films of everyday acts like people sleeping, kissing, and getting haircuts. They also foregrounded an emerging gay aesthetic—in particular, a preoccupation with the male body and an overtly camp style. Warhol's 1964 film *Blow Job*, for example, featured thirty-six minutes of facial expressions made by a young man on the receiving end of that sexual act, without revealing anything else. Cultural critic Juan A. Suárez noted that Warhol's experience as a gay man made him aware of the ways marginalized groups used style and theatrical gestures to mark themselves—a knowledge that clearly had an impact on his moviemaking.[11] *Blow Job* was also a typically Warholian prankish provocation, against both potential censors and audiences who were drawn in by the lurid title (many of whom left in droves out of boredom).

In addition to screening Warhol's early cinematic experiments at the Gramercy Arts Theatre, Mekas also operated the movie camera for *Empire*, Warhol's eight-hour "portrait" of the Empire State Building. After making several silent films between 1963 and 1965, Warhol began incorporating sound and loose narratives into his underground movies. *Soap Opera* was a transitional film that straddled his silent and sound eras—featuring actress Mari-Claire Charba, model Jane Holzer, and Warhol's printing assistant, Gerard Malanga. The film's only sound sequences were a series of commercials that broke up moments of soap opera drama, such as people silently arguing on the phone or getting slapped in the face.

Soap Opera epitomizes "Pop" in the way it appropriated from mass media—in this case, a series of old commercials made by Warhol's friend, film and theater producer Lester Persky. The connections between the soap opera segments and the ads are arbitrary at times, while elsewhere they are thematically linked, such as when an erotically charged scene cuts away to an unintentionally salacious commercial for Pillsbury cake frosting.

"Baby Jane Holzer and I played the same character," Mari-Claire Charba explained. "She played the very fancy part of the character, and I played the sort of shy, reserved, simple part of the character. We filmed it in a penthouse, and it was really a totally different universe from the bohemian scene in the Lower East Side where I lived. It was kind of like a jet-set scene. Andy never said a word to me. My experience with Warhol was through that camera lens, and it was a day of staring. I don't know what was going on in his mind." When Charba first arrived in New York to become an actress, she did straight acting work and was involved in the Actors Studio, home to Method acting patriarch Lee Strasberg. She had been working with the director Jerry Benjamin, who was friends with poets Frank O'Hara, LeRoi Jones, and Diane di Prima—who were all experimenting with underground theater. Benjamin was also involved with Warhol, which is how Charba was chosen for *Soap Opera*.

Andy's shift away from silent films began in the summer of 1964, after witnessing the opportunities offered by the Auricon camera. It was often employed by news reporters to shoot interviews on the street, and Mekas used that camera to film his version of the Living Theatre's production of *The Brig*. "You could record image and sound," he said, "and so immediately—the next day or in a few hours if you had labs available—you could project it. When Andy saw it, because I shot it and the next day I projected it, he was so impressed and amazed: 'This is it! This is it!' So I blame myself for ending his silent period with *The Brig*."

Andy used the Auricon camera for his first sync sound film, *Harlot*, which was

shot in December 1964. Gerard Malanga had been taking Warhol to Wednesday night poetry readings at Café Le Metro, where the writing of Jack Smith's friend Ronald Tavel caught the artist's attention. Warhol hired Tavel to write some "scenarios" for *Harlot,* and they soon began working together on Warhol's other film projects. These sorts of collaborations happened often because the mimeo poetry zine scene frequently overlapped with the audiences for underground movies; Beat poet and Fugs cofounder Tuli Kupferberg, for example, could be seen selling his own mimeo publications at Mekas's screening events.[12]

Harlot starred drag queen Mario Montez, who had previously appeared in *Flaming Creatures* and was named after Smith's favorite 1940s starlet, Maria Montez. Warhol's film depicts Malanga in a tuxedo blowing a puff of smoke at Montez, who is suggestively eating bananas. The only audio is Tavel and Billy Name having a conversation off-screen, perversely defeating the point of using a sync sound camera.

"Mario maintained a wonderful duality," said Montez's friend Agosto Machado. "If you saw him in the neighborhood, you would pass him on the street and he was an attractive Puerto Rican man. But you would not know that he could transform himself into a goddess as Mario Montez, this goddess muse of Jack Smith and Andy Warhol." He also appeared in several other Warhol films: *Banana, Batman/ Dracula, Camp, Chelsea Girls, Lupe,* and 1966's *Hedy,* the last of which was part of Warhol's "Hollywood trilogy" (a series of odd biopics that also included *Harlot*).

Hedy starred Mario as Viennese actress Hedy Lamarr—who, like many Andy Warhol and Jack Smith favorites, was known less for her acting skills than for her beauty and aura. In a scene that is reminiscent of a 1930s horror film, it opens with Montez on the operating table getting a face-lift. Smith played one of the doctors, the Velvet Underground provided the instrumental soundtrack, and the cast included Mary Woronov and Gerard Malanga, who were also featured dancers in Warhol's multimedia extravaganza, the *Exploding Plastic Inevitable.* "Jack Smith was just as nuts as everybody else," recalled Woronov, who met him while shooting *Hedy.* "He was a very, very strange man."

Smith appeared in two other Warhol films from that period, *Batman/Dracula* and *Camp,* which also included Caffe Cino playwright Robert Heide in the cast. "Jack more or less directed them, in terms of movement and what was going on," Heide said. "In *Batman/Dracula,* he was sort of like a Count Dracula himself, moving about and ordering people around. Jack gave me a hat to wear that said 'suicide' on it. So it was kind of a free-for-all, and everybody was on something. I remember it was kind of like a Happening." As for *Camp,* Heide couldn't recall

much. "Everyone was in some kind of a drugged gray-out, not a blackout. It was a whirlwind of time."

By 1965, Edie Sedgwick had become the Factory's newest superstar, though she soon began clashing with Tavel. Her first two nonspeaking roles were in *Horse* and *Vinyl*, followed by *Poor Little Rich Girl, Kitchen,* and several others. After she refused to play a role in what she called "Tavel's perversities,"[13] Andy turned to Heide and asked, "Would you like to be the Factory playwright to replace Ronnie?" *Sure, why not?* he thought, since he was already hanging around the scene.

During his brief stint as a Factory playwright, Heide wrote *The Death of Lupe Vélez.* The film's title was shortened to *Lupe,* and it starred Sedgwick as Mexican actress Lupe Vélez, who commits suicide and comes back from the dead. "This was the last film that Edie made with Andy, because she couldn't memorize lines," Heide recalled, "so it was basically an improvisational Andy Warhol take on the script. And after that, Andy just wanted everybody to talk in front of the camera with no script."

Heide was likely hired because Warhol had seen *The Bed* at Caffe Cino several times, and he created a film version of the play. (When the playwright approached Warhol to give a blurb for its Cino run, he said, "Well, just say whatever you want, that'll be fine.") Actor and activist Jim Fouratt recalled, "The reason Andy shot *The Bed* is because you had two young men—Red Forrest and Jim Jennings—in little tighty-whitey Jockey shorts running around on the bed, which was very provocative in 1965." That footage of *The Bed* was incorporated into the multiscreen film *The Chelsea Girls,* an underground hit in 1966 that featured a new addition to the Factory's stable of superstars: Nico, who joined the Velvet Underground the same year.

Ed Sanders fully immersed himself in the underground film scene after seeing Mekas's *Guns of the Trees* at the Charles Theatre and meeting Warhol at a Film-Makers' Cooperative screening. "Finally the inspiration of Jonas Mekas and the Film-Makers' Cooperative made me decide to acquire a 16-mm camera," he recalled. "I went to my friend Harry Smith for advice."[14] Smith was known in music circles for his *Anthology of American Folk Music,* but he was a man of many talents and interests, including experimental filmmaking. Harry suggested buying a "battle camera, like the kind they used filming the war," which he found at Willoughby's Camera on West Thirty-Second Street.[15] Filmmaker Stan Brakhage showed Sanders how to use it, and Mekas helped him locate inexpensive film stock.

By 1965, Sanders started making *Amphetamine Head: A Study of Power in America*, about Lower East Side speed demons such as Billy Name and Ondine. "There were plentiful supplies of amphetamine," Sanders recalled, "sold fairly cheaply in powder form, on the set." *The set*, as Sanders's friend Peter Stampfel explained, was their slang term for *the scene*: "Like, 'That guy's such a dick, he should be bricked off the set,'" Stampfel said. "You know, being kicked out of the scene for being an asshole." Sanders observed that because so many "viewed their lives as taking place on a set, there was no need to hunt afar for actors and actresses. What a cast of characters roamed the Village streets of 1963!"[16]

As it turned out, Sanders became better known as *Fuck You*'s publisher and the frontman of the Fugs than for filmmaking. This was due in part to the fact that the police raided his Lower East Side apartment and seized ten thousand feet of footage he had shot; later, Sanders's camera was stolen from his apartment, which effectively ended his underground film career. But while he was still making movies, Sanders began collaborating with Shirley Clarke and fellow filmmaker Barbara Rubin on a satirical anti-Vietnam project, *Fugs Go to Saigon*. (Sanders also suggested several alternative titles: *Eagle Shit, Aluminum Sphinx, Oxen of the Sun, America Bongo, Vampire Ass, Gobble Gobble, Moon Brain*, and *It's Eating Me!*) After Rubin took Sanders to see the Velvet Underground at Café Bizarre in late 1965, they began discussing ideas for the film, which was to star the Fugs alongside William Burroughs, LeRoi Jones, Allen Ginsberg, and a host of other downtown denizens.

Clarke attempted to fundraise from summer to fall of 1967, but she still wasn't being taken seriously as a filmmaker, despite her previous successes with *The Connection* and *The Cool World*. Her niece, Tracy Tynan, recalled that Clarke had to fight for her bit of turf in what was still very much a man's world. "I think she was very good at that in some ways," Tynan said, "but the downside was that it eventually took a toll on her. I think she was very up and down. She could be very excited and enthusiastic, and then she could be very discouraged and depressed. I think this had to do with her addiction issues, and that obviously had an impact on her personality."

Clarke's inability to get funding for *Fugs Go to Saigon* may have also had to do with the outrageous "plot" ideas supplied by Sanders: "William Burroughs dressed as Carrie Nation attacks opium den with axe," he wrote. "LeRoi Jones as homosexual cia agent. naked viet cong orgasm donuts suck off gi's with poisoned teeth. . . . horny priests disguised as penguins fight savagely for captured viet cong grope boy. . . . Shower of candy canes comes from sky over us headquarters in Saigon."[17]

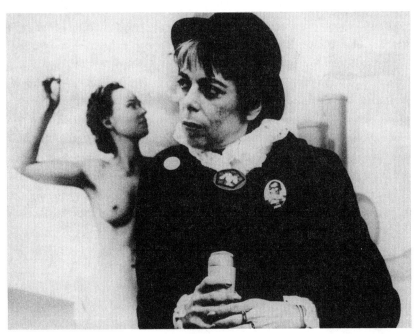

Shirley Clarke
COURTESY THE WISCONSIN CENTER FOR FILM AND THEATER RESEARCH

After the *Fugs Go to Saigon* experience, Clarke began work on *Portrait of Jason* with Carl Lee. She had already divorced her husband and began living with Lee, the actor who had appeared in her first two feature films, *The Connection* and *The Cool World*. Their off-and-on romance lasted twenty years. "Though I'd known nothing about Shirley's affair with Carl," her sister Elaine Dundy recalled, "I'd known for some time that besides being an actor (and maitre d' at the Café Bohemia, where Miles Davis played), Carl was now a drug dealer who was himself on hard drugs."[18]

"As I saw it," Dundy added, "Carl satisfied her need to rebel against bourgeois morality as she'd done as a young communist in the thirties and a postwar anti-nuke marcher. I think his outlaw activities must have excited her."[19] At one point Clarke decided to tell her mother about the mixed-race relationship, but then abruptly changed her mind. "Absolutely, there was tension surrounding her relationship with Carl," her daughter Wendy Clarke said. "She never told her parents, so it was a secret."

These tensions may have contributed to a mental breakdown—though drug use may also have also been a factor—and Clarke checked into a rehab facility for six months. After being discharged, she asked her sister to use her connections to get a place in the Chelsea Hotel, a hotbed of bohemian activity. Dundy told hotel

THE DOWNTOWN POP UNDERGROUND

co-owner and manager Stanley Bard that Clarke was special and should be looked after, and he later moved her into the hotel's penthouse. This gave Clarke access to the rooftop, which became the base for her film and video activities.

Around this time, Clarke worked with Mekas in setting up the Film-Makers' Distribution Center, mostly out of economic necessity. "Shirley's *The Connection* was one of the films that managed to get into some commercial theaters across the country," Mekas said. "The film had a run, and then she received the accounting. The income was like $1.2 million, and with the accounting came a bill that the film had lost something like $100,000, because she went with the commercial outlets." With this in mind, Mekas, Clarke, Lionel Rogosin, and other cinematic conspirators met at the Chelsea Hotel and decided to create a distribution system for more commercially accessible films, like Warhol's *The Chelsea Girls.* "They were avant-garde underground films that had a small audience," Wendy Clarke added, "and so that's why they decided also to distribute themselves."

Portrait of Jason was the first film project Clarke shot in the Chelsea. She produced it with no funding by using donated stock film left over from an NBC television production and a very small crew. "I was the set dresser for *Portrait of Jason,*" said Wendy, who was a teenager at the time. "I left before they started filming. It was a very closed set." This feature-length documentary was distilled from a twelve-hour interview with a gay African American male prostitute who went by the name Jason Holliday and was the only person who appeared onscreen. Clarke and Lee stirred up Jason with their off-screen questions, which ventured into uncomfortable, very personal territory—getting him to respond, riff, and perform for the camera.

"It was the first time a black gay hustler had ever been seen by most human beings," Wendy Clarke said. "It's a very provocative film, and it raises a lot of issues about race, class, politics, sexuality." *Portrait of Jason* was, in part, a pointed critique of cinema verité documentaries, implicating filmmakers who claim to objectively capture real life—without acknowledging how their very presence alters that reality. This desire for authenticity was certainly not a concern for Warhol, whose films knowingly acknowledged the presence of the cameras. Art and everyday life, fact and fiction, artifice and authenticity blurred together in a druggy haze at the Factory.

CHAPTER 11

Multimedia Experiments at the Factory

Like many who were part of the Factory scene, Bibbe Hansen had a chaotic childhood. Her mother was, at times, an amphetamine and heroin addict who had troubling alliances with men. By the time Hansen was fourteen, an escalating series of troubles landed her at the notorious Spofford Juvenile Detention Center in the South Bronx. After serving several months in 1965, she was released into her father's custody on a Friday. The next day, Bibbe and Al Hansen resumed one of their weekend rituals: walking the uptown art gallery circuit that stretched from Fifty-Seventh Street to Seventy-Ninth Street.

After their visit to Castelli Gallery, they wound up at a restaurant-bar called Stark's, where her dad's artist friends asked them to join their table. "Roy Lichtenstein offered to buy us burgers, and after a few months in the youth house, that was really a wonderful thing, let me tell you," Bibbe said. "They're all talking artist-guy stuff, which is pretty uninteresting to me, but I'm very happy with my burger. Suddenly, eyes are peering at me from across the table, and it's Andy Warhol." He was a familiar sight from Jonas Mekas's underground screenings, which she attended with her dad and where she would sometimes nap on a pile of coats.

"And you," Andy asked Bibbe, "What do you do?" Before she could say a word, Al Hansen proudly blurted out, "I just sprung her from jail!" The curious artist asked, "*Jail?* Why? Please tell us all about *that!*" In her element, Bibbe jumped up and performed three or four of her best war stories from the big house. Clapping his hands in delight, Warhol said, "We *have* to make a movie out of that. Would you come to the Factory and make a movie with me about jail?" Bibbe of course said yes, and Warhol assistants Gerard Malanga and Chuck Wein made plans for her to come to the Factory at the start of the next workweek.

"She can't come Monday," her dad countered. "She has to go to school! If she doesn't go to school they're gonna send her back to jail." Everyone burst out laughing: "Oh, right, right, right. She has to go to *school!* Of course!" In a compromise, it was agreed that she could go to the Factory after school let out that Monday,

and they eventually shot the feature-length *Prison* with Edie Sedgwick. The film consists of a static shot of Bibbe telling Sedgwick about her jail experiences as they sit on a box in a bare room; at one point, some female guards burst in and rob them of their possessions.

The Factory became a second home for Bibbe Hansen, a streetwise kid who—rather than feeling out of place among all these strange adults—felt they were entering her world. "We were the ones with miniskirts," Hansen said of her generation. "We're the ones with silver everything. We're the ones with great pop music. Because with the Beatles and all these things, these cultural explosions absolutely captivated the world. So not only did we have the numbers, we had the culture, we had the PR, we had the forward thinking, the enlightenment, the freedom, and then we had this incredibly rich cultural scene happening all around us in the Village."

On a typical day at the Factory, Hansen might go up to the roof and smoke a joint with someone, or get a double bacon BLT with a milkshake or a soda at the corner diner. "Lunch was big," she said. Hansen already knew Factory people like Ondine and Billy Name, part of the contingent of speed-freak Mole People who lived near her Lower East Side tenement apartment. Ondine liked to repurpose clothes left lying around at the Factory, turning a cashmere sweater into a loincloth or turban. "One time we came in to find him in a plastic bag outfit made out of trash bags," Hansen said, "years before that punk fashion became popular."

Ondine, born Robert Olivo, appeared in more Warhol footage than anyone because of his acid tongue and ability to talk for hours, days even, while taking speed. Warhol scholar Callie Angell noted, "His unique improvisational monologues—hilarious blends of aesthetic rant, erudite wordplay, campy outbursts, assumed personae, opera lore, street smarts, and poetic introspection, inflected with unpredictable moods of bitchiness or sweetness—were not only recorded in nearly twenty-five hours of Warhol footage, but also served as the topic of Warhol's only published novel, *a: a novel*, an uncorrected, typo-filled transcription of twenty-four tape-recorded hours of Ondine talking."[1]

"Ondine was older," said Mary Woronov, who arrived at the Factory soon after Hansen. "He wasn't young and beautiful. He was old and wasted looking. He used to be beautiful, that's what he had. Plus, he was hysterically funny. I once saw Ondine pick up a salad bowl, dump it on his head, and say, 'Do you think this is a good look?' I mean, he was not afraid of humiliation or embarrassment."

Off-Off-Broadway actress and musician Ruby Lynn Reyner recalled finding Ondine casually walking around his apartment with a beer goblet tied by a

leather thong to his well-endowed penis. "What are you doing? There's a glass hanging from your dick." He replied, "Yeah, I want to get it big enough so I can blow myself." Ondine's manic behavior was fueled by massive amounts of speed, though he wasn't alone in his excesses. "All of the Factory was on amphetamine, including Warhol," Woronov said. "There are very few people who were not on amphetamine." Stimulants were also one of the drugs of choice for mainstream America during the 1950s and 1960s; millions of women regularly took diet pills, and President John F. Kennedy reportedly consumed significant amounts of amphetamine.[2]

At the Factory, druggy downtown scenesters such as Ondine and Billy Name mixed with druggy Ivy Leaguers and socialites such as Edie Sedgwick and Brigid Berlin, which created many cinematic opportunities that Warhol preserved. Between the years 1964 and 1966, he shot 472 silent three-minute film portraits of visitors to the Factory: Lou Reed and the other members of the Velvet Underground, Donovan, Bob Dylan, Susan Sontag, Dennis Hopper, John Ashbery, Jonas Mekas, Harry Smith, Jack Smith, Ed Sanders, Salvador Dali, Marcel Duchamp, Robert Rauschenberg, Edie Sedgwick, Ronald Tavel, Freddie Herko, and Ondine, among many others.

When Ondine first sat for his "Screen Test" in early 1966, he squirmed and squinted in front of the bright movie lights, doing his best to endure. ("My crowd took a lot of drugs and avoided bright lights," he later explained.) For his second sitting, Ondine came armed with sunglasses, which he used as cover to close his eyes and take a short nap.[3] Bibbe Hansen, who also did two Screen Tests, viewed it as part of the Factory's initiation and vetting process. "How you behave, how you deal with that, speaks volumes about who you are, or who you are passing yourself off to be," she said. "I knew instinctively, and I behaved accordingly, because I was from the street culture and also the downtown New York outsider arts community of the fifties and sixties."

"It was as much of a Warhol gang initiation as a collaborative art portrait," she continued. "Three minutes. Did you fidget? Did you wilt? Were you uncertain? Were you apprehensive? And were you cool? The camera doesn't lie. Camera tells you what's what." Hansen acknowledged that it could be kind of petty, but at least the judgments weren't being formed around one's social position or bank balance. Bob Dylan also maintained his cool when he sat for his portrait in late 1965 or early 1966—stone-faced in his dark sunglasses, scratching his nose and looking unfazed. When he got up to leave, the acerbic musician decided to help

himself to Warhol's silkscreen print of Elvis dressed as a cowboy: "I think I'll just take this for payment, man."

"Andy's face turned tomato-soup red," Robert Heide recalled, "because Andy would promise people things, and he wouldn't necessarily deliver. He wasn't expecting Dylan to do that." The friction between the two camps was partially rooted in the cult of authenticity that surrounded Dylan, a sensibility that clashed with Warhol's unapologetic embrace of artifice and commercial culture. The musician's involvement with Sedgwick (the likely subject of his songs "Just Like a Woman" and "Leopard-Skin Pill-Box Hat") also exacerbated tensions. Dylan and his manager, Albert Grossman, hoped to turn Sedgwick into a film ingénue and encouraged her to break with Warhol, which she did.

"I don't know why Edie did it," Hansen said. "Andy and Edie were very good friends, and they loved each other very much. And what happened was Edie started hanging out with Dylan and those guys, and they just started filling her head with shit." Hansen recalled Sedgwick coming to Andy and saying things like, *Bob says I'm not supposed to do movies with you anymore because it's not good for me to be in these faggot movies, doing all these degenerate things*. Warhol's people also started playing them against each other, winding them up. "If you get to the emotional truth of the thing, Andy and Edie loved each other," she said. "Just like when two people are very, very fond of each other and something happens and people get in the way and they get riled up, the split is that much bigger."

Edie's time at the Factory lasted for just about a year, and her departure over-lapped with the arrival of the Velvets. "Before the Velvet Underground came to the Factory, Andy had heard about me having a record and wanted me to have a group," Hansen said of her brief moment in the all-girl pop group the Whippets. He assigned his assistant Chuck Wein to get Hansen some musical material and put together a band, but by that time everyone was far too into drugs to be able to pull it off. "No one could manage anything so ambitious without people who actually knew how to do this shit," she said, "but we were always playing records at the Factory and dancing and going to clubs. Pop music was such a huge part of this scene."

Warhol's association with the Velvet Underground deepened his reach into the world of popular music, expanding his multimedia empire. "The Pop idea, after all, was that anybody could do anything," Warhol wrote in *POPism*, his memoir of the 1960s, "so naturally we were all trying to do it all. Nobody wanted to stay in one category, we all wanted to branch out into every creative thing we could.

That's why when we met the Velvet Underground at the end of '65, we were all for getting into the music scene, too."[4]

Mainstream and underground cultural streams merged at the Factory, which was primed for the Velvet Underground's synthesis of pop and avant-garde music. While Lou Reed dabbled in experimental music in college, John Cale had an extensive background in that world. Born in South Wales, he received an undergraduate degree in classical music and absorbed the works of Karlheinz Stockhausen and John Cage. In 1963, Cale was awarded a Leonard Bernstein scholarship to study modern composition at Tanglewood in Lenox, Massachusetts, but he quickly fell out with composer Aaron Copland, who had helped Cale secure the scholarship.

"Copland said I couldn't play my work at Tanglewood," he recalled. "It was too destructive, he said. He didn't want his piano wrecked."[5] Cale then moved to New York and dove straight into the city's avant-garde scene, participating in an eighteen-hour performance organized by John Cage soon after arriving. Once settled there, Cale began playing with La Monte Young's Theatre of Eternal Music ensemble, which also included Factory custodian Billy Name and Tony Conrad (the friend of Jack Smith who compiled the soundtrack for *Flaming Creatures*).

Meanwhile, Reed was working his nine-to-five job at Pickwick Records writing knockoff pop songs to be sold at department stores. When asked if he felt any cognitive dissonance writing the Velvet Underground's "Heroin" by night while holding down a day job crafting commercial fare, Reed pointed out that Warhol also supported his unorthodox art with paid commercial work. "So I didn't see that as schizophrenic at all," he said. "I just had a job as a songwriter. I mean, a real hack job. They'd come in with a subject, and we'd write. Which I still kind of like to this day."[6]

Not long after Cale moved into Conrad's Lower East Side apartment at 56 Ludlow Street, the two artists met Reed after he recorded a garage-rock novelty single, "The Ostrich," under the name the Primitives. This dance song contained a one-note burst of guitar noise that anticipated the Velvet Underground's minimalist approach ("That's rock 'n' roll," Reed said of that musical moment, "keep it simple"). Pickwick quickly moved to assemble a live band that could promote this potential hit in early 1965 and, because Cale and Conrad had long hair, they were buttonholed at a party by two sleazy company men from the record label.

Eventually, Cale and Conrad agreed to meet with them at Pickwick's cinderblock warehouse headquarters in Queens. There, they discovered that "The Ostrich" had been played with guitar strings that were tuned to the same note—rather than the standard tuning of E-A-D-G-B-E—something the two were already

doing with La Monte Young. "We couldn't believe that they were doing this crap just like in a sort of strange ethnically Brooklyn style, tuning their instruments to one note," Conrad said, "which is what we were doing too, so it was very bizarre."[7] Cale, Conrad, and their Theatre of Eternal Music collaborator Angus MacLise took a leap of faith and formed a pickup band with Reed for a short promotional tour, which included appearances at a supermarket, high school, and local television dance show. The Primitives padded their short sets with inflammatory soon-to-be-Velvet Underground classics like "Venus in Furs" and "Heroin," which went over poorly.

After "The Ostrich" fizzled on the charts, the four musicians formed the Warlocks. (This name was also being used by a San Francisco band who, upon hearing about the existence of this New York group, renamed themselves the Grateful Dead.) Reed's group, which now included his college friend Sterling Morrison on guitar, changed their name after Conrad stumbled across a sensationalistic paperback book about S&M titled *The Velvet Underground*. "We thought it was a good name," said Morrison, "because it had underground in it and [because we] were playing for underground films, we considered ourselves part of the underground film community. We had no real connection to rock and roll as far as we were concerned."[8]

After Conrad left the group, the classic Velvet Underground lineup was rounded out by drummer Maureen "Moe" Tucker, who replaced MacLise after he quit. Reed was a friend of Maureen's brother, Jim Tucker, and they cofounded a mimeo poetry zine, *Lonely Woman Quarterly*, while the two attended Syracuse University.[9]

The Velvet Underground began performing at Café Bizarre, which had fake cobwebs, candles, and waitresses in fishnet stockings who looked like Morticia from *The Addams Family*.[10] "I walked by Café Bizarre a hundred times but I never went in," said Peter Crowley, who managed another coffeehouse. "It was absolutely another tourist trap, so I never bothered going." The Velvets' dissonant droning and sordid tales clashed with the Greenwich Village folk crowd's more conventional tastes. "One night at the Café Bizarre," Sterling Morrison recalled, "we played 'The Black Angel's Death Song' and the owner came up and said, 'If you play that song one more time you're fired!'" The Velvets began their next set with a ferocious version of "The Black Angel's Death Song" and were promptly fired.[11]

In November 1965, before the Velvet Underground's Café Bizarre residency abruptly ended, a theater producer named Michael Myerberg came up with the idea of opening a Warhol-branded discotheque. He approached Paul

Morrissey—Warhol's sort-of manager and assistant filmmaker—who put the word out that the Factory wanted to find a house band for the space. Malanga, Sanders, and underground filmmaker Barbara Rubin had already seen the Velvet Underground, which led to Warhol signing the group to a management deal. (Myerberg eventually chose the Young Rascals, a better business move for someone looking to draw in a large teen and young adult audience.).

Hoping to spice up the band's bland onstage image, Warhol added German fashion model and aspiring chanteuse Nico (née Christa Päffgen) to their lineup. Reed continued to sing most of the group's songs, though he reluctantly gave Nico three numbers—"All Tomorrow's Parties," "Femme Fatale," and "I'll Be Your Mirror"—which she sang on their 1967 debut album, *The Velvet Underground & Nico*. The group's first show as a Factory band was at an annual meeting of the New York Society for Clinical Psychiatry on January 10, 1966, in the posh Delmonico Hotel. Warhol was originally invited to give a lecture, but instead suggested a multimedia performance that would be staged during a dinner for the psychiatrists and their spouses. As films projected behind the group, the Velvets shared space on the stage with a go-go-dancing Edie Sedgwick.

"The second the main course was served, the Velvets started to blast, and Nico started to wail," Warhol recalled. "Gerard and Edie jumped up on the stage and started dancing, and the doors flew open and Jonas Mekas and Barbara Rubin with her crew of people with cameras and bright lights came storming into the room and rushing over to all the psychiatrists asking them things like: 'What does her vagina feel like?' 'Is his penis big enough?' 'Do you eat her out? Why are you getting embarrassed? You're a psychiatrist; you're not supposed to get embarrassed!'"[12]

When asked if Warhol's account might have been exaggerated, Mekas said, "It's embellished, yes, but not too much. The main purpose was to try to embarrass them. I think we succeeded in doing that, but we were not pushy. We did it quite politely. And because of the politeness in which our questions were presented, they sounded even more outrageous than they actually were." As Billy Name noted, "We didn't shock anybody. Psychiatrists may be stiff but they all have a sense of humor, and they're all intelligent."[13]

Soon after, Paul Morrissey booked a multimedia show, *Andy Warhol, Up-Tight*, as part of Mekas's Cinematheque series, which was then based in the Forty-First Street Cinema. "Hey, we're doing a gig tonight at the Cinematheque," Malanga told Bibbe Hansen one afternoon in February 1966. "We need go-go dancers. Will you come?" Hansen and others danced on the front sides of the Cinematheque's stage while Warhol projected *Banana, Blow Job, Sleep*, and other films that were

Jonas Mekas
© SYEUS MOTTEL

blended into a primitive light show. Malanga also danced onstage as he twirled a long strip of phosphorescent tape while the band played in the shadows.

The Velvet Underground repeated this event in March 1966 at Rutgers University, and again at Paraphernalia. This hip boutique sold clothes designed by a young Betsey Johnson, and featured a chrome and glass design with go-go

dancers in the windows who grooved to the rock 'n' roll that blared over the shop's loudspeakers. "I was the street kid at Paraphernalia," Johnson recalled. "I liked making affordable clothes."[14] She designed simple miniskirts and T-shirts, often in primary colors, and used vinyl whenever possible. "You'd spray with Windex rather than dry-clean," Johnson said. "We were into plastic flash synthetics. It was 'Hey, your dress looks like my shower curtain!' The newer it was, the weirder—the better."[15]

After Johnson met Sedgwick and Warhol, who needed silver outfits for a film they were shooting, she began designing clothes for the Velvet Underground. Johnson instantly fell in love with John Cale when he asked her to make a costume he could wear while playing viola with his hands on fire. They became the first Factory couple to tie the knot, and for their City Hall wedding Johnson made a burgundy velveteen pantsuit for herself and designed Cale's black sailcloth canvas suit. Unfortunately, New York City officials informed her that a woman could not be legally married in pants, so she returned in the tiniest of red miniskirts and completed the ceremony.[16]

The Velvet Underground continued playing for these Factory-produced events, renamed the *Exploding Plastic Inevitable*, a continuation of multimedia experiments that were taking place downtown. Elaine Summers, Jonas Mekas, La Monte Young, Jack Smith, and other artists had already been combining live music, light, dance, and moving images—such as when Mekas rented space for the Filmmakers Cinematheque at the Astor Place Theatre in 1965. "There were at least thirty artists in dance, in theater, in film, in music," Mekas said, "making pieces that involved not only their own art, but other artists and collaborators."

Elaine Summers had already staged her *Fantastic Gardens* mixed-media event in February 1964 at Judson Church, where film projections were splashed on the ceiling, walls, and floor, and the audience participated with small handheld mirrors. The results were stunning, and unprecedented. As the space was enveloped by a cacophony of lighting effects, music, movement, spoken word, and cinema, dance pioneer Sally Stackhouse performed on the balcony in front of a film of herself dancing. In his *Village Voice* column, Mekas argued that *Fantastic Gardens* was "by far the most successful and most ambitious attempt to use the many possible combinations of film and live action to create an aesthetic experience."[17] Two years later, Warhol did much the same when he projected performance footage of the Velvet Underground while they played in the *Exploding Plastic Inevitable*.

Warhol's most famous use of split screens—in which two film reels were projected side by side—was 1966's *Chelsea Girls*, though his first was 1965's *Outer and*

Inner Space. That 16-mm split-screen film was groundbreaking in the way it incorporated video footage he shot (Warhol was an early adopter of new technologies throughout his life). *Outer and Inner Space* consisted of two thirty-three-minute reels, each showing Sedgwick sitting next to a television monitor that displayed a prerecorded videotape of herself. When projected side by side, it created the disorienting effect of four Sedgwicks interacting with one another.

This melding of film and video media reflected the ways that Warhol absorbed and blended elements from many different scenes: film, music, visual art, dance, and underground theater. But it was the drug scene that had the most pronounced impact on the Factory in the second half of the 1960s. The Warhol films' speed-fueled babble and the whips wielded during the *Exploding Plastic Inevitable* were symptomatic of a darkness that was descending on this subterranean world. Chaos rippled through the Factory, Caffe Cino, and other similar scenes, leaving lifeless bodies in its wake. As the 1960s came to a close, the madness only intensified—along with other dramas stirred up by the antiwar, feminist, and gay liberation movements that swept through the downtown.

PART TWO

ACTION!
1964 – 1971

CHAPTER 12

Chaos at the Cino

Caffe Cino burned down on Ash Wednesday in 1965, an omen of trouble on the horizon. Edward Albee, who was the most famous person in theater at the time, threw benefits for the Cino, and Ellen Stewart also used Café La MaMa to stage benefits organized by Harry Koutoukas. "Now its collage walls are no longer there, Joe's not behind the espresso machines in one of his eccentric hats," the playwright lamented. "So suddenly it sinks in. What's gone is a part of each and every one of us . . . if you had a dream that wasn't quite possible, you could dream it, and pretend it was just on the verge of happening—and no one dare ever remind you that it might not."

People urged Joe Cino to use the fire as an opportunity to expand his theater and move into a bigger space, but he wanted it to retain its original atmosphere. Just two months later, Caffe Cino reopened in its original location on Cornelia with Koutoukas's *With Creatures Make My Way*. The show revolved around a transsexual, transhuman figure who lived among "baby alligators that are flushed down toilets every day," as well as other strange critters. "It was basically this crazy monologue that took place in the sewers," Robert Heide recalled, "with all these rats and lobsters."

With Creatures Make My Way was an homage to Caffe Cino—a refuge for outsiders, artists, and oddballs who didn't fit in anywhere else. As Koutoukas wrote in his stage notes, the setting was an underground inversion of "the churches of the White Anglo-Saxon Protestants, known as WASPS, that exist everywhere." Exiled from that normal world, the Creature spent his days playing Mozart on a huge pipe organ, pining for a lobster he loved many centuries ago. At the end of the show, the Creature discovered that his newest friend—a pearly piece of ectoplasm—was actually his long-lost love, the lobster. Koutoukas's "camp" concluded with the two joining together in a song and dance, as the Creature observed, "music Scotch-tapes the whole world together, doesn't it?"[1]

Koutoukas was the quintessential outsider artist, and he knew how to make an impression. For instance, when he accepted an Obie Award in 1967, he broke two large mirrors into hundreds of pieces and meticulously glued them onto a cheap suit. The ceremony's house band was Frank Zappa and the Mothers of Invention, who were easily upstaged when the playwright nearly blinded everyone as the spotlight hit his suit of mirrors. When Koutoukas first met Off-Off-Broadway artist and performer Bruce Eyster, he wore another luminous outfit that was equally memorable. "He had shiny pants and a top made of really sparkly material," Eyster said, "but it was all ragged and pinned together with safety pins, way before punk."

Koutoukas followed Eyster home that night and waited outside until morning to talk to him, and the two became friends. "The first time we went to Harry's apartment, my boyfriend and I went there and Harry said, 'Wait, before you go in, I have to do this thing.' And he did this weird thing with the locks, and then when we got in he had to push this thing aside." An automobile engine was precariously balanced on top of the refrigerator so that, according to Koutoukas, "If somebody breaks in, the car motor will fall on them and kill them." *Oh, o-kaaaay*, Eyster thought.

"Harry had very funny ways of seeing things," he recalled, "and he was very clever with words." Koutoukas could shock people, make them laugh, or do both at the same time—which was often a good line of defense. One night on Christopher Street, a black man began hassling him, so Koutoukas told the guy, "Well, I never fight with anybody I can't see in the dark." The man stood there wide-eyed, then burst out laughing and never bothered Koutoukas again.

"Harry was wild—wild, funny, loving, crazy—and was flamboyantly gay," said Larry Kornfeld, who was close to Koutoukas. "He had a tough life. He was an alcoholic at times, he was an addict at times, he was sexually peculiar." A story circulated about how he kept the body of a lover who died on his bed for quite a while before calling to have it taken away (he later went to the cemetery to sprinkle glitter on the grave). "My boyfriend Chris was fascinated by Harry," recalled Robert Patrick, "because, who would not be?" When they went to his apartment one day, Koutoukas begged Patrick to let him have sex with his boyfriend—who decided to pass. Perhaps it was because, among other things, he asked the boyfriend, "Please carve your initials on my ass."

Koutoukas shot lots of speed and could get paranoid about it, shouting from his apartment window, "Okay, everybody can see me now—I'm shooting up!" "He was kind of overweight," Eyster said, "which I found amazing, because most people that were doing that much speed were very skinny. But not Harry. Harry was

heavy." One time after throwing up neon-green bile and nearly dying, Koutoukas was taken to nearby St. Vincent's Hospital, where he wrote from his hospital bed, still wired from the speed: "When I put on the black sequined G-string and pasties for the Gay Halloween event at St. Charles next month, I'll be as svelte as an anorexic stripper. Almost. I'm outwardly still, but my contents are leaping, leaping! My shell is bursting with frogs. What the hell! I can't write! I can't think. I can only emote."[2]

<div align="center">***</div>

"The Cino was becoming well known," Robert Patrick said, "and it attracted people who just cared about publicity—i.e., the Warhol people. The first was Soren Agenoux, who did a crazy gay *Christmas Carol.*" Agenoux's show took the audience deep into the soul of Ebenezer Scrooge, with absolutely no sentimentality. Michael Smith, who directed it, recalled that it was based more on the Scrooge McDuck comic than the Charles Dickens story. "There was also kind of an anti-Vietnam streak to it," Smith added. "It was very obscure, because it was written in this kind of raving amphetamine haze that Soren Agenoux did so well."

Actress Jacque Lynn Colton, who played the Ghost of Christmas Past, recalled the show's wild run. "I was kind of on the fringes of it all," she said, "because I was not a gay boy, and I wasn't into drugs or anything." In one of her scenes, Colton was given a prop birthday cake with candles to wear on her head while she recited a two-page monologue, which was mostly poetic gibberish. Cino lighting genius Johnny Dodd slowly dimmed the lights so that when Ondine blew out the candles at the end of Colton's long speech, the Cino went pitch black. This sort of technique is common today, but it was shockingly new at the time.

One of the Factory's most notorious Mole People, Ondine, was cast in the show's starring role. "He was a maniacal sadist as Scrooge, and he was brilliant," his friend Mary Woronov said. "Ondine was the opposite of what everybody expects Scrooge to be." The play was packed with allusions to pop culture and Factory scene inside jokes, with Ondine's character spouting free-associating lines such as, "I help support certain establishments, certain recognized charities—the Girls of Chelsea Amphetamindell—THE VELVET UNDERGRINDLE."[3] Warhol saw *A Christmas Carol* several times and sent his lieutenant Paul Morrissey to film it for the compilation film *Four Stars.*

Vinyl, Ronald Tavel's loose adaptation of the novel *A Clockwork Orange,* was staged at the Cino in 1967 after Warhol shot his own filmed version. In both the movie and stage versions, Mary Woronov played the doctor and Gerard Malanga

was the victim. "I started doing movies for Andy Warhol when Ronnie Tavel was also working for Andy Warhol," Woronov recalled. "That's when I met Ronnie, and he used me constantly in his plays. That's how I ended up at Caffe Cino, La MaMa, and other Off-Off-Broadway places." Actor Norman Marshall, who also appeared in the Cino version of *Vinyl*, said that Woronov was a convincing S&M sadist: "She was really torturing the poor guy."

Many at Caffe Cino felt that the presence of the Warhol people fundamentally changed its character. "Soren Agenoux's shows were absolutely nonsense," playwright William Hoffman said. "They were doing plays that were gibberish, very speed-oriented." There was the feeling that, well, *Maybe the play might make sense on drugs?* Or not. "The Warhol crowd was what it was," Patrick added. "I don't know whether to blame Warhol. He was surrounded by freaks, creeps—some of them were okay people, some were not. Mostly, it was just a freak show and cultivated as such."

It was certainly true that Ondine and other Factory folks ramped up the amphetamine use, though it wasn't as if they brought the forbidden fruit of drugs into an innocent Garden of Eden. After all, marijuana and speed had already been around the Cino from the beginning. When hyperactive Robert Patrick was finally offered amphetamines after hanging out there for two years, he expressed surprise that no one offered it to him before. "Bob, we thought *you* were a drug head who wasn't offering *us* anything," Johnny Dodd said. "You're so wired and energetic. We thought you were a speed freak who had a secret supply." Still, the Factory crowd did change the tenor of Caffe Cino. As Harry Koutoukas put it, "The Warhol people brought in drugs we never even smelled before."

The little hallway in the back was littered with syringes, and there were always pots of amphetamine cooking in the dressing room, with people shooting up. "Cino, it was speed-infested," Caffe Cino regular Jim Fouratt said. "And of course, there was glitter everywhere. There was a lot of amphetamine use at the Caffe Cino, but I don't want to talk too darkly about it, because it was very innocent." Fouratt recalled how Ondine suggested one night that they go to the bathroom together, which turned out to be a kind of prank. "I thought I was going to get a blow job," he said, "and he pulls out the biggest dick I'd ever seen in my life, and then shoots up in it, with speed. I had never seen anything like this in my life. I was completely, *AHHH!* I must have been ashen." When Fouratt walked out, three people sitting on the other side of the room burst out laughing because they knew what just happened.

Ondine survived until 1989 before succumbing to liver disease, but others around him died much sooner. Freddie Herko was a premier dancer at the Judson Dance Theater—a wild, beautiful man whose performances were charged with his eccentric persona—until he got sucked into the drug scene. He had performed in the 1964 one-act musical *Home Movies*, directed by Larry Kornfeld, who recalled one fluid sequence in which Herko transformed from a man to a woman. "He took his pants off," Kornfeld recalled, "and rolled his shirt down into a dress and picked up a bouquet of fruits from a table and put it on his head, and turned into a Carmen Miranda character."

"Freddie was a marvelous actor and dancer," Kornfeld added, "but he burned himself out with drugs." Beat poet and Off-Off-Broadway playwright Diane di Prima was a good friend of Herko; he told her that he "needed speed to push his body so he could dance the way he wanted to. He felt otherwise he didn't have a chance; he had come to dance too late in life to make it work for him."[4] Over time, Herko mixed amphetamines with LSD and other drugs, all of which shattered his physical and mental health. "He had seen his dancer's body with acid eyes," di Prima recalled, "and seen how he had ravaged it with speed and neglect. Or, as he put it, he had 'destroyed his house.'"[5]

Michael Smith shared an apartment with Johnny Dodd at 5 Cornelia Street, where Herko spent the final moments of his life. "It was only a matter of time, and nobody could do anything about it," Smith said. "You can't stop people from taking drugs. He was just kind of fading away." On October 27, 1964, Herko stopped by the apartment when Smith was away and asked Dodd if he could take a bath—after which he rose from the water, put Mozart's *Great Mass in C* on the turntable, and began dancing around the room. Dodd just sat there, feeling like something was amiss, then Herko danced out the open window and leapt five stories to his death.

"I never bought into the idea that his suicide out the window of our apartment was some kind of performance," Smith said. "Although he had held a rooftop performance on the Lower East Side just a short time before, and people had the idea that he was going to jump off the roof. So nobody went." This time, Herko took the plunge and died instantly.

When city workers swept Herko's remains from the sidewalk, Robert Heide walked by and cynically thought, *Oh, that must be somebody I know*, and just kept on going. "The whole idea was being very cool," Heide recalled, "not showing too much emotions." The following year, around the time Edie Sedgwick was splitting from Warhol and sinking deeper into drug addiction, the artist asked Heide

to bring him to the spot where Herko hit the ground. Andy was affectless as he asked Heide to point out exactly where he landed, then looked up at the window and thought aloud, "I wonder when Edie will commit suicide. I hope she lets us know so we could film it."

Bibbe Hansen acknowledged that Warhol's comment sounds dreadful, if taken out of its context. "But that was Andy's way of processing it," she said. "Because to show emotion, none of that was acceptable for men in that age. I mean, cool was the number one thing. The whole post–World War II guy thing—it was emotionally kind of stalwart. It was a thing that was very prominent in the Village, a kind of game that the bohemians would play."

Heide felt the specter of death surrounding Warhol, and there was always a feeling that something terrible could happen. "At a certain point, I didn't hang out so much with Andy at the Factory," Heide said. "I did feel a kind of danger. I couldn't keep up with everybody else because I knew I would go out the window, so I was more careful about it. And at a certain point, I had gone as far as I could go." Larry Kornfeld added, "The Warhol Factory people were on the edge of suicide, always. That's what got Freddie Herko in the end, because of the drugs and his despair."

La MaMa playwright Paul Foster was more blunt: "Drugs came in, and creativity went out," he said. "Drugs had a nasty way of enslaving everybody. They took hold, including old Joe Cino himself." Ellen Stewart was adamantly against drugs, and would clear a room when there was a whiff of pot, or would toss anyone out of La MaMa if they were caught with drugs in their possession. "It was not a common thing for a black woman to be herding fifty different artists who were all white," Foster said. "So this was a miracle, and she wasn't about to have that miracle stepped on by drugs."

CHAPTER 13

Camping in Church and at Sea

Harry Koutoukas's plays were wild and chaotic, but they still followed a basic order and logic: what the playwright called "the ancient law of glitter." Camp developed as a private language shared among the urban gay men who populated Caffe Cino, which was frequented by Andy Warhol and others who absorbed ideas from its free-thinking atmosphere. Downtown scenester, actor, and gay rights activist Jim Fouratt recalled, "When Susan Sontag—who came from outside—looked at camp, she created a more intellectual interpretation than the sort of thing Harry Koutoukas did." Camp had been used as a gay survival tool that was meant to heighten and make fun of the reality of their surroundings, to not let the pain of life get in. "It's all coded to the straight person," Fouratt said, "but we all know what it meant, and that sensibility really was incubated at the Cino."

One important element in camp's coded language was imagery from trashy old movies. "Harry had that kind of tongue-in-cheek attitude," Robert Heide said, "and he used to come over to my apartment and we'd watch the stars of the silver screen like Gloria Swanson, shining gloriously on late-night movies on television. Harry liked that whole romantic idea of the silver screen, these actresses that were bursting out of themselves." The composer John Herbert McDowell had celluloid copies of old 1930s and 1940s Hollywood movies like Busby Berkeley's *42nd Street*, *Dames*, and *Gold Diggers of 1933*—which Koutoukas, Heide, and McDowell sometimes watched backward while tripping on LSD.

One can also draw a direct line from Busby Berkeley to the demented glitter spectacles that Hibiscus performed with the Cockettes starting in 1970. "Mom used to take us to the Bleecker Street Cinema," Jayne Anne Harris said, "and they showed all those Busby Berkeley movies, and Fred Astaire." Ann Harris brought her kids almost every weekend to see those old films, which they also watched on television in their East Village apartment. "You stayed up past one in the morning and watched, if you dared to stay up that late," Jayne Ann said, "except we always stayed up that late for theater."

Lisa Jane Persky also saw those films, on the late-night television series *Million Dollar Movie.* "Everything was glitter, glamour, glory, gold," she said. "We would all mimic those close-ups. The idea was just to take that glamour and just push it as far as you could. It was making fun of those old movies, but in a loving way. Imagine watching a Busby Berkeley film and thinking, 'Okay, let's try that.' It was a lot of fun to blow it up and make it as audacious and ridiculous as you possibly could." The revived popularity of those old films can be traced back to the mid-1950s, when Hollywood studios compensated for shrinking profits by licensing their content to television (every major studio except for MGM sold their back catalog of pre-1948 films to distributors that licensed them to broadcasters).[1]

This dramatically changed viewers' relationship to Hollywood, making those movies more readily available for playful appropriation. "Television would have another effect," wrote theater historian Arnold Aronson. "Although its content seemed to recapitulate the major dramatic forms, its structure of short segments containing rapidly changing images, and especially its rupture of narrative flow by the repeated intervention of commercials and the resultant kaleidoscope spectacle, would have a profound effect upon consciousness and the way in which an entire generation saw the world and perceived reality."[2]

Critics of mass media have often denounced popular culture for rendering their audiences passive and inert, but it is hard to view these downtowners as anything but active, knowing, and quite subversive. These gay men latched onto actresses whose over-the-top performances unintentionally parodied their femininity, like 1940s film star Maria Montez, "The Queen of Technicolor." She was worshipped by director John Vaccaro, Harry Koutoukas, Jack Smith, Ronald Tavel, and, of course, Warhol film star Mario Montez. They would often quote from Montez's 1944 film *Cobra Woman,* approximating her exotic accent: *Geeeev me that Coparah chewel!*

"I was in two or three of Jack Smith's films," Vaccaro recalled. "We were both crazy about Maria Montez. When I was a kid, I liked her. So did Jack. I liked the way she looked and the way she acted and the type of films she did." Smith was drawn to what he called "musty" or "moldy" entertainment products from the recent past, which had been swept into the culture industry's dustbin. The outmoded movie stars of the 1930s and 1940s were beneath contempt for many contemporary mainstream critics, so Smith poached these "secret flix" (as he called them) in ways that resisted the logic of capitalist cultural production.[3]

Montez's acting may have been dreadful—especially by the new Method acting standards—but that was part of the attraction.

"People laughed at her acting because it was camp," Agosto Machado said, "but there was a mystique about her. She didn't pretend to be anything more than a beautiful woman who was put in an exotic setting, and we all recognized her as our own." It also didn't hurt that Maria Montez sometimes looked like a woman imitating a drag queen dressed like a glittery starlet. Koutoukas channeled his love for Montez into 1966's *Turtles Don't Dream, or Happy Birthday, Jesus*, a play about a "Cobra Cult" that worshiped amphetamine. Harry wasn't a close friend of Warhol, but they knew each other well enough for the artist to introduce him to patrons who funded its debut at Carnegie Recital Hall—a classy midtown performance venue that certainly wasn't known for experimental freak shows.

The show's "plot" is hard to summarize. Characters uttered lines such as "Go and tell the sacred Cobra that our supply of the holy white amphetamine powder is running low. And hurry back. Being alone ain't what it used to be!" The two rules of the Cobra Cult were: (1) you weren't allowed to tell the truth and (2) you had to keep the holy amphetamine container filled. One of the show's main characters was Tacky Tess, a follower of the Cobra Cult who worked on Fourteenth Street selling wind-up cobra dolls until Jesus von Nazareth tipped her off that the police would arrest her for selling dolls without a license. After the Cobra Cult brought him into the fold, Jesus von Nazareth wreaked havoc on everything, so they crucified him.

"We're safe! Here comes the amphetamine angel," an actor announced in the final scene as Charles Stanley walked down the aisle in high-heel boots throwing amphetamine powder, which was actually shredded newspapers. (Koutoukas had not yet finished writing the show by opening night, so he told Stanley, "Do an ending at 9:30.") Koutoukas's Cobra Cult was a thinly disguised stand-in for Caffe Cino, which had by then become a speed-fueled den of glittery iniquity.

Five years later, Harvey Fierstein wrote a play at La MaMa titled *In Search of the Cobra Jewels*, an homage to both the Montez movie and Koutoukas's play. (The cultural references piled up.) As it turned out, Koutoukas had never actually seen *Cobra Woman* when he wrote *Turtles Don't Dream*, but he still absorbed its mystique through osmosis. When a St. Mark's Place movie theater showed the film in the late 1960s, Koutoukas confessed his sin to Robert Patrick. "For god's sake, Harry," he told him, "you've got to see *Cobra Woman*." As the cinema's lights dimmed and an exotic lagoon filled the screen, he clutched Patrick's arm and

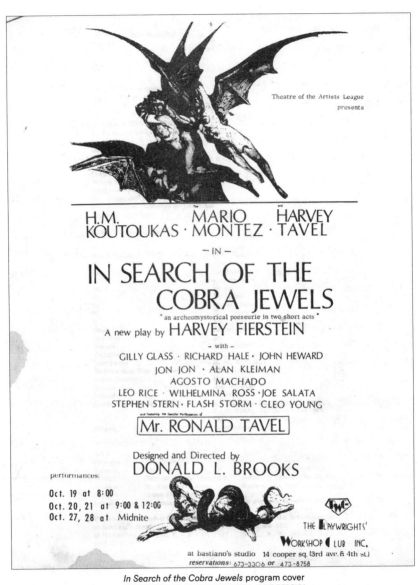

Theatre of the Artists League
presents

H.M. KOUTOUKAS · MARIO MONTEZ · HARVEY TAVEL

~ IN ~

IN SEARCH OF THE COBRA JEWELS

" an archeomystorical poeseurie in two short acts "

A new play by HARVEY FIERSTEIN

~ with ~

GILLY GLASS · RICHARD HALE · JOHN HEWARD
JON JON · ALAN KLEIMAN
AGOSTO MACHADO
LEO RICE · WILHELMINA ROSS · JOE SALATA
STEPHEN STERN · FLASH STORM · CLEO YOUNG

and featuring the Special Participation of

Mr. RONALD TAVEL

Designed and Directed by
DONALD L. BROOKS

performances:

Oct. 19 at 8:00
Oct. 20, 21 at 9:00 & 12:00
Oct. 27, 28 at Midnite

THE PLAYWRIGHTS'
WORKSHOP CLUB INC.

at bastiano's studio 14 cooper sq. (3rd ave. & 4th st.)
reservations: 673-3306 or 473-8758

In Search of the Cobra Jewels program cover
COURTESY THE ARCHIVES OF LISA JANE PERSKY

gasped, "Is it a setting or a costume?" It was an emotional roller-coaster ride for Koutoukas until the closing scene.

"A lot of the Cino scene was camp," Jim Fouratt recalled. "Just look at *Dames at Sea*. That was the embodiment of camp." Caffe Cino's biggest hit was a playful homage to old 1930s and 1940s Hollywood musicals and, in particular, the

black-and-white films of Busby Berkeley. "I think what made us such a hit was we were doing this homage to Busby Berkeley films, which had hundreds of dancers," said David Christmas, who starred opposite Bernadette Peters in the Cino production. "But there were only six of us recreating all of that stuff in this tiny storefront coffeehouse."

Patrick was the doorman during this time, when Caffe Cino brought in its biggest crowds. "You knew the Cino was sold out when someone was seated on top of the jukebox," he said. "Things like *Dames at Sea* began to make the Cino well known." Joe Cino almost always restricted productions to two-week runs in order to make room for the next play, but he made an exception for *Dames*, an inventive DIY show that raked in the money.

"It's quite amazing when you look back at how much originality was happening," said Agosto Machado. "The stage area was tiny, and they did so much with so little." Joe Cino painted his tiny eight-by-eight-foot stage with high-gloss black paint sprinkled with glitter, and the costumes, lighting, and makeup were also staged entirely in black and white. The *Dames at Sea* set used reflective Mylar to create the cheap illusion that there were many more people onstage during the dance numbers, and the other side of the rotating wall panels was decorated to look like a ship during other scenes.

"Bernadette Peters got involved after I had done summer stock with her and David Christmas," said the show's choreographer, Don Price. "Her mother did her costumes." Even though Peters was still an unseasoned seventeen-year-old, she was a star in the making who was perfect for *Dames at Sea* because she had grown up watching all those old movies with her mom. The opening number, "Wall Street," had a dazzling costume change that worked like a magic trick—with each actor helping to change Bernadette's outfit in one fell swoop. "It all took three seconds," Price recalled, "and when they took off her raincoat and everything else, she had this little polka dot costume underneath—which always got a laugh."

Show composer Jim Wise often played piano at the Cino, though sometimes his substitute was Barry Man. Later known as Barry Manilow, he accompanied Bette Midler for her cabaret shows in gay bathhouses during the early 1970s, and Midler also passed through Caffe Cino and La MaMa after she arrived in New York.

For Walter Harris, Koutoukas was like a colorful uncle and a guardian angel all rolled into one. They got to know each other during a production of *Pomegranada*,

an experimental opera that debuted in the choir loft at the Judson Poet's Theater in March 1966. Harris played drums along with pianist and Judson artistic director Al Carmines. *Pomegranada* featured a butterfly and a peacock and other creatures that were innocent until a mirror entered their lives, and they learned about a thing called vanity. "I'm superb and exquisite too / Oh, that's me, and to think I never knew / I never knew how beautiful I was," the creatures sang. The show was about how narcissism can destroy beauty, as Harris explained: "Harry was a social critic, and he played a lot with mythical tropes, but with a lot of camp."

Koutoukas certainly lived and breathed camp, but Ronald Tavel's *Gorilla Queen* took it over the top. After working with Warhol on his early films, Tavel began staging his scripts with Vaccaro's theater company, Play-House of the Ridiculous. After another split—this time with Vaccaro—Larry Kornfeld agreed to stage *Gorilla Queen* at Judson Church. The show was about a tribe that worshipped an effeminate creature named Queen Kong; like *Pomegranada*, it was an entertaining comment on society. During the gorilla's entrance, for example, Queen Kong swung on a rope and struck a swishy limp-wrist pose. "It was the funniest thing you could see," Kornfeld said, "and it was high camp. A big gorilla suddenly doing a very fey limp wrist move? Only at Judson."

Gorilla Queen debuted in the spring of 1967, with George Harris Jr. playing the lead ape role, Brute, who served as a kind of narrator. His son George III was a member of the Glitz Iona tribe, a kind of Greek chorus that would fall silent during a scary scene, or move about and screech when something provocative was said. "What a sweet family," said Norman Marshall, who played Queen Kong. "They were all lovely people. Hibiscus, or George Harris III, he was very, very young. I was twenty-seven or twenty-eight, and he seemed like a child, sixteen or seventeen. His father and I, and Jimmy O'Bryant, we were the only straight guys in the play, and we became very good friends."

A hypermasculine man with the build of a football player, Marshall was the last person one would expect to be involved in this sort of production. "I'm so butch that this reviewer said that I was 'the male version of Nick Nolte.' Anyway, here I am playing Queen Kong—in the middle of all this silliness, craziness—and I had a great time." Like many Off-Off-Broadway actors, he had never been in a play or had any theatrical experience before he walked into Judson Church for an audition. "I just decided, 'I think I'll try acting.' I had no idea what the hell it was all about."

Although *Gorilla Queen* was absurd, Tavel was a very serious man with eyes that could drill holes through you. He once told Marshall, "Don't you see? These are political plays—all my plays are political." Tavel loved the irony that so many

of those trashy old movies were made by frustrated gay men who wanted to appeal to straight audiences, but failed in the most spectacular ways. "It was the Hollywood faggots getting even with straight America," said Tavel, who expressed himself through B movies and pulp magazines—finding something mythic and profound in the pop culture he loved.

"*Gorilla Queen*'s writing was so insane," recalled Tony Zanetta, an Off-Off-Broadway actor who began working with David Bowie as his tour manager during his Ziggy Stardust period. "Insane. It was really out there. Taharahnugi White Woman sent my twenty-year-old self into hysterics." That character was played by a man dressed in a sarong, and during one gag he shocked another character by showing his hairy chest: "What's the matter? Ain't you never seen a white woman before?"

"Campy, hell," Kornfeld said of *Gorilla Queen*. "It's downright homosexual!"[4]

Musing on the ways that intellectuals and theorists have followed the lead of the downtown's underground theater movement, Kornfeld observed, "Binaries were being used in those productions, and they were being torn apart, deconstructed. Deconstructing binaries—gender binaries, racial binaries—was starting way back then, through performance. Theorists always came second."

Susan Sontag's "Notes on 'Camp,'" which appeared in the *Partisan Review* and established her as a major cultural critic, was directly inspired by the downtown underground film and theater productions she was taking in at the time. The essay identified artifice and exaggeration as the essence of camp—which was "the farthest extension, in sensibility, of the metaphor of life as theater. . . . Camp sees everything in quotation marks. It's not a lamp, but a 'lamp'; not a woman, but a 'woman.'"[5] Sontag and Kornfeld were friends, and she often attended shows at the Judson Poets' Theatre, Caffe Cino, and Joe Chaikin's Open Theater.

"Susan was brilliant," Kornfeld said. "She couldn't help but pick up and embroider and popularize and even invent things of her own, theoretically." Sontag's personal experiences likely informed the concepts she developed as an intellectual—she had a husband and children but also had female lovers, such as Judson playwright María Irene Fornés. "Irene was a remarkable woman and was very smart," Kornfeld said, "and I'm sure Susan absorbed things from her as well. Artists do things because they're seeing something—they're sensing a feeling, feeling an influence, putting together something in a way that they don't quite understand. The artists are always moving ahead of the theorists."

CHAPTER 14

Migrating East

"There was a lot of amphetamine around," Michael Smith said of Caffe Cino soon before it closed. "It created a desperate atmosphere, and played into Joe Cino's sense of burnout." After Freddie Herko leapt to his death a few doors down on Cornelia Street, the scene at the Cino grew increasingly grim. "That colored everything," playwright William Hoffman said. "That was a big change, and I think Joe Cino never really quite got over it." Then, in early 1967, Joe's personal life went off the rails after the death of his boyfriend.

"We talk about the great old days, and they really were great old days, but there was an undercurrent that wasn't so great—namely the violence between Joe Cino and his lover Jon Torrey," said Hoffman. "He wasn't always violent, but enough to be a menace. I noticed the great tension between the two, and on occasion I would see Joe was beat up." Others remember Jon Torrey as a charismatic, beautiful man who looked like a Minoan statue: tall, broad shoulders, and huge eyes, ears, and nose. He could work wonders with wiring, including finding a way to tap into the city's electrical system to power the storefront theater's shows for free.

Torrey, who would throw himself into everything with wild enthusiasm, died in a work-related accident outside the city on January 5, 1967. Those who knew Torrey could imagine him being careless to the point that the electricity spat back at him, but Cino was convinced it was suicide and descended into a spiral of depression. "Joe was very affected by his death," said Smith. "He got very isolated toward the end and he didn't have any place else to go. Joe was a very private person, so that after everybody would leave he would be all alone. I think he was sleeping in the café, sort of piling up some curtains and sleeping in them." But people competed for Cino's affection by giving him more drugs, which only accelerated his unraveling mental state.

On the morning of March 30, 1967, the phone rang at Johnny Dodd and Michael Smith's apartment down the street. "Joe was killing himself, and he was calling Johnny Dodd," Smith said. "I picked up the phone because I was awake and

Johnny was asleep. That was the reason I walked in on his death." Smith let himself into Caffe Cino and saw Joe on the floor surrounded by blood, lit only by the dawn sunlight and the café's twinkling Christmas lights. Joe picked up one of the other knives on the floor, but his hands were so slippery with blood that he could barely hold on to it. Smith screamed for him to stop and tried to pry the knife from his hands, to no avail.

An ambulance finally came and took Cino to a nearby hospital, where he survived the day and was given antibiotics. Ellen Stewart stood vigil the whole time as dozens came to donate blood, but he died three days later. "After Joe killed himself," Robert Patrick said, "both Harry Koutoukas and Ondine came to me in tears saying that they had killed Joe by slipping him some drugs. They had gotten some terrifically good, superior acid, and each of them had dropped a tablet of it in his drink. They never knew the other had, by the way. Each of them thought they had killed Joe."

Judson Church hosted Cino's memorial service, just as it had Herko's, and friends staged several tributes (such as *Dames at Sea*'s "Raining in My Heart," a low-rent Busby Berkeley number that surely would have made Joe smile). "Caffe Cino was very romantic," Smith said. "We might as well let it be romanticized. But I just don't like to see Joe's death romanticized, or Freddie Herko, or Jon Torrey. These people died because they were in despair, and there's nothing romantic about that. It's terribly sad and it was a terrible blow."

Joe Cino was the model of freedom and artistic exuberance, and for him to kill himself was like a denunciation of everything he stood for. *Oh, that doesn't work*, some couldn't help but think. *This was a wonderful way to live, but it just doesn't work.* "It was a shock, but I had had several shocks like that already," said F. Story Talbot, who had lost four good friends in a short period of time. "It was like one-two-three-four—people I was close to in the theater—and it was part of what shook me out of the theater."

A group of Caffe Cino mainstays—Smith, Patrick, Magie Dominic, and Charles Stanley—helped keep the coffeehouse open, but they were getting too many citations and summonses from the city. Even before it permanently closed in 1968, many of the regulars stayed away. "I stopped going to the Cino because I guess I was in mourning without knowing it," William Hoffman said. "It was such a shock and it was no longer the same place." During this period, he began going to Norman Hartman's Old Reliable Theatre Tavern. This old-school bar was located in a volatile neighborhood, on Third Street between Avenues B and C. "In the back room of this smelly bar," Hoffman recalled, "we put on fantastic plays at the time

and I learned how to be a director. I followed Bob Patrick there." After Patrick's turbocharged energy was unleashed at Caffe Cino, he became even more prolific at the Old Reliable.

Patrick and Hoffman were part of the bohemian migration away from the West Village in search of cheaper rents and new adventures, with ailing bars like the Old Reliable willing to let them do their thing. This establishment was one of the many Polish-Ukrainian bars scattered throughout the neighborhood—a beer-and-a-shot type of place with a stinky dog named Cornflakes that slept on the sticky floor, amid the peanut shells, spilled beer, and broken glass.

Many of the bar's regulars were likely on welfare or were drawing from a pension, and the large back room had previously been used for dancing on the weekend. "The dancing basically was dry humping," said playwright Michael McGrinder, who frequented the bar before it became a theater. "Mostly, it was black guys and white girls, and music from an old Wurlitzer jukebox" (the neighborhood had long been a safe zone for interracial couples). The Old Reliable began opening its back room to the Off-Off-Broadway crowd after playwright Jeannine O'Reilly put on shows there. "She invited us over to see them," Patrick recalled. "So when the Cino closed, there was no question that I would move to the Old Reliable."

The owner, Norman Hartman (also know as "Speedy"), was a thin man in his forties or fifties who spoke with a very heavy Polish accent and outfitted himself in a fedora, along with other snazzy flourishes. "Speedy was an unlikely Off-Off-Broadway producer," said Walter Harris, who also performed there. "He seemed like, 'Well, why not? What the heck? Let's give it a try.' And so he let all these crazy artists in." The Old Reliable's former dance floor was retrofitted with a two-sided stage with an L-shaped seating arrangement that could hold around seventy people. Robert Patrick was gregarious and likable, and he probably made a good impression on Speedy, who was something of a ham. He seized any opportunity to make announcements or play an on- or offstage role.

In 1968, McGrinder staged his first play, *The Foreigners*, at the Old Reliable, and it quickly became a second home for him. "Michael McGrinder was very rare in those circles," Patrick recalled. "He's a heterosexual. That was an amazingly gay crowd at the Old Reliable." As for the clientele in the front bar—which was mostly composed of straight truckers and dockworkers who came by for cheap booze and friendly girls—that didn't really change. And for the most part, the two groups maintained a peaceful coexistence.

"I think everybody, including the drinking workingmen, appreciated the surreal aspect of it," Patrick said. "If I did some crazy musical where actors would be entering from the bar, you'd just be leaning on the bar itself in between two Polish laborers to support your costume, or headdress. And when it was time for your entrance you said, 'See you later, fellas.' And they'd say, 'See ya.'" As Paul Foster observed, "I find that blue-collar people don't give a damn what you do as long as you pay your way and don't try to get sassy with them."

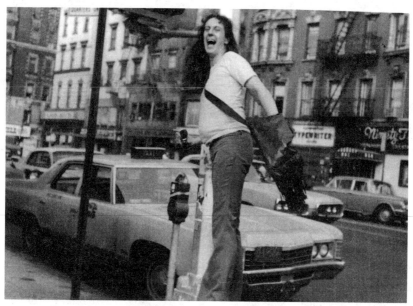

Robert Patrick on Second Avenue, 1971
COURTESY THE LA MAMA ARCHIVE/ELLEN STEWART PRIVATE COLLECTION

"More people were moving over to the East Village," Patrick said, "because it was starting to get expensive to live over in the West Village." When he and director Tom O'Horgan ran into each other on the corner of Eighth Street and Third Avenue one day after the Cino closed, they looked at each other and simultaneously said, "This is starting to be a scene, isn't it?" The little world they created at the Old Reliable was wild, just like the streets that surrounded it, and the neighborhood's foreboding atmosphere only added to the excitement. "The way to get to the Old Reliable," Jeannine O'Reilly used to quip, "is to turn left at the burning car."

Muggings were common, especially after the 1967 Summer of Love faded into a cold winter of discontent. "Tom O'Horgan got mugged one evening coming back

from the Old Reliable," Foster recalled. "Everyone was saying, 'Tom got mugged, can you imagine? It never happened here before.' Things had changed, the drugs were starting to hit around all these places."

The Holy Modal Rounders' Peter Stampfel remembered the neighborhood as being relatively safe in the early 1960s (with "relatively" being the operating word). "A lot of speed freaks had a bad reputation for running around stealing and being sociopathic and that sort of thing," he said, "which was partially true. Things started getting a little dicier in 1962, which was the year a lot of runaway kids hit the Village, so then the Forty-Second Street sleaze started hanging around the set. But when the Summer of Love bullshit happened, it really went downhill. The counterculture suddenly became something everyone was aware of. Around 1967, the flower people were being touted far and wide in the mass media, so every ex-con semi-sociopathic creep in the country was like, 'Teenage girls who fuck, take drugs, let's go!' So there was a huge influx of sleaze."

"When I got over there, hippiedom was peaking," said Richard Hell, who arrived in the Lower East Side in late 1966. "While at the same time it was collapsing, where ripeness turns to rot. There were head shops everywhere, and barefoot kids with flowers in their hair who were panhandling and were tripping. But then every few months there would be a headline story about a Lower East Side crash pad where somebody had overdone it and put out everyone's eyes with an icepick, taking 'flower power' a little too far."

For Walter Harris, the Old Reliable was the farthest east he could remember venturing. "You always had to have the appearance of looking like you were going somewhere and not just wandering around, as a way to avoid trouble." Adventurers going to the bar walked down the middle of the street because there would be almost no one on the roads in the evening, and one could avoid potential dangers lurking around the corners of alleys or basement stairwells. Homeless people burned trash in barrels, providing a little light where the streetlights no longer worked. "People who would go to the Old Reliable would walk down Third Street because they considered it safe, because of the Hells Angels," McGrinder said. "The Hells Angels kind of made trouble among themselves, but they didn't make trouble for others, for the most part."

Theatre Genesis, also located in the East Village on Tenth Street and Second Avenue, was another hotbed of Off-Off-Broadway activity. Along with Café La MaMa, Judson Church, and Caffe Cino, it was one of the key venues of the downtown's underground theater movement. And like Judson, it was housed in a church—St. Mark's Church-in-the-Bowery, which in 1963 hired a radical young

rector named Michael Allen, who was committed to supporting the artistic scenes flowering around him.

Theatre Genesis was the brainchild of Ralph Cook, who was a head waiter at the Village Gate, a popular venue where jazz artists like Rahsaan Roland Kirk and Cannonball Adderley played. "Ralph approached Michael Allen, the rector at the church," recalled Genesis playwright Anthony Barsha, "and that's how they got set up there, in '64. Michael Allen was a very open guy, and he was the opposite of Ralph. He was a sort of jolly fellow who could've played Santa Claus."

Cook brought along his Village Gate coworker Sam Shepard, whose first two one-acts—*The Rock Garden* and *Cowboys*—opened at Theatre Genesis on October 10, 1964. The playwright lived in the Lower East Side at the time with his roommate, Charlie Mingus Jr., a painter and the son of jazz legend Charles Mingus. Shepard was also a musician who often incorporated rock 'n' roll in his plays and, in 1966, he joined the Holy Modal Rounders as their drummer (which is how he later met Patti Smith, with whom he cowrote the play *Cowboy Mouth*).

Shepard and Mingus lived in a condemned cold-water apartment on Avenue C, past the Old Reliable. The two young men saw it as an urban frontier, and would act out "cowboys and Indians" games on the streets. These sorts of scenarios—along with tales of revolutionary street-fighting men and rough-and-tumble masculinity—made their way into several of Shepard's early plays. "Genesis was distinguished by being much more heterosexual than any of the other places," said Robert Patrick. "Sam Shepherd, Murray Mednick—a lot of their plays had references to cowboy movies, and westerns, and things like that."

Their shows veered toward what one reviewer dubbed "Macho Americano," and they thought of themselves as the "Hells Angels of the Off-Off-Broadway scene," as Barsha put it. "Off-Off-Broadway started with the gays at Cino, so it was pretty much a gay scene," he observed. "Ralph Cook and Leonard Melfi, Kevin O'Connor, Sam Shepard, myself, Murray Mednick, and Walter Hadler—we're all straight guys. It was that kind of a scene. A lot of pot, and a lot of women, and a lot of messing around in that area, so Genesis definitely had that reputation, and rightly so." When asked about an old interview—in which Barsha said he wouldn't have felt comfortable in the more campy, openly gay theaters—he acknowledged, "That was probably true, yeah. It was a different time."

Still, many of the gay men in Off-Off-Broadway said they never felt any bad vibes emanating from Genesis. "They were never homophobic to me," William Hoffman said. "I was a neighbor of Sam Shepherd. He was perfectly nice, and I knew other people who worked at Theatre Genesis—like Leonard Melfi—they

First Street and Bowery, circa 1971
(Hilly's on the Bowery was around the corner to the right)
© CHRIS STEIN

seemed very nice. I just didn't identify with their kind of theater." Michael Smith added, "I was quite involved at Theatre Genesis for a while. In its early days, it was kind of a bunch of straight guys doing very straight plays. But it opened up more later on. I did Ron Tavel's *Big Foot* there, for example. They even did a Harry Koutoukas play there."

Theatre Genesis's bare-bones, no-nonsense space was an ideal setting for the butch plays that Shepard, Barsha, and their peers wrote. It was a little black room that had a floor-level stage with folding chairs that could be moved around so that the space could be easily reconfigured for each production, and the lights were attached to pipes on the ceiling. But with a little hard work and imagination, they transformed St. Mark's Church into a theater—just as the Old Reliable became a DIY performance space and, a few years later, a nearby bar named Hilly's on the Bowery was reborn as the punk club CBGB.

CHAPTER 15

Lower East Side Rock and Radicalism

"The Fugs, the Holy Modal Rounders, and the Velvet Underground were the only authentic Lower East Side bands," guitarist Sterling Morrison said, perhaps with a bit of exaggeration. "We were real bands playing for real people in a real scene. We helped each other out if we could and generally hung out at the same places."[1] Poet and provocateur Ed Sanders had already formed the Fugs in late 1964, a few months before the Velvets coalesced. "I felt camaraderie towards The Velvets," Sanders recalled. "We overlapped. So people would come to both shows. Nico used to come to my bookstore, the Peace Eye."[2]

The connections among this lowly trinity of bands ran deep. The Holy Modal Rounders first emerged on the Lower East Side in May 1963, and about a year later Peter Stampfel and Steve Weber joined the Fugs—contributing radio-unfriendly songs to the group's repertoire (like Stampfel's "New Amphetamine Shriek" and Weber's "Boobs a Lot"). "The Rounders were actually invented by my ex–old lady Antonia," Stampfel said. "She talked about her ex-boyfriend Steve Weber, who was a serious speed freak. He'd been living in the street for a year, year and a half, walking around barefoot and stepping in dog shit and glass, as the story goes."

Stampfel was expecting a scary old guy, but Weber was only nineteen and looked like an idealized Li'l Abner. *Hey,* Stampfel thought, *it looks like my long-lost brother.* Better still, Weber played a steel-stringed guitar, not the type of "Michael Row Your Boat Ashore" nylon-stringed guitars that Stampfel loathed. The plan of action was obvious: Take a bunch of amphetamine and play some music! After a few hours of crazed jamming, Peter said, "I gotta go to work. Do you want to come play with me?" The audience at the Gaslight was instantly knocked out by their act, so the speeding folkies basically kept playing for three days straight, bouncing from place to place.

At the end of their musical bender, they glimpsed themselves in a mirror while performing in Café Rafio. *Holy fuck,* Stampfel thought, *that's the most weird-ass shit I've ever seen.* The two were sporting what could be called an old-timey style:

jeans, vests, pony-skin shoes, and long hair (a look that was later adopted by the hippies). This uniform was favored by traditional musicians, who worshiped Folkways Records' *Anthology of American Folk Music.* When the Holy Modal Rounders got together, the traditionalists maintained a strict purity—for example, they would not perform songs written after the Great Depression.

Around 1963, Stampfel wondered, *What would happen if you could take all the* Anthology *people at the age they were then—you know, young—and introduce them to what was going on in the 1960s—you know, rock 'n' roll?* This was a lot more interesting than following the dictum "Don't do anything past 1939." More practically, this meant that whenever Stampfel couldn't understand the original words from an old, crackling 78 rpm record, he had some creative license. "So the fact that my alterations were actually an improvement was still another reason to not be a cookie-cutter copy."

The Rounders' self-titled debut was recorded on November 21, 1963, the day before the assassination of John F. Kennedy, and its song "Random Canyon" contained the first use of the word *psychedelic* on record. "Take me back to Random Canyon, where the gryphon's always riffin' and the unicorn is horny in the spring," Stampfel sang in his high-pitched warble, "and the psychedelic sage keeps the cattle in a rage, and the changing range is getting pretty strange." Stampfel said he wanted to be the groundbreaker, so he very consciously inserted the word *psychedelic* into his song. The Rounders were irreverent to their core, which ruffled some folkie feathers, and their first album was largely ignored by their target audience—save for folk bible *Sing Out!* magazine, which dismissed the group as not being serious enough.

The duo split up in the summer of 1965, but the next year the Holy Modal Rounders were offered a princely sum to reunite at a music festival. Neither man could pass up the money; Stampfel was so broke he had put his fiddle in hock at a Second Avenue pawn shop, which he retrieved for the show. As he stood in the shop holding his instrument, Sam Shepard walked up to him and asked, "Hey, do you play bass?" One thing led to another, and the playwright-drummer joined the Holy Modal Rounders, and ESP-Disk signed them to make a new record. Shepard played drums on 1967's *Indian War Whoop,* but the record company didn't include his photo on the album's sleeve because he had cut his hair short (as a way of protesting "all that Summer of Love bullshit," as Stampfel put it).

The band signed with Elektra Records and went to Los Angeles in March 1968 to record *The Moray Eels Eat the Holy Modal Rounders,* which included their best-known number, "The Bird Song." It ended up on the *Easy Rider* soundtrack

after being edited by Dennis Hopper into a memorable scene with Jack Nicholson on the back of a chopper, flapping his wings. While out West, the Holy Modal Rounders opened for Pink Floyd at the Avalon Ballroom in San Francisco and appeared on the comedy variety TV show *Laugh-In*. "Somebody from Elektra Records knew a guy from the show, and he got us on," Stampfel said. "They didn't even let us finish the fucking song. I really screamed the words way too loud. It was definitely a weird performance for network TV."

Remarkably, both the Rounders and the Velvet Underground appeared on national television, reaching millions of households. In 1965, legendary *CBS Evening News* anchor Walter Cronkite introduced "The Making of an Underground Film," a five-and-a-half-minute segment that featured Jonas Mekas, Edie Sedgwick, Andy Warhol, and the Velvet Underground (whose members—except for drummer Maureen Tucker—were shirtless and wearing body paint). "Some underground films have been criticized for dealing too frankly with such themes as sex and nudity," CBS correspondent Dave Dugan reported, "but many movies such as this one may simply seem confusing."[3]

Even the Fugs came close to making it on network television after Sanders's face landed on the cover of the February 17, 1967, issue of *Life*—one of the nation's highest-circulation magazines. This led to a call from *The Tonight Show* to appear as Johnny Carson's guest. Sanders stubbornly insisted that the Fugs should be allowed to perform "Kill for Peace" on the program as a protest against the Vietnam War but, not surprisingly, the network refused to let the Fugs sing, "If you don't like the people or the way that they talk / If you don't like their manners or they way that they walk / Kill, kill, kill for peace!"

When Ed Sanders signed the lease for his Peace Eye Bookstore in late 1964, at 383 East Tenth Street, Beat hero Tuli Kupferberg was already living next door, above the Lifschutz Wholesale Egg Store. They first met in 1962 outside the Charles Theatre on Avenue B, where Jonas Mekas screened underground films and Kupferberg was selling copies of his magazine *Birth* to the audience. Sanders let Kupferberg publish a poem in *Fuck You/A Magazine of the Arts* and the two attended poetry readings at Café Le Metro, where Andy Warhol and Gerard Malanga mixed with literary heavyweights like Allen Ginsberg. After these readings, everyone congregated at a dance bar on St. Mark's Place called the Dom—formerly a Polish wedding and social hall—where Sanders suggested to Kupferberg that they should form a band.

"Tuli was truly a hippy," Jim Fouratt said. "A hippie poet, and older. The Fugs came out of the folk scene and the old Beat scene." Ginsberg referred to Kupferberg in his poem *Howl* as the man "who jumped off the Brooklyn Bridge . . . and walked away unknown and forgotten into the ghostly daze of Chinatown." (In fact, it was the Manhattan Bridge.) Sanders had seen photos of Kupferberg in books and knew the lore about his jump, which Kupferberg didn't like to talk about. "Throughout the years," he recalled, "I have been annoyed many times by 'O did you really jump off the Brooklyn Bridge?' as if that was a great accomplishment. Remember I was a *failure* at the attempt."[4]

Sanders suggested various band names such as the Yodeling Socialists and the Freaks, but it was Kupferberg who came up with the Fugs—*fug* was a term that writer Norman Mailer had used as a euphemism for *fuck* in his novel *The Naked and Dead*. With a name secured, their next order of business was to write songs. Sanders had been setting William Blake poems to music since his days of sitting in Washington Square Park as an NYU student, and he was more a poet than a rocker.

"Sanders looked exactly like Mark Twain," *Village Voice* rock critic Richard Goldstein recalled, "this ratty midwestern look." Poet Andrei Codrescu concurred on the likeness, adding, "He was also from Missouri. There is a kind of a localism there that I picked up later—where they say the most incredible things, and you just can't be sure if they are serious." Sanders was a great confabulator, and his personality, as expressed in *Fuck You* and the Fugs, was a seamless mix of earnestness and whimsy. "I don't think I took the Fugs seriously as music. I just liked the scene, but I didn't really listen to it as music," said Goldstein. "But the idea of Blake's 'Ah! Sun-flower! / weary of time' as a rock song was amazingly unusual."

Kupferberg knocked out several songs—including "Jack Off Blues," "That's Not My Department," and "Hallucination Horrors"—while Sanders contributed an homage to Ginsberg's *Howl* titled "I Saw the Best Minds of My Generation Rot" and several naughty numbers such as "Group Grope." Soon after, the Holy Modal Rounders teamed up with Ed Sanders and company to create the first incarnation of the Fugs. "Someone told me Sanders and Tuli had written a bunch of songs like 'Coca-Cola Douche' and 'Bull Tongue Clit,'" Stampfel recalled. "So I went to listen at the Peace Eye Bookstore, and I saw that the only instrument was Ken Weaver playing a hand drum. So I said, 'Hey, you can use a backup band.' It was an obvious thing to put together, so that's how Steve Weber and I started playing with them."

After signing a deal with Folkways Records, the band recorded their first album in April 1965. Along with several original songs, the Fugs included two Blake poem

adaptations on their Harry Smith–produced debut, *The Village Fugs Sing Ballads of Contemporary Protest, Point of Views, and General Dissatisfaction*. In addition to live gigs and vinyl records, the group could also be heard on free-form radio shows. Their performance of "Carpe Diem" at a Judson Church memorial service for comedian Lenny Bruce, for example, was recorded by Bob Fass and aired on WBAI (Bob Dylan, Allen Ginsberg, Abbie Hoffman, and many other musicians, poets, and political activists also made appearances on Fass's show over the years).

The Fugs rehearsed at the Peace Eye Bookstore, where they recorded the number "Spontaneous Salute to Andy Warhol" during a rehearsal, which appeared on a later Fugs release. "Warhol came to a number of Fugs performances," Sanders said. By the end of the summer of 1965, they played an antiwar benefit at the Bridge Theatre titled "Night of Napalm," which Warhol attended. After playing "Kill for Peace" and "Strafe Them Creeps in the Rice Paddy, Daddy," they enacted a ritual dubbed "The Fugs Spaghetti Death"—for which they boiled pots of noodles and filled a wastebasket with them.

Food fight!

Chanting the phrase "No Redemption," the band flung pasta at the audience and themselves, slipping and sliding in the noodles onstage. "I spotted Andy Warhol in the front row," Sanders recalled. "It appeared that he was wearing a leather tie—then *blap!* I got him full face with a glop of spaghetti."[5] Stampfel noted that these sorts of unvarnished performances helped sow the seeds of punk. "The idea that you have no knowledge of music whatsoever but you have an attitude, and you just do it," he said. "Like, you're not technically ready for it, but you just go for it. In 1976, the Ramones go to England and everyone thinks punk is invented then, but there's this whole twenty-five-year lineage that starts with the Harry Smith *Anthology* and goes through the Fugs."

Eventually, Stampfel left the Fugs because he could no longer deal with Steve Weber. "I quit because Weber basically got crazier and crazier," Stampfel said. "He was taking fuck-tons of speed and was up, like, eight days in a row." The last straw was the time at a Howard Johnson's restaurant in Baltimore when the strung-out musician gave a waitress a chunk of hash. "I mean, giving a stranger drugs? Obviously, a train wreck was imminent and I didn't want to be around when it happened." Sanders likewise had little luck taming Weber. After falling asleep onstage during a gig and not showing up for an important concert at Carnegie Hall—a deal-breaker—the guitarist was let go.

In April 1966, the Velvet Underground began their residency playing with Warhol's *Exploding Plastic Inevitable* at the Dom, where Factory newcomer Mary Woronov joined in. "Gerard Malanga felt we would be center stage and liven things up," Woronov said. "So he brought me on with the black leather suit and a whip, and we worked out a dance with a sort of S&M kind of theme." Their routines were supposed to be dark and theatrical, but they sometimes veered into much more goofy realms. "For 'Waiting for the Man,' I would lift weights," Woronov said. "For 'Heroin,' Gerard would run around with a plastic needle that was two feet long and shoot up. It was sort of an act, to music."

Meanwhile, the Velvet Underground unleashed sheets of sound as Warhol slipped colored gelatin slides over film projector lenses or just stood on the balcony, observing the crowded scene. One night he saw "a small, muscular blond kid make a ballet leap that practically spanned the dance floor."[6] Warhol promptly went downstairs and met the young man, Eric Emerson, whose good looks and magnetic personality secured him a spot in several Warhol films. He was cast alongside Nico and Woronov in *The Chelsea Girls* and appeared in *Lonesome Cowboys, San Diego Surf,* and *Heat.*

Emerson also played a fateful role in torpedoing the Velvet Underground's (slim) chances of commercial success soon after the release of their 1967 debut album, *The Velvet Underground & Nico.* The album's back cover originally featured a shot of the band playing with an image of Emerson's face from *The Chelsea Girls* projected prominently in the background. Emerson either needed drug money or was simply broke, so he threatened to sue the record label because he hadn't signed a photo release. Verve Records pulled the album from record stores and redacted Emerson's face from the back cover, which was a disaster for the band. "The album vanished from the charts almost immediately in June 1967," Sterling Morrison lamented, "just when it was about to enter the Top 100. It never returned to the charts."[7]

The Velvet Underground & Nico was recorded in 1966 but wasn't released until the following year. Bucking the music industry norm of securing a contract with a record label, Warhol and the Velvets went the independent route—recording it themselves. "The album says, 'Produced by Andy Warhol,'" Morrison noted. "Well, it was produced in the sense that a movie is produced. He put up the money. We made the album ourselves and then took it around because we knew that no one was going to sign us off the streets. And we didn't want any A&R department telling us what songs we should record."[8]

During the recording sessions, Warhol and the band left for California, which didn't warm to the Velvets' anti-hippie, proto-punk attitude. Things went downhill when they played a Los Angeles club named the Trip with Frank Zappa and the Mothers of Invention—a show that was attended by Cher, Jim Morrison, a couple of members of the Byrds, Mama Cass, and other rock royalty. Zappa and his audience were hostile to the Velvets, and the New Yorkers retaliated by concluding their set by creating a wall of feedback with their guitars, which were piled on the stage floor as they walked backstage. "It will replace nothing," Cher quipped to a newspaper the next day, "except maybe suicide."[9]

After returning to New York, the Velvets won over future Blondie cofounders Debbie Harry and Chris Stein, who saw them on separate occasions. "The stage was bright and colorful and beautiful," Harry said of a show she saw not long after she moved to the Lower East Side. "I remember Nico was wearing a chartreuse outfit and it was stunning. It was just beautiful to look at, as well as to hear, and I remember Andy being there in the balcony. Andy Warhol was running the lights, and it was just this beautiful burst of colors and vibrations. The projections behind them were just so lovely and impressionistic, but also dark and scary at the same time. I guess I was drawn to the darkness."

Stein and his teenage pals loved the group's debut album, and one day in 1967 they realized every garage band's dream: opening for the Velvet Underground. "My friend Joey Freeman's job was basically to go wake up Andy at his house," Stein recalled, "and one day he told me that the band that was supposed to open for the Velvet Underground had cancelled. We just went up there, set up, and played at a place called the Gymnasium." That casual pickup band was sometimes known as First Crow on the Moon, which Stein didn't really take seriously, but the show itself was a life-changing event. "That Velvet Underground show was completely awesome, in every sense of that word," Stein said. "It was just overpowering."

"That's what Blondie came out of—we all had that influence," said Harry, referring to the Velvets and the Warhol scene. "Chris and I came from an art background, and it's part of the way we think. There was also our association with Warhol, and Chris was really friendly with William Burroughs. Chris went to art school, and would either have become a photographer or a painter—and then the music evolved."[10]

Warhol and his collaborators regularly blurred the lines between the mainstream and margins—such as the time when the Velvet Underground appeared at "Freak-Out '66," with Warhol doing lights. The music festival's lineup included

Lower East Side noise anarchists the Godz, Top 40 girl groups the Ronettes and the Shangri-Las, and baroque pop one-hit wonder the Left Banke, of "Walk Away Renée" semi-fame.[11] (Coincidentally, the Left Banke was formed from the ashes of the Morticians, another Brooklyn band that Chris Stein played in as a teen.) Fans who went to check out the Ronettes or the Shangri-Las surely were in for a surprise with the Velvets' musical dissonance.

In New York City, even the most fringe artists were often just one or two degrees removed from loud media megaphones in the heart of midtown—just a few subway stops away from these downtown neighborhoods. From the Velvet Underground's appearance on the *CBS Evening News* to the Holy Modal Rounders' performance on *Laugh-In*, underground artists cast seeds of subversion that flowered throughout America.

"Announcing the Fugs Cross Country Vietnam Protest Caravan, October 8–28th," trumpeted Ed Sanders's press release in advance of their 1966 tour. The group planned to promote their antiwar message across America, and the primary destination was Berkeley, California—another site that fostered the emerging peace movement. At the University of California, the Fugs played among the Bunsen burners on the chemistry room's demonstration table, along with Allen Ginsberg and the first-ever performance by Country Joe and the Fish.[12]

Back in New York, the Fugs were banned from their regular venue, Astor Place Theatre, after they burned a flag that was printed with the words LOWER EAST SIDE. The point was to illustrate how burning a symbol didn't actually hurt the thing it represented, but newspapers claimed that the group burned an American flag—which led to an FBI investigation. The Bridge Theatre came to the rescue and gave the Fugs a new home, where they settled into a successful residency that ran for seven hundred-plus performances from late 1966 through 1967. The Bridge was above the Café Au Go Go on Bleecker Street, which benefited from the abundant Greenwich Village foot traffic, so the shows were often sold out. "The theater was filled," Sanders recalled, "and the shows were fluid, well done, and hot. It was the peak time for the Fugs."[13]

The Fugs mixed humor and activism, an approach shared by Sanders's friend Abbie Hoffman. An exemplar of this was the August 24, 1967, action that targeted the New York Stock Exchange, where Hoffman dropped a few hundred-dollar bills from the viewing area above. The goal was to create a mass-media spectacle in order to highlight the connection between the military-industrial

complex and corporate war-related profits. Fellow activist Jim Fouratt hatched the idea, and Hoffman executed it with Jerry Rubin. "At first, they didn't want to let them in because they were a bunch of hippies," Paul Krassner recalled. "Then Hoffman said, 'We're a group of Jews and you don't want to be accused in the media of being anti-Semitic, do you?' So they got in, and the trading ticker-tape stopped."

Two months later, the same cast of downtown characters decided to levitate the Pentagon—a famous protest/prank that brought together the politicized wing of the counterculture and the hippies who were more invested in cultural revolution. The levitation stunt was a joke, but one with serious undertones that helped publicize their antiwar protest, the first of its kind in Washington, DC. "If you don't like the news, why not go out and make your own?" Hoffman wrote in *Steal This Book.* "Guerrilla theater events are always good news items and if done right, people will remember them forever."[14]

Even Pentagon officials joined in on the levity when the organizers sought a permit to levitate the building. "Well, don't raise it higher than twenty-two feet, because that's the height of our ladders," they were told by a bemused official, who finally bargained them down to three feet. "So then we were able to go out and tell the newspapers that the Pentagon said that we could 'only' raise it three feet off the ground," Krassner said. "It was a great quote. It was funny, and it served as an organizational tool of media manipulation—in order to inform people about the demonstrations that were going to take place that October at the Pentagon."

The proto-Yippies staged two different media events filled with humorous hooks that they dangled in front of journalists, who took the bait. During one press conference a week before the protest in Washington, they performed a demonstration of the levitation at the Village Theater, complete with wires used to raise a small model of the Pentagon. While Sanders and others chanted, it rose high above the stage like a cheap magic trick.

The conspirators showed off the effects of a fake new drug, Lace, at another press conference staged at the Electric Circus (formerly the Dom, across the street from where Abbie and Anita Hoffman lived). "We called it Lace because it rhymed with Mace, which was a pepper spray," Krassner said. "Abbie said it was a combination of LSD and DMSO that would be absorbed by the skin into the bloodstream, which served as an aphrodisiac." They staged a scene in which a faux reporter and an onlooker were accidentally sprayed, then had sex in front of reporters from *Time* and other major news outlets—who nonchalantly took notes. "We told the journalists that there were going to be gallons of Lace brought

with water guns to the October 1967 demonstrations," Krassner said, "and that they were going to spray the National Guard. We were getting free publicity by giving them a good story."

When they arrived at that antiwar rally in the nation's capital, the New York underground stood center stage in American politics and popular culture. Sanders and the rest of the Fugs flew there in time to perform a show the night before the big protest, and Shirley Clarke was at the airport to document their arrival. She also filmed the exorcism ritual Sanders performed at the Pentagon with musical accompaniment from the Fugs. "In the name of the Amulets of Touching, Seeing, Groping, Hearing, and Loving, we call upon the powers of the Cosmos to protect our ceremonies," Sanders said, reciting his tongue-in-cheek incantations. "For the first time in the history of the Pentagon, there will be a grope-in within a hundred feet of this place."[15]

George Harris III had lived a fairly apolitical life until he appeared with James Earl Jones and Al Pacino in *Peace Creeps*, which awoke him to the horrors of the Vietnam War. He drifted away from the New York theater world and began to be more openly gay and free, taking different lovers, including Allen Ginsberg. George accepted a ride to San Francisco in a Volkswagen van driven by Ginsberg's longtime partner Peter Orlovsky, who took a detour to the antiwar protest

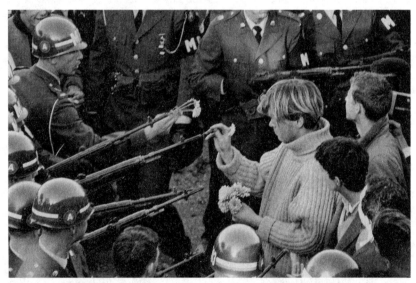

Walter Harris III placing flowers in National Guardsmen's rifles
COURTESY RIT ARCHIVE COLLECTIONS, ROCHESTER INSTITUTE OF TECHNOLOGY / © BERNIE BOSTON

Aerial view of demonstrators and the National Guard, October 21, 1967
COURTESY WENDY FISHER

in Washington—where George was famously photographed placing flowers in National Guardsmen's rifles.

This act was influenced by the street theater that surrounded him in downtown New York, and it effortlessly displayed the idea that love can overcome political tyranny and break the war machine. The next day, G3 excitedly called home to tell his mother that photojournalists snapped pictures of him. "George loved having his photograph taken," recalled Jayne Anne Harris. "So it was probably a combination of things. He probably saw the cameras, he of course was a bit theatrical, he was probably high, and he believed in peace and love."

It was the largest antiwar protest in the nation's history, and a major turning point in the shifting opinion against the Vietnam War. The *East Village Other* described it as a "mystic revolution" led by protesters who "cast mighty words of white light against the demon-controlled structure"—that is, until the riot police descended on them in full force later that night.[16]

The brand of activism favored by Sanders and Krassner was radical, but they were much more impish than other self-styled revolutionaries who prowled the Lower East Side. "There was a group called Up Against the Wall Motherfucker, or just the Motherfuckers," Krassner recalled. "They could cause trouble. So there

was the Motherfuckers and the Guardian Angels, who would follow cops around, and on the corner of my block was the Puerto Rican group, the Young Lords." The Motherfuckers' anarchist agitator Ben Morea wore a headband emblazoned with "LSD" (which stood for "Lower-East Side Defense"). He hung out in front of Gem Spa, and sometimes started riots on weekends. "The Motherfuckers guys all wore these headbands," recalled poet Andrei Codrescu, "and their thing was to follow the police around and drive them crazy."

Codrescu, too, was antiwar, but he wasn't necessarily compelled to go around chanting slogans like "LBJ, LBJ, how many kids did you kill today?" He found other creative ways to express his antiauthoritarian impulses, like staging the mock-assassination of the prominent poet Kenneth Koch. Codrescu was roped into the action by the publisher of *Guerrilla: Free Newspaper of the Streets*, Allen Van Newkirk—"this guy who had the craziest fucking ideas," according to Codrescu. Koch was one of the first-generation New York School poets and was therefore too uptown, so Newkirk stood up during a reading, fired a fake pistol in the air, and shouted, "Death to bourgeois poetry!" Koch didn't lose his cool for a second, and just turned toward the towering pistol-packing radical and said, "Grow up."

The only time Codrescu went to a traditional mass demonstration was with a bunch of Puerto Rican guys from his neighborhood. He asked them to shout the phrase "oxidize the gargoyles," a line he got from an Arthur Rimbaud poem. "So I had these guys with accents saying, 'Oxidize the gargoyles! Oxidize the gargoyles!' The cops were afraid of us, because they didn't understand what the fuck we were saying, and we obviously looked like we're foreigners with accents, and we were saying absurd things." This street theater sensibility inevitably influenced—and was influenced by—what was happening in underground theater venues such as Café La Mama, where Ellen Stewart continued to cultivate an oddball cast of directors, playwrights, and performers.

CHAPTER 16

La MaMa Gets Ridiculous

Ellen Stewart extended the downtown diaspora's connections across the globe, touring shows overseas and bringing international troupes to her theater. La MaMa's first forays abroad began in June 1965 with a European trip taken by Jacque Lynn Colton and Mari-Claire Charba (who appeared in the Andy Warhol film *Soap Opera*). Colton and Charba met when they were cast in a LeRoi Jones play, *The Baptism*, and they appeared together in Tom Eyen's Off-Off-Broadway hit at La MaMa, *Frustrata, or the Dirty Little Girl with the Red Paper Rose Stuck in Her Head Is Demented*.

The two soon hatched a plan to get Eyen to write them a play as an excuse to go to Europe, and they had quite a send-off. "Tiny Tim and Harry Koutoukas and Tom Eyen and all of Off-Off-Broadway came down to the boat to see us off," Colton said, "and threw roses at us. She and I had our floaty chiffon scarves blowing in the wind. It was all very picturesque." Charba and Colton performed Eyen's *The White Whore and the Bit Player* on a transatlantic ocean liner, then put on Eyen's show everywhere from Amsterdam to Paris. By the time they returned, musician and director Tom O'Horgan had become part of the La MaMa family.

"Tom came into the Cino," playwright Robert Patrick recalled, "moping and sulking that his life was over and he wasn't getting anywhere, and that he was a woebegone, middle-aged gay musician. Then Joe Cino said, 'Here, you can have the floor.' Tom did two rather conventional nightclub-type reviews with eccentric touches. After Paul Foster saw that, he brought him to La MaMa, where Ellen supported him." He eventually directed some sixty plays at Stewart's theater and had even greater success directing the Broadway debuts of *Hair* in 1968 and *Jesus Christ Superstar* in 1971.

Much earlier, in 1964, O'Horgan had directed an important production of *The Maids*, the first to cast men in the two pivotal female roles (as playwright Jean Genet intended). "I played the Madame," said Charba, who was also cast in *The Maids*. "We presented it at La MaMa, and it was a big success. That was the

beginning of his directing career, because before that he was really a composer and a musician." Charba's earliest memory of O'Horgan was at a Happening he orchestrated at Judson Church. "He did this thing where everybody was inside the Judson," she said, "and then they all came out onto Fourth Street where all these drag queens were."

It was during this time that O'Horgan formed the La MaMa Repertory Company, which took root at an artist commune run by Danish writer Elsa Gress and her husband, American painter Charles Clifford Wright. Although based in Denmark, they were friends with John Cage and had several connections to the influential Black Mountain College group. "Ellen sent us to Europe," O'Horgan explained, "and we went through an incredible, wonderful kind of circumstance. We played Copenhagen and Paris and back to Copenhagen where we played for six months, moving around Denmark and Sweden, performing in every possible kind of theatre, state-of-the-art theatres to those in homes, and every place in between. And we developed something quite amazing."[1]

"We all lived there together and we created this new style of theater," said Charba, who played the Termite Queen in Paul Foster's *Tom Paine*, one of the shows the La MaMa troupe developed while abroad. They traveled from Nice, France, to Spoleto, Italy, astonishing audiences all along the way. "No one there had ever seen Off-Off-Broadway," Foster said, "let alone a company of twelve naked people, but they took it in stride."

Stewart was open to anything, including a play with no onstage actors: just two Ping-Pong balls swinging back and forth. Foster wrote *Balls* after he had an argument with some La MaMa actors, and as he was stomping and huffing about, he thought, *That does it! What I need is a play without actors!* The show's two main characters—two swinging balls—were voiced from offstage over a loudspeaker, and all the audience could see was the white spheres moving in and out of their own shadows. It was pure white against pure black, an empty world in which the two deceased protagonists played ball and talked. "They're in a little cemetery by the sea," Foster explained, "and a storm is threatening to engulf their graves. But the balls didn't change tempo, they were always slowly, slowly just going back and forth. You're left with the feeling of great loneliness: 'Well, if we can't play ball, what the hell are we going to do with the rest of eternity?'"

After Café La MaMa's move to 82 Second Avenue, Stewart was still under the watchful eye of the city. She had already been sent to the Women's House of Detention in Greenwich Village a few times and risked becoming a felon—all for the crime of running a DIY theater—and the city was planning another raid.

Someone tipped off Stewart, and she was able to quietly secure a new place down the street and move the entire contents of her theater literally moments after the end of a show.

"It was the closing performance of *Balls*, Paul Foster's play," Ellen recalled. "There must have been thirty-five people who came to see the play. Many of them had never been there before. I told them just to strike the café." Some audience members had no idea what she meant, but they followed the lead of others and began picking up chairs, tables, and set pieces. Everyone went down the steps at 82 Second Avenue, walked up the street past the dry cleaner, and arrived at a second-floor loft at 122 Second Avenue, where they set up the new theater. "We took everything—paintings, tables, chairs, coffeepots—everything," Stewart said. "Well, they moved me in one hour."[2] One lady in high heels who was carrying an armful turned to another woman and innocently asked, "Do they do this often?"

La MaMa's third home was a slightly larger space. It was twenty-three by seventy-five feet and had twelve-foot ceilings, all of which housed the usual coffee bar, dressing room, toilet, a bit of storage, and a stage that stretched the width of the room. The legal capacity was seventy-four, though more would often be squeezed in.

City officials had run Stewart out of three locations by 1968, but she never gave up on her theatrical pushcart. "The only way around all the problems with city government regulations was to get our own theater," Foster said, "and that's when we got the Rockefeller and other foundation grants." Unfamiliar with the process of submitting a formal proposal, Stewart naively called up the Ford Foundation and extended an invitation to visit La MaMa. After Ford Foundation Vice President McNeil Lowry and his wife attended a performance, Stewart brought them to the Fifth Street Deli and charmed them over hot dogs and sauerkraut. Stewart told them she needed $10,000 for a down payment on a building at 74A East Fourth Street, along with $15,000 to renovate the four-story space as a theater; a week later, in November 1967, La MaMa received its first foundation grant of $25,000.[3]

"Ellen was the P. T. Barnum of the Lower East Side," said underground theater actress and singer Ruby Lynn Reyner, who appeared in several La MaMa productions. "She was very good at hustling and getting grants. And Ellen was adorable. She had this strange accent, which I don't know where it came from." Foster recalled that her modified Geechee accent, which sounded like a vaguely French dialect, was somewhere between authentic and theatrical—a useful tool she used when soliciting grant money. "It was a very effective device," he said. "She was keeping the empire alive."

La MaMa's newly acquired building, a former hot dog factory, needed a lot of work. Two floors were made into theaters that sat eighty-five people, one floor was set aside for rehearsal space, and the top floor became Stewart's residence. As she worked on setting up La MaMa's permanent home, her theater continued staging shows in a temporary space at 9 St. Mark's Place. At last, on April 2, 1969, a renovated and newly renamed La MaMa Experimental Theatre Club opened its doors to the public.

Ellen Stewart sitting in front of a *Balm in Gilead* poster, 1969
COURTESY THE LA MAMA ARCHIVE/ELLEN STEWART PRIVATE COLLECTION

"It was in the winter, it was freezing," recalled Agosto Machado. "She didn't have working plumbing then, but she was determined to open." The predominantly working-class Puerto Rican neighborhood viewed Stewart with suspicion, just like her Ukrainian neighbors at La MaMa's first location. "They didn't want all these gay people coming and going on their block," Machado said. "It got so nasty. She had plants in front of La MaMa to sort of dress up the block, and they poured battery acid or what have you in her plants to kill them. It was made known that they didn't want her or these people coming into their neighborhood, and so we were always minding our p's and q's."

Through her day job designing swimsuits, Stewart worked hard to keep La MaMa's lights on. "Ellen was getting the money from the foundations," Foster recalled, "making sure the sidewalk was swept so the city wouldn't give her a ticket, and settling arguments—because theater people were highly argumentative." Perhaps the most antagonistic theater person she took under her wing was John Vaccaro, the mercurial director who orchestrated the Play-House of the Ridiculous. "John Vaccaro was a mad genius," Foster said. "John became a La MaMa director because he had an argument with someone he was working with, which happened a lot, so then he came to La MaMa and Ellen found him an apartment." Together, they helped spawn a new style of performance that encompassed several mediums and art forms, personifying the connections between visual art, theater, and music.

"I consider Ellen Stewart my honorary mother, and John Vaccaro my honorary father," Machado said. "Through both of them, I felt part of a larger group, and a family." Another member of that extended family was performer Penny Arcade (née Susana Ventura), who first worked with Vaccaro on his 1967 play *Conquest of the Universe*. "John Vaccaro is the most singularly underrated person in the alternative arts," argued Arcade. "So much of what went into queer culture came through John Vaccaro, and it was John who first did that kind of rock 'n' roll theater. There wouldn't have been a punk scene without John."

Play-House of the Ridiculous shows were literally in-your-face—unrelenting explosions of color, glitter, and noise underscored by social satire. "There was always a strong political undercurrent," said Ridiculous actor Tony Zanetta. "Kill the king or, you know, mainly kill—kill someone. It was all total insanity and nonsense, but it was really compelling." Vaccaro fell in love with Bunraku puppet shows and Kabuki theater during his World War II military service in Japan and took these traditional theatrical forms in demented new directions after settling in downtown New York.

Despite Stewart's steadfast support and patronage, which allowed him to develop his peculiar brand of theater, Vaccaro wasn't necessarily the most appreciative person. "John Vaccaro had a thing against Ellen, for some reason," Zanetta said. "They had a love-hate relationship, though for John it was mostly hate." Ruby Lynn Reyner agreed that Vaccaro was the source of much of the rancor between the two, which was rooted in his perception that she was getting rich off of the grants La MaMa received. "Ellen Stewart wasn't nice," was all he would say. "There were too many things wrong. I really don't want to speak about her because it's no good."

Vaccaro's combative nature was perhaps rooted in his working-class Italian immigrant background, which he desperately wanted to escape. "He reminded me of my Italian grandmother," Zanetta recalled, "Sicilian and hardcore." Vaccaro first performed comedy in a nightclub act while at Ohio State University and then began doing plays like *Waiting for Godot*; after graduating in 1961, he moved to New York City. "When I got to New York," he said, "I had a loft and everybody used to come to my place on 9 Great Jones Street—artists, jazz musicians. I ended up paying seventy-five bucks a month. I had a big record collection, and we'd hang out and listen. I had everything. Jazz and the Beatles and stuff like that. I was heavy into rhythm and blues, but mostly jazz."

Vaccaro got to know Thelonious Monk when the pianist regularly performed alongside other jazz legends at the Five Spot Café, which was frequented by Allen Ginsberg, Frank O'Hara, and other writers. "John was coming out of the world of beatnik poetry readings, with bands playing in the background," said Arcade. "His friends were all these big jazz guys, and also he was an intellectual. When I met him, he had just stopped working as a rare book appraiser."

He became part of the New York Poets Theatre, which Diane di Prima ran out of the Bowery Theatre on East Tenth Street, near Third Avenue. The first show they mounted was the Frank O'Hara play *Loves Labor*, with Vaccaro part of a cast of twenty cavorting on the tiny stage. "There was a screaming queen in a tiger skin playing a shepherd, with many dancers for his sheep," di Prima recalled. "Freddie Herko in a black cape was Paris; John Vaccaro, slim and monocled, with a top hat, played Metternich, and no less a personage than the 'great' freak show artist and drag queen Frankie Francine portrayed Venus."[4]

Vaccaro, di Prima, and their friends also helped Jack Smith with his 1963 film *Normal Love*, which was shot over the course of three days in Connecticut. It was a sharp contrast from the baroque black-and-white imagery of *Flaming Creatures*, his previous film. "*Normal Love*, blazing with gorgeous color, left no holds barred," di Prima recalled. "So many sequins, lizards, rhinestones, pythons, so much stained glass, makeup, art, flesh, costume jewelry, papier-mâché, spray paint, had never before seduced the filmgoer's eye."[5]

When Vaccaro formed the Play-House of the Ridiculous in 1965, Smith helped design sets and costumes, which made the shows sparkle and glow. "There was no one person who invented glitter," Machado said, "but it was Jack Smith who gave a sense of purpose to it. In the early 1960s, Jack was the first one who used it in a way that made it copyable. The Play-House of the Ridiculous loved to use glitter, and Hibiscus and the Cockettes also loved glitter." Play-House performer

Michael Arian concurred. "John always gave a tip of the hat to Jack Smith," Arian said. "Jack was the original gay glitter freak, and John always acknowledged that he got a lot of his sensibilities from him."

Vaccaro was alternately described as a sort of gnome with an arched, monkey face, a scary owl with raised eyebrows, and a hunched-over troll. "He was very conscious of himself and his bizarre look," Mary Woronov said. "He was not a handsome man." But he had a grand sense of his own abilities as well as a maniacal drive, and that combination meant he was rarely easy on those working with him. "John Vaccaro loved to berate his actors and called them all kinds of names," Caffe Cino playwright William Hoffman said. "Essentially, he loved them, but he didn't hesitate to push them. He was really talented, although infuriating, because he could be very perverse."

"I mean, Artaud—the Theatre of Cruelty—had nothing on Vaccaro," Arcade said. "There would be a moment where John would, in the middle of the rehearsal, just start picking on somebody and would just torture them. I mean, super-psychological torturing, and the whole room would freeze." During those maddening rehearsals, Vaccaro might lock his actors in a loft all night long or would scream, "If you make a mistake, *DO IT AGAIN*"—as in, do the entire play over, even if it was four in the morning. Woronov fondly described the director's "homicidal" antics: "I say *homicidal* because whenever an actor was late he would close his eyes and say, 'I killed him,'" she recalled. "Every night he hissed in my ear, 'Do anything you like to them, I want fear in their eyes.'"[6]

Not everyone warmed to his methods. "John Vaccaro was a sadist," said Off-Off-Broadway actor Norman Marshall, who had starred in Ronald Tavel's *Gorilla Queen*. "His idea of putting on a show was to get the actors so crazed and so paranoid, then you throw them onstage and they have a freak-out right there. I never worked with him. He didn't like me and I didn't like him. He was a very intense, little Italian man—mean as shit." But Woronov said he wasn't physically abusive, and noted that it all served a larger purpose. "He would humiliate you by saying you didn't do it right, and so on and so forth, and when you would lash out, he'd say, '*Oh*, that is *great!*'"

The company attracted misfits of all kinds, such as Chris Kapp, who didn't blend in with her peers growing up in the 1950s. "I find that most people that go into show business have had horrid lives, and they sort of all joined together," she said. "It was very much a second family. I think we all were outsiders—all the drag queens, certainly, and gay men. We had this common bond." Arcade added, "We had grown up in our imaginations and didn't really have playmates, and

suddenly we had all these playmates. So we would create cacophonous explosions everywhere we went, and part of Vaccaro's genius was he corralled those kids."

The Play-House mostly consisted of people Vaccaro bumped into around town and on the scene. "Like with Penny Arcade," Reyner said, "John used to pick people from the streets and put them on the stage. He used to take bums off the Bowery—you could go out during the day, and they would be lying all over the street—and he'd bring them onto the stage." All shapes, sizes, genders, ages, and dispositions found a home in the Play-House of the Ridiculous. One kind of person Vaccaro *didn't* want was traditionally trained actors, and instead he recruited people who were creative forces of nature onstage. "Don't be an *ac*-TOR," the director would say, making fun of Method acting.

When Ellen Stewart first brought Michael Arian to Vaccaro, he was suspicious because Arian had been to acting school. "John wasn't sure that people with training could adjust to his style," he said, "but I did really fast because I liked it. It was the most fun I've ever had in my life." Reyner added, "Michael Arian and everybody directed themselves, pretty much. John got people who were creative and didn't need that kind of direction." Vaccaro wanted his performers to be over the top, and used to say, "There's a close-up on you at all times! Louder, louder! I can't hear you. Bigger, bigger! The spotlight is on you. *SHINE!*" Everyone fought to have their face in front, and because all the performers were doing it with energy and gusto it became quite cohesive, even if it was still rough around the edges. "With the Play-House, we were bigger than life all the time," Machado said. "What made those shows a hit was that energy level, and all that wonderful glitter and sparkle and the madness of the script."

The Play-House of the Ridiculous initially developed out of a collaboration between Vaccaro and Tavel. In 1965, they staged Tavel's one-acts *The Life of Juanita Castro* and *Shower* at a little gallery on 89 East Tenth Street, between Third and Fourth Avenues. "That street was originally inhabited by de Kooning and Jackson Pollock and all those types of artists," recalled Vaccaro. "It was an art gallery called the Coda, and we had sixty folding chairs and no theater lights."

Vaccaro also directed the Tavel plays *Screen Test, Indira Gandhi's Daring Device,* and *The Life of Lady Godiva*. The transgender glam-punk rocker and Off-Off-Broadway performer Jayne County (then known as Wayne County) recalled seeing the latter show in 1967, not long after she arrived in New York.[7] "My mind was blown, totally blown. It was a life-changer," County said. "First of all, I was shocked and very embarrassed. It hadn't been that long since I had just come from Georgia, so I really had a lot of that little farm girl in me. The scene that really

got me was when Ruby Lynn Reyner was fucking a wooden horse, and I had never seen anything like that. It embarrassed me. But it was genius, of course, genius."

Tavel and Vaccaro first called themselves Theater of the Ridiculous, but after city officials harassed them for running an unlicensed theater they became the Play-House of the Ridiculous Repertory Club, a semantic sleight of hand that allowed them to evade the letter of the law. The first three years of the Play-House's existence were turbulent, and the itinerant company bounced from location to location until finding a home at La MaMa in 1968. There was also quite a bit of turnover, beginning with the departure of Tavel. He balked when Vaccaro wanted to cut out two-thirds of the seventy-page script for his camp masterpiece *Gorilla Queen*, so the playwright took it to Judson Church and left the Play-House of the Ridiculous for good.

Vaccaro then directed *Big Hotel* by newcomer Charles Ludlam, who also quit, taking most of the cast with him to form his own Ridiculous Theatrical Company. "*Conquest of the Universe* was the one Charles wrote, and then he left," Vaccaro explained. "So I got all these people from Warhol—like Taylor Mead, Ondine, Mary Woronov, and Rene Ricard—to do the show at the Bouwerie Lane Theater." Vaccaro's press release described *Conquest* as a "paramoral" science fiction story where Adolf Hitler's writings mixed with old movie scripts and dialogue from television shows: "The dour pornography of the daily Vietnam reports is here met by the screaming pornography of the truth."

Ondine played the King of Mars ("I've come to Venus to see the ka-ween!") and Woronov was Conqueror of the Universe ("Seize him! Sterilize him!"), while Holly Woodlawn covered her nearly naked body in baby oil and rolled in glitter on the floor.[8] "It wasn't sexy, even if there was nudity," Woronov recalled. "It didn't have much to do with sex. My minions would spend half the time onstage trying to shit in a pail." Woronov already had a masculine image because she had played strong characters in Warhol films such as *Vinyl*, so she brought that persona to Vaccaro's stage. "I would be in a dress, but I was obviously a woman posing as a man, doing manly things," she said. "So in other words, it was playing with gender—which is much different from a queen dressing up as a woman." Costar Ruby Lynn Reyner added, "It was all very sexually ambiguous in those days. Gender roles were being exploded."

Reyner started out in the chorus in *Conquest of the Universe*, then got her big break after one of the lead actresses had an accident and could no longer perform. "Beverly Grant broke her ankle, like in *42nd Street*, the Busby Berkeley film. Ondine and Louis Waldon came over to my apartment, and I was getting ready

to play my usual chorus part when they told me." They worked all day to help Reyner learn her new lines, telling her not to worry if she forgot them, because she could always improvise.

Even though *Conquest of the Universe* was Ludlam's play, Vaccaro had already secured the rights to produce the show, which became a downtown hit that attracted the likes of Marcel Duchamp, who declared, "This is a Dada play."[9] Ludlam staged a lightly rewritten version, pointedly titled *When Queens Collide*, and then gained much more acclaim when he mounted *Bluebeard* at La MaMa in 1970. It was camp pastiche of the old French folktale, in which Bluebeard was a mad scientist who tried to create a "third sex" by performing gruesome operations on his wives. It unfolded like a mash-up of Victorian melodrama and 1930s horror films—culminating with the newest wife, played by Mario Montez, closing the show displaying an ambiguous "third genital."

While *Bluebeard*'s plot was way-out, it never veered into the alternate dimensions conjured up by Vaccaro's shows. "Charles Ludlum's style was about 'gay' theater," Woronov said. "It was guys dressing up as women and performing. Vaccaro didn't care if you're a girl or a boy. It had nothing to do with changing sexes, or being gay or straight." Tony Zanetta added, "Charles Ludlam just took an aspect of the Play-House of the Ridiculous and went in quite a different direction than John's work. To me, Charles's form was very traditional. It was a little *commedia dell'arte*-ish."

Whereas Ludlam leaned heavily toward straightforward camp—with references to old Hollywood films and other common tropes—Vaccaro's work was something else entirely: satirical, political, operatic, and visually over the top. "John felt he was painting with theater," Zanetta said, "and he used actors like they were his colors. They were his tools. But he wasn't really so much about traditional theater at all like Charles was." When the two queens finally collided socially, after years of not speaking to each other, all Vaccaro said he could muster was, "Oh, Charles. You're as ridiculous as I am."

Despite all the stories of Vaccaro throwing tantrums and locking his performers in a loft until sunrise, those around him remained extremely loyal. "He was my mentor, and I admired him profoundly," Reyner said. "He brought a vision. It was high energy, and it was like a live acid trip." Many of his Play-House performers, like Agosto Machado, ended up working with him for several years. "With John Vaccaro," he said, "no matter how difficult he was, we knew we were working with a great artist. I think he might have been more recognized if he was a little more accommodating, but he would have given up his artistry."

CHAPTER 17

Jackie Curtis Takes Center Stage

"Ellen Stewart took John Vaccaro's Play-House of the Ridiculous under the umbrella of La MaMa, and she gave them a regular space to rehearse and perform," recalled Agosto Machado. "They were her 'babies,' as she would say, and she always took care of them." Actress Jacque Lynn Colton, who met Stewart when she opened the first La MaMa location, recalled that "Ellen was wonderful and warm, kind of like a mama hen. She sewed endlessly, tried to help with the preparations. She was like Joe Cino, in that they had an instinct about people, and if people talked to them about a project they wanted to do, Ellen would sense something special about the people and back them fully, and make it possible for them to do their thing."

One of Stewart's most notable babies was Jackie Curtis—born John Curtis Holder Jr.—who was about fourteen when they met in the early 1960s. "Jackie was just a boy when he came to La Mama," she said. "I thought he was a genius. And he created many beautiful things. Jackie was a wonderful writer. And he said that being a drag queen brought him more fame, but he wished that his work as a playwright would establish him as a very great writer."[1] By the time Curtis was cast in the Vaccaro-directed *Cock-Strong* in 1969, the gender-fluid playwright and performer had already written and staged two Off-Off-Broadway plays. "Ellen really treated Jackie like an honorary child," said Machado, who appeared in Curtis's *Vain Victory: The Vicissitudes of the Damned*. Stewart generously let Curtis use La MaMa's rehearsal space during the lead-up to that show, a downtown hit that secured her status as an underground celebrity.

Before Jane Wagner became Lily Tomlin's longtime collaborator and partner, she met Andy Warhol in 1965 and developed several Factory connections. The writer, artist, and Village resident was especially drawn to Curtis, who befriended Wagner and sometimes stopped by her apartment (and, on one occasion, called from jail for help after being arrested). "When Lily and I first met in New York, we fell in love," she said, "and the only thing I could think of that I wanted to do

with her was to see Jackie Curtis's *Vain Victory*. Lily just flipped over it. That's how much I loved Jackie—there was so much to do in New York at that time, but that was the main thing I wanted to take her to."

Curtis loved the limelight and couldn't have been happier than when Lou Reed immortalized her in "Walk on the Wild Side," his best-known song: "Jackie is just speeding away," Reed sang, "thought she was James Dean for a day." (Friends and acquaintances tended to use both "she" and "he" pronouns when describing Curtis, which was fitting for someone who insisted, "I'm not a boy, not a girl, not a faggot, not a drag queen, not a transsexual—I'm just me, Jackie."[2])

Curtis made the most of the radical shifts happening downtown, when bohemians escaped rising rents in Greenwich Village by moving eastward. A Lower East Side slum kid, he was raised in a quasi-criminal atmosphere by a grandmother, known as Slugger Ann, and an aunt, Josephine Preston. Slugger Ann, who owned a bar with the same name, earned her nickname after working as a taxi dancer in a Times Square dance hall (where lonely guys paid female companions for a dance). "You were supposed to keep your hands raised and you weren't supposed to get fresh," Machado said. "She was famous because this man kept his hand on her ass, so she slugged him and knocked him down—which is how she became Slugger Ann."

Slugger Ann's was a dimly lit Lower East Side corner bar with a few tables. One could find a cross section of low society and working people there, mostly truck drivers and laborers who would stop in for shots and beer. "Jackie really grew up in the bar," said Melba LaRose, the star of Jackie Curtis's first play, *Glamour, Glory, and Gold: The Life and Times of Nola Noon, Goddess and Star*. "Slugger Ann was a great old babe, loudmouthed. She obviously had been a beauty in her day, a sexy beauty. Bleached hair, and a feisty personality, great fun. And Jackie's aunt Josie was great fun, too."

"Slugger Ann's had all kinds of weird things," added Bruce Eyster, a friend of Jackie's. "There were pictures of Jackie as a boy, and there were lots of memorabilia. Slugger Ann would be sitting in the back, and she had these really nasty Chihuahuas." She would sometimes have a half dozen Chihuahuas stuffed inside her low-cut dress, propped up by her enormous breasts.[3] Jackie sometimes tended the bar in jeans and a white T-shirt with a cigarette pack rolled up in a sleeve, and other times in a shredded dress. "It wasn't a gay crowd or a drag queen crowd, but sometimes Jackie was tending bar in drag," LaRose said. "But if any customers would have said anything about Jackie, Slugger Ann would have punched them out. She was very protective of Jackie."

Ann Harris remembers Curtis as a ubiquitous presence around the neighborhood. "My older kids ran into him around town," she said. "Jackie was definitely around." George Harris III, later Hibiscus, was Jackie's classmate when they both attended Quintano's School for Young Professionals, a special high school for performers in midtown Manhattan. (Jackie, Hibiscus, and actress Pia Zadora were all in the same math class.) Along with George's brother Walter Michael Harris, Curtis was cast in a 1965 La MaMa production of Tom Eyen's *Miss Nefertiti Regrets,* as the love interest of Bette Midler, who had just arrived from Hawaii.

One day, the temperamental Curtis stormed off the set, and Eyen asked Walter to take the vacant role. He was already the drummer in the offstage band that performed the show's music, so he would run back and forth performing various duties, like singing a lover's duet with Midler. "Bette played the Nefertiti role and

Bette Midler and Walter Michael Harris in the premiere of Tom Eyen's
Miss Nefertiti Regrets at La MaMa, 1965
© JAMES D. GOSSAGE

I took on Jackie Curtis's role, Tobias, an angel sent by the god Ra to be Nefertiti's downfall," Harris said. "I was about fourteen. So I got to sing and perform with a nineteen-year-old Bette Midler and played drums for the other people's songs when I wasn't onstage."

"Sometimes he'd kind of have a James Dean style, but ragged," playwright Robert Heide said of Curtis, "and other times Jackie would dress as Barbara Stanwyck. She would look really good in a red wig or that kind of thing." Jackie wasn't the kind of drag queen who tried to pass herself off as a woman and instead developed a sui generis style—as Jane Wagner and Lily Tomlin learned when she would drop by Wagner's apartment dressed either as a man or woman. "What Jackie did was more like performance art," LaRose said. "I never thought of him as a woman. He went back and forth so many times. When I met Jackie, he was a little boy with a shopping bag. He had bangs. He was very cute."

Curtis was big, not at all femme, and looked like a man in a dress: a little stubble or a beard, torn stockings, trashed dresses, smeared makeup, and plenty of body odor. This tattered look came out of necessity because Curtis was constantly broke, though it was also deliberate—because if a rich patron gave her a brand-new designer dress, she didn't think twice about shredding it. "They would get rips and things in them," recalled her friend Jayne County, "and she really didn't have the money to buy new ones, so she would just continue to wear them and they'd get more and more holes in them. Finally, they were just kind of rags on her legs. They became works of art. Sometimes she would put them together with safety pins, not because she was trying to be cute, but because she was really trying to keep the dress together. It became a style and a fashion, but she was the first person I ever saw to wear that style."

Curtis loved 1930s dresses, which could easily be found in thrift stores or by raiding Slugger Ann's and Aunt Josie's closets. One time, when a neighbor passed away, Jackie crawled through the window onto the building ledge and broke into the deceased woman's apartment, bringing back an entire wardrobe of black Italian dresses, shoes, and accessories. "Jackie was blowing up the idea of gender," LaRose observed. "When he was a boy he liked to look really rough: saddle shoes or other big shoes, vest sweaters like a boy jock." Machado recalled, "With Jackie, you never knew what she was going to wear or what she was going to do, but she had a force of personality."

"That was the beginning of pansexuality, and David Bowie picked up on that," said Tony Zanetta, who worked with the glam rock singer. "I find a lot of similarities between Jackie Curtis and David Bowie." Noting that Jackie had the same

DIY aesthetic as Vaccaro's Play-House of the Ridiculous, Zanetta added, "Jackie Curtis's tattered clothes look was do-it-yourself, number one. Like at Warhol's Factory, it was about how, if you wanted to be an artist, you just basically said you were. Like with punk, if you wanted to be a musician or you wanted to be in a band, well, you didn't really have to learn how to play an instrument. So Jackie Curtis, the Ridiculous, and punk are all connected."

Bruce Eyster first laid eyes on Curtis in a Chicago art house theater that screened Warhol's 1968 film *Flesh*, her film debut, and after arriving in New York, Eyster went to Max's Kansas City because he heard they had great hamburgers. He had no idea it was also a Warhol hangout, so when Curtis walked into the front area Eyster exclaimed, "Hey, it's *Jackie Curtis!*" They became fast friends.

Eyster recalled that being with Curtis was akin to running around with Harpo Marx in a slapstick comedy—like one time when they needed to cross a busy street and Jackie hailed a taxi, then crawled through the cab's backseat and came out the other side, then crawled through the back of another car, and then another. "We did four cars to get across the street instead of just taking the crosswalk," Eyster said. "He was just so hilarious. Jackie would walk into a room and you could feel the electricity. He really did have a movie star quality about him." Kristian Hoffman, whose band the Mumps would later become regulars at Max's and CBGB, vividly remembered the time when someone asked Curtis to do something "camp" for them. "Camp? I'll give you camp," Curtis shouted. "*CONCENTRATION CAMP!*"

In addition to Curtis, *Flesh* introduced Candy Darling to the underground film world, after which the two became regulars at Max's (in "Walk on the Wild Side," Reed observed, "Candy came from out on the Island, in the back room she was everybody's darling"). Born James Slattery, Darling grew up in Massapequa Park, Long Island—where she was friends with future Off-Off-Broadway director Tony Ingrassia. By the mid-1960s she and Ingrassia made their way to New York City, where Darling became part of the street scene. Hanging out on the stoops or in the parks, she would often be invited back to people's apartments in the hope that she could inject a little glamour into their evenings. "Candy looked beautiful," Jane Wagner recalled, "like she just stepped out of a movie."

Curtis quickly took Darling under her wing and, one evening, brought the new arrival to Jim Fouratt's apartment. "I would like you to meet this boy that just arrived in town," Curtis told him. "His name is James, but we're going to call him Candy—Candy Darling. And Candy Darling is never going home again." Reflecting on Darling's sexuality, Tony Zanetta recalled, "Maybe Candy actually was transgender, but in the beginning we didn't think of Candy as a woman, or

someone who was trying to be a woman. Candy was a boy who was being a star. He recreated himself in the guise of Lana Turner or Kim Novak. Candy's life was performance art about stardom, more than anything. We were attracted to the movies, but we were especially attracted to the stars."

Curtis, Darling, and another newcomer, Holly Woodlawn, appeared in many Warhol films, on cabaret stages, and in underground theater productions. As with the other two, Woodlawn (née Haroldo Santiago Franceschi Rodriguez Danhaki) was also name-checked in that Lou Reed classic: "Holly came from Miami, F-L-A, hitchhiked her way across the USA, plucked her eyebrows along the way, shaved her legs and then he was a she." In fact, Holly Woodlawn didn't hitchhike—she took the bus to New York—but the rest was more or less true. "Through Jackie, I would end up at Max's with Jackie and Candy and Holly," Eyster recalled. "They were all very funny in different ways and had their own take on things. Holly was kind of like the Martha Raye comedienne slapstick girl."

Ruby Lynn Reyner also hung out with all three, and would act out scenes from 1940s movies and 1950s televisions shows with them. "They knew all the dialogue from old Kim Novak movies, Joan Crawford movies, or *I Love Lucy*," she said. "We'd switch off playing the roles. Jackie and I would always fight over who would be Lucy and who would be Ethel. Oh, and Holly and I had adventures together. We used to wear these old vintage 1930s nightgowns and wander through the East Village, clinging together in the night. One time she came to answer the door and she was just out of the shower and she had a big dick. I couldn't believe it. I always thought of Holly as my girlfriend."

Machado remembered Woodlawn as a very open, childlike, and loving playmate and friend. "One of the things people noted was her vulnerability," he said. "She didn't have that protective armor, but Holly was so much fun and so good-spirited." Woodlawn, Darling, and Curtis were sometimes homeless and crashed where they could, making their destitute surroundings glamorous through sheer force of will. Sometimes they were allowed to stay in a place behind Slugger Ann's, a little studio apartment with crumbling concrete steps that led to the door. Aside from a mattress for Curtis, it was filled with books, photos of movie stars tacked to the walls, and notebooks of Curtis's writings.

"I'm a loner," Curtis said. "I hate hangouts! But I do haunt old bookshops and music stores, because you never know who or what you might find there."[4] Despite a very visible exhibitionist streak, Curtis remained fairly private while at home. "Jackie didn't like to receive anybody if she wasn't shaved or put together," Machado recalled, "but for us, we'd all seen each other when we didn't look our best

or had slept over and our beards grew out." Amid the crumpled bed sheets and pillows that were smeared with makeup, the friends would relax and dish about the previous night's shenanigans.

"Jackie was a natural satirist," Lily Tomlin observed, "because he was an outsider and an artist. All the notions he had about living and being made him really able to see the absurdity of the culture."[5] Melba LaRose first met Curtis and Darling during a production of *Glamour, Glory, and Gold*, a ridiculous send-up of Hollywood melodramas. She played the lead role as Nola Noon, an amalgam of old movie stars like Jean Harlow and Joan Crawford. The play—Curtis's first—began with Noon working in a burlesque house, followed her rise as a big Hollywood star, and ended with LaRose's character mock-tragically walking into the ocean as the *Warsaw Concerto* played.

Glamour, Glory, and Gold was directed by Ron Link, who went on to direct many Off-Off-Broadway shows, including Tom Eyen's *Women Behind Bars*. During the opening scene of this explosive production, LaRose walked onstage wearing nine feather boas and started throwing glitter. "It was everywhere," she said. "The set was covered with sparkles and glitter." Oddly enough, the show's title came directly from Lady Bird Johnson (President Lyndon Johnson's wife) when she crossed paths with an extravagantly dressed Jackie Curtis, who was lurking in the lobby of the Lincoln Center. As Johnson came down a set of stairs, she saw Curtis and exclaimed in her regal southern accent, "Oh my. Glamour, glory, and gold." Jackie thought, *Ding! Yes. That's gonna be the title of my play.*

"Jackie wanted to write something that was a comedic takeoff on all those Hollywood stars of the thirties," LaRose said. "We were trying to make those movies our own." Living through the chaos of the Vietnam War and the assassinations of the Kennedys and Martin Luther King Jr., they sought refuge in Hollywood's dream factory. "I think we all came from very dysfunctional backgrounds, and we just sort of lived through those films," LaRose said. "There was, of course, all the glamour and we genuinely loved all that—the makeup, the clothes, the feathers, the glitter. It was the beginning of camp. We thought we were really living out these parts onstage and in life, so we didn't think of it as campy. It was a style that we created. Everything was larger than life, but still had reality in it, and it still had something in it that we really believed. It wasn't *just* clowning."

Curtis and her friends weren't simply passive consumers, as mass culture critics such as Theodor Adorno and Dwight Macdonald have characterized media audiences. They knowingly appropriated and subverted the heteronormative products of the culture industry, liberating them from their ideological

constraints. Speaking of a more literal kind of appropriation, Curtis swiped the clothes for *Glamour, Glory, and Gold* from Slugger Ann and Aunt Josie, who had tons of old velvet dresses and other clothes from the 1930s and 1940s hanging in their closets. When the cast burst onstage during opening night at Bastiano's Cellar Studio in Greenwich Village, the two stood up and shouted, "They stole our fucking clothes!"

Glamour, Glory, and Gold served as the stage debut of both Candy Darling and a young actor named Robert De Niro, who played all the male roles in the show. Even before Darling transformed herself from a brunette into a peroxide blonde goddess with blue eye shadow, false eyelashes, and an icy wit, she could play a convincing woman. *New York Times* theater critic Dan Sullivan commented without irony in a review: "A skinny actress billed as Candy Darling also made an impression; hers was the first female impersonation of a female impersonator that I have ever seen."[6] Candy loved that review, which mistakenly warped Darling's gender like a Möbius strip. The wider public didn't know the truth until Ron Link did a big reveal when he directed Darling in *Give My Regards to Off-Off Broadway*.

Darling even convinced aging film director Busby Berkeley that she was a woman during an open audition for a Broadway show he was involved in. Darling wore a black 1930s dress with leaping gazelles, while Curtis looked decidedly less femme in a ratty raincoat, torn stockings, and glitter-damaged face. Darling and Curtis were cooing and talking to the director, who took one look and said to Darling, "If it's based on looks alone, you'll get it." He had no idea Darling was in drag.

Curtis and Darling first met Warhol on the Greenwich Village streets, asking for an autograph and inviting him to *Glamour, Glory, and Gold*. "Walking just ahead of us was a boy about nineteen or twenty with wispy Beatle bangs," Warhol recalled, "and next to him was a tall, sensational blonde drag queen in very high heels and a sundress that she had made sure had one strap falling onto her upper arm."[7] Warhol loved Curtis's show and provided a publicity blurb—"For the first time, I wasn't bored"—which led to parts for Curtis and Darling in Warhol's *Flesh*.

Curtis, who was always writing, quickly followed his theatrical debut with a musical, *Lucky Wonderful*. It was based on the life of Tommy Manville, a playboy socialite who had several strange, exotic wives. "Jackie decided to write a musical," LaRose said, "and he starred in it, and Paul Serrato wrote the music for it." Serrato also composed music for Curtis's biggest underground hit, 1971's *Vain Victory*, and he later did a cabaret act with Holly Woodlawn. He first met Curtis when he worked at the Paperback Gallery, one of Greenwich Village's literary hotspots. "Jackie would come in, as everybody did," He first said. "Through one

THE DOWNTOWN POP UNDERGROUND

thing or another—we were all very young then—Jackie and I became friends. Jackie learned that I was a musician and composer, and he came in and told me, 'I'm writing this script for this musical. You want to do the music for it?' And so I said, 'Of course.' And that's how we met, in a Greenwich Village bookstore."

Lucky Wonderful included a lovely bossa nova number, "My Angel," along with the sultry "White Shoulders, Black and Blue" (the song was later revived in *Vain Victory* for Candy Darling to sing). The songs were fairly low-key, though the acting was wildly animated. "Jackie wrote things with tremendous energy," LaRose said, "and each show was only an hour and ten minutes straight through. It was high, high octane energy." The cast started taking amphetamine pills, Dexamyl, and drinking backstage—anything to keep the energy up for the shows. "So it was easy to gravitate into drinking and drugs, and I was seeing people getting worse, and I was caught up in it myself," LaRose said. "So I just decided to take an escape and leave town."

Jackie Curtis's next play was *Heaven Grand in Amber Orbit*. She wrote it while touring with John Vaccaro's Play-House of the Ridiculous, which appeared at the Pornography and Censorship Conference at the University of Notre Dame (ironically, their show was censored by university officials *during* the conference). "Everybody went there," Vaccaro said. "Allen Ginsberg, we all went, and I did a show called *The Life of Lady Godiva*. We took a train to South Bend, and on the train Jackie wrote *Heaven Grand*, speeding out of his mind. He got the names of the character from a racing form."

The script was written in a large wallpaper sample book that was covered with Curtis's tiny handwriting, filling the margins. Like many of his scripts, it was littered with references to old movies, television shows, and a random assortment of other pop culture ephemera, including the 1958 TV movie *The Secret Life of Adolf Hitler*, *TV Guide* magazine, *All About Eve*, a menu from Howard Johnson's, *Gone with the Wind*, *The Ten Commandments*, *The Wizard of Oz*, and the surf rock group Dick Dale and His Del-Tones thrown in for good measure.[8]

"Jackie was a force of nature," recalled *Heaven Grand* cast member Penny Arcade. "When we met I was speeding out of my mind, and so was Jackie. She was a very interesting combination of a completely self-absorbed narcissistic personality who also had a huge heart and a tremendously curious mind." Many of the lines in the play were borrowed from old films and television sitcoms, though a lot also came from what Curtis witnessed on the streets of downtown New York. The main character was partially based on a demented person he had seen wandering through a store shouting, *"FASCINATION!"*

In an unlikely turn of events for such an underground show, the mainstream magazine *Newsweek* published a glowing review: "What this is can only be experienced, and seeing *Heaven Grand in Amber Orbit* is seeing an explosion of pure theatrical energy unconfined by any effete ideas of form, content, structure, or even rationality. It is an insanely intense, high-velocity, high-decibel circus, costume ball, and scarifying super-ritual in which transvestism, scatology, obscenity, camp, self-assertion, self-deprecation, gallows humor, cloacal humor, sick humor, healthy humor, and cutting, soaring song all blast off through the tiny, backless-benched theater."[9]

Vaccaro played Princess Ninga Flinga, an aspiring actress whose career was hampered by the fact that her arms were cut off at the elbows, and the show featured designed-to-offend songs such as "Thalidomide Baby" and "In God's Shitty Lap." As for the plot, Reyner summed it up thus: "The show was nonsensical." She recalled that when Curtis brought the script to Vaccaro, "it was nothing but gibberish. It was a litany, a mishmash—dialogue that was taken from old movies and transposed into a play." Vaccaro had to make sense out of it, so he set it in a carnival sideshow filled with bizarre characters. He liked directing plays that made little sense, because he could imbue them with his own brand of social satire. "With *Heaven Grand in Amber Orbit*," Arcade said, "once again, John took that play and made it into something entirely different, which had nothing to do with anything that Jackie had planned."

Vaccaro also added original music. "I turned everything into musicals," he said. "I did a lot of changing. I was very creative, but not everyone liked to have their plays fucked with." Vaccaro was one of the originators of rock 'n' roll theatrical music, though others would go on to greater renown (Gerry Ragni and Jim Rado, the cocreators of *Hair* came to Play-House shows and soaked up ideas). "*Heaven Grand in Amber Orbit* had great songs," Michael Arian recalled, "like 'He's Got the Biggest Balls in Town.' It was all pretty extreme. It was exceptional, and really spoke to the time." The song "Freakin' On In" was definitely of the moment—a kind of musical manifesto of the East Village scene:

> We were "exceptional children"
> "Under-achievers" so it seems . . .
> We were born to be looked at
> Street stars on side-show screen
> Now we're full fledged freaks, folks
> Our Christmas is your Halloween

"It was pretty psychedelic," Zanetta said, "with all the bright color and the glitter in the show." Vaccaro was deeply influenced by visual art, and his shows were akin to living paintings composed of flesh, colorful makeup, and brightly lit glitter. "*Heaven Grand* was the most incredibly entertaining piece of theater I've ever seen," Arian added. "It was total non sequitur and was as funny as funny could be." He first saw it while high on LSD, when the cast passed around a dead fish throughout the night just to see what the next person would do with it. "And boy, I got to tell you," Arian said, "it was really entertaining. It was a sensory overload for real." Adding to the surreal scene was the venue where *Heaven Grand* premiered—a funeral home-turned-theater in the midtown district.

"Jackie was a nice person," Vaccaro said, "but she was very screwed up with drugs." Some would say the same about Vaccaro, but what really stirred up trouble between the two was their diverging choice of mind-altering substances: Curtis was a speed freak, and Vaccaro's go-to drug was marijuana ("John always had tons of pot around," Zanetta said, "really, really good pot"). During the *Heaven Grand* rehearsals, the mercurial Vaccaro grew frustrated with Curtis—who played the lead character, Heaven Grand—after she showed up late and a bit out of it. "I'm going to *kick your ass!!!*" Vaccaro would shout, until one day he fired the playwright from her own show. "They were always having these horrible fights," Reyner said, "and so finally he just turned to me and said, 'You're playing Heaven Grand.'"

The fallout between Vaccaro and Curtis blurred the lines between high drama, slapstick comedy, gangster movies, and real life—Vaccaro ranted every day that he was going to have Curtis killed (it was rumored that the Italian director had ties to the mob). "I'm gonna call Joey Gallo," he would scream. "I'm gonna break Jackie's legs!" Curtis hid out at an Avenue B loft belonging to painter Larry Rivers, and Arcade would stop by after rehearsals. "It was totally insane," Arcade said. "I mean, Jackie was terrified of Vaccaro, but it was also kind of a joke. Like it was both, a joke and it was real. Reality, per se, didn't exist."

CHAPTER 18

Madness at Max's and the Factory

Soon after Mickey Ruskin opened Max's Kansas City in December 1965, his bar and restaurant became one of the downtown's premier social hubs. Ruskin—who Lou Reed described as a hawk-faced man with dark stringy hair that hung over his right eye—had already developed several music and entertainment contacts in the previous decade. Most notably, he ran the East Village's Tenth Street Coffeehouse and Les Deux Mégots, and Greenwich Village's Ninth Circle (which in the 1970s and 1980s transformed into a well-known gay hustler bar).[1]

"Les Deux Mégots was a coffeehouse that was part of the underground poetry scene," said Max's regular Jim Fouratt, "but at Max's, Mickey really mixed. It was the center of the universe, it really truly was. It was always a place where everyone passed through." Large abstract art hung on the white walls, including a Frank Stella painting, though everything else was red—from the tablecloths to the red bowls filled with chickpeas, which sustained many a hungry artist.[2] "What Mickey would do is he would trade credit for art," said Off-Off-Broadway actor Tony Zanetta. "So basically, that's how he built his business. Some of it was probably just luck, in that the Factory moved across Union Square, so the Warhol people started going there."

One might say Ruskin was an art patron who happened to run downtown bars and coffeehouses. Warhol gave him art in exchange for an unlimited bar tab, so that he and his Factory associates could eat and drink for free. "Mickey had always been attracted to the downtown art atmosphere—at Deux Mégots, he'd held poetry readings—and now painters and poets were starting to drift into Max's," Warhol recalled. "The art heavies would group around the bar and the kids would be in the back room, basically."[3] Future Warhol superstar Viva (born Janet Susan Mary Hoffmann) began going to Max's with a couple of painter friends well before she met Warhol. "We went to the opening of Max's," she recalled. "Soon, everybody congregated there, including Andy Warhol, but I met a lot of people at Max's before I even got involved with Andy."

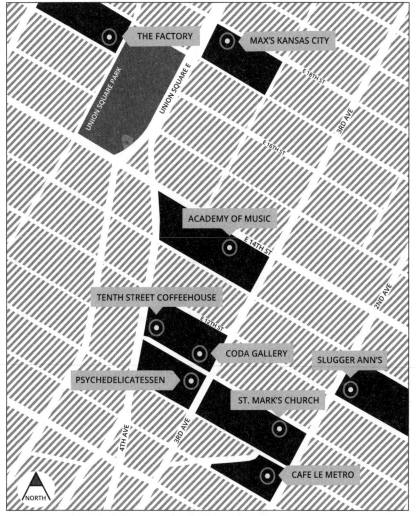

THE FACTORY

MAX'S KANSAS CITY

UNION SQUARE PARK

UNION SQUARE E

E 18TH ST

3RD AVE

E 16TH ST

ACADEMY OF MUSIC

E 14TH ST

2ND AVE

TENTH STREET COFFEEHOUSE

E 12TH ST

CODA GALLERY

SLUGGER ANN'S

PSYCHEDELICATESSEN

ST. MARK'S CHURCH

4TH AVE

3RD AVE

CAFE LE METRO

NORTH

UNION SQUARE

The energy at Max's Kansas City increased in the spring of 1966 when Ruskin opened up the unused back room to Warhol, who lurked at a big roundtable.[4] Dan Flavin's red neon light sculpture, which lit the room, cast even the most innocent visitors in a hellish light. "Max's was the place where all the different scenes crossed and merged, which was what made New York so fabulous in the late sixties and early seventies," recalled Jayne County. "The gay scene, the drug scene, the theatre scene, the music scene, the art scene. Everyone was getting ideas off everyone else, and everyone ended up in a film or a band or something."[5] During

the 1970s, County became one of the club's resident DJs, and her various bands regularly performed there with the Ramones, Blondie, and other punk groups.

Fouratt was a radical "revolution in my lifetime" kind of Yippie, but his ties to the underground art, music, and theater worlds also gained him entry into Max's back room. As a left-wing activist, he produced *Communication Company*, a street newsletter predecessor to social media. "There was no Internet, no Twitter, no cell phones," Fouratt said. "This is how you built community, and one of my points of distribution was the back room of Max's. I would go there every night, and Andy liked that. I think he thought, *Oh, he's our political person.*"

Fouratt recalled that all the macho painter guys drank at the bar in front while Warhol and his entourage hung out in the back, where the artist sat at the precise spot where he could observe everything. "This beautiful boy, an absolutely, a stunningly beautiful California boy shows up at the bar," Fouratt said of the time that he, Nico, and Warhol first saw singer-songwriter Jackson Browne. "And we all go, '*Ahhh.*'" Warhol, the master passive-aggressive manipulator, asked "Who is that?"—prompting Factory scenester Andrea "Whips" Feldman to jump up from the table to find out. "Word comes back, 'He's a singer from California, he's seventeen. Would you like to meet him?'" Fouratt said. "And Nico goes, '*Mine. Mine.*' She's already staked him out."

"Jackson Browne comes back and he's beautiful, he's California, he's sunlight. You know, this is New York, where everyone's in black—in red lighting, from the neon in the back room—and he invites all of us to come hear him perform the next night." Browne was playing at the Dom, the bar on St. Mark's Place where Warhol's *Exploding Plastic Inevitable* multimedia shows had been staged. After Nico left the Velvet Underground in 1967 to pursue a solo career, she enlisted him to accompany her on guitar. Three of Browne's songs appeared on Nico's solo debut, *Chelsea Girls*, including his classic "These Days."

Several other future stars and cult artists also passed through Max's Kansas City. New York Dolls frontman David Johansen and the Modern Lovers' Jonathan Richman worked as busboys, and country singer Emmylou Harris was a waitress in the late 1960s. Jayne County recalled another waitress who "was always stoned and regularly dropped cheeseburgers in people's laps. Her name was Debbie Harry."[6] She had sung backup vocals in a short-lived hippie band named Wind in the Willows, then quit the group and worked as a waitress at Max's. "I had fun and I certainly had friends there," she said, "but I wasn't part of the Warhol crowd. I wasn't part of any single crowd. I was pretty much the fly on the wall, so to speak."

The back room crowd was always trying to one-up each other and gain Warhol's attention—like Andrea Whips, who might jump on the table and announce, "It's SHOWTIME," then insert a wine bottle in her vagina. "Max's back room was everything you'd think it would be," said Play-House of the Ridiculous actor Michael Arian, "with art on the walls and people freaking out and jumping up on the tables, throwing chickpeas everywhere, wagging their feet at people, and fucking on the floor in the back. It was a great place."

For the Play-House crowd, Max's was a second home. "We'd hang out in the back room," Vaccaro said. "It was fabulous just being back there because not just anybody was allowed back there, and it was fabulous back in the days of LSD. Everybody was taking acid." He staged the show *Monkeys of the Organ Grinder* in Max's upstairs room, as well as *The Moke Eater* (Jack Smith was a collaborator and early Velvets member Tony Conrad provided taped sounds for the latter show). Although the Vaccaro and Warhol people sometimes overlapped, the director had little time for the famous artist. "Warhol was in one corner," Vaccaro said, "and I had my group in the other corner. My friends stayed with me and Andy had his group. Andy and I knew each other, but I didn't take him very seriously, because, well ... [makes yawning sound]."

"Andy and John didn't get along," Zanetta said, "or, at least, John didn't get along with Andy, even though they had common immigrant backgrounds. When John came to New York, it was about the Cedar Tavern—where the Abstract Expressionists were—who were a bunch of macho guys who thought Andy Warhol was a little fairy illustrator. Which he was. Basically, I think John didn't like Andy because he was fruity, and he was a very successful illustrator. So number one, that wasn't real art. Second, he had money. Third, Andy was very calculating."

It was at Max's Kansas City that the pioneering electronic rock duo known as Silver Apples made a name for themselves downtown. Consisting of keyboardist Simeon Coxe and drummer Danny Taylor, Silver Apples regularly performed in Max's second-floor room starting in 1968. Coxe said they were the only band that Ruskin would allow to play there at the time (turning down overtures from the Band and other high-profile artists). "We were just wild and crazy enough to fit his whole concept of the restaurant," he said, "so we became the house band up there for the longest time, pretty much for a whole year."

Coxe grew up in New Orleans, and around 1960 he decided to move to New York City and become an artist. "Back then, the whole Lower East Side was pretty much inhabited by artists, writers, musicians, poets, and actors," Coxe said, "and there were all kinds of part-time jobs available." He recalled working at the American

Kennel Club proofreading dog certificates along with up-and-coming painter Robert Rauschenberg and future members of the Velvet Underground. He first played rock 'n' roll covers around Greenwich Village in the Random Concept and later joined the Overland Stage Band, which included drummer Danny Taylor.

"Silver Apples were way ahead of their time," said Ruby Lynn Reyner. "They were the original electronic band who had a huge, bulky, humongous piano-sized computer." Coxe's primitive synthesizer looked like a DIY spaceship control panel with several oscillators mounted on plywood. Taylor's unique, pulsating drumming style developed because it was hard for Coxe to use his electronic equipment to play bass lines, which was the traditional way drummers locked into an instrumental groove. "He decided to explore the whole idea of drumming in patterns, not beats," Coxe said, "and just keep a drum pattern going over and over and over again."

In an unlikely turn of events, Mayor John Lindsay took a liking to Silver Apples and invited them to perform in Union Square Park and other city parks. ("He just loved our stuff," a mystified Coxe said. "I don't know why.") The mayor dubbed their droning, minimalist music "The Sound of New York," and even commissioned Silver Apples to provide a live soundtrack for the Apollo 11 moon landing

Simeon Coxe and kids during Silver Apples performance in Washington Square Park
© SYEUS MOTTEL

on June 20, 1969. They performed in Central Park while video projections showed the lunar module touching down on the surface of the moon.

Silver Apples signed to a major label that had no idea how to market them, so the duo wound up on the oddest assortment of live bills. "They hooked us up with Jethro Tull, MC5, Procol Harum, Blue Cheer, 1910 Fruitgum Company, T. Rex, Tiny Tim," Coxe said, "the whole spectrum." The group's star was rising, but disaster was just over the horizon. The trouble started when Coxe and Taylor shot the cover photo of their second album, *Contact*, in the cockpit of a Pan Am airplane. "They thought they were getting a lot of free publicity," Coxe said, "so they put their logos all over the place." However, Pan Am airline officials didn't realize that the back cover would feature the two musicians superimposed on a photo of the wreckage of an actual plane crash.

The next thing the duo knew, they were on the receiving end of a career-killing lawsuit filed by an angry multinational corporation. "They got an injunction and they managed to get all of the records pulled off of all the shelves nationwide," Coxe says, "and they forbade us from performing any of the songs live." Pan Am's henchmen repossessed Taylor's drums that were stored upstairs at Max's Kansas City and were coming back for Coxe's synths, so the two hid the equipment at a friend's loft and laid low. When Silver Apples called it quits later in 1970, Coxe made an unexpected transition into television news reporting—landing a string of jobs in cities around the South, where he could be seen standing by a crime scene, signing off: "Simeon Coxe, Action News."

"We used to see the Silver Apples at Max's all the time," Vaccaro recalled of those evenings at Max's. "God, the sounds they made were just fantastic." Coxe said that the Play-House people would always come to their Monday night residency, take acid, and watch the group play. "After a while," he said, "John asked if we would be interested in doing an insane musical—right up our alley! What a beautiful but bizarre bunch of folks." The musical was *Cock-Strong*, starring Ruby Lynn Reyner, and it ran in early 1969 at La MaMa.

"Ruby was the queen of the Play-House of the Ridiculous," Zanetta said. "She was very talented. She just had an energy, and the thing about John's work was that it was all about energy, this explosive energy." The actress was loose, free, and wild as the female lead, Denise—running across the stage on her knees and stretching her expressive, rubbery face. She stood about five feet five, was skinny as a twig, and had bright red hair (when she performed sans clothes, it was clear she was a natural redhead). Reyner recalled, "Ellen Stewart, God bless her soul,

she would sit backstage and go, 'You're showing your pubic hair. I don't want you doing that. It's dirty. It's not nice.'"

Even dirtier was *Cock-Strong*'s set piece—a giant penis with a big eyeball on the tip—which was placed center stage. "It was a sixteen-foot cock, with a winking eye," Vaccaro said. "It was called Old One-Eye." The show was a satire of male virility, in which the lead rooster character was arrested for not being masculine enough and was also fined for the crime of laying an egg. But the most memorable aspect of the show came from the big discount bags of glitter that Vaccaro would buy on Canal Street, which helped create the Play-House's cheap explosions of psychedelic Technicolor. "John would have these bags that weighed probably twenty pounds each," Michael Arian said, "full of colors of glitter that you just never ever imagined you'd see. We had glitter on the costumes. We had glitter everywhere."

Vaccaro usually painted vivid, colorful designs on his face that conveyed something about his character, sprinkling the glitter on the makeup while the color was still wet. "I was raining glitter for years," Reyner said. "I had so much glitter. With my makeup, people used to think I was a drag queen because I had big Joan Crawford lips and had completely filled them in with red glitter. My eyelashes, I dipped them in glitter with surgical adhesive—so I had glittery eyelashes, glittery eyes, glittery mouth." It was easy to know if a friend was sleeping with someone from the Play-House, because glitter littered their beds or showers.

Each night of *Cock-Strong*, Vaccaro randomly chose the order of the show's scenes—a wedding, a funeral, an autopsy, a doctor's visit, and so on—though the finale was always the same. "There was a long sequence of utter, absolute insanity," Arian recalled. "We did a 'Kama Sutra Ballet,' performed by all of us doing weird fucking positions: humping, blow jobs, and this and that and the other." As they mock-performed every imaginable sexual act, still partially clothed, Silver Apples did their thing. "Danny and I played this wild and crazy music," Coxe said. "It was the only time we were allowed to improvise during the whole show, so Danny and I would play as wild and crazy as we could."

"When everybody was singing the last big high note," Coxe added, "the whole audience got sprayed with water from the giant penis." It was hooked up to a sink in La MaMa's backstage area, and the giant prop erupted when the glitter-slathered cast sang, "Get it up, get it up! You're gonna get it up!" Reyner recalled, "I remember there was a heat wave at the time. It was in the summertime, and instead of the audience getting outraged, they went, '*Aaaahh!*' They loved it. There was no air conditioning in those days at La MaMa. It was hot as hell."

"After the first show people came with umbrellas," Coxe said. "When that cock started to come out of the stage and go out over the audience, everybody would pop their umbrellas." Before Arian joined the Play-House of the Ridiculous as a cast member, he witnessed the spectacle as an audience member. "It was just funnier than hell. We'd be drunk and just in glee. It was so much fun. We would always sit in the front and we would put up an umbrella, and I saw every single performance."

"In those days," Reyner said, "the Play-House of the Ridiculous was like a band you'd go out and see every night. We were the entertainment." Plenty of people came to Play-House shows, including John Waters, who developed a shared sensibility with downtown artists like Vaccaro, Smith, and Warhol after he started taking the bus to New York City as a teen. "I went to a lot of the John Vaccaro stuff," Waters said. "Also, Charles Ludlam was my friend. That's what influenced my movie *Multiple Maniacs*, like the lobster rape scene. It was the Theater of the Ridiculous."

The Play-House of the Ridiculous's DIY techniques (and penis props) literally broke down barriers between performer and audience, helping to pave the way for punk's provocations a few years later. "He had a really apocalyptic vision of the world in the middle of peace, love, and happiness," Penny Arcade observed of Vaccaro, "but New York was not a place of peace, love, and happiness in the sixties." This dark atmosphere was reflected in his plays, which isn't to say they were not exuberant and filled with life. "It was like a circus, where every performer was on acid and all the audience is on acid," Reyner said. "It was just original, it created a look. It was a very exciting time." Original and exciting, but also dangerous.

"There was always this sense that something could go terribly wrong at the Factory," recalled Robert Heide, "like the time Dorothy Podber came up there and shot a stack of Marilyn Monroe silkscreens with a gun." In the fall of 1964 she walked into the Factory with her Great Dane named Carmen Miranda, motioned to the Monroe silkscreens, and asked, "Can I shoot those?" Warhol said yes—assuming that Podber was going to take a picture—but she instead pulled out a pistol and shot a hole through the canvases. On another occasion a young man came to the studio with a gun and played Russian roulette, fired some shots that missed, then left (a nonplussed Andy said nothing).[7]

George Harris III first visited the Factory after he met Warhol in the back room of Max's Kansas City, but Harris misread the situation and thought it was a date. After he arrived Warhol sat passively while some of his male friends tortured the

young man. While Harris begged them to stop, they extinguished cigarettes on his skin and roughed him up—refusing to let him leave and keeping him at the Factory all night.[8]

"So when Valerie shot Andy," Heide said, "it was almost inevitable, because of the people that were surrounding him."

Jackie Curtis, Candy Darling, and Holly Woodlawn weren't clinically insane or homicidal, but they still contributed to the Factory's edgy atmosphere. It was fueled by heavy drug use and hard living, which Warhol mined as grist for his movies *Flesh* (1968), *Trash* (1970), and *Women in Revolt* (1972), which featured this trashy trio. "He took advantage of them, and I didn't really like that at all," said Curtis's friend Melba LaRose. "I always found Andy very cold, and with not much to say. And of course the people around him said all these witty things and then he'd get credit for it. Jackie and Candy were always very witty." Their exhibitionism, which made for compelling cinema and great PR, stood in contrast to Warhol's wordless, blank persona.

"Jackie, Holly, and Candy had problems with Warhol because he didn't really pay them," said another friend, Bruce Eyster. Warhol did give them token money, but they still ended up marching over from Max's Kansas City to the Factory to scream and beg for more money—something that underscored a genuine divide between Warhol and some of those he mixed with. Even though many vied to be in his social world, Warhol wasn't revered or respected in the same way as Jack Smith, Harry Koutoukas, and other struggling downtown artists who prioritized art over money. "You wondered if some of the entourage people—Billy Name, Taylor Mead, and so forth—would jump out the window," Heide added. "They'd go back to their shabby little rooms because there was this double standard going on. I think ultimately that's one of the reasons I think Andy got shot."

Valerie Solanas had previously been known around downtown as a hustling street urchin who wrote the satirical-but-serious *SCUM Manifesto* in 1967. "Life in this society being, at best, an utter bore and no aspect of society being at all relevant to women," the Society for Cutting Up Men's manifesto began, "there remains to civic-minded, responsible, thrill-seeking females only to overthrow the government, eliminate the money system, institute complete automation and destroy the male sex."[9] In addition to promoting her SCUM movement, Solanas wanted someone to produce *Up Your Ass, or From the Cradle to the Boat, or The Big Suck, or Up from the Slime*—a gender-bending romp that took place in the social gutters.

The play featured a character named Bongi who ran into a variety of degenerates: Alvin, the ladies' man with a revolving bed; Ginger the *Cosmo* career girl who gets ahead by "lapping up shit"; a misogynous bore named Russell; a sex-crazed homicidal mother named Mrs. Arthur; her penis-obsessed child, the Boy; and so on. *Up Your Ass* climaxes during a scene about a "Creative Homemaking class" that encouraged mothers to combine their sex lives with the mundane task of washing baby bottles. They are instructed to lather up the baby brush and surprise their husbands by "r-a-a-m-m-ing the brush right up his asshole. So, you see, Girls, marriage really can be fun."[10] When Solanas was staying at the Chelsea Hotel, she recruited actors for *Up Your Ass* by passing out her outrageous mimeographed literature in the lobby—which prompted resident Arthur Miller to complain to the management.

Warhol ultimately chose not to produce *Up Your Ass*, which started a chain of events that led to the shooting. Before he turned down Solanas, she had already approached Charles Stanley and Robert Patrick at Caffe Cino about directing the play. "I'd seen her around Washington Square," Patrick said, "and you honestly felt you were being pulled into some unwholesome vacuum." Stanley wanted Patrick to direct the play, but it was a little too extreme and filthy even for his tastes, so Patrick declined. "I remember her look," he said. "She shot Warhol for not doing that play. I wish I had done it. It might have saved Andy Warhol. I deeply regret it."

Ed Sanders was another man who dashed Solanas's dreams after she delivered the twenty-one page *SCUM Manifesto* manuscript to his Peace Eye Bookstore. She hoped he would publish it, but after he sat on it for too long, Solanas left a terse note for him at the bookstore. "She wanted the manuscript back," Sanders recalled. "I got the impression from the store clerk that she was miffed."[11] Adding to her frustration, Solanas unsuccessfully approached *Realist* publisher Paul Krassner about publishing *SCUM*, yet another male gatekeeper who turned her down. "It didn't fit whatever my editorial criteria were," he said, "but I did give her fifty dollars because she was an interesting pamphleteer and I wanted to support her." She ended up self-publishing the manifesto and sold it at Paperbook Gallery, the Greenwich Village store where Jackie Curtis collaborator Paul Serrato worked. "Valerie would pop in with her *SCUM Manifesto* and she'd chat, just like anyone else," Serrato said. "Who knew what she was gonna do, right?"

Solanas began showing up at the Factory more frequently, asking for money, so Warhol put her to work by casting her in his 1967 film *I, a Man*. Over the course of 1968, she became increasingly agitated until she finally snapped on June 3.

Earlier in the day, Krassner ran into Solanas on the street when he was heading over to have lunch at Brownie's, a vegetarian restaurant near the Factory. When she walked into Brownie's a little bit later and asked to sit with him, Krassner politely declined because he was with his daughter, who he didn't get to see much. "She said she understood and she left," Krassner recalled. "Right after that, she went and shot Warhol. I still think about that. It's like, suppose it wasn't Warhol she shot. Suppose she said, 'What do you mean I can't join you?!?' *BANG!* It was kind of scary because she really obviously had some kind of mental problem."

Solanas walked from Brownie's, took the Factory's elevator up to the main offices, then shot Warhol multiple times as he crawled under a desk and pleaded for her to stop. Sanders heard about the shooting that afternoon when he was in his apartment and became justifiably concerned. "I was afraid she might come to Peace Eye or, worse, to our apartment, with her smoking .32," he recalled. "I hid behind the police lock on Avenue A until she turned herself in to the police on Times Square a few hours later."[12]

CHAPTER 19

Darkness Descends on the East Village

Two blocks south of St. Mark's Place, on Second Avenue and Sixth Street, was the Fillmore East. For a brief period between 1968 and 1971, it hosted everything from the Living Theatre and Paul Krassner's stand-up comedy routines to the downtown sounds of the Fugs and Silver Apples, along with touring acts like the Who, Jefferson Airplane, and Jimi Hendrix. Before that time, the city had been devoid of large rock-friendly venues, and those who did promote rock music were ignorant about the underground scene. "They weren't really a part of it, so they didn't understand it," Silver Apples' Simeon Coxe said. "Finally, Bill Graham came up with the idea of opening the Fillmore East, which was a major part of the downtown rock scene in the late sixties and early seventies."

Graham grew up in New York as a German Holocaust survivor and an aspiring actor, and after moving to San Francisco he found success as a live music promoter by opening the Fillmore Auditorium to capitalize on the city's thriving psychedelic music scene. Lighting designer Joshua White recalled that Graham initially resisted the idea of running a New York venue, despite many overtures. White had been involved in booking rock acts that played in the old vaudeville theaters that lined Second Avenue, and he and others finally convinced the promoter to fly out to one of their sold-out shows. Graham heard the sound of ringing cash registers after he saw the full house, so White and others began working night and day to convert an old Yiddish auditorium into the Fillmore East.

Everyone who worked there came out of theater school—including White—and they also had the good luck of sharing a building wall with NYU's Tisch School of the Arts. "Their students came over because rock 'n' roll was exciting," White said, "and many of them got involved in the Fillmore. So we began with this very high level of well-trained people." White had studied lighting at film and theater school and worked at discothèques before his tenure at the Fillmore East. "Lighting was always a key interest in my life," he continued, "but I didn't know where to apply it." White initially created lighting systems for discos such

as Arthur, Salvation, and Trude Heller's, where he began to develop techniques that he refined at the Fillmore East: color washes, lights mounted on motors that could rotate and reverse, and reflective objects that moved and bounced light in asymmetrical ways.

White had seen Warhol's *Exploding Plastic Inevitable*, but he was much more impressed by what was happening in a venue that opened on St. Mark's Place, in the basement space where the Dom had previously been located. "It was now remodeled as the Electric Circus," White said. "Now, when you say remodel, what it really means is they put stretched nylon over the space inside, changing the space by throwing light all over the place. Even though it was just a ratty ballroom, it now had a shape, and they brought in an older light artist from the San Francisco scene named Anthony Martin who filled the place up with psychedelic-type projections based on the San Francisco ballrooms. They did very good stuff there."

The Electric Circus featured acrobats, go-go dancing, and even John Cage playing chess. In 1968, the experimental composer asked a young electronic musician named Lowell Cross to create a chess board with sixteen different audio inputs that triggered sounds whenever a piece was moved. Cage first played this aural game of chess against Dadaist Marcel Duchamp in Toronto, then recreated the conceptual performance at the Electric Circus later that year. "It was a discothèque," Cross recalled. "There was a whole lot of cigarette smoking, and other kinds of smoking, and acid going on. It was very casual, not very structured at all. And that fit right into what Cage liked." Although John Cage was in his mid-fifties by this point, he remained open to new things and continued to circulate in a variety of New York scenes until his death in 1992.

Curious about the light shows at the Fillmore Auditorium, White made his way out to San Francisco in 1967. "I was really struck with how sloppy it was, in the sense that the light show wasn't particularly great," he recalled. "The people in the audience all together, that was the exciting part, but there was something wrong about the light show—because it wasn't that dynamic." White and his partners still picked up some ideas from the venue's oil and liquid projections, and when one of the Fillmore's lighting designers moved to New York, they all began collaborating. "He showed us the artistic things which were hard," White said, "and we showed him how to do mechanical things which were hard—like attaching a color wheel to a motor in front of the projector."

The psychedelic Joshua Light Show became part of the Fillmore East experience as soon as it opened on March 8, 1968. Bands usually performed two separate

John Cage at the Martha Jackson Gallery
© SYEUS MOTTEL

shows an evening, often for multiple-night runs, which allowed the Joshua Light Show to experiment and refine their techniques. "It was a perfect way to grow a light show," White said. "You just keep doing it, and we kept doing it for two years. We developed a palette, and that palette just got bigger and bigger."

The venue was an instant commercial success, which led to a clash between Graham and the East Village neighborhood radicals who demanded he "give back to the community." The Motherfuckers insisted that the theater should be turned over to them one night a week, so the first "Free Wednesday" featured the Living Theatre performing *Paradise Now*. When one of the actors announced that they

were going to "liberate" the theater, Graham ran onstage to stop the madness, but the crowd overwhelmed him and forcibly tied him to a chair. The psychodrama continued for hours, with Graham and the crowd yelling back and forth at each other well into the early morning.

"The free nights at the theater were just drunken homeless people screaming and hitting drums. It didn't last very long," said White, recalling the combustible mix of people in the Lower East Side. "There were Hells Angels, and they tried to establish their presence, and there were the political radicals and dropouts, but it was also a Jewish neighborhood." The area was filled with little clothing stores and delis that sold cheap flatbread, cream cheese, and caviar sandwiches—as well as dealers selling pot and much harder drugs.

The Fillmore East was two blocks from St. Mark's Place, a street that functioned as a major pedestrian thoroughfare to the West Village (it turns into Eighth Street after crossing Third Avenue). The print shop that published the *Realist* was near Sheridan Square, and Paul Krassner regularly walked there from his loft on Avenue A. "It was just a great feeling to walk along St. Mark's Place," he said, "and then Eighth Street to Sheridan Square to deliver stuff to the printer—going back and forth. There was a lot of smoking of marijuana on the streets. It was just a very friendly atmosphere and people would walk along and smile."

Krassner also used to watch the Fugs perform free concerts at the shell stage in Tompkins Square Park, where St. Mark's Place terminated to the east. Future punk singer Joey Ramone and his younger brother Mickey Leigh (then known as Jeffrey and Mitchel Lee Hyman) occasionally came from Queens to hang out. "When I was fourteen or so, my brother and I would go down to Tompkins Square Park and watch David Peel play—'I Like Marijuana' and those kind of songs," Leigh said. "We never heard anybody doing anything like that, really. He was the first radical folk singer that we were exposed to, and he was a big influence on me and my brother."

Off-Off-Broadway performer Agosto Machado would take acid trips with people in that park, where he sometimes slept. "Suburban kids—or 'weekend hippies,' that was the new term—populated the area after Bill Graham opened Fillmore East," Machado said. "That's when the media and suburban people came and overwhelmed the East Village and Tompkins Square Park. They would say, 'You are so free. You can live your life the way you want but we can't.' They were already branded and enslaved by the ideals of their family, and yet they could admire us, the homeless, who didn't have anything, because we could do what we want. They thought our struggles were glamorous."

This bohemian oasis was invaded by the New York Police Department early in the morning on January 1, 1966, when Ed Sanders's Peace Eye Bookstore was raided for allegedly distributing obscene materials. Ironically, Sanders had been selling *Fuck You/A Magazine of the Arts* via the United States Postal Service since 1962 without being hassled, despite regularly receiving mail addressed to "Ed Sanders, Fuck You, Stuyvesant Station, New York" or "Fuck You, Peace Eye." Sanders observed, "It made me proud of being in a free country and having a tolerant post office branch."[1] Apparently, that tolerance didn't extend to the local police precinct; Sanders was placed under arrest, and boxes full of printed matter were carted away to the station.

"Indeed, there was a marked contrast of facial expressions between the grumpy arresting officer and the policemen at the station house," he recalled. "For being such a serious matter—that is, booking of a likely criminal, me—there certainly was a lot of mirth in the Ninth Precinct. 'Hey, you're Peace Eye!' one officer boomed. I nodded. 'Hello, Peace Eye!' another exclaimed. I nodded. 'Let me take a look!' another commented and smiled, and laughing officers passed magazines hand to hand."[2] Sanders was charged with possession of obscene literature with intent to sell, a misdemeanor. The trial finally began May 22, 1967, and the legal battle would be among the last in a wave of obscenity trials that resulted in expanded boundaries regarding free speech in America.

The American Civil Liberties Union agreed to defend Sanders, and the case lasted eighteen months, which led to the demise of *Fuck You* (he was advised to cease publishing while the case was still pending). Sanders's pro bono attorney, Ernst Rosenberger, was a Civil Rights era veteran who fought to desegregate the interstate busing system in 1961. His legal strategy was to force the prosecution to produce evidence that Sanders's satires actually existed in real life, and weren't merely figments of his twisted imagination. Sure enough, it turned out that the assistant district attorney mistook the whimsical advertisements that Sanders regularly placed in *Fuck You* for actual obscene products. "Rosenberger had them! They did not have six copies in evidence of 'The Lady Dickhead Advertising Company,'" Sanders recalled, "or any proof of actual sale of anything."[3]

After the case was dismissed, Sanders turned his attention to the Fugs and away from Peace Eye, which he decided to turn over to the community. "The community," unfortunately, threw out most of the store's books and mimeo publications and turned it into a mattress-strewn crash pad. Sanders began to tire of the rock 'n' roll life as the Fugs struggled through a series of recording contracts—Atlantic Records, for instance, dropped them almost as soon as they were signed—along

with other disappointments that turned the band into too much of a burden. Reclaiming the Peace Eye in 1969, Sanders focused on running his bookstore and restoring it as a popular literary destination.

"Even though I was breaking up the Fugs, the rest of '69 flamed past, as full of projects as any other year of the decade. I kept the Peace Eye Bookstore open throughout the year and minded the store on many days."[4] Its days were numbered, however, in part because the Lower East Side's streets were growing meaner. "The 'Make Love Not War' thing was big in the East Village," Machado said, "but I'm painting it with rose-colored glasses. It was still iffy and dangerous in the late sixties and early seventies. If it was iffy, you had to walk in the street along the cars, or you had to zigzag to avoid certain blocks."

Sanders lived in one of those iffy areas, on Avenue A, where he was attacked as he opened the door to his apartment in April 1969. "I was rushed from behind by two guys who tossed me to the floor and pushed a knife against my throat, chanting, 'Where's the amphetamine—where's the amphetamine?' with an insistence that portended arterial insert." It was a case of mistaken identity in a drug deal gone wrong, but fortunately one of the guys stopped and said, "Hey, man, the guy that burned us didn't have no red boots on."[5] Sanders's rock 'n' roll boots may very

Defunct Fillmore East, 1972
© CHRIS STEIN

well have saved his life, but the incident convinced him to leave the neighborhood he had called home throughout the 1960s.

The area had grown more grim thanks to a combination of spiraling poverty, decaying city infrastructures, harder drugs, and sleazy opportunists drawn into the counterculture. Sanders was able to secure a new place for his family in the relatively tonier West Village when a nonprofit housing complex, Westbeth Artists Community, opened in a building that had been vacated by Bell Labs. "I pulled strings and landed us a new pad—a beautiful duplex for $186 a month!" During this time, Sanders closed Peace Eye, deciding to give away thousands of books. "Wow, did they flock into the store to get free stuff! It was like the old Digger Free Store, but only for a couple of days."[6]

Along with the demise of Peace Eye, Bill Graham closed the Fillmore East's doors in the summer of 1971, citing the changing economics of the concert industry and an inhospitable atmosphere in the surrounding neighborhood. By the time it shut down, Joshua White had witnessed how drug consumption was shifting from psychedelics to cocaine and heroin, which created even more tension inside and outside the theater. "One of the things that I noticed right away," he recalled, "was that even though people went around smiling and grinning at each other, there was a lot of anger and hostility there. It was not a good time, and it was going to get worse before it got better."

CHAPTER 20

From the Margins to the Mainstream and Back Again

Café La MaMa's secret weapon was Tom O'Horgan: a multitalented director, musician, and choreographer who worked on dozens of shows at Ellen Stewart's theater. A musician with no traditional theatrical training, he had worked throughout the 1950s as an offbeat variety entertainer, cracking jokes while playing early English ballads on the harp—even appearing on *The Ed Sullivan Show*.[1] "He was ambidextrous when it came to his playing, whatever he thought the piece needed," playwright Paul Foster recalled. "It added a whole new dimension to theater."

O'Horgan merged music, gesture, and dialogue by using performers' bodies to create what he called kinetic sculptures. One exemplar of this approach was Foster's *Tom Paine*, a "living play" that seamlessly integrated the auditioning, casting, rehearsing, and script development processes into an organic whole. To master this new theatrical style, all fifteen members of the La MaMa troupe attended five-hour-a-day, five-day-a-week workshops that included music making, movement exercises, and dialogue. "There were people fiddling around with theater form," Robert Patrick said, "and so Tom O'Horgan and Paul Foster and the La MaMa troupe put it all together into a workshop method that developed the idea of collaborative creation in theater."

"Tom was least interested in the dialogue," actress Mari-Claire Charba recalled. "He was least interested in the script." Instead, the director said he wanted to remake the theatrical experience through "frenetic physical activity, tableaux, bold anti-illusionistic devices, amplified music and sound, strobe lighting, and gimmickry of various sorts."[2] To achieve this, Charba recalled endless days of slow-motion exercises that integrated physical motions with the words they uttered. "I felt that I could sort of move the dialogue with the same kind of movement," she explained. O'Horgan's performers might come out wearing drapery—chanting and moving about—then suddenly swirl and shift into a scene that was developed from another overlapping theme. "Sometimes,"

Foster noted, "you just wanted to emphasize the texture, and you're willing to lose comprehension."

"We were doing all these exercises that became the epitome of that performance style of *Hair*," Charba said. "Tom shifted Broadway into all this physicality, and we were precursors to that. Like *Hamilton*, we did that with *Tom Paine*. When I saw *Hamilton*, I thought, 'Oh my God, that was like *Tom Paine*,' which was done—what, fifty years ago? Same thing. Tom O'Horgan took a historical play and moved it into mixed media."

The busy director was simultaneously working on *Tom Paine* at La MaMa while running the first rehearsal workshops for *Hair* in early 1968. "There was a lot of crossing of inspirational ideas with those two plays," Foster said, recalling one moment in *Tom Paine* that was absorbed into *Hair*. Foster had a scene in which the people of France were starving in order to feed the Termite Queen, who attacked the hungry mob and began eating the clothes off their back. "No, don't stop, just keep going," O'Horgan said during a rehearsal, so the performers kept tearing off their clothes until they were naked. "These were young kids and they didn't have any qualms about getting naked," Foster recalled. "It was a powerful moment in the show, and it rose out of a need to say something visually." Two weeks later, *Hair* featured a similar nude scene when it debuted at the Biltmore Theatre on April 29, 1968.

Sixteen-year-old Walter Michael Harris was the youngest cast member in the Broadway version, though he hadn't appeared in the previous Off-Broadway productions. He had seen the show when it played at the midtown disco the Cheetah—a transitional production that split the difference between its more stilted debut at the Joseph Papp's Public Theater and the explosive Broadway version. *Hair* was constantly evolving in the lead-up to its Broadway debut. Show creators James Rado and Gerome Ragni continued working on the script and songs at the same time O'Horgan held auditions, which is how Harris got involved. When he accompanied a friend on piano during *Hair*'s open auditions, O'Horgan asked him if he wanted to try out. "Well, if you're involved, Tom, then yes!" Harris had previously worked with the director as both an actor and musician in Foster's *Madonna in the Orchard*, and also participated in a Happening that O'Horgan orchestrated at Judson Church.

The *Hair* cast rehearsed at the Ukrainian Hall, one of the many old ballrooms located on Second Avenue. "Tom was kind, very self-effacing, not at all dictatorial as a director," Harris recalled. "He could get tough when he needed to, but that was very rare. He was just a very soft-spoken conductor." The word *conductor*

was appropriate, for O'Horgan visualized scenes in musical terms—much like a flow of a symphony or a jazz composition. "I always said Tom directed the cast like they were an orchestra of flesh," recalled Patrick. "His work was much more akin to dance and music than to what had been thought of as theater before. People would come onstage writhing, dancing, singing, crawling, tiptoeing—then slowly they would build into some exposition and then suddenly two or three or four of the actors would snap into character. Or perhaps other actors moving around them would be making visual or audible comments. The storytelling was less paramount."

The night before the Broadway opening of *Hair* at the Biltmore, Harris and three other cast members snuck into the theater to conduct a kind of holy ritual. Knowing the theater well, they hid in different locations to evade the security guards, who locked the theater and left for the evening. "We knew how to turn the lights on, the stage lights, and we brought a few lights of our own, and we burned some incense, and maybe smoked some grass," Harris said. "Basically, the idea was to purify the space with our presence, with our chants, so that it would be ready for the opening night. We also probably took LSD, or mescaline, or something like that."

Who knows how effective this ritual was, but the show was an aesthetic and commercial success. "Yet with the sweet and subtle lyrics of Gerome Ragni and James Rado," *New York Times* theater critic Clive Barnes wrote, "the show is the first Broadway musical in some time to have the authentic voice of today rather than the day before yesterday. It even looks different. Robin Wagner's beautiful junk-art setting (a blank stage replete with broken-down truck, papier-mâché Santa Claus, juke box, neon signs) is as masterly as Nancy Potts's cleverly tattered and colorful, turned-on costumes. And then there is Tom O'Horgan's always irreverent, occasionally irrelevant staging—which is sheer fun."[3]

Barnes's rave review ensured that the show sold out for months, turning *Hair* into a massive pop culture hit, complete with a best-selling soundtrack and international tours. Musicals had long been a prominent part of twentieth-century popular culture and had spawned many a hit record, but *Hair* was truly the first modern musical. It established the template for the Broadway blockbuster and was an obvious precursor to contemporary shows such as *Rent* and *Hamilton*.

Though it savvily repackaged the counterculture, making it safe for the masses, O'Horgan's staging retained a subversive spark. "*Hair* was an antiwar play," Harris emphasized. "It wasn't 'happy hippies doing their trippy thing,' which is what a lot of people think about when they think about *Hair* today. In Tom's hands, it

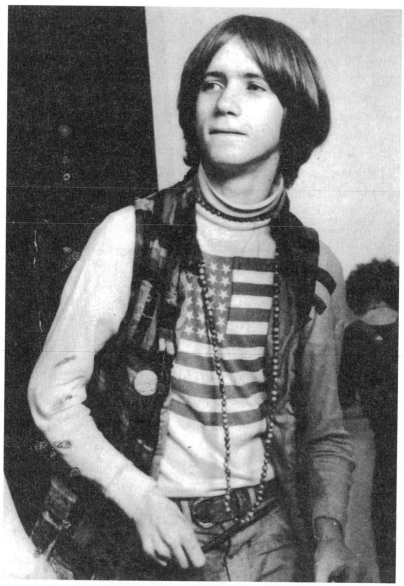

Walter Michael Harris backstage during *Hair* rehearsals, 1968
© DAGMAR

was really quite focused on opposition to the war in Vietnam—which was a big, big reason why it was written to begin with. I know Jim and Gerry were really fascinated with youth culture at the time, and what the young people were doing and saying and thinking, and what their hopes and dreams were."

The final number, "The Flesh Failures (Let the Sunshine In)," could easily be reduced to a hippie cliché, but it was a sober reminder of the horrors of the Vietnam War when the death of *Hair*'s main character, Claude, was revealed. "Nobody was smiling, nobody was waving the peace sign, nobody had flowers, it was very serious stuff," Harris recalled. "What the audience saw was Claude laid out on a funeral bier, on top of the American flag, dead." It was a shocker, a belly punch to the audience—who were left in darkness for a minute before the curtain call, contemplating what they had just seen.

"I think this was all kind of new to everybody," Harris said, "the notion of down-town underground going uptown, and Tom was sort of the vanguard of that." La MaMa regular Michael Arian added, "The *Hair* organization to this day considers La MaMa the spiritual home of that show. Jimmy Rado and Gerry Ragni saw every-thing. They were there all the time. Tom O'Horgan continued to work there, and was there all the time. Nobody was copying, outright. It was all interconnected."

The links between the downtown underground and the midtown mainstream can be seen in Walter Harris's varied creative outlets. "I managed to simultane-ously be in *Hair* and also participated in a Bob Patrick show at the Old Reliable at the same time," he said. "We had already collaborated on a few things, and he asked me if I would help him with the music to an Easter pageant he wrote. The first one was *Dynel* and the second one was *Joyce Dynel*, which opened on April 7, 1969—which was exactly one week after I left *Hair*." *Joyce Dynel* was staged at Easter as a sequel to Patrick's 1968 Christmas show, *Dynel*, whose title referred to a synthetic hair fiber used in wigs ("It's not fake anything. It's real Dynel," the ads declared). While rehearsing the first show at the Old Reliable, someone asked the playwright if it was his imitation of *Hair*, so Patrick quipped, "It's not imitation anything. It's real Dynel"—and the name stuck.

"Because most of us lived on the Lower East Side," Harris said, "the *Dynel* shows amplified our location-based personalities and perspectives." *Joyce Dynel* began like a piñata explosion as street kids gathered on an East Village corner one Easter evening. "Feathers, fringe, serapes, boleros, bells, beads, incense and streaming hair," the stage notes explain. "No flowers—that was the West Side! And this is the East Side, the Lower East Side, of Greater Babylon." The actors playing America's Street Children passed around joints and begged the audience for money until two actors playing police officers emerged in glittering blue jumpsuits, twirling their nightsticks: "Rrrrrroutine duties to attend to, tend to."

Patrick wrote each scene within the framework of Christ's story, giving it an absurd spin, and Harris helped him arrange the music in his tiny loft on Second

Avenue, between Third and Fourth Streets. "My one window looked out to the large window of the Hare Krishna temple across the street," Harris recalled. "Each morning I awoke to pleasant chanting by the devotees, and incense wafted my way if the wind was right." Much of this East Village atmosphere was incorporated into *Joyce Dynel*, which featured Mary (who wore chic white "swinger" garb), God, and their long-haired, guitar-playing hippie son, Jesus Christ.

At one point, a panhandling character named Punkin stops in front of Christ and shouts, "Ten cents for muscular dystrophy! Ten cents for muscular dystrophy!"

CHRIST: Oh . . . sure . . . here's ten cents.

PUNKIN: And here's your muscular dystrophy!

Sprays him and scuttles off. CHRIST instantly buckles like a squashed cockroach.

Some CHILDREN enter and carry him off as a souvenir. MARIA walks on.[4]

Even though Harris maintained his underground theater roots during his time in *Hair*, he was uneasy about being in a Broadway show. One day he called in sick, hopped on a plane, and headed out to San Francisco. He felt a bit hypocritical being *paid* to play a hippie when he really wanted to be more like his brother, George, and *be* a hippie—so he quit the show. "I went into *Hair* as an actor," he said, "but I came out as a hippie, and it was George who inspired me to come West."

Before forming the Cockettes, George Harris III, aka Hibiscus, initially lived at the Friends of Perfection Commune—informally known as Kaliflower—which was run by Irving Rosenthal, a writer and editor who was part of the Beat scene. "Hibiscus had been a lover of Allen Ginsberg and various bohemians," recalled Cockette Lendon Sadler, "and Irving immediately fell for him." Another future Cockette, Pam Tent, found Kaliflower shockingly uptight. "It was to me not my idea of communal living," she said, "because it was so regimented and controlled by Irving Rosenthal. He wanted to create a society where everyone lived off the grid and developed their own system of barter. Everybody had a job and nothing got done unless it was okayed by Irving, and no one slept with each other unless he said it was okay. I only lasted a couple of weeks before I left."

Rosenthal's commune printed a free newspaper, the *Kaliflower*, which was part of San Francisco's communal network that provided free food, clothing, and other goods that were traded. Sadler, Hibiscus, and others distributed the paper by walking from communal house to house—stopping to talk, have tea, or smoke

a joint. "The Kaliflower community ran a big free clothing store," Sadler said, "and they had a lot of clothes. They gave us access to incredible drag, so Hibiscus started circulating pieces of drag." The Cockettes' use of drag and glitter can be traced back to New York underground filmmaker Jack Smith, whom Rosenthal had befriended and somehow acquired the garb that was used in some of Smith's films, such as *Normal Love*. "The costumes for the first night the Cockettes got together originally came from Irving," Tent said, "because they had the key to Irving's drag room, which had all these fantastic costumes."

Hibiscus also staged guerrilla theater performances in front of Grace Cathedral on Christmas and Easter. Dressed as a drag Jesus, he corralled a bunch of kids who lived in the Haight district into his oddball parade of biblical characters. "We were doing what felt good," Sadler said, "having fun, because we were just kids. Hibiscus was a real drama queen. Theater was his life, and he was slightly crazy too, but crazy in a genius sense. He was really willing to die for his art." The free spirit sometimes hitchhiked in dresses, or walked through rough parts of Oakland wearing drag, glitter, and makeup without a worry in the world. "Hibiscus was so whimsical," Tent recalled. "He danced about, he was so filled with life."

While the Cockettes' shows were silly and playful, many of its members had pretty serious activist backgrounds. Sadler was born in Atlanta in 1950, and he was an active member of Martin Luther King Jr.'s Ebenezer Baptist Church. "Besides the hippies," he said, "the Civil Rights organizers were the most inspirational movement at the time because they had so much energy." One fateful day he was walking in his neighborhood to see MLK give a speech when two white people stopped their car to ask for directions. The driver, Ashton Jones, was an infamous pacifist who had gone to jail for not serving in World War II, and he now traveled the country with his wife and pet Chihuahua—sporting STOP THE KILLING IN VIETNAM and other radical signs on the front of their car.

After this encounter Sadler began attending antiwar demonstrations in downtown Atlanta. "When we started there, at first I was scared to death," he said of these protests. "People in suits would save up their shit and throw it in our faces, cursing." In 1967, Jones convinced Sadler's mother to let him take him on a trip to New York. "One of the first places I stayed was the Catholic Worker soup kitchen in the Bowery," Sadler recalled. "I lived in the East Village, but I hung out in the Café Wha in Greenwich Village, and of course hung out in Washington Square. I was naive, and I didn't know anything about any of these places and then, boom, this world was opening up to me."

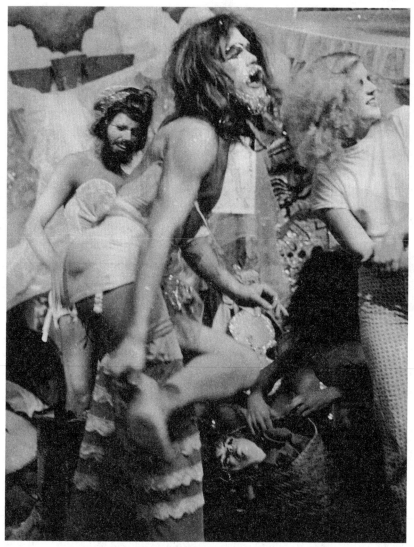

Hibiscus at the Sutter Street Commune, San Francisco
COURTESY THE FAMILY ARCHIVES OF GEORGE EDGERLY AND ANN MARIE HARRIS

Pam Tent also lived in downtown New York in the late 1960s. She was squatting in a rundown building on East Third Street that was populated by a biker gang, the Aliens, who rode their motorcycles up and down the stairs. "It was pretty wild," she said. "It was a very scary scene, very dubious, so we didn't stay there long." Tent didn't have a steady job, so she panhandled in the streets

while singing "Pennies from Heaven" and catching coins that people threw at her. She had been a natural performer since she was a child, when her mother made curtains and set up bleachers in their backyard for a "circus" that she produced every summer.

While she was still living downtown, Tent met future New York Dolls frontman David Johansen. He was working after high school in a clothing store in the St. Mark's Place area that had all sorts of garish clothes strewn throughout—fantastical outfits with boas, rhinestones, and other glitter-camp materials. "It turns out that he was making costumes for Charles Ludlam's Ridiculous Theatrical Company," Johansen said of the store's owner. "So I started going around to where they would rehearse and getting involved in that, playing guitar or doing the sound and lights. Sometimes I would be a spear-carrier or something."[5] He appeared in a few Ludlam productions, such as *Whores of Babylon*, where he appeared as a lion, nude with teased hair.

"David was walking down the street and we got into a conversation," Tent said of the first time they crossed paths. "There was never stranger danger. Everybody just was brothers and sisters. David and I used to sit around St. Mark's Place, which was a place for all the hippies." The two became quite close, and he introduced her to Max's Kansas City, where he had worked. "David was so funny," she recalled. "I remember seeing him once and I asked him, 'What have you been doing, David?' And he says, 'I've been snorting ground-up 78s.'"

At one point Tent was homeless in New York and sitting on a street corner with her suitcase and a teddy bear named Cosmo. She had a sign around her neck that read TAKE ME HOME, so a man named Marshall Olds brought her back to live with his wife and child on the corner of Tenth Street and First Avenue. Olds later moved to San Francisco and joined the Cockettes (they used to point to him and say, *Of course we've got every sexuality in the Cockettes. There's Marshall, and he's got a wife and a kid!*). Tent eventually moved to San Francisco, too, after a stint in Colorado's Rocky Mountains—where she and Johansen would take acid and dance naked around the campfire with their friends.

When Sadler arrived in San Francisco, he recalled feeling settled for the first time in his life. After moving into a house in the Fillmore neighborhood, he saw an ad for a Committee for Homosexual Freedom meeting in the underground newspaper, *Berkeley Barb*. "Again, another world unfolded before me," Sadler said. "This is where I met the core people of the Cockettes, like John Flowers. One of the first things we did was organize guerrilla theater actions." They targeted a convention of the American Psychiatric Association, which still categorized

homosexuality as a mental illness, so they playfully called the doctors out by pretending they were escorting the doctors into the convention, much to their embarrassment. "We would hoop our arms around their arms," Sadler said, "and they didn't know what to do."

Sadler was in Golden Gate Park in an area called Hippie Hill when he first came across Hibiscus, who was sitting in a tree singing a tune from *Madam Butterfly* in his screechy falsetto. "First of all, he freaked all the hippies out," Sadler said. "We were obviously hippies, but he cornered another market in freakiness. There was crazy Hibiscus singing arias and show tunes, and there began to amass more people of like mind." Pam Tent had a similar experience. She had been up all night on acid, and in the morning she wandered into Golden Gate Park—where she heard people singing from up above: "We're having a heat wave, a tropical heat wave!"

"In those days, everything was possible and everything happened," Tent said. "I saw these three people up in a tree, and this incredible creature was a display of golden hair, red lips, and this flowing cap up in a limb of a tree. And they're singing. I went over there and they said, 'Oh, come on up. Come on up.' And so I did." Hanging out with Hibiscus, she got to learn all the old 1930s and 1940s show tunes that inspired many Cockettes production numbers. "Oh my god, it

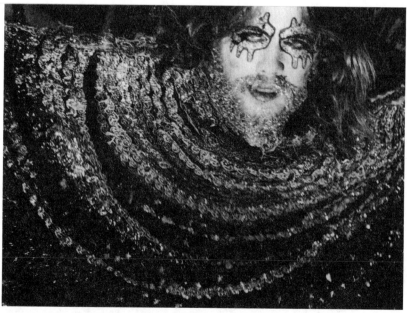

Hibiscus
COURTESY THE FAMILY ARCHIVES OF GEORGE EDGERLY AND ANN MARIE HARRIS

was amazing," Tent said. "Hibiscus had so much knowledge of show business because of his family, which he brought to the Cockettes."

It wasn't much different than what George Harris III had done with his family back in Clearwater, Florida, putting on a show for the fun of it. Fast forward to New Year's Eve 1969 at San Francisco's Palace Theater, which catered to the city's counterculture crowd with midnight movies. Hibiscus corralled a handful of residents of Kaliflower and elsewhere who got onstage and danced the cancan to the Rolling Stones' "Honky Tonk Women," wearing hoop skirts, tinsel tiaras, feather boas, and other accouterments. "It was so well received," Tent said, "that every month they started putting together a show during the intermission of the Palace's midnight movies, the 'Nocturnal Dream Show.' It was where they showed grindhouse movie crap and all the freaks flowed in."

On the afternoon of their first performance, the group still did not have a name. Hibiscus suggested that it should sound something like the Rockettes, and his friend Ralph Sauer came up with the perfect troupe name: the Cockettes. Of course, not everyone in the Cockettes had male genitalia, and for that matter not everyone was gay. "People weren't so worried about being straight or gay," Tent said. "We were hybrid hippies. It wasn't as isolated as right now, where you have got so many groups that subdivide themselves. It was just this expression coming from people who hadn't drawn lines yet. It was us versus them. We were the freaks, and the cops and the politicians were the straights."

As for Sadler, he felt they were like aliens. "We were lost in a land that was very different from us, and we had a story to tell and we were passionate," he said. "We were like missionaries. We were just getting the confidence to say, 'Whatever we are, we are going to push it in your face and we demand to be ourselves.'" That impulse helped launch a cultural revolution that began to dismantle rigid conceptions of gender—a movement that reverberates to this day.

CHAPTER 21

Femmes Fatales

New Jersey native Patti Smith lived in a dream world filled with poetry and rock 'n' roll. She had fallen for Little Richard when she was a young girl, and at the age of sixteen came across a copy of *Illuminations* by nineteenth-century French poet Arthur Rimbaud. By spring 1967, she had had a child and given it up for adoption, and was doing temp work at a textbook factory in Philadelphia. Smith plotted her escape to New York, where at first she was homeless and had to sleep in Central Park.

"I walked for hours from park to park," Smith recalled in her memoir *Just Kids*. "In Washington Square, one could still feel the characters of Henry James and the presence of the author himself. Entering the perimeters of the white arch, one was greeted by the sounds of bongos and acoustic guitars, protest singers, political arguments, activists leafleting, older chess players challenged by the young. This open atmosphere was something I had not experienced, simple freedom that did not seem to be oppressive to anyone."[1] She finally landed a job at Brentano's bookshop, where she met photographer Robert Mapplethorpe. During their first evening together they wandered through downtown, taking in the scene at St. Mark's Place and buying a cheap egg cream at Gem Spa.

Soon after, Smith and Mapplethorpe moved in together and continued their explorations of the area. "After work," she recalled, "I would meet him downtown and we would walk through the yellow filtered light of the East Village, past the Fillmore East and the Electric Circus, the places we had passed on our first walk together."[2] Mapplethorpe took a job at the Fillmore East just after it opened in early March 1968, reporting to work in an orange jumpsuit. They were too broke to pay to see concerts, but Mapplethorpe was able to get Smith a pass to see the Doors play—another turning point in her creative life. "I felt, watching Jim Morrison, that I could do that. I can't say why I thought this. I had nothing in my experience to make me think that would ever be possible, yet I harbored that conceit."[3]

The following year, Smith and Mapplethorpe moved into the Chelsea Hotel after escaping a dangerous Lower East Side loft building and a stint in a fleabag hotel. In this shabby artist-friendly residential hotel, Smith cultivated social connections that led her to become a performer—first on Off-Off-Broadway, then as a poet, and finally as a musician. Stanley Bard, co-owner and manager of the Chelsea, filled the lobby with art created by those who couldn't pay for their rooms. (Bard not only accepted artwork in lieu of rent money, he also charged artists lower rent than other professionals.) Smith offered Bard the couple's portfolios as collateral, which secured them Room 1017 for fifty-five dollars a week.[4]

"Stanley was real schizophrenic," Warhol superstar Viva recalled. "He could be extremely generous and then he could be really mean." Lisa Jane Persky saw both sides of Bard when she worked as an assistant for another Chelsea resident, fashion designer Charles James. "Even though Stanley was a real bastard," she said, "he did care about the talents of people" (perhaps because he hoped to sell their work). When Persky met "America's first couturier," as James was known in his prime, he had been on the downslide for years; James's friend Harry Koutoukas helped secure her a job as his assistant, which entailed a variety of tasks. "Charles would send me downstairs because I was cute and young, and I would say, 'Please don't lean on him right now—he's not well.' So Stanley would give him a little more time, and it was always like that for a lot of people in that hotel."

Shirley Clarke had lived at the Chelsea since 1965, and at times her daughter Wendy also had a room in the hotel, where the two often crossed paths with Smith and Mapplethorpe. "I remember spending afternoons in their apartment, just hanging out," Wendy said. "Everybody there was really friendly, and it was great. The Chelsea was a place where all these different kinds of artists lived, lots of different people—Jonas Mekas, Viva, Larry Rivers, Gregory Corso, Virgil Thomson, and George Kleinsinger." (Kleinsinger's legendary room was like a jungle—hot, humid, and filled with reptiles, birds, monkeys, and other creatures that lived with the eccentric composer.)

Viva first lived at the Chelsea in 1963, though when she moved in she didn't feel it was all that strange. "I never thought it was an oddball place or anything," Viva said. "It just didn't occur to me, but I'm sort of naive. I don't have a lot of opinions. I'm kind of open-minded." She lived next door to Smith and Mapplethorpe, who would often stop by her apartment to chat or hang out. "Every time I had to do a TV show," she said, "Robert would make me some plastic and leather piece of jewelry, and they'd come and tie it around my neck."

Smith prowled the hallways and peeked in other rooms, each of which was its own little universe. On some days she loitered in front of Arthur C. Clarke's room, hoping she might get a glimpse of the famous author. During another one of her hallway adventures she came across the underground filmmaker, folklorist, and occultist Harry Smith, who wore big Buddy Holly–style glasses that complemented his wild silver hair and tangled beard.[5] Wendy Clarke had known Harry Smith since she was a young teen, back when they used to run through the Village streets causing trouble. "One day on Eighth Street, we vandalized cars and broke off the radio antennas," she said. "It makes no sense, and we must've been really stoned or something because we thought it was just so funny."

Wendy felt that the Chelsea was a great place for her mother because it connected her to other like-minded souls. "It was the perfect lifestyle for her," she said. "The lobby was like your living room, so you can sit in the lobby for hours and just have conversations with the most amazing people—Jonas Mekas, Divine, the guys who did *Hair*, Jim Rado and Gerry Ragni." Just off the lobby was El Quijote, a Spanish restaurant and bar that served inexpensive lobster and was a popular hangout. Smith wandered in one night and came across Grace Slick, Jimi Hendrix, and other rockers who were downing mounds of shrimp, paella, sangria, and bottles of tequila. She was amazed, but didn't feel like an interloper because they were on her turf.[6]

Smith was wary of the Warhol scene, but she supported Mapplethorpe's desire to break into that world. This led them to what she called the downtown's "Bermuda Triangle": Brownie's vegetarian restaurant, Max's Kansas City, and Warhol's Factory, which were within walking distance of one another. Warhol had become reclusive after he was shot, but the back room of Max's remained one of the downtown scene's hot spots. Its social politics were reminiscent of high school, though the popular people were not jocks and prom queens, but rather drag queens (who, as Smith observed, knew more about being a girl than most females).[7]

Mapplethorpe and Smith sat for hours nursing twenty-five cent coffees or a Coke as they slowly edged their way into the dark, red-lit cabaret that was Max's back room—where "superstars" made grand entrances, blowing theatrical kisses. Smith was especially taken by Jackie Curtis, Holly Woodlawn, Candy Darling, and Wayne County, whom she viewed as hybrid performance artists and comedians. "Wayne was witty, Candy was pretty, and Holly had drama," she recalled, "but I put my money on Jackie Curtis. In my mind, she had the most potential. She would successfully manipulate a whole conversation just to deliver one of Bette Davis's killer lines."[8]

Through hanging out in Max's, Smith became friendly with Curtis—who cast her, Wayne County, and Penny Arcade in *Femme Fatale*, which debuted at La MaMa on May 6, 1970. Wayne County, who would become Jayne County by the end of the 1970s, was the newest addition to the downtown's glitter mafia. She met Curtis, Darling, and Woodlawn in 1969, soon after moving from Georgia to New York, and by this point she was living with Curtis and several others in a tiny cold-water apartment on the Lower East Side. "It was during this time that I first got the idea of going on stage," County recalled. "Jackie had been writing a play called *Femme Fatale* at the flat, and she was looking for people to be in it. So she said to me one day, 'Wayne, you should be in *Femme Fatale*. You'll play a lesbian.'"[9]

County's first line was the setup for a gross-out gag: "You scared the shit out of me" (after which she pulled a plastic poop novelty item from under her dress). "That was my debut on the New York stage," she said, "in Jackie Curtis's *Femme Fatale*. You can imagine." County said that the title of Curtis's play was a reference to the Velvet Underground's song of the same name—"Jackie, of course, was very aware of the Velvet Underground, and the song 'Femme Fatale'"—though Arcade believed differently. "I think the title *Femme Fatale* was totally from the forties," she said. "Jackie was completely in a house of his own creation that was based on forties movies, fifties television. Jackie's look was based on Barbara Stanwyck, Joan Crawford, Bette Davis—all of those people."

County recalled that Patti Smith "played a mafia dyke with a mustache and a really ridiculous Italian accent, like 'Heeeeeey, wassa matta, you fuck-a-wid me, I blow-a ya fuckin' brains out!' She had a big phallus hanging between her legs and she was always picking it up and waving it at people."[10] The ambiguously gendered Smith also shot-gunned lines like "He could take her or leave her. And he took her and then he left her." At the end of *Femme Fatale*, the cast crucified Curtis's character by stapling her to a giant IBM computer punch-card as one character said, "Christ, you're hung!"

While Curtis put on an unforgettable act, it was Smith who struck audience member Lenny Kaye as one of the show's breakout performers. "It was pretty sweet," the future Patti Smith Group guitarist recalled. "I immediately thought she was one of the most engaging persons I'd ever seen, and I didn't even get to meet her that time. I just remember seeing her from afar. She was with Robert Mapplethorpe, and was a gloriously charismatic person with a lot of style."

When Smith was performing in *Femme Fatale* during the summer of 1970, she got to see the Velvet Underground for the first time in the upstairs room at Max's,

which held about a hundred people.[11] That same evening, Ridiculous director Tony Ingrassia asked Smith to read for his play *Island*. It was about a family that met at Fire Island for summer vacation, and Smith played another amphetamine-crazed character who rambled incoherently about the Rolling Stones' Brian Jones. "It's probably Tony Ingrassia's best work," Off-Off-Broadway actor Tony Zanetta said. "It was this big ensemble cast, where Patti was a speed freak niece who shot up onstage, threw up onstage."

Smith didn't actually vomit—that effect was achieved by a mouthful of cornmeal and crushed peas—nor did she really shoot up onstage. Ingrassia had assumed that she was a genuine speed freak because of her disheveled hair, pale skin, and skinny frame, but Smith nearly fainted when he casually asked her to use a needle to shoot water into her veins and pull a little blood (they ended up putting hot wax on her arm to make it look real). Smith said that her experiences doing *Island* finally solidified the notion in her head that she could be a performer. However, she hated memorizing lines and didn't like how scripted action constrained her—something that wasn't true of performing poetry and music, her next destinations.

After *Femme Fatale*, Curtis wrote the underground hit *Vain Victory: The Vicissitudes of the Damned*. "La MaMa to me was an acknowledgment that we kind of made it," recalled Zanetta. "It was very respectable. So if Jackie Curtis did *Vain Victory* there, it was taken seriously, even though it was a total mess." The show featured Curtis alongside a star-studded downtown cast that included Candy Darling, Holly Woodlawn, Taylor Mead, Mario Montez, and Agosto Machado, among many others. *Vain Victory* was Machado's first Off-Off-Broadway show, even though he had been hanging around the scene throughout the 1960s. "It never occurred to me that I would cross the footlights, but with the encouragement of Jackie Curtis I suddenly was on the other side, and people were so welcoming," he said. "I couldn't understand why, because I don't sing, dance, or act—and yet it was like, 'Be part of our show!'"

Eric Emerson and his band the Magic Tramps played *Vain Victory*'s backing music, and the glitter-slathered frontman had his own solo number as a naked cowboy, wearing little more than chaps. "There was glitter all over his pubic hair and what have you," Machado said. "He was not self-conscious about nudity because he had done that in Warhol films." Darling performed as a wheelchair-bound mermaid who was sad about having a tail but no legs (Woodlawn took that role after Darling left *Vain Victory*, accidentally rolling over the edge of the stage and into the audience during her first night as the mermaid). The

show also included an appearance by Larry Ree, who founded the cross-dressing Trockadero Gloxinia Ballet Company—playing "the world's most beautiful six-foot-six hairy-chested ballerina."[12]

Paul Serrato, who had composed music for Curtis's *Lucky Wonderful*, returned for *Vain Victory*. The show's most iconic song was "White Shoulders, Black and Blue," which Darling sang in a breathy, sultry Peggy Lee style. Ondine played a character named Nunca, for whom Serrato wrote the slinky, mysterious number, "Nunca the Divine." Ondine loved the opera, and he affected an operatic diva persona as he belted out, "I am Nunca the Divine / I make stars like Garbo and Lamarr." Montez and Machado nearly stole the show with their rendition of "You Never Hold a Winning Hand When You Hold a Man."

Vain Victory was, at its heart, a demented variety-type show that bore some resemblance to *Hair*, which was running concurrently. "*Hair* was a vaudeville kind of show, a revue, and so was *Vain Victory*," Serrato said. "Plot? Go find a plot. It didn't matter. It was an assortment of all these wonderful, off-center talents." *Vain Victory*'s rehearsals at La MaMa's practice space in the East Village were scheduled around *I Love Lucy* reruns, which Curtis watched twice each afternoon. ("*I Love Lucy* was a staple of Jackie's life," said County, who recalled that she would often act out scenes from the show in the apartment they shared.)

These rehearsals started mid-afternoon and would sprawl into the evening—which made it accessible for people like Lily Tomlin and Jane Wagner to drop by, along with others. "It was a gathering, and a continuation of an almost party-like atmosphere," Machado said. "From there, people could just stroll up to Max's Kansas City, a little north of Union Square. As they say, 'Location, location, location.' Jackie would meet someone at Max's Kansas City, and invite them, 'Would you like to be in my play?'" *Vain Victory* morphed considerably as Jackie added and subtracted cast members over the course of the extended six-month rehearsal period. "During that time we departed from the original script," Machado said, "because Jackie would see something on TV or heard something and said, 'Oh, we're going to do this.'"

"It was terribly imaginative," Tomlin said, "connected with all kinds of pop culture references that took on another angle the way Jackie used them." Sometimes, lines from *I Love Lucy* would make their way into the play, or dialogue from an old film that Curtis saw on late-night television. "Jackie would put speed in her coffee," County recalled, "and she'd sit there and write and write—sometimes outrageous things that made no sense at all, and sometimes it would be things from the telephone book, or things from *TV Guide*. She took a lot from *TV Guide*,

because she loved old movies." Curtis's plays were among the first to heavily appropriate from popular culture, a pastiche-heavy style that would become associated with postmodernism (not that she thought of her plays in such highfalutin terms).

After *Vain Victory* sold out at La MaMa, it moved to the much larger WPA Theatre on the Bowery and ran a total of sixty-six performances. "Jackie Curtis's beloved aunt—Josephine Preston, who helped raise her—joined the cast of *Vain Victory* at the WPA Theatre," Machado recalled. "She used to dance in the dance halls of Times Square, and when she joined *Vain Victory*, she said, 'Oh, what you kids are doing, you should have seen what *we* did back in my day!' And she showed off some of her old moves. She really had personality." Only Machado and Curtis performed in every show, until it finally petered out. "There was only a few of us left by the end of *Vain Victory*," Machado said, "just six of us onstage."

The show brought in rich people who were trying to "slum it" downtown, sometimes inviting the cast to their fancy uptown residences. Machado said it was like inviting a sideshow performer to dinner for your friends to gawk at, something that Tomlin also found troubling. "You just felt that someone was bringing them to be amused," she said, "or be hip or to rub elbows with that culture—but not really take it in or embrace it totally. I just felt that it was kind of exploitative."

"The Ridiculous people—and Jackie, Holly, and Candy—were always getting invited to these big uptown parties," Tony Zanetta said. "They were kind of like toys of the rich people, these little social freaks." Despite the patronizing attitudes, Machado and his friends made the most of it. "It was such a novelty for many of us, being invited uptown. You could tell they were from different classes because they had nice teeth and could afford dentists. People who were like us, we didn't have manicures."

Both Jackie Curtis and Candy Darling held on to a sincere hope that they would become actual stars, but they were too far ahead of their time to crack the glitter ceiling. When Lily Tomlin was performing in the early 1970s at the popular midtown venue Upstairs at the Downstairs, she got Darling an audition for the nightclub's musical review. "I thought Candy was really good in the audition," Tomlin said, but the show's producer had a more uptight midtown audience to contend with, so he passed. "My frustration is that they couldn't break through to the mainstream culture," Jane Wagner added, "but that was what made them unique, so that's ironic. You wanted them to be accepted in a bigger way because they wanted it so much, but then if they had been, they wouldn't have been who they were."

The last time Robert Patrick saw Darling, he was cruising around Times Square with friends in a baby-blue Thunderbird convertible when they saw her on the sidewalk looking distraught. "We stopped and said, 'What's wrong, Candy?' She said, 'Well, I'm supposed to go to this party and I get $500 for going to a party now, but my ride hasn't come.'" When they offered to take Candy, she hopped in the back of the convertible with the grace and poise of a beauty pageant winner. "She sat up on the backseat," Patrick said, "and waved at people like Miss America as we drove her to a party."

In 1974, at the age of twenty-nine, Darling died of lymphoma, perhaps caused by the questionable hormone treatments she received. "By the time you read this I will be gone," she said in a deathbed letter written to Warhol, which captured the exhaustion that saturated that era. "I am just so bored by everything. You might say bored to death."[13] By the mid-1970s, the Off-Off-Broadway and Warhol Factory scenes were also on life support. Their energy was being redirected to a new, burgeoning scene that media outlets would dub "punk," a trend that was also reflected in Smith's career arc.

"Even though she became known for her music," Zanetta said, "Patti was kind of a natural actress. She was obviously at the beginning of something, because she had a little following already." Theatre Genesis playwright and director Anthony Barsha ran an acting workshop that Smith was a part of, in which they worked with sounds and movements, and did other theater games. "She got more into more physical stuff like that as a result of the workshop," Barsha recalled. "Later, Patti said she had learned a lot from that, and it helped her become more of a rock performer onstage."

CHAPTER 22

Underground Video Ushers In a New Media Age

Andy Warhol dabbled in video, but it was Shirley Clarke who fully realized the potential of this new technology. She and many other downtown artists who embraced video weren't trying to make low-budget movies or television shows but instead wanted to explore the unique potentials that portable video cameras offered. "With video, you can use it like film, but there are so many other possibilities with it that you can't do with film," said Wendy Clarke. "Just viewing it live, you can see yourself in the monitor while you're doing something, which you can't do with film. Nobody else was doing this, and you felt like everything that you did you were inventing."

There has been quite a bit of celebratory talk about how the Internet made possible "user-generated media"—materials made and shared by everyday people, as opposed to the products of corporations—but as early as the 1960s the denizens of downtown were laying the groundwork for a new media age. Through their experiments in video, Clarke and her peers were in some ways beginning to imagine the Internet before its technological infrastructure existed. She advocated for what she called "participatory communication," imagining what we now call videoconferencing by setting up cameras and video monitors in different parts of her Chelsea apartment and rooftop space.

"My mother would be pretending that one of the monitors was in China, one was in Russia, one was in France," Wendy Clarke said, "and we would sort of act like we were talking to each other across space and time. It was really crazy fun playing with this new medium." Wendy's way of rebelling against her mom was to not do anything artistic, though she eventually found herself making visual art. "Then I stopped painting and drawing, and just did video," Wendy said. "My mom and I became video artists, so we stopped what we had done before. We had lost interest because video was so exciting. It was so new. There was no history, which was very freeing."

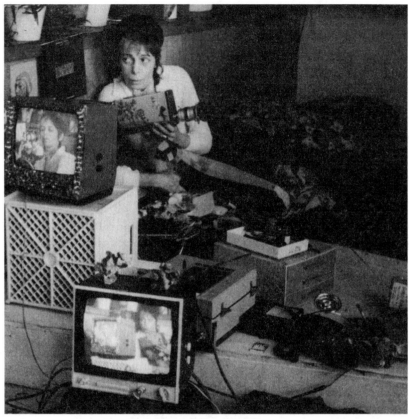

Shirley Clarke with her video equipment
COURTESY THE WISCONSIN CENTER FOR FILM AND THEATER RESEARCH

After getting a New York State Council on the Arts grant to create video art, Shirley Clarke began acquiring video cameras, monitors, and other recording equipment. Unlike today's portable digital cameras and mobile phones with high-definition video capabilities, Sony's reel-to-reel DXC 1610 Portapak camera was quite bulky. It weighed about six pounds, not including the heavy batteries, external microphones, headphones, and other gear. As Shirley acquired more video equipment, her Chelsea Hotel penthouse became a hub for video aficionados of all kinds. "There were different groups that were happening in New York," Wendy said. "We all would do these events at the Chelsea, on the roof."

"One time," Wendy recalled, "Arthur C. Clarke came over and he had just gotten this small laser that you can hold with your hands." The science fiction author, another Chelsea resident, had been given the handheld laser beam projector by a crew member who was working on the film adaptation of his novel *2001: A*

Space Odyssey. The mischievous Clarkes (who were not related) projected the laser onto the Twenty-Third Street sidewalk below—and then Shirley, dressed as Groucho Marx, did a slapstick routine while playing with the beam on the ground. "People on the street would become fascinated with the beam," said Nancy Cain, a member of another collective called the Videofreex. "They would try to take the beam with them as they walked all the way down the street and then they would turn the corner, but the beam couldn't turn the corner with them."

"I was with Arthur when he and Shirley had the laser," recalled Viva, another Chelsea resident. "I said, 'Isn't it kind of dangerous?' They said, 'No no no, it's fine.' Well, I wasn't so sure." Viva and Shirley got to know each other when the two worked together on the 1969 film *Lion's Love.* "I was married at the time to Michel Auder, the director of *Lion's Love,* and he, Shirley, and I all moved into the Chelsea. Shirley had the penthouse, and we also had a place, so we became close friends." Viva considered Shirley an evangelist for video, and when they were living in the Chelsea she urged the married couple to buy a video camera. "So I did," Viva said. "I got Michel to do video, and we both did it, for years."

Cain remembered Shirley Clarke as a wonderful, lively person whose rooftop penthouse was like a salon, filled with artists, students, visitors, and her two little poodles. Videofreex member Skip Blumberg added, "Shirley was very eccentric, and I think, kind of out of her mind." Her frenetic nature was expressed in the way she looked and dressed, with lipstick that sometimes smeared beyond her lips, and her place was a cacophony of cables, electronics, and other equipment.

The Chelsea rooftop's focal point was a two-story pyramid tower, nicknamed the "Tee Pee," which contained a kitchen and a room with a bed on the first floor and a second-floor loft, where Shirley stored equipment. "On the top floor, she had a Plexiglas platform built, so you could shoot videos through the Plexiglas," Wendy said. "There were different places to experiment, like on the roof garden. Video equipment was everywhere, and there were probably, like, fifty monitors of all shapes and sizes and configurations." This teepee-like structure provided the namesake for Shirley and Wendy Clarke's group.

"The Tee Pee Video Space Troupe was kind of like a theater troupe," Wendy said. "All of us came from different art backgrounds. I had been a painter, and my mother a filmmaker and a dancer, and we had photographers or others who worked in different mediums. There were a lot of visitors all the time. We would start playing and experimenting with video in the evening, as the sun went down, and we would go through all night long until the sun rose." Videofreex members

participated in the Tee Pee Video Space Troupe activities as well, and Shirley was also involved in their group. "Things were fluid then," Blumberg said. "It wasn't proprietary. So when Shirley worked on our thing she was one of the Videofreex, and when I worked on her things I was part of the Tee Pee Troupe."

The Videofreex came together in the late 1960s when Mary Curtis Ratcliff met David Cort, who was one of the first to get his hands on an early Sony Portapak camera. Ratcliff had been raised in an upper-middle-class midwestern family and attended the Rhode Island School of Design, then worked as a teacher. She and Cort moved into a Lower East Side loft previously used as an old stocking factory, which was about one hundred by three hundred feet, with floor-to-ceiling windows, a typical postindustrial loft. "Today it might cost $3,000 a month, just for rent," Ratcliff said, "but I bought it back then for a total of $3,000."

In August 1969, Cort hauled his Portapak upstate to the Woodstock Festival, where he met another early videographer named Parry Teasdale, and they joined forces. Together, they focused on shooting the crowd instead of what was happening onstage, creating a unique document of the everyday happenings at that festival. Cort told Ratcliff, upon his return downtown, "I met this really neat guy named Parry. And, oh, by the way, Parry's going to come and live with us." *Oh, really?!* she thought. "So anyway," Ratcliff recalled, "Parry turned out to be this wonderful young man and he hung around us for a while."

The three began collaborating on video projects and gathered other like-minded artists into their collective. "David, Parry, and I and called ourselves the Videofreex," Ratcliff said, "but we quickly gathered new members." Cort met Davidson Gigliotti, who was holding a video camera in a bank, and he too was invited to come aboard. "Davidson was a huge asset because he's an incredible artist and he is a really great carpenter," said Ratcliff, who began developing her own distinctive camera style—which was very slow, with steady camera pans and zooms.

Next came Nancy Cain, a former actress who had taken a job working on a CBS pilot that was to replace *The Smothers Brothers Comedy Hour*. CBS executive Don West had hired writers from Chicago's famed improvisational comedy troupe, Second City, to create a hybrid television variety show, though Cain recalled that "he really wanted to create a cutting-edge documentary show." West heard about the Woodstock footage, so he and Cain headed down to Ratcliff's loft and were stunned by the tapes. "*First Day #1* and *First Day #2* documented a help tent for kids who were freaking out on drugs," Cain said of the fuzzy black-and-white footage. "Don hired them immediately, and we all started on a pilot show to present

to the network." The group went from having no money to working with a healthy five-figure budget, which was a lot of money for the time.

Ratcliff remembered going to the bowels of CBS and, like kids at Christmas, hauling away whatever they wanted from a massive video equipment room. The 'freex stood out in CBS's headquarters, a high-rise building called Black Rock where everything was carefully controlled by the network, from the air conditioning to the artwork on display. "There we were in our new suite of offices," Cain said, "with posters and tacks on the walls—and music, *boom boom boom*—people going in and out twenty-four hours a day." With all the resources and equipment they could ask for, the group began working on their doomed television show pilot, *Subject to Change*.

Cain's first assignment as West's assistant was accompanying the Videofreex to Chicago. Abbie Hoffman, Jerry Rubin, and six other alleged conspirators were standing trial there, facing federal charges after organizing demonstrations at the 1968 Democratic National Convention. While planning the protests, these downtown radicals invented a political party—the Yippies—a name that Paul Krassner coined. "*Y* was for *Youth*," he explained, "because there was a generation gap, and the *I* was *International*, because this kind of revolutionary consciousness was around the world, and *P* was for *Party*, in both senses of the term. *Yippie!* The moment I said it, I felt it would work. It was a form of marketing an attitude." These prankish tactics provided free publicity for the demonstrations, but, unfortunately, the riots that ensued in Chicago resulted in conspiracy charges against the organizers, known as the "Chicago Eight."

The Videofreex got access to the defendants and their attorneys as they planned their legal strategies, and they also interviewed the head of Chicago's Black Panther Party, Fred Hampton. "He laid it out about the politics of being black in America," Cain recalled, "and then someone asked Fred Hampton the question of the week: 'Are you afraid of getting murdered?' He said, 'No,' but three weeks later, he was murdered in his bed by the police." The city reached a $1.8 million settlement with Hampton's family after a grand jury "found evidence that seventy-six expended shells were recovered at the scene, and that only one could be traced to a Panther."[1] Hampton's murder radicalized Cain. "After Chicago," Ratcliff recalled, "Nancy decided to jump ship from CBS and join the 'freex."

The collective needed studio space to work on their DIY television show, so the network rented the Videofreex a loft at 96 Prince Street, the same building where the Paula Cooper Gallery opened in late 1968. "This was right when SoHo

was beginning to happen," Cain said. "There were some art galleries popping up here and there, but mostly it was still little factories making clothes or baking bread." Unlike the Lower East Side, which was packed with people, only a few artists and other residents occupied SoHo's empty industrial buildings, along with a smattering of small factories that were still operating. There were few stores around the Videofreex's new loft—just a Puerto Rican bodega and some other small businesses. The biggest draw was Fanelli's, right beneath the Videofreex's loft, an old-fashioned bar that served inexpensive bean soup for lunch. "I loved that part of downtown," Blumberg said. "Everybody who lived in the neighborhood knew each other because of its small scale."

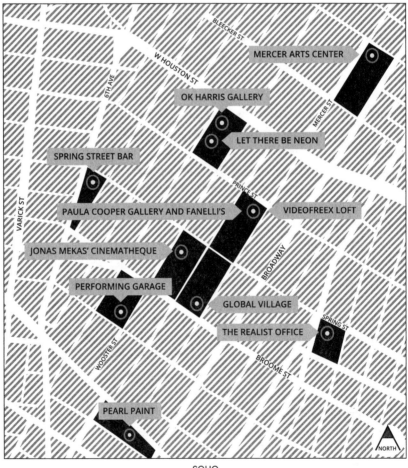

SOHO

THE DOWNTOWN POP UNDERGROUND

Blumberg moved into the Prince Street loft when their ragtag television studio was still being built; he put his mattress on a tall pile of sheetrock and every day it got a little lower as the construction continued. The control room was at one end of the loft—a large, open space where they hosted video shows every Friday night. The three-camera setup was much like any other television studio, but much looser and more informal (the audience sat on cushions placed on the floor and sometimes smoked pot). "There would be naked yoga going on in one part of our loft with somebody taping that with a multi-camera setup, which would be blended or mixed together," Blumberg recalled, describing an average day at the Videofreex loft. "Then there would be a meeting in the other part of the loft about doing video projections with the people that were starting the first Earth Day celebration, and then our accountant would be in another meeting."

Cain remembered people on the street being amazed by their Portapaks because, at that time, most people had never seen themselves on a video screen before. More than being a mere novelty, the Videofreex were trying to create media on their own terms. "We wanted to make our own world," Ratcliff said, "and this video movement was part of changing the world. There were only three networks—ABC, NBC, and CBS—so this was an underground way of getting information out." Blumberg added, "We had this front-row seat to everything that was going on, because the major media wasn't covering it. And if they were, they were covering it from the outside and we were covering everything from inside."

Predictably, the other CBS executives hated West's pet project. When the network suits descended from Black Rock to watch the *Subject to Change* pilot on December 17, 1969, they were taken aback by the Videofreex's studio production. Buzzy Linhart led the show's house band, and the downtown audience sat in bleachers. "We put the CBS executives in our neighbor's loft," Cain said, "and they were smoking these big smelly cigars, like, straight out of central casting. They were obnoxious and they burned a hole in our neighbor's futon, stuff like that. Then at the end, they just stomped out. I never really thought it was going to get on the air, and I was right. But it was a great adventure, then everybody got fired. Don West, he got fired."

Over the course of five months, the Videofreex had blown through about $70,000 of CBS's money, about half a million in today's dollars. They may have failed in landing a major network television show, but this freed them artistically and left them with a lot of equipment—some of which belonged to CBS. "They wanted it back," Ratcliff said. "I remember people coming to the loft and Parry and

David rolling their eyes saying, 'I don't know what happened to *that!*'" Cut loose from the network, the Videofreex pooled their savings and geared up, forging an independent path that reflected their utopian ideals.

For the first time, women played a large role in developing an emerging technology. Of the nine Videofreex, four were women, and they participated equally in most of the technical aspects of the productions. Unlike the film industry—which had a significant barrier to entry for women, as Shirley Clarke discovered firsthand—video emerged at a time when gender roles and relations were transforming in the United States. "It just all collided at a lucky moment in history," Wendy Clarke said, "in terms of being able to be among the first people to explore a medium. That was so unique, and I feel so lucky to have been around then."

Videofreex in their Prince Street loft control room
© VIDEOFREEX

"With the video camera, I was seeing it for the first time and so was everybody else, males and female, everybody," Cain said. "It was a level playing field. You all began with a same amount of knowledge: none. I must say that the men in the Videofreex, they were great. Everybody taught each other, and then you went out. We truly were equal, and I could do whatever I wanted. It was the best

thing." Another early video pioneer, Steina Vasulka, maintained that so many women were involved with video because it was an underdog medium. "There were no men there saying, 'Let me direct this scene,' or anything like that," she said. "So this allowed women to take control of the video-making process, like Shirley. She had a huge success at the Cannes Festival, and came back home and thought that Hollywood would be waiting for her, but they didn't want to have anything to do with her."

There was a major divide between the emerging video community and the established film world, which remained aloof and dismissive toward video. "I don't understand why," Vasulka said. "We were such nobodies that there was no reason to resent us, but they did. So Shirley, in that sense, was kind of a video renegade, a traitor to them." Rather than making cheap imitations of established television show formats, videomakers played with the new possibilities this medium offered—from creating visual feedback loops to capturing the mundane experiences of everyday life with handheld cameras. Some of these video experiments appealed primarily to the avant-garde, but something that became known as reality television would begin reshaping the cultural landscape by the twenty-first century.

THE TWISTED ROAD TO PUNK

1970 – 1976

CHAPTER 23

An American Family Bends Reality

Andy Warhol did not appear in television's first weekly reality series, *An American Family*, but he was a looming influence behind the scenes. Shot in 1971, the PBS show premiered on January 11, 1973, and became an immediate pop culture sensation. It was discussed by newspaper columnists, debated by television pundits, and taken seriously by respected scholars such as Margaret Mead. In a *TV Guide* article, the anthropologist declared that the show was "as new and significant as the invention of drama or the novel—a new way in which people can learn to look at life, by seeing the real life of others interpreted by the camera."[1]

Though *An American Family* primarily took place in the Loud family home in Santa Barbara, California, several key moments were filmed in New York—exposing the likes of Jackie Curtis and Holly Woodlawn to millions. It also introduced audiences to the first openly gay man on television, Lance Loud, who had already forged links with the downtown underground in the mid-1960s. After he saw a *Time* magazine article about Warhol and Factory superstar Edie Sedgwick at the age of thirteen, Loud dyed his hair silver. He even struck up a long-distance friendship with Warhol—via mail and, eventually, telephone—but the letters and late-night phone calls abruptly ended after Warhol was shot in 1968. "I tried to write him, but the letters came back," Loud said. "He suddenly became very, very private. He got very scared after that for a long time."[2]

Serendipitously, Sedgwick—who had been in a downward spiral after breaking with Warhol in 1966—appears momentarily in *An American Family* while attending a fashion show in her hometown of Santa Barbara. "Edie came up, drawn like a moth to flames by those cameras," Loud recalled. "I was frightened. I thought suddenly it would appear that I was standing there with a ghost of myself in the future."[3] Later that evening, Sedgwick died of a barbiturate overdose after her final ephemeral brush with fame.

Because the reality television format would not be established until the early 1990s, *An American Family* felt completely new and fresh, but it still had all the

hallmarks of a typical hit television show. The Louds were an attractive, econom-ically privileged family bubbling with conflict just beneath the surface. The two most prominent sources of dramatic tension were Lance's unrepressed homo-sexuality and the onscreen divorce of parents Pat and Bill. It is often erroneously reported that Lance "came out" on the show, but he never really tried to hide being gay in the first place. It was fairly obvious when the cameras began rolling.

Homosexuality wasn't openly discussed on television, so it was the parents' divorce that framed the overall narrative. For instance, *An American Family*'s title sequence ends with a cracked-glass effect, with the word "family" shattered into pieces. "The story of Pat and Bill's failed marriage was perhaps straight-forward enough in what it suggested about the problems of the contemporary family," wrote historian Andreas Killen, "but the Lance story line opened up an altogether more complicated Pandora's box: issues of generational conflict, sexual orientation, and not least, the medium's claims to realism. Lance and his mother quickly emerged as the series' central characters—hardly surprising, given that it was their actions that brought the traditional family most sharply into question."[4]

Kristian Hoffman quickly became part of the Louds' extended family after he and Lance met in their high school art class in Santa Barbara. "Whenever one of Pat's children brings home someone, it's her kid," Hoffman said. "So it was real exciting to have such warm company to be allowed into." Of many lessons that Lance taught his best friend, the most important was *When in doubt, just do it.* The pair often took road trips to see concerts, as when they rode up to San Francisco to see the Rolling Stones headline the Altamont Speedway Free Festival in 1969. "We were gone for three days," Hoffman said, "and my mom didn't even notice." The exasperated Pat Loud was aware, but there wasn't much she could do. "Lance would sneak out without my permission," she sighed. "He'd just disappear, and it kind of got to be routine."

Having been obsessed with the Warhol scene since he was an adolescent, Lance was already an avid Velvet Underground fan. The two friends ducked out one night and saw them play in Los Angeles, which Hoffman counted as one of the greatest concerts of his life. "I wasn't prepared for seeing them," he said. "Lou Reed came out and he was pretending he was going to hit you in the head with his guitar. He would swing it like an ax right in between the heads of people in the audience. For me, it was eye opening and exciting."

Loud and Hoffman formed a band during high school and eventually moved to New York—where Loud became reacquainted with Warhol and formed a punk

LOUD
Lance Loud
Kim Cheeseman Michele Loud
Kevin Loud Delilah Loud Kristian Hoffman
David Collert Jay Daugherty

Loud band (pre-MUMPS) group photo, circa 1972
COURTESY KRISTIAN HOFFMAN

group. "Lance was one of the most curious and terrific kids around," recalled Warhol, "and I always told him that he had the best band around, called the Mumps."[5] Loud, in turn, described Warhol as "the greatest father figure . . . [of] that generation," noting that, "He was always parental."[6] The New York economy had crashed, so the rents were low enough for the two friends to put down roots in the city and live on next to nothing. "That's why these landlords were desperate to rent an apartment to anybody," Hoffman said, "because why else would a landlord rent an apartment to unemployed seventeen-, eighteen-year-old kids?"

When *An American Family* went into production, Loud and Hoffman didn't think twice about having cameras record every moment of their lives, for it was all part of their master plan. "We were in a self-deluded dream that we were going to somehow become big rock stars or big artists like Andy Warhol, or some crazy thing," Hoffman said. "So when this opportunity came to us with *An American Family*, it didn't seem unnatural at all. It just seemed like, 'Well, life is progressing like we expected. Someone is paying attention,' so we're going to move forward and do something crazy. Also, we were young and thought we were the most fascinating people in the world. It didn't really occur to us that we might not be that interesting."

When filming started, Lance was living at the Chelsea Hotel with roommate Soren Agenoux (who had written the twisted version of *A Christmas Carol* that debuted at Caffe Cino in 1966). "My first clash came immediately," wrote Pat Loud in her 1974 memoir *A Woman's Story*. "I flew to New York to spend a few days with Lance, who, as the world now knows, was staying at the Chelsea Hotel, a place I'd pictured as a nice, quaint, middle-class hostelry where a white-haired grandma type with a big bunch of keys at her waist clucked over boys far from home and brought them hot toddies and did their laundry."[7] She soon discovered otherwise.

"Lance had endeared himself to Soren Agenoux, who was a kind of creepy guy," Hoffman recalled, "but he had an apartment in the Chelsea Hotel. So that's who Lance was living with when Pat first visited Lance in New York." The second episode of *An American Family*, which focused on her first encounters with the underground, provided fodder for water cooler conversations around the country. "We're going to the La MaMa theater tonight," Lance told his mother. "*Vain Victory* with Jackie Curtis. It's the ultimate of the underground, honey. You'll just think it's so neat."[8]

Several minutes of campy performance footage from Curtis's show were included in that episode, as well as an awkward moment in which Holly Woodlawn

met Pat Loud in a Chelsea hallway. Later that evening, in a diner after the play, the cameras made it clear that Pat was not impressed by what she saw at La MaMa:

"I hope you don't think it was too gross," Agenoux began. "We had no idea what—"

"I thought it was pretty gross," Pat interrupted, "yes."

"Well, we had no idea it was going to be *that* much," Agenoux said.

"I loved the costumes," Lance added. "And some of the one-liners were so good I couldn't believe it."

"I don't like things that make me feel uncomfortable and embarrassed," Pat said matter-of-factly.

"All the time?" Lance asked. "I can't imagine . . ."

"Oh, no, not *all* the time," she replied. "Part of the time I was bored, and part of the time I was amused."[9]

Pat Loud explained her reaction to *Vain Victory* decades later, which mostly had to do with the fact that it was a hot summer night, and La MaMa had no air conditioning. Along with the outré dialogue and uncomfortable bench seating, it was all a bit too much for her. "I was just a housewife from Santa Barbara, California," she said, "which was a small town at that time, and I had no idea there were people like this in the world. And it was pretty crazy. I remember there was a toilet in one of the major scenes, and it just did not appeal to me. It did not have my name on it."

The omnipresent cameras gave Loud and Hoffman a cachet they hadn't earned—people saw the production crew and assumed they must be famous. "Lance learned posture in front of the camera," Hoffman said, "and out of all of the family, I think he was the quickest learner of how to make a drama center around him." He impishly broke the frame and addressed viewers directly in a knowing, Warholian way—an early televised expression of the emerging postmodern sensibility. Loud made fun of the conventions of documentary filmmaking and even turned the personal drama of his parent's divorce into a meta moment. He spoke of their split in a highly theatrical tone during one episode, noting that Pat and Bill Loud had been rehearsing this tragic scene for ages.

"While the performances of the other family members reflected a controlled self-consciousness that both denied and unconsciously reflected the camera's presence, Lance's was pure artifice, overacted burlesque," Andreas Killen argued. "It is impossible watching Lance not to be reminded of the presence of the camera, not least because of his preoccupation with clothing, makeup, and hair. In Lance's scenes, reality television took on increasingly surreal qualities, no more

so than in those moments in the Chelsea Hotel in which Warhol superstar Holly Woodlawn appeared, or in the performance of *Vain Victory*."[10]

The embrace of artifice is a cornerstone of camp, something the first openly gay man on television knew quite a bit about. Near the end of the series, for example, Loud could be seen in full drag when he arrived at the Santa Barbara airport. Back at the family home, in a scene soundtracked by the Velvet Underground, the big brother gave his sisters makeup tips and paraded around in colorful clothes.[11] His playful undermining of the codes of observational cinema certainly made for great television, and it also helped make the medium safe for campy irony.

Loud's flamboyant persona, along with Curtis and Woodlawn's glitter-trash look, were unprecedented on network television, opening up new possibilities, especially for those outside of urban centers. For viewers like actress and performance artist Ann Magnuson, *An American Family* hipped her to downtown New York well before she moved there in the late 1970s. Growing up in West Virginia, she didn't have access to many cultural outlets. "So around '73, '74, I watched the episodes," Magnuson recalled. "The TV was always on in the kitchen. My mother watched PBS because she was very arts-oriented, so I remember they reran things all the time. *An American Family* was how I found out about that underground scene."

Lance became the show's breakout star—appearing with the other Louds on *The Dick Cavett Show*, the cover of *Newsweek*, and other major media outlets in 1973. The coverage was shaped by PBS's advertising campaign and PR materials, such as the following copy: "Since the rules of the game are clear, family members speak in private code. 'Don't depend on Soren,' Pat says to Lance. (Translation: This whole homosexual scene is shifting, sinister. You must try to get out.) When Lance complains he can't talk to his father, she smiles faintly. 'No problem. He's such a conversationalist he takes care of the whole thing.' (Socially, sexually, emotionally, that's how he is.)"[12]

Pat Loud recalled how every Thursday morning—the day the show aired—newspaper ads trumpeted headlines such as Are You Ready for the Louds? and He Dyed His Hair Silver and Clothes Purple.[13] The show was supposed to be titillating, but the featured players found *An American Family* rather dull. "I think we all were excited that we were on TV, but when we saw the series we thought it was so incredibly boring," Hoffman said. "Like, we could barely make it through an episode. We just thought they cut it so peculiarly. They didn't stick to the high points, except of course when Pat was going through her husband's files and discovered he was cheating, which was gripping."

"The press response was totally bewildering because we expected it to be reviewed as a documentary, and instead they reviewed the family," he continued. "The vitriol was just palpable. So that started to hurt after a while." Writing for the *New York Times Magazine*, journalist Anne Roiphe exemplified the mainstream critical reception—particularly her treatment of what she called "the flamboyant, leechlike, homosexuality of their oldest son, Lance."[14] For these critics, he epitomized both the stupidity of mainstream television programming and the perversity of underground culture.

"Lance Loud, the evil flower of the Loud family, dominates the drama—the devil always has the best lines," Roiphe wrote. "Lance is twenty years old and living in the Hotel Chelsea in New York as the series opens. He describes his family with a kind of campy wit and all the warmth of an iguana singing in the driving rain. The second episode shows Pat Loud coming to New York to visit her son at the Chelsea. It was in this episode I most admired her strong self-control. She is confronted, brutally and without preparation, with the transvestite, perverse world of hustlers, drug addicts, pushers, etc., and watches her son prance through a society that can be barely comprehensible to a forty-five-year-old woman from Santa Barbara."[15]

Lance Loud
© KRISTIAN HOFFMAN

Lance Loud became a symbol of the breakdown of traditional values at a time when the women's and gay liberation movements were challenging and reshaping attitudes about the family. But mostly, the critical reception felt personal. "In a weird way, the impact on Lance and me was not nearly as much as it was on Pat and Bill," Hoffman said. "They were already distraught being in the divorce, and then they had this sort of thing cast upon them. There wasn't a lot of stuff that said, 'Oh, they must be in so much pain to be going through that divorce.' It was more like, 'Look how stupid they are. And now they are divorcing.'"

Pat Loud finally had a chance to defend herself on *The Dick Cavett Show*, a popular ABC program. "I said we'd been had," she recalled, "and *cinema verité* didn't work and they'd made us look tragic and terrible by cutting out all the good parts and, even if we'd gotten a divorce and Lance had a few problems, we were neither monsters nor zombies."[16] At times, Cavett physically recoiled during his one-on-one segment with Lance Loud. The talk show host's discomfort was surely increased by the presence of a conceptual artist friend of Lance's who was sitting in the studio audience shirtless with a sequined clothespin through his nipple—wearing nothing else but tight pants, wraparound goggles, and a white helmet.

"Television ate my family," Lance later remarked, though his sister Delilah pointed out that *he* was actually the carnivore—"eating the ridicule and scorn to throw it back in the faces of the phonies, the put-down brigades, and the hypocrites."[17] In the midst of the critical firestorm, Pat Loud stood her ground in the face of the homophobic attacks against her son. "Frankly, I'm proud of Lance," she wrote in 1974, "of his candor, his daring spirit, and his frontal assault on life."[18] By the mid-1970s, Pat Loud could be seen at CBGB cheering on her son and his friends while the Mumps shared stages with the Ramones, Television, Blondie, and other punk bands.

CHAPTER 24

Pork, Glam, and Audiotape

The play *Pork* was based on transcripts of Andy Warhol's audiotaped conversations with Factory regular Brigid Polk (née Brigid Berlin), with some notable alterations (Brigid Polk became "Amanda Pork" and Viva became "Vulva"). "Andy was just a very quiet guy who didn't say anything," recalled Tony Zanetta, who played the Warhol character in the show. "He liked to instigate other people to talk, and he started carrying around a tape recorder everywhere. What Warhol did with everything, he would take something real and then put it on the wall and it was 'art.' *Pork* was that as well because, really, what was it? It was a bunch of words. It was real conversations, but it was put onstage with actors speaking the lines. *Pork* became a play in the same way that his art was created."

Pork, which debuted at La MaMa, also marked the beginning of the end of Warhol's significant ties to the downtown scenes, a transition embodied by the evolution of *Interview* magazine. Warhol launched it in 1969 as an underground movie magazine printed on cheap black-and-white newsprint—much like what was available in indie bookstores such as the Peace Eye—but by the early 1970s, *Interview* was reborn as a glossy magazine filled with celebrity photographs and transcripts of verbatim interviews.

He traded in downtown companions like Jackie Curtis, Candy Darling, and Holly Woodlawn for the high-rolling glitterati of uptown and Europe, who could afford his art. Anyone could have a Warhol portrait made for $25,000—about $150,000 in today's dollars—which became the bread and butter of the Factory operation. "If his Factory had been an incubator for many of the experimental tendencies of the New York underground of 1960s," historian Andreas Killen wrote, "by the early 1970s it had been transformed into an increasingly professionalized operation dedicated to chronicling the lives of celebrities."[1]

Zanetta recalled that he and his friends also shared Warhol's obsession with celebrity culture. "Andy was the epicenter of the downtown scene for most of us, and we all wanted to be superstars," he said. "We all wanted to be discovered by

Andy Warhol. We wanted to be in that scene. We thought that was the ultimate." Zanetta grew up as an oddball kid immersed in popular culture and, like Warhol, was drawn to the bright lights of New York City. "I was always artistic," he said. "Sure, I was always gay—I didn't know what that meant, but I didn't play baseball, and I had more friends who were girls than boys. I was a loner, but I wasn't socially awkward. I was just smart and I read a lot." Some of Zanetta's big influences were mass-market magazines like *Life* and *Look*, and it was in one of those publications that he learned about the existence of Off-Off-Broadway at the age of ten.

After the gay witch hunts of the 1950s began to subside, major publications such as *Time, Life, Newsweek*, and the *New York Times* began publishing pieces on the "gay lifestyle," bringing it into the public eye.[2] "*Life* magazine corrupted me because I read that every week," echoed director John Waters. "*Life* taught me about Tennessee Williams, it taught me about beatniks, it taught me about everything that I didn't know about in Louisville, Maryland. So *Life* magazine was really my key out of that world." Zanetta also learned from one of those magazines that Fire Island was a gay hotspot. "I didn't even know gay people existed at Fire Island," he said, "so these ideas would come through the mass media." Located off the coast of Long Island, that resort area was the setting for *Island*—a play that costarred Patti Smith and was directed by Tony Ingrassia, the larger-than-life figure who also directed *Pork*.

Zanetta graduated from high school in 1964 and went to art school in Buffalo, then dropped out. While coming to grips with his sexuality and discovering the gay world, he had a roommate from Massapequa, Long Island, who grew up with both Tony Ingrassia and Candy Darling. Zanetta got to know them both when he moved to New York City, where he lived fairly deep in the East Village on Twelfth Street and Avenue C. At first he did only conventional theater, though Zanetta was familiar with the underground theater scene. "I was aware of the Theater of the Ridiculous and I had seen two things that I absolutely loved, including *Gorilla Queen*, which was Ronald Tavel's," he said. "I also saw *Night Club*, which was directed by Tony Ingrassia."

Ingrassia directed several other Off-Off-Broadway shows, including Curtis's *Femme Fatale* and the Wayne County–penned three-act play *World: Birth of a Nation*. "I went to the audition for *World*," Zanetta said, "and I had previously met Tony Ingrassia through my college roommate. So Tony's like, 'Darling, you don't have to audition. You can be in my play.'" Because County loved the Velvet Underground, many of the lines from the first scene of *World* quoted the band's song titles:

"What goes on?"

"I'm beginning to see the light."

"Oh! Sweet Jane!"

The intimidating presence of Mary Woronov, who wielded a whip while those lines were uttered, pushed this Velvet Underground homage to more absurd heights. The play takes place in a hospital, and its plot revolves around a necrophilic nurse who has sex with a dead dog. It also features a memorable scene in which John Wayne gives birth out of his anus, followed by a slapstick routine in which the plastic baby was dropped on its head and kicked around the hospital floor until various body parts fell off. "Oh no," a nurse exclaimed, "he's born dead!"

Ingrassia's prankish casting decisions ratcheted up the madness. The more square the actor, the likelier they would be asked to play a wild part—just to see what these normal, straight thespians would be willing to do in the name of acting. The person who played John Wayne, for example, was just a mainstream actor who responded to the casting call ad with no idea what he was getting himself into. He refused to do full frontal nudity, but still agreed to expose his rear end for the birth scene.

While Zanetta performed in *World* (as Dr. Louise Pasteur) and worked on the crew for Ingrassia's next show, *Sheila,* Warhol was arranging for him to direct *Pork*. One day during rehearsals for *Sheila,* Ingrassia turned to him and said, "You could play Andy," and Zanetta was happy to oblige. One of the first things he did was cut his hair like Warhol's, and he also closely studied the artist when he came to rehearsals. "For me, it was the thrill of a lifetime to do *Pork*," Zanetta said, "because I just thought that Warhol was, like, *it*. I look at pictures of the show and, sure, I don't look like Andy Warhol—but if you look at pictures of me made up to look like Andy, there are a lot of physical similarities that I wouldn't have even been aware of."

County played Vulva, and *Pork* also featured a young actor and playwright named Harvey Fierstein in his La MaMa debut (he would go on to win two Tony Awards for writing and starring in *Torch Song Trilogy*). "*Pork* was still the Ridiculous theater thing, but it pushed Ridiculous into a whole different area," Zanetta recalled. "Ingrassia's way was more polished, sort of like *I Love Lucy*. It was like TV acting. It was very broad, very exaggerated."

Pork debuted on May 5, 1971, in downtown New York before moving to London's Roundhouse theater with the Amanda Pork character now played by Cherry Vanilla. Her character appeared naked throughout the show and shot up a speed-like substance called Vitameatavegamin (a classic reference to *I Love*

Lucy). She also rolled around in a bed with two pretty boys named the Pepsodent Twins who wore high heels, and also powdered their pubic hair blue and green. The onstage action was controversial, but it was nothing compared to the cast's offstage antics. "That outrageousness really flowered in London when we went to do *Pork*," Zanetta said, "because we were like Ingrassia. We were really loud, really vulgar exhibitionists. We like to attract attention to ourselves."

David Bowie, who had long worshipped Warhol and the Velvet Underground, attended the Roundhouse production of *Pork*, but when he invited the cast to one of his concerts the Americans were not impressed with what they saw. Zanetta had been intrigued by *The Man Who Sold the World* album cover—in which Bowie wears a dress that made him look like Lauren Bacall—but in person he was far from glamorous. "He just looked kind of hippie-ish when he came to see *Pork*," Tony said. "He had long, stringy hair." As County recalled, "We'd heard that this David Bowie was supposed to be androgynous and everything, but then he came out with long hair, folky clothes, and sat on a stool and played folk songs. We were so disappointed with him."[3]

Despite claims that he ripped off his Ziggy Stardust look from County and other *Pork* cast members, by that point Bowie was already in the midst of developing his glam rock character when they crossed paths. "David's makeup wasn't feminine," Zanetta said. "It was really kind of a mime on acid. It was like a cross between mime and Kabuki and *A Clockwork Orange*." Bowie collaborated with experimental mime artist Lindsay Kemp, who drew on elements of Kabuki, drag, mime, dance, and music to create a unique assemblage that suited the singer. "You steal a bit of this, you steal a bit of that," Kemp would say, "but you shop at the best stores and you make it your own."

Bowie wasn't directly influenced by New York's Ridiculous theater movement, though Zanetta believed that he did tap into their exhibitionistic tendencies. "Most of us were pretty much sexually out there, promiscuous, very open about our sexuality," he said. "I'm talking men, women, and I don't necessarily mean gay, straight—I mean everything. We were sexual outlaws. When we came along, I don't think it escaped David's attention that there was something very modern and very sexy about this exhibitionistic quality we had. So I think if he picked up on anything from us, it was that."

Bowie's manager, Tony DeFries, certainly recognized the benefits of these associations. With his eye on breaking Bowie in America, DeFries hired Zanetta and Cherry Vanilla to work at the New York offices of MainMan, his management company, alongside photographer and scenester Leee Black Childers. Zanetta

became president of MainMan, Childers was vice president, and Vanilla directed publicity. They had absolutely no business experience and were fairly irresponsible, but no matter—DeFries was selling an image one couldn't learn about in business school.

"MainMan was definitely about Tony DeFries wanting to make money," Zanetta said, "but I was there because I liked David Bowie and I liked what he was doing." MainMan's new president became friends with Bowie and toured with him during the Ziggy Stardust era, which further fueled his Warholian infatuation with stardom and image-making. "Once I admitted that to myself," Zanetta said, "it kind of freed me and the whole world kind of opened up, especially rock 'n' roll." Warhol, however, did not receive Bowie quite as enthusiastically. When he paid a visit to the Factory, the artist muttered something about liking his shoes, but things got more awkward when Bowie played him "Andy Warhol," a rather corny track from his *Hunky Dory* album.

Silence.

While visiting New York, Bowie also connected with Iggy Pop, who signed a management contract with MainMan, and Bowie finally got to know his musical hero, Lou Reed. He produced Reed's *Transformer* album—released in 1972 at the height of glam rock's reign—which became a hit thanks to the single "Walk on the Wild Side." The cover photo of Reed wearing makeup emphasized a more fluid performance of gender and sexuality, as did the album's title. Fittingly, *Transformer* contained the song "Make Up," with the chorus, "We're coming out / Out of our closets / Out on the streets."[4] A couple of years after the album's release, Reed became involved in a serious relationship with a trans woman named Rachel (born Richard Humphries), to whom he dedicated his 1976 album, *Coney Island Baby*.

Compared to Wayne County, however, Reed and Bowie seemed as transgressive as the era's most chaste pop act, Donny and Marie Osmond. While working for MainMan, Zanetta cooked up a plan to manage County, who had developed an eye-popping rock 'n' roll stage act with her first band, Queen Elizabeth. She began as a woman and stripped throughout the show until revealed as a man—all while singing songs such as "Man Enough to Be a Woman" and "Toilet Love." The latter number involved a toilet prop that was brought onstage, which County would sit on while singing. "He put Alpo dog food in the toilet bowl," recalled Peter Crowley, who began managing County. "He pretended to eat the shit and people would be throwing up, but it was Alpo. Wayne said, 'I was deranged, but not that deranged!'"

The glam-punk pioneer brought Off-Off-Broadway to the rock 'n' roll stage and, on one memorable occasion, a 1972 lunchtime performance at NYU. "I came out

wearing a multicolored wig, full makeup, and trashy charity shop clothes, and we launched into a song called 'Wonder Woman,'" County recalled. "Then we'd do 'Goddess of Wet Dreams,' which is about the pagan goddess Astarte, and I'd pull out a water gun in the shape of a dick and start squirting the audience with milk." As County's backing band rocked out during the song "It Takes a Man Like Me to Find a Woman Like Me," she performed mock sex with herself using a rubber vagina and double-ended dildo. An unamused college dean finally cut the power.[5]

With the New York Dolls monopolizing the downtown rock 'n' roll spotlight with their own drag act, Zanetta figured that the only way to set County apart from her peers was a full-blown theatrical show. This led to *Wayne at the Trucks*, staged in a theater instead of a rock venue. "The Trucks" refers to one of Zanetta's favorite downtown hotspots—a gay cruising area at the end of Christopher Street, by the Hudson River, where delivery trucks parked at the piers. "You would just sit there all day long smoking pot," Zanetta said, "and it was like a parade of fashion and incredible clothes and looks." He and County came up with the idea of setting the show at the Trucks while having lunch: "Well, it should be kind of *Gidget Goes to Hawaii*," Zanetta said, "like, *Wayne Goes to the Trucks*."

They rented a theater for a week for rehearsals and one performance, and brought in Tony Ingrassia to direct the show. The set had pivoting walls that established the location with a big backdrop of the Trucks, then rotated to reveal a huge painting of County's face. At the start of the show, she vomited herself out of her own mouth while wearing a teased silver wig and green lamé dress outfitted with dozens of inflated condoms. County sang an a capella version of "The Rose of Washington Square" on a stage that was bare except for some fabulous shoes beckoning to her. "The heels were the balls and the shoes were the cocks," Zanetta recalled, "and they were red glitter, like the shoes Dorothy wore in *The Wizard of Oz*." County said they were by far the show's most outrageous props—with a realistic looking penis that curled up in front, like Persian-style "genie" shoes.

When County clicked the heels, it cued her offstage band—the Backstreet Boys—to start rocking. Play-House of the Ridiculous musicals usually placed the musicians to the side of the stage, an idea that County borrowed for this show and was later adapted by Bowie. "In a way," Zanetta said, "*Wayne at the Trucks* was a little bit of a rehearsal for Bowie's *Diamond Dogs* tour, because Bowie wanted to do this theatrical tour but we weren't sure how to stage it." As Blondie's Chris Stein recalled, "It was one of the first times that a rock show was done with a band out of sight. Many people think that was a big influence on the *Diamond Dogs* tour, where Bowie was onstage with a band behind a screen."

MainMan staged *Wayne County at the Trucks* just for one night, inviting the press and music industry people in hopes of getting her signed. It was an overly optimistic plan. The 1970s corporate rock complex was not remotely ready to market such a transgressive and transgender rocker. Given that many American DJs were still averse to playing Bowie, Wayne County and the Backstreet Boys were not going to rock FM dials anytime soon.

Wayne County performing, 1973
© PAUL ZONE

CHAPTER 25

Literary Rockers

Patti Smith began pivoting from Off-Off-Broadway to poetry and rock 'n' roll around the time she befriended playwright and drummer Sam Shepard. They first met after a Holy Modal Rounders show downstairs at the Village Gate, where Shepard had previously worked as a busboy. Smith was planning to write about the Rounders for the rock magazine *Crawdaddy*, but as Shepard's bandmate Peter Stampfel said, "As soon as she saw Sam she forgot about the article. They took up with each other right off the bat."[1]

"It was like being at an Arabian hoedown with a band of psychedelic hillbillies," Smith recalled, describing seeing the Holy Modal Rounders in action. "I fixed on the drummer, who seemed as if he was on the lam and had slid behind the drums while the cops looked elsewhere." Near the end of the set Smith was struck by Shepard's song "Blind Rage," which he sang; Stampfel described it as a "power-punkish number," with lines such as "I'm gonna get my gun / Shoot 'em and run." Smith told biographer Victor Bockris that Shepard's "whole life moves on rhythms. He's a drummer. I mean, everything about Sam is so beautiful and has to do with rhythm. That's why Sam and I so successfully collaborated."[2]

When Smith met Shepard, he had recently married nineteen-year-old actress O-Lan Jones at St. Mark's Church, home of Theatre Genesis. The ceremony was filled with poetry, music, and purple tabs of acid distributed by some members of the Holy Modal Rounders, the wedding band, which also worked with Shepard on many of his shows.[3] *Melodrama Play*, performed at La MaMa in May 1967, was the first of a series of Shepard's rock-infused plays, followed by several more over the next few years.

After *Melodrama Play*, Shepard began incorporating Holy Modal Rounders songs into his plays whenever possible, particularly in *Operation Sidewinder*. It was his most elaborate and sprawling work, addressing the failures of a counterculture that was increasingly in disarray at the end of the 1960s. "We were out in California at the time," Stampfel recalled, "and Sam was writing *Operation*

Sidewinder. He thought that a lot of the scenes really tied to a lot of the songs that the Rounders were doing, so he put them in the play." Written in 1968, it debuted at the Vivian Beaumont Repertory Theater at Lincoln Center in March 1970 with the Holy Modal Rounders performing the music. The uptown setting was not a good fit, and Shepard was disappointed with the way the show was cast and with the director's decision to concentrate on spectacle. "The first time he came to rehearsal, he hated it so much he left," Stampfel said. "When he came back a few days later, he hated it even more, so he never came back."[4]

Shepard met Smith not long after *Operation Sidewinder*'s debut, though at the time she had no idea that the Holy Modal Rounders' drummer was a celebrated playwright. She didn't even know his real name—he told Smith it was "Slim Shadow"—and when they began their love affair, she also didn't know that he had a wife and child. On one occasion early in their romance, Shepard asked Smith if she liked the lobster at Max's Kansas City, and she admitted that she never had tried it. After living off of Max's free bowls of chickpeas, she jumped at the chance to have this mysterious Slim Shadow fellow buy her a fancy lobster meal (two South African lobster tails cost $2.95 at Max's back then, a luxury far beyond the reach of many back room inhabitants).

As they ate, Smith noticed Jackie Curtis giving her hand signals from another table and assumed she wanted some of their food. Smith wrapped some lobster meat in a napkin and met Curtis in the ladies' room, where she was interrogated.

"What are you doing with Sam Shepard?"

"Sam Shepard?" Smith said. "Oh no, this guy's name is Slim."

"Honey, don't you know who he is?"

"He's the drummer for the Holy Modal Rounders."

"He's the biggest playwright Off-Broadway. He had a play at Lincoln Center. He won five Obies!"[5]

Smith said that this revelation was like a plot twist in a Judy Garland–Mickey Rooney musical. By this point, she and Robert Mapplethorpe had moved out of the Chelsea and were living across the street on Twenty-Third Street in an apartment that gave them more space to pursue their art (he was focusing more on photography, and Smith continued to create visual art and write poetry). She was happy to return to the Chelsea after Shepard began living at the hotel, where they spent hours in his room reading, talking, or just sitting in silence. During this time, Smith wrote two sets of lyrics for songs that Shepard used in his play *Mad Dog Blues*, and they also began to collaborate on a one-act, *Cowboy Mouth*.[6]

One evening Shepard brought his typewriter to the bed and said, "Let's write a play." He proceeded to type, beginning with a description of Smith's room across the street: "Seedy wallpaper with pictures of cowboys peeling off the wall," described the stage notes. "Photographs of Hank Williams and Jimmie Rodgers. Stuffed dolls, crucifixes. License plates from Southern states nailed to the wall. Travel poster of Panama. A funky set of drums to one side of the stage. An electric guitar and amplifier on the other side. Rum, beer, white lightning, Sears catalogue."[7]

Shepard introduced his own character, Slim Shadow—"a cat who looks like a coyote, dressed in scruffy red"[8]—and he then gave her the typewriter and said, "You're on, Patti Lee." Smith called her character Cavale. "The characters were ourselves," she recalled, "and we encoded our love, imagination, and indiscretions in *Cowboy Mouth*."[9]

Theatre Genesis playwright and director Anthony Barsha first met Smith when she and Shepard performed *Cowboy Mouth* on the same bill as *Back Bog Beast Bait*, which starred James Hall and Shepard's estranged wife. "It was pretty crazy," said Hall. "He cast his own wife in a play that was followed by a one-act about his affair with Patti." Barsha, who directed *Back Bog Beast Bait*, confirmed that it was a complete debacle—though he acknowledged that *Cowboy Mouth* itself was quite stunning. "Their chemistry was like Richard Burton and Elizabeth Taylor," he said. "It was an excellent performance, Patti and Sam. It was a treat to see. It's too bad it had to end abruptly."

Cowboy Mouth opened and closed at the American Place Theatre on West Forty-Sixth Street at the end of April 1971. "Patti and Sam's thinly disguised characters' relationship was destined to end," Hall recalled, "just like what really happened between them. Then we found out that Sam had disappeared, and even Patti didn't know where he went." Shepard found the emotional strain too much—"like being in an aquarium," he later said—so he fled to a Holy Modal Rounders college gig in Vermont.[10] Like his character in *Cowboy Mouth*, Shepard returned to his family and responsibilities; meanwhile, Smith set off on new adventures.

Around this time, Smith met her future musical collaborator Lenny Kaye at a downtown record store. After playing in garage bands during the second half of the 1960s, he was working at Village Oldies while also freelancing as a music writer. "You work in a record store, you're surrounded by music," Kaye explained, "and then you think, 'Hey, it's not unreasonable for me to try to make that music and

be one of a hundred million records that we're selling here.' It makes it less mysterious in a certain way, and gives you a sense that you could perhaps participate."

"Those older records also provided me with the way that I met Patti," he added, "because I wrote an article about those songs for *Jazz and Pop* magazine around 1970." Kaye's article spoke to Smith about her own youth, when boys would gather to harmonize on doo-wop songs in southern New Jersey. She called him up and began dropping by Village Oldies, which sold vintage 45 rpm singles. "I'd play some of our favorite records—'My Hero' by the Blue Notes, and 'Today's the Day' by Maureen Gray, and the Dovells' 'Bristol Stomp,' " Kaye said, "and Patti and I would just sit around and shoot the breeze."

They were attracted to not only classic group harmony records, but also artists like John Coltrane, Albert Ayler, and others who pushed jazz beyond traditional Western harmonics. That improvisational spirit influenced their later musical collaborations, but before the two began playing together Kaye took one last deep dive into the world of rock 'n' roll singles. When Kaye was working at Village Oldies, he came to the attention of Elektra Records president Jac Holzman. "Jac called me in one day and asked if I would be an independent talent scout for the label. And he also had an idea for an album called *Nuggets*, which would compile songs that had kind of fallen between the cracks."

Nuggets was an influential anthology released in 1972 by Elektra—sort of the garage rock equivalent of Harry Smith's *Anthology of American Folk Music*. A record collector from a young age, Kaye got more serious about his obsession when he drove across the country in 1967 while listening to local radio stations and then seeking out the singles he heard, some of which made their way into *Nuggets*. The album was like a roadmap for mid-1970s punk bands, who gravitated toward Count Five's "Psychotic Reaction," the Standells' "Dirty Water," and *Nuggets*' twenty-five other tracks.

The simplicity of those songs—which walked the line between proto-punk angst and playful bubblegum fun—was refreshing at a time when rock had become overly complex. "It was a way to reconnect with the virtues of the short and very catchy single," Kaye said of the collection's appeal to the punk bands that played CBGB. "They were just innovative bands that were taking a step backwards to see what made a great record, in the same way that *Nuggets* looked at that moment in time and showed that these were great records that had certain virtues."

Kaye's liner notes for *Nuggets*—which include an early use of the term "punk rock"—celebrated the kinds of bands that were "young, decidedly unprofessional,

seemingly more at home practicing for a teen dance than going out on a national tour."[11] His friend Greg Shaw championed this kind of music in his self-published magazine *Bomp!* and he also wrote a rave review of *Nuggets* in national rock magazine *Creem.* Under the headline "Psychedelic Punkitude Lives!!" Shaw marveled, "I never thought I would see the day when anybody'd take this music seriously."[12]

While Kaye was in the thick of compiling *Nuggets*, he sent a letter to Shaw that captured this critical moment in his life. "At the end of the letter I said, 'Oh, I'm doing some cool stuff, but next week I'm going to play at St. Mark's Church with a local poet, and that should be interesting.' This was January 1971, and I have to say at that moment my creative life begins—because in that moment, I'm thinking about *Nuggets* and I started playing with Patti."

Smith was interested in doing public poetry readings, though she was wary of many of the poets' staid, practiced delivery. Around this time, Beat poet Gregory Corso started taking her to readings hosted by the Poetry Project at St. Mark's Church, a collective based at the same church where Theatre Genesis was located. It was home to A-listers like Allen Ginsberg, Robert Creeley, and Ted Berrigan, but Corso was less than reverent. He heckled certain poets during their listless performances, yelling, "Shit! Shit! No blood! Get a transfusion!" Sitting at Corso's side, Smith made a mental note not to be boring if she ever had a chance to read her poems in public.[13]

On February 10, 1971, Gerard Malanga was scheduled to do a reading at the Poetry Project and he agreed to let Smith open for him. Her collaborations with Shepard taught her to infuse her words with rhythm, and she sought out other ideas about how to disrupt the traditional poetry reading format. "Patti kept herself kind of distant from the rest of us in the plays she was in," Tony Zanetta recalled. "She wasn't singing at that point, but she had a very rhythmic performance style as a poet that was very musical, very rock 'n' roll." For the St. Mark's event, Shepard suggested that Smith add music—which reminded her that Lenny Kaye played guitar. "She wanted to shake it up, poetry-wise, and she did," said Kaye, who recalled that it was primarily a solo poetry reading, with occasional guitar accompaniment. "I started it with her," he said. "We did 'Mack the Knife,' because it was Bertolt Brecht's birthday, and then I came back for the last three musical pieces."

Setting chords to her melodic chanting, Kaye recalled that she was easy to follow because of her strong sense of rhythmic movement. "I hesitate to call them 'songs,' but in a sense they were the essence of what we would pursue," he said. "But it wasn't really meant to be a band. It wasn't meant to be anything more than

just a performance, an artistic moment in time, but as it turns out, that was the moment where everything turned around for me." The same was true for Smith, whose reading opened up several opportunities—from *Creem* printing a suite of her poems to the publication of a poetry chapbook for Middle Earth Books. One of the poems she performed that night, "Oath" (which begins, "Christ died for somebody's sins / But not mine"), was adapted for her 1975 debut album, *Horses*.

Punk compatriots Richard Hell and Tom Verlaine followed a similar path from poetry to music. Born Richard Meyers and Tom Miller, they met in the mid-1960s at a boarding school in Delaware and were both drawn to New York. They settled into a life of letters and worked at several bookstores, including Cinemabilia, where future Television manager Terry Ork and *An American Family*'s Kristian Hoffman worked. Verlaine also hung around the Poetry Project at St. Mark's Church, a block from his apartment, and Hell had already been publishing his own poetry magazine, *Genesis : Grasp*. "I started when I was seventeen and I brought out six issues across four years," Hell said. "It was like a high school literary magazine. I was very ignorant, and I was not a very good writer, and I was just trying to figure out what I was capable of."

"By the time I did the last issue," he continued, "I was printing them by myself on a $300 desktop offset printer, like the size of a milk crate. The next stage after *Genesis : Grasp* was about starting fresh and doing something that would achieve what I was grasping at. That was Dot Books." Hell started the Dot Books imprint in 1971 with the intention of publishing a list of five books, including Smith's poetry, but he wound up printing only a collaboration between himself and Verlaine, as well as a book by Andrew Wylie—who became the infamous literary agent known as "the Jackal." Wylie, in turn, published Smith's first poetry book, *Seventh Heaven*, in 1972.

Hell saw Smith perform several times between 1971 and 1973: at her poetry debut at St. Mark's Church, in the play *Island*, and even in a performance at the gay disco Le Jardin. "She fulfilled Andrew's demand for an electrifying, rock-and-roll-level poetry," Hell recalled. "Patti was triply stunning at the time, not only because her stuff was hair-raising on the page, but because her performances were so seductive and funny and charismatic that the writing was lifted way beyond the page, and then, third, she was self-possessed and plugged in to the point that she would improvise and riff extensions as she read, like a bebop soloist or an action painter, off to a whole other plane beyond the beyond."[14]

Smith had already published *Witt*, her second book of poetry, when she began working with Hell on her Dot Books poetry volume. During this time, Hell and

Verlaine began writing collaborative poems, sharing a typewriter much as Smith and Shepard did with *Cowboy Mouth*. "Writing the poems was so much fun," Hell recalled. "Night after night we'd be up late with maybe a quart of beer, or a fresh-scooped pint of vanilla ice cream from Gem Spa, in Tom's bare rooms, smoking cigarettes and passing the typewriter back and forth."[15] As their writing experiments progressed, Hell thought it would be fun to conceive of it as a work of a separate third person. Verlaine liked the idea and suggested making the author a woman, Theresa Stern.

"Feminism and androgyny and transvestitism were in the air," Hell wrote. "We'd cash in! I started imagining her biography."[16] Theresa Stern became a Puerto Rican prostitute-poet who worked the streets of Hoboken, New Jersey. Her debut book, *Wanna Go Out?* was published in 1973 just as Hell and Verlaine were forming their first band, which evolved into Television. "I had a book of Patti's that we had compiled with me as editor, and there was a book of mine, and a book of Tom's," Hell said. "But it was just Andrew's book and Theresa's book that were actually published. The other books were ready to go, but then I got into rock 'n' roll and I just transferred all my energies to music. And so did Patti."

Hell and Verlaine cared deeply about writing, but they knew they would have a more pronounced impact through music. One of their key sources of musical inspiration was Lenny Kaye's *Nuggets* compilation, which Verlaine brought home one day and listened to constantly. "It was a very small self-contained world downtown and, basically, you could mix and match," Kaye observed. "There was a lot of interweaving between the literary and the cinematic worlds, and musical performance, and it didn't seem to have many boundaries."

CHAPTER 26

Hibiscus Heads Home

Hibiscus and the Cockettes borrowed songs from Vaudeville and old Hollywood musicals, changing the lyrics to suit their demented productions. "The appeal of those thirties, forties films was the glamour, the extravaganza," Cockette Pam Tent recalled. "Hibiscus always tried to recreate Busby Berkeley films with all these fantastic dance moves, or other old films. We had one where we were all the spokes of a wagon wheel spinning, turning round and round, singing 'Happy Trails (to You).'" Another show, *Hollywood Babylon*, featured various Cockettes playing Marilyn Monroe, Jayne Mansfield, and Judy Garland. "Hibiscus loved glamour," Tent said, "and he would channel people. When he played Jayne Mansfield, he channeled her. I mean, he wasn't even Hibiscus anymore."

The Cockettes also had an unwitting benefactor: the American Chinese Opera, which had several big steamer trunks filled with traditional Chinese opera costumes that disappeared under mysterious circumstances. "I don't know nothing about it," Lendon Sadler said, "but all I can tell you is for years we did Chinese shows." The Cockettes performed *Pearls over Shanghai* several times, constantly rewriting and adding new acts. Hibiscus believed that theater should be free, like something that just existed in the air, so they performed *Pearls* in a back alley in Japantown—a more traditional, conservative neighborhood. "With people in their apartments looking out their windows with all these drag queens in an alley," Tent recalled, "well, you could imagine."

Their Halloween-themed *Les Ghouls* featured an unplanned showdown. Goldie Glitters had quit and John Rothermel became the new Bride of Frankenstein, but on opening night they both showed up dressed for the role, ready to take the stage. Neither would back down, so the Cockettes featured two Brides of Frankenstein that night until Goldie had an onstage epileptic seizure. Everyone thought it was part of the show until somebody finally realized that something was wrong and shouted the old chestnut "Is there a doctor in the house?" After a bearded hippie doctor dressed as Marie Antoinette rushed to the stage, the Bride, complete with

platform shoes, was carried away on a gurney while shouting, "I'm going to the hospital, *darling!*"

"You know," Sadler recalled, "Goldie could do high drama."

Before the disco artist Sylvester had a string of hits in the late 1970s, he was one of three African American members of the Cockettes, along with Sadler and Anton "Reggie" Dunnigan. After moving into the Cockettes' Haight Street commune in 1970, he was immediately invited to join the group. "The first time we heard Sylvester sing," said Tent, "we were like, 'Oh my *god*, he wants to join *us?*' Everyone was completely amazed." Sylvester's Cockettes debut was *Radio Rodeo*, singing the *Mickey Mouse Club* theme song dressed in a miniskirt.

After they began receiving offers to tour regionally and nationally, Hibiscus left the group because he only wanted to do free theater. "The rest of us were supposedly greedy because we wanted to make fifteen or thirty dollars," Sadler recalled. "But it really had nothing to do with money. It was an ideological divide, because there wasn't much money to be made. As Hibiscus grew, he grew away from us. His original exit was starting a group called Angels of Light, who were divine. They were the crème de la crème."

But free shows did not pay for food, rent, or other living expenses, so Hibiscus and his new troupe were helped by a wealthy patron whose commune was about an hour and a half from San Francisco. She housed everyone from the Angels of Light to poet Andrei Codrescu, who moved out west after his stint in New York. "It was a mad commune," Codrescu said. "She was our barefoot hippie goddess heiress, and she had everybody on a little allowance, so she made the Angels of Light performances possible. She bought things that they needed and, of course, she had closets full of stuff that they tried on endlessly."

Meanwhile, the Cockettes began taking paying offers to perform, which set the stage for their disastrous New York City debut on November 7, 1971. The show's producers put the cast up in dumpy hotel rooms, and they were forced to stage *Pearls over Shanghai* in an even dumpier theater. The Anderson seated over three thousand people, and like many similar theaters in the neighborhood, it had been left to decay since the glory days of vaudeville. "The theater was a mess," Play-House of the Ridiculous member Michael Arian said, "and it was too big, and it just needed to be torn down. It was like going into a haunted house, tile floors with dead leaves and that kind of thing." When Ann Harris discovered that the producers were using her son's image in the publicity posters, even though he had left the group, the firebrand matriarch marched down to the Anderson and ripped all of them down.

"We only had quick run-throughs," Sadler recalled. "We were improvising a show by the time the premiere happened." The pre-show buzz spread quickly, and opening night became a full-on gala event, with klieg lights and paparazzi; street traffic was so jammed, the attendees had to get out of their limousines and taxis in order to walk a few blocks to the Anderson. With such high expectations, there was only one way to go: down. "That show would have been okay in San Francisco," Sadler said, "but we had limousines pulling up in front of the theater. Andy Warhol and John Lennon were there, everybody was there. The reviews the next day were so bad that they were good."

When Off-Off-Broadway performer Bruce Eyster was living in San Francisco, he witnessed the Cockettes' act—glittery makeup, rhinestones, feathers, toilet paper, and all. "When they said the Cockettes were going to go to New York, I went, '*Mmm*, that's not a really good idea. There's three queens in New York that really have their shit down—Jackie, Candy, and Holly—and it's not going to go over.'" This seasoned theatrical audience was indeed not impressed with the Cockettes' West Coast whimsy, and they let it be known. "I thought that Cockettes show was just the most screwed-up stupid mess," said Arian, one of those skeptical New Yorkers. "Okay, we at the Play-House of the Ridiculous were stoned on acid and all that, but we didn't fall down and act like the Cockettes did. They were very unorganized."

On opening night, the heckling started almost immediately—culminating in Taylor Mead shouting an icy quip from the seats: "Where's Jackie Curtis?!" Agosto Machado remarked, "Taylor was disappointed because he felt there wasn't enough glamour or humor. It was unfortunate that people were so cruel to them." The Cockettes nevertheless found several admirers downtown. "I thought the Cockettes were a trip," said Off-Off-Broadway actor Benton Quin, who contributed props and sets to Blondie's early live shows. "They were immensely entertaining to me, but most of the New York audience hated them. It was more like a home team kind of thing."

Another fan was Machado, who caught their opening night after rushing from the final performance of *Vain Victory*. "I had been onstage in San Francisco with them previously," he said. "I wasn't officially a Cockette at that point, but then I was actually voted in when they were in New York." As a newly minted Cockette, Machado participated in their preshow rituals—dishing and drugs and makeup—and of course all the after-hours parties. Despite the show's negative buzz, the Cockettes themselves were treated like kings and queens in the downtown's hip inner sanctums. "Everybody wanted hang out with us," Sadler

said, "so we could go to all these places and eat and drink free, which was great, because we weren't being paid very much. I think they gave us $30 a week to eat on, but we could go to the clubs and be wined and dined like royalty. The pop stars would come in and give us an open tab and it was great."

Around the same time, prodigal son Hibiscus returned home with his boyfriend Angel Jack (born Jack Coe). They arrived at the door of the Harris family's East Ninth Street apartment wearing long hair and white robes, looking like two apparitions through the peephole. "He was screaming, 'HONEY!'" sister Jayne Anne Harris said. "So I knew it was him." No longer the preppy-looking teen who left the fold in 1967, he was now wearing outlandish Angels of Light costumes all the time. This was no shock, for she and her sisters were used to crazy clothes growing up in New York's avant-garde theater world. "Regular life moments in those days looked a lot like theater," recalled Mary Lou. "No one walked around in regular clothes."

Hibiscus hit the ground running, recruiting his sisters and mother into the Angels of Light. "It was like Mickey Rooney and Judy Garland in *Babes in Arms*," Jayne Anne said, "when they do the show in the barn: 'Let's put on a show!' That's what it was like."

Their brother was a one-man Off-Off-Broadway Metro-Goldwyn-Mayer studio system, and whoever happened to wander into Hibiscus's view was cast in a show. He had an eye for spotting talents and skills, whether it was tap dancing, crooning, or ballet dancing. The entire family knew how to sew costumes, build sets, and other theater basics, and their mother also taught the kids how to tap dance. Ann Harris had learned tap routines while attending the Dan Harrington School of Dance as a kid in the 1930s, until her father pulled her out because the costumes were too skimpy. "But she remembered every single dance," Jayne Anne said, "and taught all the queens in the West Village how to tap dance. The Vietnam War was still raging, and we just did these colorful, happy midnight shows, and whoever came was in it."

"Sometimes you created your own part," Mary Lou said. "So Jayne would say, 'I want to be Pandora,' and we'd create a big Busby Berkeley, Georges Méliès number around Pandora's box. All these wonderful, beautiful gay boys would come out of the box—some would be evil and some would be good." They also foraged for costumes in thrift stores, where Jayne Anne found a bright yellow see-through skirt studded with heavy gold sequins that she wore in every Angels of Light show. She augmented it with rhinestones that weighted down the hem so that the skirt would fly open like an umbrella when she spun around. "I remember Hibiscus and

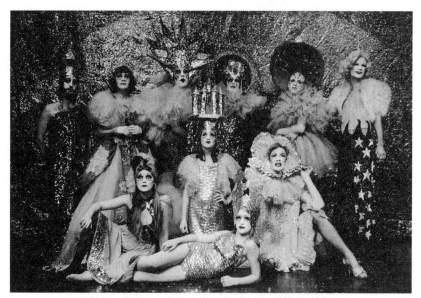

Ann Harris, Hibiscus, the Harris sisters, and other Angels of Light
COURTESY THE FAMILY ARCHIVES OF GEORGE EDGERLY AND ANN MARIE HARRIS

Angel Jack made me my first sequined dress for my mermaid costume," Eloise added. "They found the most beautiful material and made a big fuss over the tail and the crinoline and the wig."

It felt magical. Hibiscus and the girls would run through the streets in full drag to the Angels of Light's home base, the Theater for the New City. "That's when Timmy Robbins came into our lives," Eloise said. "He was lighting the shows, and the shows were beautiful, visually—really enchanting. I mean, you couldn't take your eyes off the visuals." Long before he became a Hollywood star, Tim Robbins was a thirteen-year-old with a crush on Eloise, whom he met while doing backstage work at the theater. "If the homophobic Catholic school kids I went to school with ever figured that I was going to the theater at night," Eloise recalled him telling her, "I would have been in big trouble."

The girls stayed very busy throughout the Angels of Light period, rehearsing for performances while also trying to finish their homework. "It was around the clock, sister," Mary Lou said. "I don't remember a day or a weekend or not one moment where I wasn't in a show or in school." Eloise added, "School was sort of my straight job, and then I would come back and I'd go to the theater." Mr. Ringo, their elementary school teacher, noticed the glitter around their tired eyes, so he and another curious faculty member came to an Angels of Light performance and thought, *How can we possibly compete with this?* The sympathetic teachers

eventually allowed Eloise and Mary Lou to come to school two hours late so they could get some extra sleep.

Angels of Light shows were hallucinatory homages to 1930s Busby Berkeley musicals, a cinematic tap-dancing fantasy world in which Angel Jack and Hibiscus subbed for Ginger Rogers and Fred Astaire. Their first show was *Studio M*, a lovingly produced family affair that was performed on a small semicircular stage that ratcheted up the dazzle factor. For each show they put on, Hibiscus created elaborate storyboards, his sisters joined him onstage, and their mother composed the songs. "I wrote almost all the music for the Angels of Light," Ann Harris said. "George would say, 'Oh, I need a sheik scene, with a sheik in it,' and then I would come up with a song."

"Devil Man," one of many songs written by Ann Harris, became an Angels of Light staple ("Go to the Devil and dance in Hell / You know the reason and you know it well / Down to the underground then see what we could be / If we were free to be we"). It was used in *Enchanted Miracle* and in another Angels of Light show, *Gossamer Wings*. The latter production featured a massive storybook whose pages turned, moving the action forward from the Ice Age to the 1970s. Many of their shows dealt with environmental disasters that were occurring with an alarming frequency during that decade. "Who cares if the birds don't sing as long as the cash box rings?" they sang in "Disposable Everything."

Ironically, these shows indirectly benefitted from the consumer culture–driven economy of abundance, which produced the junk they used for their shows. "You could find plenty of things in New York that were beautiful, *beautiful*," Ann Harris recalled. "That's how people did those shows, with costumes from fabric found on the street." When the family discovered that a factory was throwing out piles of feathers, for instance, Ann and the kids used them for another one of their productions, *Birdie Follies* (which featured their friend Agosto Machado).

The Angels of Light's cast included everyone from very serious theater people to delusional drag queens, and their outrageously dressed fans sometimes got a little out of control. One time, when the audience began ripping out a theater's cement stairs, Hibiscus had to send out an actor dressed as a cop to calm them down. Their secret weapon, Miss Marsha, regularly whipped audiences into a frenzy. Marsha P. Johnson was a street queen and early gay liberation activist who wandered into an Angels of Light show and decided to jump onstage. Hibiscus extended an open invitation to join them anytime, for Miss Marsha's impromptu banter with the audience always brought down the house. "After a while, Hibiscus

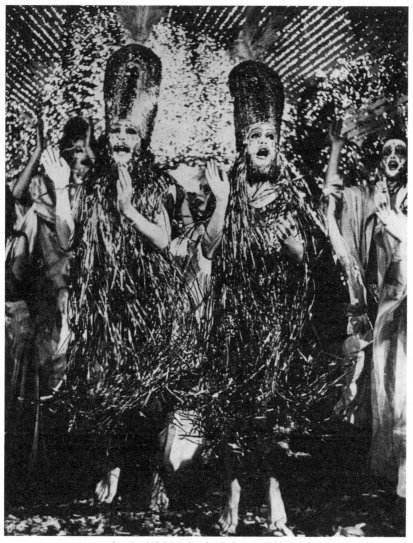

Angels of Light performing in Gossamer Wings
COURTESY THE FAMILY ARCHIVES OF GEORGE EDGERLY AND ANN MARIE HARRIS

just stopped writing for her because she'd never get to it," Mary Lou said. "She would just get a huge cheers and standing ovations."

The Harris sisters described themselves as straight girls who were socialized as gay men. "The queens were kind of my role models," Eloise recalled. "Marsha was very motherly, even though she was kind of living on the street. She was kind

of our nanny." When Hibiscus or their mom went out, Miss Marsha would take them out for ice cream or babysit them at home. They would take turns pretending to be Barbra Streisand or Judy Garland, and also sang duets à la Marilyn Monroe and Jane Russell performing "Two Little Girls from Little Rock." Hibiscus and Angel Jack also paid a lot of attention to the girls, showing the Harris sisters how to wear makeup and other ways to be glamorous. "They would do things like spit in eyeliner to apply it," Eloise said. "They were hardcore theater people. They were bigger than life and a lot of fun."

Miss Marsha also appeared with the gay theater group Hot Peaches, who were part of the same circuit as the Angels of Light. While there was certainly competition among these groups—and among individual queens such as Miss Marsha, International Chrysis, or Flawless Sabrina—for the most part it was a healthy competitiveness. "There were rivalries, there was bitchiness," Mary Lou said, "but that sort of propelled them forward to get better and better—to try to one up each other. I think it ultimately led them to creating bodies of work that led them to become important figures, which in turn led to the laws and freedoms that are just beginning to bloom today."

"They helped change the world," Jayne Anne added, "and they didn't even know it. Nobody was doing that back then, and it was dangerous what Hibiscus was doing." He didn't really think of himself as changing the culture, because all he really wanted to do was to put on colorful, fun shows with his mom, sisters, and friends. "We were a very close family" Eloise said, "a really close and really supportive family, and we understood the artist's way. We are artists at heart, and I think in some ways, activists at heart as well. When people talk about the Angels of Light, the word *pioneer* comes to mind. I feel like Holly Woodlawn and Miss Marsha and all of those people were pioneers. They were suffragettes."

Debbie Harry, whose punk-trash look drew heavily from the downtown's drag and trans performers, recalled that they weren't politely disguised in cuteness. "It was out," she said, "it was definitely out. And it was such a small scene, such a small movement at the time that it was hardly recognizable to the general public." After decades of remaining underground, gender nonconformity became more visible throughout the world thanks to the work of Hibiscus and his family of accidental activists. But before it conquered the globe, this style incubated itself in a scene that formed at the Mercer Arts Center—where the aptly named New York Dolls mixed it up by wearing combat boots and blouses or gold lamé shirts and high-top basketball shoes.

CHAPTER 27

Mercer's Mixes It Up

After Andy Warhol discovered Eric Emerson dancing at a 1966 *Exploding Plastic Inevitable* show, he was promptly cast in *The Chelsea Girls* and several other Factory films. By 1971, Emerson had become the frontman of one of New York's earliest glam rock bands, the Magic Tramps. He would wear giant glittery angel wings and other eye-popping accouterments onstage; when he chose not to wear clothes he just showered himself in gold glitter dust that flaked off when he flexed his muscles—lasciviously staring at some of the boys in the audience.[1] "Eric Emerson was this beautiful blond boy," said Jim Fouratt, who used to see him in the back room of Max's Kansas City. "First of all, he was working class. He wasn't a rich kid. And he was very pretty, but he was also very strong—handsome, sexy, sort of masculine."

The Magic Tramps started a residency at Max's in early 1971 after owner Mickey Ruskin gave them access to the upstairs room, which had largely gone unused since the Velvet Underground played their final gigs with Lou Reed a year earlier. The Magic Tramps outgrew Max's as the city's glam rock scene flowered, so Emerson scouted for a new space to play and stumbled across the fledgling Mercer Arts Center. It was the brainchild of air-conditioning magnate Seymour Kaback, a theater lover who turned an old downtown building into a large maze-like arts complex with several theaters and concert rooms. In addition to two three-hundred-seat theaters and two two-hundred-seat theaters, Mercer's had an art-house cinema, jazz lounge, bar, restaurant, two boutiques, and the Kitchen—an experimental film and performance venue housed in the hotel's old kitchen.

All the rooms in Mercer's emptied into a central gathering space that had an all-white design, which some people called the Clockwork Orange Room. "Whatever you were going to see," Tony Zanetta recalled, "you would run into other people who were going to see something else. That's what made it more

interesting. So maybe you were going to see *One Flew over the Cuckoo's Nest* and I was going to see Wayne County or the New York Dolls. We would be sitting in the same room before or after the show, but we might not have been in that room otherwise." On some nights, David Bowie could be seen slouched in a bright red plastic chair next to a massive antique mirror, absorbing the atmosphere.

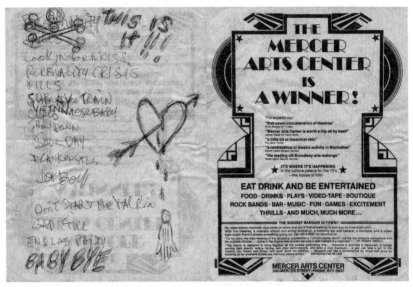

New York Dolls set list on the back of Mercer Arts Center flyer
COURTESY KRISTIAN HOFFMAN

Emerson helped fix up Mercer's in exchange for rehearsal space, and when it officially opened in November 1971 his band performed regular cabaret sets in the venue's Blue Room. "I met Eric when I went to see the Dolls for the first time," Blondie's Chris Stein recalled. "The whole scene was very accessible, hanging out backstage and all that. Eric was a great character." Stein became the Magic Tramps' informal roadie after he booked them to play a Christmas party at the School of Visual Arts, where he was a student, and the two became roommates in a welfare apartment on First Street and First Avenue. "Eric was very dynamic and there was something very lovable about him," Zanetta said. "Everyone was drawn to Eric—men, women—and he was pretty much an equal opportunist."

Debbie Harry, for instance, recalled making out with Emerson in a phone booth at Max's.[2] "He was such a big flirt and he was such a madman who was a lot of fun," Harry said, "but he was a complete maniac, just sort of raging all the time." Emerson wreaked all kinds of havoc, but for the most part he was harmless. "Eric

would just walk around in those shorts and nothing else except glitter on his chest," recalled Lisa Jane Persky. "He would bump up against you and kiss you, and you would get it all over you." *An American Family*'s Kristian Hoffman had a similar experience. "Eric just ran up to me and gave me a great big tongue kiss for no reason," he said. "I thought it was quite an accomplishment until I found out that since he was high all the time he would French kiss anybody."

"The Magic Tramps were fun enough," Hoffman added. "It seemed like a campy drag show, but then you kept waiting for a song to arrive. It wasn't really about music, but with the New York Dolls, it was really solid music. It was exciting." Emerson invited the Dolls to open for the Magic Tramps at Mercer's, and they sent a jolt through the downtown scene by reminding folks that enthusiasm trumped technical proficiency. For drummer Jerry Nolan—who started out playing in Wayne County's Queen Elizabeth before joining the New York Dolls—David Johansen and company returned rock 'n' roll back to basics. "I fell in love with them right away," Nolan recalled. "I said, 'Holy shit! These kids are doing what nobody else is doing. They're bringing back the three-minute song!' "[3]

The Dolls first threw rent parties at their downtown loft on 119 Chrystie Street before hitting the DIY concert circuit. With Jackie Curtis as the opening act, they played their first proper show in early 1972 in the Hotel Diplomat. The group also had a short residency at a gay bathhouse, the Continental Baths, where Bette Midler regularly performed with Barry Manilow (who sometimes blended in with the patrons by wearing nothing but a white towel). Underground rock, Off-Off-Broadway, and the cabaret scenes converged in the early 1970s, cross-pollinating each other. Midler, for example, had appeared at La MaMa in Tom Eyen's *Miss Nefertiti Regrets* before she leveraged her act at the Continental Baths into pop stardom.

Roberta Bayley, who later worked the door at CBGB, noted that the Dolls' glittery, feminine clothes stood in sharp contrast to their masculine swagger. "That's what was interesting," Bayley said, "because these real guy-guys were wearing off-the-shoulder blouses and being very confident in their heterosexuality." The Dolls had several ties to the fashion world; guitarist Sylvain Sylvain, for instance, was a designer who had a successful clothing company called Truth and Soul. "There were lots of people who wore colorful clothes or scarves or what have you," said Agosto Machado. "It wasn't unusual to see a more masculine man with a pink scarf, or have a few of their nails painted different colors." Lisa Jane Persky added, "Growing up in the Village, everybody already dressed like the New York Dolls. And everybody was dressing like that in theater."

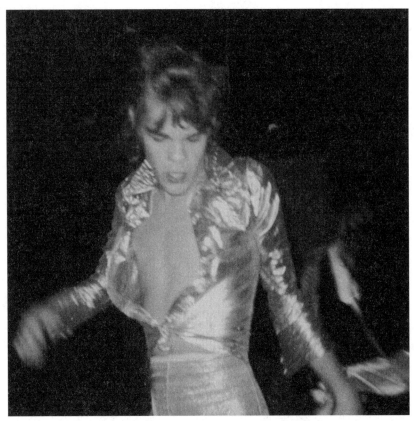

David Johansen performing at the Mercer Arts Center, 1972
© KRISTIAN HOFFMAN

Lance Loud and Kristian Hoffman found out about the Dolls when the British music weekly *Melody Maker* raved about them. "Lance and I thought, 'God, they're just playing right down the street,' and so we went and saw them, and then we went every single time they played." They would sometimes bring along Lance's mom, Pat Loud, who was game for anything. "I have pictures of Pat Loud in the audience at Mercer's," Hoffman recalled. "I was on the dance floor right in front of the stage and I had my Brownie Instamatic, and she got in the picture in front of the New York Dolls."

Their new friend Paul Zone had first seen the Dolls at the Hotel Diplomat, where the crowd numbered about a hundred and everyone dressed in their own original styles. "It just seemed so different from anything that we'd ever seen before," Zone recalled. "We just knew right then and there that there was a place that we could feel like we can express ourself without feeling like an outcast." The New York

Dolls became downtown stars after they began performing every Tuesday night in the Mercer's two-hundred-seat Oscar Wilde Room, which was perfect for the group because of its theatrical lighting. "Just walking into the Mercer that first time and seeing them onstage and everyone in the audience," Zone said, "you were just like, 'This is it.'"

Richard Hell was also drawn to the Dolls' simple songs and sloppy performances, which he found riveting. "Their gigs were unlike any I'd ever experienced," he recalled. "They were parties, they were physical orgies, without much distinction between the crowd and the band."[4] The Dolls attracted future members of Television, the Ramones, Blondie, and other early punk bands to the Mercer Arts Center.

Throughout the late 1960s and early 1970s, Debbie Harry and Chris Stein circled each other's social orbits without quite making contact. Harry quit her job as a waitress at Max's Kansas City in 1969 and briefly worked as a Bunny in a Playboy Club, then left New York City. She eventually moved back to her parents' house in New Jersey while she worked as a beautician and health spa instructor, but she couldn't resist the pull of the city. Around 1972, she began returning to visit friends. "Nothing really had changed since I moved away," Harry said, "though some of the faces were new, like the New York Dolls, who were the kings of the Mercer's scene." On some nights, the room likely contained all four original members of Blondie—vocalist Debbie Harry, guitarist Chris Stein, drummer Clem Burke, and bassist Gary Valentine—though the only ones who knew each other were Burke and Valentine (born Gary Lachman).

The two were friends from high school in Bayonne, New Jersey, where this glam rock–loving pair stood out amidst the sea of denim bellbottoms. "David Bowie changed everything for me," Burke said. "In my high school and early college days, most people I knew liked the Grateful Dead. I didn't like their style, I guess. I was more interested in the style of people like David Bowie or Iggy and the Stooges." Not surprisingly, that look didn't go over in their hometown. "We were putting makeup on and fingernail polish and other very strange things and then going from Jersey over to New York," Gary said. "So we'd have to run kind of interference. There was a sort of a greaser gang that didn't care for that kind of thing. It was, you know, still rather extreme kind of behavior."

"At the Dolls shows at Mercer's," Zone said, "there would be opening act Eric Emerson and the Magic Tramps, and Patti Smith would be doing poetry, and Suicide would be in one of the other rooms." Suicide keyboardist Marty Rev and frontman Alan Vega eschewed the traditional rock group lineup by forgoing bass,

drums, and guitars altogether—opting instead for synths, drum machines, and vocals. "We weren't interested in rehashing the same rock 'n' roll," Vega said. "We wanted something new, and we weren't even necessarily thinking musically, but theatrically."

Suicide tried to bring Antonin Artaud's Theatre of Cruelty into music by breaking down the boundaries between performer and audience. "We wanted to make them participants in the performance, whether they liked it or not," Vega said. "People found that threatening." As he physically and psychologically terrorized the audience, a rigid Rev produced a wall of sound from behind a bank of primitive keyboards and other crude electronics. "As you were leaving Mercer's, you would hear something," Zone recalled. "You would open the door and it would be Suicide, with no one in there, and of course we would go in. Alan would be in silver makeup and wearing a blond wig."

Vega wasn't that crazy about the New York Dolls' songs, which to him sounded like backward-looking 1960s party music. "The Dolls' audience definitely didn't like what we were doing," Vega said, "but when we played the Blue Room their audience had to walk through it when they exited, because it was like a central corridor. If the Dolls' room was like a party, our room was like a scene of carnage. Sometimes I would block the exit if people tried to leave. People thought I was fucking insane, and I guess I was, but I never, ever tried to hurt people. Myself, yes, I hurt myself. I would cut myself with a switchblade. I would always do it so that I got the most amount of blood with the least amount of pain."

Vega spent the first three years of his life on the Lower East Side before his family moved to a more middle-class area of Brooklyn (his father was a renowned diamond setter). At the age of sixteen, he got involved with a collective named the Art Workers' Coalition, then started working with the Project of Living Artists. "It was basically this group of about a half dozen people that got money from the New York state government," Vega said. "With that money we got a huge loft, a big open space, by Broadway, where anyone could wander in off the street. I was basically the janitor there." This job allowed him to pursue a career as a visual artist and sculptor, creating large light paintings with colored fluorescent tubes. "I incorporated some glass things later on," Vega said, "and also TV sets, subway lights, electrical equipment, and anything, really, I could get my hands on."

His interest turned toward music after seeing the Stooges in 1969, when Iggy Pop enthralled him with his confrontational theatrics. Vega had never considered going onstage, but he wanted a challenge. "I wanted to evolve as an artist, because what I saw Iggy do was so futuristic and so new," he said. "If I stayed a sculptor,

a visual artist, I would have stagnated." Vega had already been experimenting with electronic sounds, and after he saw Marty Rev play at the Project of Living Artists, the two formed Suicide. One of their earliest shows was in 1970 at OK Harris, one of the first galleries to open in SoHo. It was owned by Ivan Karp, an art dealer who played an early role in promoting Andy Warhol, Roy Lichtenstein, and Robert Rauschenberg.

"I told him Suicide should play at his gallery," Vega said, "and to our surprise he said yes, and they printed up postcards and everything saying Punk Music by Suicide. It was a pretty intense show, but we got invited back, even though we freaked everyone out." The OK Harris show flyer contained the first use of the word "punk" by a band, one of the many ways in which Suicide was truly cutting edge. "I remember seeing Alan Vega around the scene very early on," said Chris Stein. "Suicide was so groundbreaking, it's hard to convey how far ahead they were in relation to what was going on at the time." Debbie Harry added, "As a performer, Alan was sometimes a baffling struggle of danger, drama, pathos, and comedy. He held nothing back from us, and the interaction with audience hecklers was fundamental."

Not only was their music radically different from the New York Dolls, so was their look. "We were street guys, we took what we could get, sometimes from the garbage," Vega said. "I remember Marty went through the trash and other thrift store or Salvation Army type stuff, mainly out of necessity. We didn't have any money, so what became the punk look was born out of necessity. I cut holes in socks so that my fingers went through and I stretched the socks up to my elbows and had a cutoff pink jacket. That was really something, man! Basically, I just wore what I could afford. I'm not sure really what the fuck I was thinking."

Several of the bands that played at the Mercer Arts Center came out of theater—like Ruby and the Rednecks, which straddled the glam and punk eras. "I formed a band out of the musicians who played with the Play-House of the Ridiculous," recalled Ruby Lynn Reyner, "and I said, 'Why don't we play these songs from the shows?' I asked John Vaccaro's permission and he said he didn't care." Ruby and the Rednecks' staple, "He's Got the Biggest Balls in Town," was a favorite from Jackie Curtis's *Heaven Grand in Amber Orbit*:

He's got the biggest balls in town, even upside-down.
You ain't seen balls till you've seen Paul's:
Round, firm, and meaty; You could write a treaty on those balls!
He's got guts in those nuts! When Gabriel calls they'll blow his balls.

"Ruby sang quite a few songs from *Heaven Grand* and *Cock-Strong*, and some original material," said Play-House of the Ridiculous actor Michael Arian, a backup singer for the group. "All of her songs were not so much singing as little theater pieces, like Bette Midler did. Ruby was just extraordinary and was very, very entertaining." Reyner often acted out the lyrics while contorting her rubbery face or shaking her glitter-slathered breasts like maracas to a Latin beat. Ruby and the Rednecks were one of the staples of the Mercer's scene, appearing on the bill at a legendary New Year's Eve 1972 gig with Jonathan Richman's Modern Lovers, Suicide, Wayne County, and the New York Dolls.

David Johansen, Kristian Hoffman, and Jonathan Richman (left to right)
COURTESY KRISTIAN HOFFMAN

"Patti Smith was an opening act at Mercer Arts Center for a couple of shows when I played with the Dolls," Reyner recalled. "She went on early, reading her poetry, so not that many people were there. She didn't have her musicians yet, but she picked up the music pretty fast." Reading poems to an unruly audience that was waiting to hear the headlining rock 'n' roll act schooled Patti in the art of crowd control and stage presence. "I read my poems, fielded insults, and sometimes sang songs accompanied by bits of music on my cassette player," she recalled, and by the summer of 1973 she was hitting her stride. "I took to ending

THE DOWNTOWN POP UNDERGROUND

each performance with 'Piss Factory,' a prose poem I had improvised, framing my escape from a nonunion assembly line to the freedom of New York City."[5]

Lenny Kaye described these early shows as being very loose; they were still not thinking in traditional rock band terms and instead just followed their instincts after he began playing with her again later in 1973. "You're right next door to where the loft jazz scene is taking place, you're in an area in which experimentalism is encouraged," Kaye said. "That experimentalism was so far off the mainstream that you didn't really worry about it—you didn't think you're going to suddenly have a hit record. You're doing it for your peer group, essentially."

The Kitchen was founded by Steina and Woody Vasulka, two immigrants who wanted to create an alternative arts space at Mercer's that programmed everything from video to electronic music—though they also made room for rock 'n' roll. "The New York Dolls started in the Kitchen," Steina said. "They rehearsed in the Kitchen and then they performed there, and it got very wild. Their audiences were very out there." She recalled one night when she saw a bag of heroin on the floor during a Dolls show; Steina ran over to hide it from the police just outside the room, but an enterprising audience member snatched it up first.

The Vasulkas also helped incubate an all-male ballet troupe founded by Larry Ree. "Les Ballets Trockadero started in the Kitchen, after he performed his dance in *Vain Victory*," she said, referring to Ree's interpretation of Anna Pavlova's famous dance, "The Dying Swan." "I knew Larry through Jackie Curtis, and he asked if he could rehearse there." Steina gave the Kitchen's keys to Ree, who used it as a rehearsal space for his troupe, which was originally named Trockadero Gloxinia Ballet Company (some members eventually branched off and formed the well-known Les Ballets Trockadero de Monte Carlo company). Many other contemporary dancers also performed at the Kitchen, including Shirley Clarke collaborator Daniel Nagrin, who asked the composer Rhys Chatham to accompany him in 1971. "I saw these Slavic-looking people that Daniel also invited to come play, and it was Woody and Steina," Chatham recalled. "Steina was on viola and Woody had his synthesizer. So we hit it off."

They asked Chatham to organize some concerts at the Kitchen, which he began staging on Monday nights. The room was a big rectangular box with high ceilings, so they installed baffling insulation to flatten the sound and improve the acoustics. Folding chairs allowed them to move the seating around to fit a musician's needs.

"It was great presenting at the Kitchen," Chatham said. "We programmed dance from time to time, but mostly it was electronic image and electronic music." The young composer extended an invitation to La Monte Young, whose musical collective the Theatre of Eternal Music deeply influenced him. Chatham regularly attended Young's concerts as a teenager, and later joined his group in 1973 when experimental musicians Jon Hassell and Terry Riley were also members. "We just wanted to open the place and see what would happen," Steina said, "and it was really fun for two years." But running the Kitchen became something of a grind for the Vasulkas, as well as for Chatham, so they stepped down from their duties to focus on their own art.

"I was the music director from '71 to '73," Chatham said, "and then we all got tired—Woody, Steina, and me—because we were all working for free." They turned the Kitchen over to Robert Stearns, a solid administrator who was good at fundraising. "He hired Arthur Russell as music director from around 1974 to 1975," the composer continued, "and Arthur did something that raised a lot of eyebrows. He invited Talking Heads to play, along with the Modern Lovers." Footage of that Talking Heads show at the Kitchen is among the earliest video-taped documentations of New York's punk scene.

Like Russell, Chatham also played a role in the convergence of underground rock and experimental music. This connection began when he was talking to his composer friend Peter Gordon, who asked, "Have you ever in your life been to a rock concert?" No, the twenty-four-year-old replied. Gordon laughed and told him about a great neighborhood club where a cool local band was playing, and asked him to go. "So this was me in 1976," he said, "the band was the Ramones, the place was CBGB's."

Chatham had never seen or heard anything like it, and it was utterly romantic to him. "The music was complex," he said, perhaps the only time "complex" was used to describe the Ramones—a group best known for its short, fast, and sweet bubblepunk songs. "I was playing one chord, and they were playing three, but I felt something in common with that music." He got an electric guitar and began developing a new compositional style that led to his first major breakthrough, "Guitar Trio." Informed by both classical minimalism and punk rock, Chatham's landmark instrumental piece carved out a hypnotic, dissonant template that influenced 1980s post-punk groups such as Sonic Youth.

The Mercer Arts Center's aesthetic was wide open enough to make room for glam groups, avant-garde composers, and even funk bands like Dance—which regularly played with the New York Dolls. "What was popular at that time was

a kind of non-rhythmic pop music," said Dance frontman Marion Cowings, one of the handful of African Americans in that scene. "A lot of audiences back then weren't conditioned to dancing, but the Mercer's crowd was great." The band's guitarist, Nestor Zarragoitia, grew up in Greenwich Village and in the early 1970s was living in SoHo in the same building with Cowings and Dolls frontman David Johansen.

"SoHo used to be a garment district," Cowings recalled. "All of a sudden the factories started folding and moving out, and the artists came in and fixed them up and became a community." Only a few galleries like OK Harris dotted the area, along with the occasional bodega, martial arts studio, and what was left of the industrial sector. "The workers would come out of the factories," Zarragoitia said, "so you'd see them sitting outside eating their lunch." Cowings was friends with Johansen, which led to Dance playing at Mercer's with the New York Dolls. "We opened up for them a lot," Zarragoitia said, "and the last gig we did at the Mercer Arts Center with the Dolls was that night before the collapse."

On August 3, 1973, the Mercer's walls—which were structurally linked to a neighboring derelict hotel—had been ominously groaning all day. At 5:10, just twenty minutes before the first scheduled Friday evening performances, the hotel "fell like a pancake," said fire chief John T. O'Hagan.[6] The Magic Tramps were in their rehearsal space when the building began shaking, so Emerson and his bandmates ran for their lives.[7] Alan Vega happened to be walking down Mercer Street about an hour after the hotel fell, while the dust was still settling. "It looked like a bomb had been dropped on it," he said. "You could see the Blue Room, where we used to play, and it was just surrounded by rubble." Only part of the Mercer Arts Center building came down with the hotel, but the rest of it had to be torn down for safety reasons.

The fall of the Broadway Central Hotel epitomized New York's precarious condition in the 1970s, when the city was on the brink of bankruptcy, its infrastructure was crumbling, and crime was rampant. Those who witnessed the collapse recalled seeing rats fleeing the scene and fanning out into the streets; likewise, the artists and musicians who frequented Mercer's scrambled to find new places to perform. During the dying days of glam rock, many of them began populating a Bowery bar that became known as CBGB, where the final act of this drama played out.

CHAPTER 28

DIY TV

The Mercer Arts Center's many rooms provided a home for underground rock, contemporary dance, Off-Off-Broadway, and even Shirley Clarke's video experiments. The former filmmaker embraced the egalitarian potential of video as an alternative to broadcast television, a mass medium that encouraged passive media consumption. "It was very important for her that it should go back and forth in a two-way type of communication," recalled Andrew Gurian, her longtime assistant. "She was very democratic and ahead of her time in that way. And I think she really was excited by the fact that all this equipment was getting smaller and smaller and more accessible to everyone."

Clarke also found creative ways to subvert the masculine-coded domain of electronics. "One day Shirley just painted all the equipment pink," Gurian said. "You associate it with six-year-old girls and their dolls, which I think was the point. She constantly would refer to what we did as being 'playful.' We were adults playing around. So if you wound up with a pink screwdriver, there was something lighthearted about that. It desterilized the equipment so it became an extension of your eye and your hand." Clarke's aim was to make the hardware feel more user-friendly, so that no one felt excluded.

The Kitchen, cofounded by Steina and Woody Vasulka, provided a testing ground for Clarke and others to imagine these new modes of electronic communication. "Shirley's idea was to have video always going, constantly there," Steina said. "So the first programming we had was video on Wednesdays, an open house where anybody could come in and show stuff." In addition to the Tee Pee Video Space Troupe and Videofreex, several other downtown video groups had formed by the early 1970s—Raindance, People's Video Theater, Global Village—most of which made use of the Kitchen. "People would be coming with a tape, which was at that time reel-to-reel, just totally hot," she said. "They ripped it off their equipment and ran as fast as they could down there to show it."

Steina was born in Reykjavík, Iceland, and at age nineteen received a classical music scholarship to the Prague Conservatory in Czechoslovakia, where she met Woody Vasulka. "He had a very hard time getting out of the country, because behind the Iron Curtain, you couldn't move," she said, explaining why they eloped and eventually moved to the United States in 1965. Woody had been working in Prague as a television engineer, and when they arrived in New York he began working for a firm that produced multiscreen video projections. "They did a project in Montreal for the '67 World's Fair, and Woody was involved in two of the projects that were shown there," Steina said. "That was our first introduction to video."

That was the same year that Sony introduced the Portapak video camera to the consumer market, and the couple soon began documenting the scenes that surrounded them. "The Vasulkas videoed everything," recalled *Pork* actor Tony Zanetta. "They didn't just videotape theater, they did it all. They have an incredible archive of everything that went on downtown." The couple could be seen shooting a Fillmore East underground rock band or behind the video camera at an Off-Off-Broadway show. Steina taped her friend Jackie Curtis's first play, *Glory, Glamour, and Gold*, as well as *Femme Fatale* and *Vain Victory* a few years later. "That's how I discovered that this was what I should do, shooting video," she said, "and then after that, Jackie would always call when she thought we should be there."

In 1970, the Vasulkas got an opportunity to fix up the Mercer Arts Center's old kitchen, which is how the venue got its name. "Everyone thought the Kitchen would sound mystical," Steina said, "like we were going to cook art in there."

By the time the Kitchen opened its doors, the Videofreex were preparing to leave New York. When their CBS funding ran out, the group reassessed their options. "We didn't have any income," Mary Curtis Ratcliff said, "and all of us were trying to live in Manhattan, but there was no real market for this stuff we were doing." So the 'freex did what many in the counterculture did at the time: moved to the country and lived communally. They found a huge twenty-seven-room boarding house called Maple Tree Farm located in Lanesville, New York, about a three-hour drive north of the city. "In Lanesville, we had visiting artists all the time," Nancy Cain said. "Like Twyla Tharp's dance company, she would come up and they would do things out in the meadow—just amazing, amazing choreography."

"Shirley Clarke would come to stay with us in Lanesville," Skip Blumberg recalled. "There was the 'Shirley Clarke Memorial Guest Room,' we called it,

because she decorated one of the rooms." She painted it entirely with a glossy red hue, and it was like a playroom—which was fitting for a childlike middle-aged woman. When Ratcliff asked Clarke for advice about getting married, she said, "Oh, when you get married, I'll bring a cake and a case of champagne to the wedding." But when that day arrived, Clarke brought only her video cameras. "She produced what she called a Marx Brothers movie," Cain recalled, "with a background being the wedding that was taking place in Lanesville." Shirley played the part of Groucho—her favorite—and recruited others to play Harpo and Chico. "I could've strangled her," Ratcliff said. "But it didn't matter. It was all kind of funny."

When the Videofreex arrived in 1970, Lanesville was a rural hamlet whose townsfolk didn't know what to make of them. "But the long-haired hippie types turned out to be very friendly and quite interesting," Ratcliff said. "We would go into town and videotape what was happening down at the bar, or talk to pig farmers, or whatever was happening." While there, the Videofreex also set up America's first pirate television station, thanks to Abbie Hoffman. He had known David Cort from their college days, and the activist met the rest of the Videofreex during their time downtown. When Hoffman wrote *Steal This Book*, his subversive how-to guide published in 1971, he paid the 'freex to build a transmitter to test out for the chapter on pirate broadcasting. "We realize becoming TV guerrillas is not everyone's trip," he wrote, "but a small band with a few grand can indeed pull it off."[1]

"Abbie had tried to get us to broadcast guerrilla television all over Manhattan," Ratcliff said, "but you couldn't broadcast from a VW bus, and you couldn't get a signal with all those huge buildings all around." In Lanesville, this wasn't a problem, so the Videofreex used the equipment to build a little broadcast tower atop their farmhouse. "We turned on this little transmitter that Abbie had given us," Cain said. "We took a TV set down to a bar about half a mile down the road, Doyle's Tavern, and we turned on the TV set and the signal was there!" The local community—which previously couldn't get network television signals because of the surrounding mountains and foothills—started tuning into these wildly illegal broadcasts, which were never shut down by the government.

It turned out the Videofreex had an ally in Federal Communications Commission commissioner Nicholas Johnson, who promoted independent media through his strong advocacy of video technologies and public access television. In 1966, President Lyndon Johnson appointed Nicholas Johnson to the FCC, where he

served as a rabble-rouser for media democracy until 1973. "We were inspired by Nick Johnson and those other authors who were challenging the status quo," Blumberg recalled. "He was part of a group of people like Marie Winn, who wrote *The Plug-In Drug* and did boycotts of watching TV. These people were heroic because they were smart, they were tough, and they worked inside the system, but they were doing something entirely different than us. We were creating a new world and we were having a lot of fun doing it."

The Videofreex weren't the only video artists who moved upstate. At the time, the New York State Council on the Arts was heavily funding work in video, which was originally concentrated in New York City. Because those funds were required to be distributed evenly across the state, video artists migrated from the Lower East Side and SoHo because they had a better shot of getting arts funding elsewhere. One video hub developed at Syracuse University, which founded a video-oriented visiting artist program called Synapse. "The people who started it were interested in Buckminster Fuller and Portapaks and the *Whole Earth Catalog*," said Paul Dougherty, a college student who later documented the early punk movement in New York City. "You can imagine a whole matrix of things, long-haired hippie video-freak-type folks."

There were few places to present video in the early 1970s, aside from screening venues like the Kitchen, Synapse in upstate New York, and the pirate broadcasts of Lanesville TV. Into this vacuum emerged public access channels on cable television. In the early 1970s, public access stations began popping up around the country, channeling underground culture into people's living rooms. There weren't many options to choose from on cable television back then; HBO was still a small-time operation, and only three television networks existed, plus PBS. "Public access got fabulous exposure," recalled Dougherty, who began working at one of New York's first public access channels. "So you're channel surfing Channel 11, WPIX, Channel 13, WPBS, and then the next channel that you come to is public access. So location, location, location."

Before Chris Stein cofounded Blondie with Debbie Harry in 1974, the guitarist collaborated with some former members of the Cockettes on a public access show called *Hollywood Spit*. "It was the four of them—Fayette Hauser, Tomata du Plenty, Gorilla Rose, Screaming Orchids," he said. "They considered themselves kind of the Drag Beatles. We just edited in the camera, carefully in sequence, as we were shooting, and it was just a weird, ahead-of-its-time drag situation comedy. Unfortunately, the tapes were destroyed in a fire in my friend's loft."

Interview magazine contributor Anton Perich—who documented the scenes at Max's Kansas City and the Mercer Art Center with his Super 8 film and Portapak video camera—also began making his own public access show, *Anton Perich Presents*, which debuted in January 1973. "Video was the freshest flower in the machine garden, fragrant and black and white," he said. "The Portapak was this miraculous machine in a miraculous epoch. It was truly a revolutionary instrument. I was ready for revolution." In one infamous episode of *Anton Perich Presents*, downtown scenester (and soon-to-be Ramones manager) Danny Fields acted out a scene in which he tried to cure a television repairman's hemorrhoids by inserting a lubricated lightbulb into his anus. "The show was censored during the cablecast," Perich recalled. "They inserted a black screen and Muzak. It was the biggest scandal. Every major media outlet did a story about it."

By the early 1970s, many downtown artists were taken by video—including playwright Harry Koutoukas, who turned 87 Christopher Street's fire escapes into a staging area captured by Global Village's trusty Portapaks. Koutoukas's neighbor, James Hall, had acted in some television shows, commercials, and theater—including *Back Bog Beast Bait* in the ill-fated Sam Shepard double bill that included *Cowboy Mouth*. One day in October 1972, Koutoukas knocked on Hall's door to see if he had anything to eat or drink. "We didn't have regular jobs, so we were just riffing on our usual 'what to do today?' back-and-forth," Hall recalled. "And while we were eating breakfast Harry said, 'Let's do a play! I'll write it, and we'll perform, and you cast it. We'll call it Fire Escape Theater!'" Koutoukas ended up naming the play *Suicide Notations*, and he conscripted his neighbor Lisa Jane Persky in her New York debut as an actress.

If Off-Off-Broadway opened its doors to nonprofessionals, *Suicide Notations* was more like Off-Off-Off-Broadway. Persky's mother let Koutoukas use the fire escape on the front of her apartment for the actors to shout their lines, and other scenes took place on Hall's fire escape directly above them. Persky played the Girl in Gown—wearing her own exotic long yellow dress with red moons and stars—and Hall was the Sleepwalking Poet. Koutoukas stole the show as Louis XIV, wearing a crown and a gaudy silk bathrobe, complemented with feathers, beads, and glitter. "I didn't think about *Suicide Notations* as being in a play," Persky said. "It was just an off-the-cuff kind of thing—like a Happening, really. We had a dress rehearsal, which was a performance for the street, because we knew we were going to shoot it on video."

It was taped by Rudi Stern, who cofounded Global Village and had previously produced light shows for LSD guru Timothy Leary. When Stern shot it at night, he

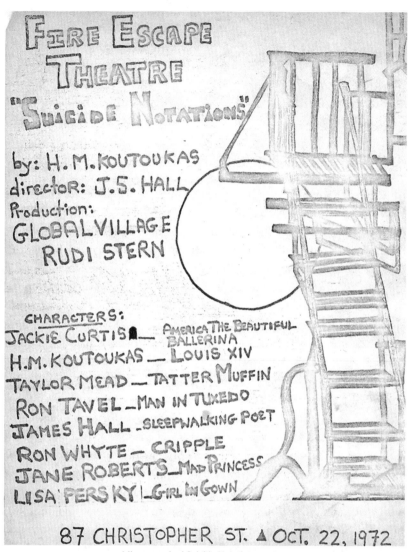

FIRE ESCAPE
THEATRE
"SUICIDE NOTATIONS"

by: H. M. KOUTOUKAS
director: J.S. HALL
Production:
GLOBAL VILLAGE
RUDI STERN

CHARACTERS:
JACKIE CURTIS — AMERICA THE BEAUTIFUL BALLERINA
H.M. KOUTOUKAS — LOUIS XIV
TAYLOR MEAD — TATTER MUFFIN
RON TAVEL — MAN IN TUXEDO
JAMES HALL — SLEEPWALKING POET
RON WHYTE — CRIPPLE
JANE ROBERTS — MAD PRINCESS
LISA PERSKY — GIRL IN GOWN

87 CHRISTOPHER ST. ▲ OCT. 22, 1972

Mimeographed Suicide Notations poster
COURTESY THE ARCHIVES OF LISA JANE PERSKY

lit up the fire escapes on all six floors and ran the master switchboard in Persky's apartment. "My friend on the street," Hall recalled, "he threw his crutches in front of a bus to stop the bus so we could shoot a scene." Taylor Mead, Ronald Tavel, and Jackie Curtis were also cast for the video production, but like many early video pieces, the *Suicide Notations* tapes were lost years ago. All that remains is a faded mimeo flyer.

CHAPTER 29

The Lights Dim on Off-Off-Broadway

After Harry Koutoukas's apartment caught fire in 1972, actor and playwright Harvey Fierstein wrote a show about his attempt to help clean up the mess, *In Search of the Cobra Jewels*. Fierstein played the Koutoukas character, mixing real details from the apartment (such as how Koutoukas partitioned his living space by tying together large scarves) with bawdy surrealism. He recited a poem about a lover as he cut a folded piece of paper with scissors—then opened it up to reveal a string of little paper men with penises, holding hands. The *Cobra Jewels* cast also included Agosto Machado, Ronald Tavel, Harvey Tavel, and the unpredictable Koutoukas himself, who began slicing his wrists with a razor onstage one night. "Take the razor out of Koutoukas's hand!" people screamed as Ellen Stewart tried to stop him. *"Take the razor out of his hand!"*

"We all walked offstage," Machado recalled, "and Koutoukas—who is fabulous—he just said, 'Oh, are you going to *condemn me* for getting *blood on the stage?'"* In Michael Smith's *Village Voice* review, he reported that "the opening night blood-letting introduced too much reality onto the stage for my taste. I was sickened and horrified."[1] Stewart was also disturbed by the spectacle, and some time after she reminded him, "Harry, I actually saved your life, remember? You were onstage and you slit your wrists and then you started to cut your throat and I stopped you." The stubborn playwright retorted, "Yes, but I still object to you stopping my performance, for censoring me. But I do thank you."

The following year, Koutoukas waltzed up to Lisa Jane Persky on the street and said, *"Darling,* I've written a play for you. Rehearsal starts Sunday. The pay is twenty-five dollars a week. I'll send someone to pick you up." That Sunday, actor Benton Quin came by and walked Persky to La MaMa for a rehearsal of *Grandmother Is in the Strawberry Patch.* Quin was cast as Eunice, the Woman Next Door, and Persky was Cordelia Wells, the World's Most Perfect Teenager; Grandmother was played by Koutoukas's favorite actress, Mary Boylan, who had worked in film during the 1930s and 1940s, and television in the 1950s.

H. M. Koutoukas (left) behind Gerry Ragni (right) on Christopher Street at Sheridan Square, 1976
© LISA JANE PERSKY

The play was full of Koutoukas's characteristic non sequiturs and weird moments that erupted from his twisted, hyperintelligent mind. In one memorable scene, Eunice and another character had the ill-conceived idea to put contact paper on a very nice wooden table. "Look," they said, "It looks almost like *real* Formica!" The script was a rich source of drama and comedy, as was the playwright—who had another meltdown during the show's opening night. About twenty minutes in, the actress who played Persky's mother forgot her lines and froze. It felt like ten minutes, though it was probably only sixty seconds, but Koutoukas rose from the back of La MaMa and stormed down the aisle. He was trailed by large swaths of fabric, screaming, "Stop. *Stop!* This. Is. *Professionalism?!* Begin again! Start over!" And they did.

Koutoukas replaced the actress with a woman he claimed was his therapist, which could have been a complete fiction—or not. Later in the 1970s, Persky ran into her friend Tomata du Plenty (a former Cockette who formed the punk band the Screamers in Los Angeles). "He knew me for a long time," she recalled, "and he said, 'I had been meaning to ask you. When Harry came down and freaked out, was that part of the play?' And that was the first time it even occurred to me, like, 'Oh, yeah. They didn't know.'"

After *Grandmother Is in the Strawberry Patch*, Koutoukas had another big row with Stewart. Both had strong personalities, and they clashed several times over

the years, culminating in him sending her tumbling down a few stairs—though because this legendary incident had been embellished over the years, who knows exactly what happened. Real life often blended with fantasy, especially when highly theatrical people got involved. The story resonated because it reminded some on the scene of an over-the-top moment from the 1947 film noir classic *Kiss of Death*, in which Richard Widmark rolled a wheelchair-bound woman down a flight of stairs. "I was there the night Harry threw Ellen down the stairs of La MaMa," playwright Robert Patrick recalled, "and she forgave him. Everybody forgave Harry for everything. He was the most extreme example of what we all were—dropouts, freaks, originals, or 'gargoyles,' as he would put it."

Koutoukas finally returned to the La MaMa fold on Christmas day 1975 for a presentation of his play *Star Followers in an Ancient Land*. Because Machado was friends with Koutoukas and had known Stewart from La MaMa's early days in the basement of East Ninth Street, he was asked to help smooth things over. "Ellen was so pleased," he said, "and Harry was so honored to be back at La MaMa, because it really was important to him."

Machado also performed in *Star Followers*, as did Koutoukas's friend Bruce Eyster. "One day I was walking around," he recalled, "and Harry came up to me and said, 'You're going to be in my Christmas show.' And I said, 'Oh, really? Well, okay.'" Eyster played a Heavenly Body, Machado was one of the Three Wise Men, and Koutoukas once again cast Mary Boylan, who was given lines from the Bible. "Harry, you didn't write this," she told him. "Well, no," Harry replied, "but if you're going to plagiarize, I believe you should plagiarize from the best."

The show's music was performed by Tom O'Horgan, who continued working with La MaMa even after his 1968 success with *Hair*. "He came to a rehearsal of *Star Followers in an Ancient Land* and got the idea of the show's mood," Machado said, "and he did some music that gave a feeling of ancient times." There was no set the night before the show opened, so Koutoukas instructed Eyster to do something—anything. "I sent everybody out to get as much cardboard off the street as they could," Eyster said. "I painted it white, airbrushed it with clouds, and hung it all around the set. I was doing makeup, costuming, and the set, and then I was also in the show itself."

Eyster's next Koutoukas play was *Too Late for Yogurt*, in which he had to perform a non-sequitur-filled solo monologue that ran the entire second act—all while standing in a huge tennis shoe. "Right before the show opened, Harry came to me and said I had to bleach my hair white and shave all my body hair off. I just

said, 'Harry, you can't ask me to do that. I won't do it.' He said, *'No one says NO to Harry Koutoukas!'* So I said, 'Okay. I guess I'm not in the show.'" It was the first time the two had a real conflict, and they didn't speak for three years. As payback, Koutoukas kicked Eyster out of his "School for Gargoyles"—an imaginary institute that included some of his favorite people, such as Persky and Fierstein.

Being an Off-Off-Broadway playwright and performer certainly did not pay the bills, and Koutoukas never held a real job, but he survived with a little help from his friends—and various patrons that he juggled. "More or less, they were women who had money who needed a walker," Machado said. "You know, that term for a gay male who escorts a lady to functions, so she won't be alone. They really thought he was so unique and unusual and talented." Koutoukas also wrote many chamber plays that were performed in candlelight in the apartments of wealthy uptown patrons who were dazzled by his wit and wordplay. "Now and then, Yoko Ono might give him a call," Machado continued, "but it didn't mean automatically she's going to help him out, though she often would."

Harry also had a patron, Angela Boone, who ran the restaurant Pennyfeathers near his apartment. After discovering he was a playwright, she set him up at a little round table and would introduce him as the house playwright. "Harry would always come in," Eyster recalled, "and he would have all this food and then say, 'Oh, put it on my bill.' Until Angela died, he sent me to go over there and say, 'Harry needs two sandwiches, roast beef.' And she'd say, 'Okay,' and she would make it and send it over." Despite the speed demons and drug-fueled craziness that nearly killed him, Koutoukas beat the grim odds and lived into his seventies, spending a full half century in a building he called home—with his trusty DECEASED: RETURN TO SENDER stamp ready when the bills piled up in his mailbox.

<p style="text-align:center">***</p>

After Persky made her stage debut at La MaMa, she performed her next role in *Women Behind Bars* at the Truck and Warehouse Theater, located across the street. The show was written by Tom Eyen, who had humble beginnings at Caffe Cino but later created the hit Broadway musical *Dreamgirls*. *Women Behind Bars* was a trashy satire of women's prison movies with a cast that included Divine, who had also worked with the Cockettes in San Francisco. The gender-bending group first saw Divine in the John Waters films *Multiple Maniacs* and *Mondo Trasho*, which their manager, Sebastian, screened at the Palace Theatre. When the Cockettes met Divine at the airport, it was love at first sight. "We were wearing

Hibiscus with Divine, circa 1970
COURTESY THE FAMILY ARCHIVES OF GEORGE EDGERLY AND ANN MARIE HARRIS

all this high finery and crazy drag," Lendon Sadler said, "and we went out there and turned the airport up! Of course, Divine arrived in drag and we acted like kids greeting the Beatles."

Sadler lived for a while in a Cockettes house on Dolores Street, where director John Waters stayed when he first came to San Francisco. "We were natural soulmates, the Cockettes and John Waters's people," Sadler said. "Divine was a complete original, and he really did become a star in San Francisco." During *Journey to the Center of Uranus*, Divine dressed in a huge electric-red crab outfit and sang "A Crab on Your Anus Means You're Loved." In another show, he played a lion tamer who made the Cockettes jump through hoops like circus animals and threw raw meat at an audience of vegetarians and food purists who refused to even eat white sugar (it was unrefined pure brown sugar, or bust).

Waters said that the Californians he spent time with were more like out-of-their-minds Yippies, rather than hippies who grooved on a peaceful, easy feeling. "We would mess with other communes, like Kaliflower," Waters recalled. "Our commune—the house I lived in was called Flo Airwaves—we used to dump white sugar on their doorstep or throw meat. It was fun. It was hippie

wars. I made all of my movies to offend hippies. We were just punks, but they didn't have a name for it yet."

After moving to New York, Divine was cast in the second production of *Women Behind Bars*, directed by Ron Link, who directed Jackie Curtis's first play *Glamour, Glory, and Gold*, along with several other underground theater productions. One day in 1974, Lisa Jane Persky ran into Sweet William Edgar, a warmhearted actor who had a very nasal voice and brilliant comedic timing. "They're casting for this new show, *Women Behind Bars*," he told her. "You should audition!" She didn't get a part at first, but she was hired as the understudy for all the roles and became Link's assistant, which meant she did everything—from running lights and ironing costumes to bringing a rooster back to her apartment on weekdays. (The rooster played a chicken named Rosalita, a gender-bending casting decision that was typical of Off-Off-Broadway.)

The original production was performed at Astor Place Theatre. Starring Pat Ast, Helen Hanft, Mary Woronov, and Sharon Barr, it was funny and entertaining, but it was also a starker version. Even the set was stripped down, with just a couple of benches and fake prison bars. "Ron could make something out of very little," Barr recalled, who played a Marilyn Monroe type named Cheri Netherland. "Sharon Barr was fabulous," recalled Woronov. "She was gigantic and gorgeous, and she walked around like she was on Mars. It was very funny."

Eyen's script was wild and over-the-top, and under Link's direction the show burst with the energy of punk rock. "It had to move like the Ramones," Persky said. "It just wasn't anything without that pace." After the original run, *Women Behind Bars* opened at the Truck and Warehouse Theater, with Divine as the Matron and Lisa playing the Innocent Raped by the System. "I would get brought in to see the Matron," she said, "and I would be all trembling and everything. It was arch. Divine would pull a chain and this giant bed with satin quilt came down, which would go *boom*! It fell on the floor, and then things proceeded from there."

The Matron laid Persky down on the bed, spread her legs in the air, and pretended to violate her with a dildo as the stage lights went out (the dark silence was penetrated by the quiet buzzing sound of the vibrator, which always got a laugh). "It sounds so harrowing," Persky said, "but if it was working, most nights people were just laughing hysterically because it was just ridiculous. Of course, rape really isn't funny. As a person who got mugged by a man and was almost killed, it wasn't funny to me then either, but I understood that this was something exaggerated to a point of ridiculousness." As Barr noted, "With camp, when it was at its best, there was a lot of truth and honesty behind the exaggeration."

The Matron (Divine) and the Innocent Raped by the System
(Lisa Jane Persky) in *Women Behind Bars*
COURTESY THE ARCHIVES OF LISA JANE PERSKY

Mainstream and underground culture often overlapped downtown, as when 1970s pop superstar Elton John frequently came to the show. "He'd buy a whole row of seats and fill it with friends," Persky recalled, "and you could hear him laughing loudly in the audience." John asked Divine to join him onstage at Madison Square Garden and invited the whole *Women Behind Bars* cast to the arena. Kiki Dee—who duetted with him on the 1976 hit "Don't Go Breaking My Heart"—came out for a couple songs, then Divine did a number in front of the biggest audience of his career. Divine was certainly not a household name outside of the worlds of trash cinema and Off-Off-Broadway but, as Persky recalled, "It turned out that the Elton crowd *loved* Divine. They went crazy!"

Back in the underground, Persky volunteered Divine and the rest of the *Women Behind Bars* cast to perform some scenes at a benefit for Wayne County that Peter Crowley organized, staged at Max's Kansas City. County was arrested in 1976 after an altercation at CBGB with Handsome Dick Manitoba, a professional wrestler who also performed in the punk band the Dictators. He had drunkenly heckled County with homophobic slurs during her set and then tried to climb onstage, which sparked a bloody melee that broke Manitoba's collar bone. The *Village Voice* ran the ironic headline: "Mad Drag Queen Attacks Poor Defenseless Wrestler." Blondie also performed at the benefit, along with a who's who that included Talking Heads, Richard Hell, Jackie Curtis, and Holly Woodlawn—all in an effort to raise money for County's legal defense fund. (The charges were later dropped.)

Blondie first connected with Divine through Persky when they performed in *Women Behind Bars*, and Stein and Harry met Waters later in 1976 when they drove down to Wilmington, Delaware, to attend the First Annual World Sleaze Convention with the *Punk* magazine staff. The couple's association with Waters continued when they wrote songs for his 1981 film *Polyester*, and Harry also appeared with Divine in 1988's *Hairspray*. "She really wanted to do *Hairspray*," Waters said, "regardless of the fact that it may not have been the perfect next step or exact order that she would have done things to benefit her music career."[2]

Persky left for Los Angeles in 1977, just as the underground theater scene was winding down. The symbolic beginning of the end occurred in 1974, when an organization called the Off-Off-Broadway Alliance staged a festival in the outdoor plaza of Lincoln Center. "It was a great celebration of Off-Off-Broadway as a community," playwright Michael McGrinder said, "but I realized also that we were celebrating our own demise as a community, because we had outgrown ourselves. So Off-Off-Broadway, as a smaller communal scene, no longer existed. It was omnipresent, everywhere."

"There were only a handful of downtown underground do-it-yourself theaters in the beginning," *Village Voice* theater critic Michael Smith said. "But by the end of the sixties, there were, I don't know, seventy-five or a hundred. I always felt in a way that I had destroyed the Caffe Cino by publicizing it. It was the same with punk, where there were a whole bunch of bands after the scene got overexposed." A new cast of characters appeared downtown, and the faces were changing; the Angels of Light, for instance, had fewer performing options, so around 1975 Hibiscus and his sisters headed off to Europe to put on shows. Throughout the first half of the 1970s, the frenetic energy and scrappy DIY spirit that had fueled the underground theater movement morphed to what became known as punk.

CHAPTER 30

Punk Rock's Freaky Roots

Debbie Harry's campy pre-Blondie group the Stilettoes were right at home per-
forming at Club 82 on a bill with Wayne County. During the early 1950s and 1960s,
when it was known as the 82 Club, this Lower East Side venue hosted nightclub
revues that attracted A-list stars looking for edgier entertainment. Judy Garland
frequented the basement venue and, according to a legendary showbiz rumor,
movie star Errol Flynn once unzipped his pants and played the club's piano with
his penis. It had been one of the premier venues for drag queens—who were largely
shielded from homophobia behind its closed doors.

"I used to go to the 82 Club," recalled Agosto Machado. "Gray Line Tours used
to go down there, and they would advertise female impersonators there with a
postcard of the showgirls in costume, which said, 'Who's No Lady?'" The drag
queens who appeared at the 82 Club were relatively traditional—a far cry from
the likes of Wayne County and Jackie Curtis, who never bothered passing as
"real" women.

Like other bars and clubs that catered to gay crowds, it was subject to periodic
police raids. This harassment intensified in the lead-up to the 1964 New York
World's Fair, when city officials cleaned up the streets to make it seem more fam-
ily friendly. "You'd have the police clear the sidewalks and the streets," Machado
said, "so where could you go? Into mafia bars, or after-hour clubs. Conveniently,
Stonewall was just down the street from where a lot of people hung out on Chris-
topher Street." In the years before the 1969 uprising at the famed gay bar, one part
of Jim Fouratt's experiences of being gay was going to those establishments. "The
gay bar," said the Yippie cofounder and early gay rights activist, "as oppressive
as it might be—and the Stonewall was one of them—was the only place that gay
people could mingle together without it being an anonymous sex site. That's why
the Mob played a very important role."

Fouratt was one of the handful of people who witnessed the start of the Stone-
wall rebellion in the wee hours of June 28, 1969 (many more would join over the

next few evenings, and even more would claim to be there after the fact). As he was walking down Christopher Street on his way back from a nightcap at Max's Kansas City, Fouratt saw a police car parked in front of Stonewall, after which the doors flew open. "Out comes what you would call a bull dyke," he said. "The nice term of that period was called a 'passing woman.' She passed as a man. She was like, *Rr-rr-rr*, like being as butch as she could be, and the police officer puts her in the car." (She was arrested for not wearing three pieces of clothing "appropriate to one's gender," as was mandated by a New York statute.[1]) About fifty people watched outside the bar as the woman began rocking side to side until the car door popped open. She got out and began throwing her weight against the police cruiser, which nearly tipped over.

"There's a moment—which is, to me, the critical moment—where the crowd screams," Fouratt recalled. "It's the moment of, to me, liberation. It is the moment when all of that stuffed-down feeling, all of that oppression that every gay person had ever had, gets released, in that crowd." The growing crowd began fighting back, with Christopher Street regular Marsha P. Johnson flinging debris at the cops. "It was fun, almost," Fouratt added, "and the police had no clue what to do because gay people never acted like this before." The uprising was followed by the founding of the Gay Liberation Front and the debut of the indie newspaper *Gay Power!* within a couple months. *Gay Power!* mixed art and activism by including photography by Robert Mapplethorpe and written contributions from Jackie Curtis, Taylor Mead, and political columnists.

After Stonewall, gay men no longer felt that they needed to hide behind the closed doors of Mafia-run bars. The crowds at the 82 Club thinned because drag queens could freely camp it up in the streets, and gay culture was also shifting away from a femme aesthetic. "There was a big difference between what had been gay in the fifties," Tony Zanetta said, "and what gay life was in the late sixties, early seventies. The whole macho man thing emerged. Drag had a special place within gay culture, but after Stonewall it changed. The 82 Club had basically emptied out." The neighborhood was also deteriorating; the cashier at the nearby corner bodega sat behind an inch of bulletproof Plexiglas, and on one occasion a man was gunned down in front of the 82 Club's battered steel door.[2]

Looking to bring in new customers, the management inverted its name from the 82 Club to Club 82 and began booking underground rock bands like the New York Dolls, the Stilettoes, Wayne County, and Television. David Bowie, Lou Reed, and Bryan Ferry would also drop by when it was operating as an after-hours club (County recalled that Club 82 was where Reed met Rachel Humphries, the

transgender woman who was his live-in lover for three or four years in the 1970s). "It was basically geared to look like a scene from Liza Minnelli's *Cabaret*," Paul Zone said, describing its elongated stacked stage, glittery curtains, and fake palm trees. "It was for drag shows—so the stage was elongated—but it was basically a basement." Blondie's Chris Stein added, "The most impressive thing it had was a photo wall in back. There was a photo of Abbott and Costello with a bunch of drag queens, which I thought was utterly amazing."

The butch lesbian bouncer rocked a classic 1950s DA haircut and wore a white T-shirt with a pack of cigarettes rolled up in the sleeve, which added to the venue's eclectic atmosphere. Club 82's mix of theatricality and gender-bending made sense, given that it was located next to La MaMa. Off-Off-Broadway and underground rock audiences often overlapped during the first half of the 1970s, especially when local bands such as the New York Dolls or Wayne County and the Backstreet Boys began playing at Club 82.

Future Blondie members Clem Burke and Gary Valentine also hung out there when they were crashing at a friend's storefront pad. "I was living in New York," Valentine said, "and I was basically leading a kind of decadent juvenile delin-quent life in the East Village. I was hanging out at Club 82 prior to when I was playing in Blondie." Burke played drums in a band called Sweet Revenge, which sometimes performed at Club 82, where they covered David Bowie and Mott the Hoople songs mixed with some originals. "One of our big songs was called 'Fuck the World,'" Burke said, "which was kind of punk rock."

Lance Loud and Kristian Hoffman were in the crowd when the Dolls played there on April 17, 1974—as was just about everyone else who became key play-ers in the early punk scene. "It was a big deal because the New York Dolls were playing in actual drag in honor of Club 82," Hoffman recalled. "David Bowie was in that audience. That's pretty cool to be in your neighborhood club with one of your favorite bands, with only about probably a hundred people there, and two of them were David Bowie and Bryan Ferry. So I walked right up to both of them, asked for autographs. They knew that it was ridiculous, but they gave me really great autographs anyway."

Paul Zone, who would join his brothers' group the Fast in 1976, was also at that Dolls performance at Club 82. It was there that he met Harry and Stein, as well as Loud and Hoffman—all of whom would go on to play a big role in his life. "We all met at that Dolls show," Zone recalled. "That was one of my first times with Kristian, at a Dolls show." Hoffman added, "Paul and his brothers knew who we were, like, 'Oh, it's *An American Family*!' Something like that. So Paul just came

up and just started talking to us. Paul wasn't in the Fast yet. He was kind of like the designer-manager person for the band." Also in attendance was Roberta Bayley, who later worked the door at CBGB and shot album cover photos for the Ramones and Richard Hell and the Voidoids. Bayley had recently moved from London to New York and heard about the New York Dolls, but hadn't yet seen them. "It just happened that the Dolls were playing directly downstairs from the loft where a friend of a friend lived on East Fourth Street," she said. "That was Club 82."

Aside from a few bands that played there, by this point it had evolved into a shoddy underground disco. "It was a basement club, and this was the age of disco," recalled the Cockettes' Pam Tent. "Lights and glitter everywhere. Alice Cooper was there, Jobriath was there, Lou Reed was there. Everybody who was anybody in New York would turn up the 82 Club, and we all would do cocaine and dance all night." Noting that Blondie absorbed some disco influences there, Burke said, "The music that they would play at Club 82 in between sets would be like 'Rock the Boat' or 'Shame, Shame, Shame,' and all this dance music. The whole disco scene was going on simultaneously to the punk scene."

Early discos and punk clubs often coexisted in the same downtown neighborhoods and occupied similar kinds of spaces: lofts, storefronts, basements, and bars. But, of course, only one of these subcultures was praised by rock critics. Most white male rock writers turned a blind eye to disco's subcultural leanings, or were outright hostile to the music and its fans. Many of these same critics also helped popularize a macho, cartoonish version of punk that had little to do with the much more artistic, gay scene that originated downtown.

The fact that Blondie eventually crossed over with their disco hit "Heart of Glass" underscores how Lower Manhattan incubated several musical-cultural movements throughout the 1970s. An important early disco known as the Loft was originally located just a few blocks from CBGB, and many downtown gay bars and discos hosted punk shows. "Blondie used to play with the Ramones and lots of our other friends in gay clubs and drag clubs," Burke said, "and the music that was playing was dance music. I always point out that disco music was probably more subversive than punk rock. That whole lifestyle—the underground clubs, the gay culture, the leather scene—all that stuff revolved around disco. Before it became Studio 54, it was an underground phenomena in New York gay clubs. That was definitely a left-of-center movement, the same way punk was."

"The people that were at Club 82," Burke continued, "Lenny Kaye, Joey Ramone, Tommy Ramone, myself, Gary Valentine, Debbie and Chris, Johnny Thunders—essentially, everybody took their platforms off, cut their hair, walked

around the corner, and wound up at CBGB. That's basically what happened, because everyone was living in the neighborhood. It literally was around the corner from CBGB." The bar had been around since 1969 in an earlier incarnation, Hilly's on the Bowery, which was named after owner Hilly Kristal. He began his nightlife career in 1959 as the manager of the jazz club the Village Vanguard, and went on to open Hilly's on East Thirteenth Street, where he booked folk and blues acts throughout the 1960s.

Like many in the downtown's bohemian circles, Kristal put down roots on the east side. "One of the drinking places we went to when I was doing shows at the Old Reliable was a place called Hilly's on the Bowery," recalled playwright Michael McGrinder. "It was a big, big, place. One day there was a new sign outside and it said, CBGB & OMFUG. I said to Hilly, 'What's going on? What do those letters mean?' He said, 'CBGB—Country, BlueGrass, Blues and Other Music for Uplifting Gourmandizers.' I don't know if it was a whim or what the hell was going on, but Hilly couldn't put his name to anything because he had no credit left in the world. Everything was in his wife Karen's name."

The Old Reliable was three blocks to the east of Hilly's, in much more hostile territory. Comparatively, CBGB was a safe space thanks in part to the presence of the Hells Angels biker club, whose headquarters was just down the street. "The Hells Angels hung out there," McGrinder said, "and some of them did work for Hilly Kristal, like polish the bar and stuff like that to make a few bucks." Bayley recalled that Kristal was friends with Hells Angels president Sandy Alexander, and many bikers hung out at CBGB in its early days. "But as soon as it started to really take off as a rock club they didn't really have much interest in being there," she said. "They were just there to drink, not to see any music. I don't think it was their style."

Just as Eric Emerson had helped kick-start the scene at the Mercer Arts Center by offering his carpentry skills to fix up the venue, he did much the same for Kristal back when it was Hilly's on the Bowery (Kristal didn't change the name to CBGB until late 1973). Emerson frequented the Hells Angels clubhouse and spent time in the area, and around 1972 he convinced Kristal to let him and his Magic Tramps bandmate Sesu Coleman build a small stage there. "I saw the Magic Tramps at CBGB before I saw them at Mercer's," said Chris Stein, "though it might not have been called CBGB at that point, maybe it was still called Hilly's on the Bowery. I just randomly walked into the bar and saw them play."

Between 1972 and 1973, Suicide, the Magic Tramps, Wayne County's Queen Elizabeth, and a variety of other downtown musicians performed on that stage. "It

was pretty much the same when it was called Hilly's," Suicide's Alan Vega recalled. "The bathrooms were already horrific, even before it was renamed CBGB." After Marion Cowings's band Dance broke up following the Mercer Arts Center collapse, he was in a band named Squeeze that occasionally played at CBGB. He recalled that Hilly's dogs used to run loose and defecate on the floor, so people had to watch where they stepped. "He was like a wild Bowery guy," Cowings said, "just wild and dirty. At that time the Bowery was *the Bowery*. There were lots of bombed-out buildings and fleabag hotels, and lots of people sleeping on the street."

Craig Leon, who produced early singles and albums by Blondie, the Ramones, Richard Hell and the Voidoids, and others, would sometimes see dead homeless people on the sidewalk. "It was right on the borderline between the bohemian upmarket West Village and the very underground Beat scenes and junky neighborhoods," Leon said. "It had a mixture of old fifties and sixties Beat people living there." William Burroughs lived with poet John Giomo in his "Bunker" residence in that part of the Bowery, just a few blocks south of CBGB—where his friend Patti Smith recalled that the sidewalks were often lined with burning trashcans that helped warm the street people.[3]

Like Smith, Richard Hell transitioned into rock after spending time in the underground poetry scene, where he learned a useful DIY skill set. "I had become completely acclimated to that culture of doing it yourself as a writer in the world of street poets," he said, "so when I started doing music it felt familiar." Hell was a bit nervous about having no previous musical experience, but Tom Verlaine assured him that the bass was an easy instrument to learn, and the two friends began rehearsing in Verlaine's apartment. "At the same time I started working on lyrics and melodies to some guitar compositions he'd got going that he hadn't worked up words for," Hell recalled. "The idea was that he'd sing his lyrics and I'd sing mine, and eventually I'd write music, too. I had the name for the group: the Neon Boys."[4]

Hell and Verlaine wanted to strip rock 'n' roll down to its essential core, doing away with the showbiz theatricality of the glam bands and jettisoning the kind of excesses that dominated 1970s corporate rock. Looking to flesh out their lineup, they placed an ad in the *Village Voice* classifieds section: "Narcissistic rhythm guitarist wanted—minimal talent okay." Blondie's Chris Stein auditioned, but wasn't a good fit, and Dee Dee Ramone also tried out even though he couldn't play guitar. Hell and Verlaine never found the right musician for the Neon Boys, and in 1974 the fledgling group hooked up with guitarist Richard Lloyd and morphed into Television.

Television's first gig was at an art house cinema on 122 West Forty-Fourth Street. They rented the Townhouse Theater, charged two dollars admission, and advertised the show by posting flyers around Greenwich Village and the Lower East Side. Reflecting the multimedia experimentation that permeated downtown, the group's first show mixed live video, broadcast television, and rock 'n' roll. "My idea for ramping up our presentation was to place four or five televisions onstage," Hell recalled. "During our performance each was tuned to a different channel, while one of them was hooked up to the Portapak of the video guy who'd been taping our rehearsals. He roamed the theater shooting our act as we played, as well as the audience, and that stream was fed to one of the monitors onstage, too."[5]

Hell also helped define Television's early visual style, wearing ripped T-shirts held together by safety pins and, in one case, a shirt with "Please Kill Me" hand-written on the front (a cheeky and somewhat brave thing to wear downtown in the crime-ridden 1970s). Soon after their Townhouse show, Verlaine and Lloyd asked Hilly Kristal if they could play at CBGB, but the owner declined because he wasn't interested in booking rock bands. They returned with their manager, Terry Ork, who suggested that Television play on the bar's worst night—Sunday—and guaranteed that all their friends would make the bar's cash registers ring. It was music to Hilly's ears.

"Television had been percolating around for awhile, and then they started playing at CBGB on Sunday nights," recalled Bayley. "I was living with Richard Hell at that time and their manager Terry Ork said, 'Do you want to sit at the door and take the money?' So that gave me something to do. Then later I started to do it full-time at CBGB."

Hell invited Patti Smith to one of their shows during the band's CBGB residency in spring 1974, and Lloyd invited Lenny Kaye. Before heading downtown that night, Smith and Kaye attended a glittery, star-studded premiere of the Rolling Stones' live concert film *Ladies and Gentlemen: The Rolling Stones*. (Hibiscus, his sisters, and other Angels of Light had been hired by the theater to add even more sparkle to the occasion, performing a short vignette before the film.) "The first time I went to CBGB was on Easter Sunday 1974," Kaye said, "when we left—symbolically, amazingly—a Rolling Stones movie uptown at the Ziegfeld Theatre and took a cab down and went there for the first time."

Television's raw, jagged music reminded Smith of the first time she heard Little Richard as a girl, or seeing the Rolling Stones when she was a teen. It was electric, and transformative. In the pages of *Rock Scene* magazine, she waxed poetic about

Verlaine's guitar sound (like "a thousand bluebirds screaming") and described the tall skinny musician as "a languid boy with the confused grace of a child in paradise. A guy worth losing your virginity to."[6]

Like Smith, who honed her performance skills on Off-Off-Broadway stages, Debbie Harry learned several lessons from that subterranean theater world. "I approached the songs from kind of an acting perspective," Harry said. "With each song, I could be a new character." One of those characters was inspired by the streets of New York, where truck drivers and construction workers used to yell "Hey, Blondie!" at her. Harry eventually appropriated this catcall as the name of her onstage alter ego. "I originally saw Blondie as something like a living cartoon character," she said. "I was thinking pop. The band was always into that pop aesthetic—B movies, comic books, combining pop culture and art and rock 'n' roll and dance music. Mainly, I wanted the Blondie character to be funny and sassy and colorful."

Harry augmented her ratty blonde hair with thrift store clothes and cheap sling-back shoes, a style that was influenced by the drag queens they hung around with. "Her look definitely came from that trash aesthetic," Stein said. "It came from the Dolls and that whole scene, and all that came from Jackie Curtis." When Harry became an international superstar, many of the straight guys who pinned her posters to their walls had no idea they were lusting after the image of a woman imitating men who were dressed as women.

Onstage, Harry often played the straight role of a hot and horny woman, but she also broke character to reveal how femininity was just a performance, an act. "Blondie, as a character, was kind of bisexual or transsexual, and would change perspectives," she said. "Or sometimes she would observe things from a third person point of view. Blondie was always morphing and taking on a new identity from song to song." Her emphasis on acting over authenticity—fragmentation over cohesion—reflected what was happening around her in the underground theater scene.

Harry's image was an assemblage of tropes drawn from glamorous 1940s Hollywood starlets, seedy 1950s pinups, sneering 1960s rock rebels, and in-your-face 1970s glam queens. She began using the Blondie stage name when she was in the Stilettoes, though the idea of inhabiting another character developed back when she was a little girl. Feeling like an outcast because she was adopted and looked conspicuously different from her other family members, Harry fantasized that her birth mother was Marilyn Monroe and began bleaching her hair when she was about thirteen.

As an adult, she cultivated her theatrical sensibility while working as a waitress at Max's Kansas City, witnessing Jackie Curtis and others' backroom shenanigans. Later, in 1975, Blondie performed as the backing band in a revival of Curtis's *Vain Victory*, with Harry playing the role of Juicy Lucy and the boys in the band wearing identical blue sharkskin suits that Stein found at a discount store on Broadway. Danny Fields wrote about the show in his *SoHo Weekly News* column, which was the first time Blondie was mentioned in print. "That was big for us at the time," Stein recalled, "and we got a lot of attention. We got exposed to a lot of the intelligentsia through that." Local media outlets like the *SoHo Weekly News*, *Village Voice*, and the soon-to-be-launched *New York Rocker* played a pivotal role in the development of the downtown's various arts scenes. Influential rock writers like the *Voice*'s Robert Christgau publicized what was happening and accelerated their momentum, creating a kind of feedback loop.

Tony Zanetta was also cast in the revival of *Vain Victory* with Blondie, which was directed by the ubiquitous Tony Ingrassia. "I think a singer or a star needs to be able to magnify their own personality," Zanetta said, "and Tony was really, really good at that. I mean, he worked with Debbie Harry, Patti Smith, Wayne County, and Cherry Vanilla, and I think they all took something from those experiences." In 1973, Harry and Stein hired Ingrassia to help the Stilettoes with choreography, projecting a cohesive image, and singing with attitude. "Tony did a lot of stage work," Stein said. "He was a very flamboyant and a loud guy, and was responsible for a lot of cool projects, even though he was very unsung." Harry added, "He was a slave driver. He was making us work very hard and not to sing technically, but to sing emotionally. And that was a great lesson, to make sure that you really had a connection with what you were saying or talking about or singing about, rather than just singing a nice melody with good technique."

"We knew a lot of gay and theatrical people from around the scene," Stein continued, "people like Fayette Hauser and Gorilla Rose, who were in the Cockettes. They used to open for early versions of Blondie and did little skits and stuff like that." Hauser and Rose had also previously collaborated with Stein on the public access television show *Hollywood Spit*, which was shot with Joey Freeman. An assistant to Andy Warhol who was responsible for a teenaged Stein opening for the Velvet Underground, Freeman was embedded in the social networks that linked the downtown's overlapping arts scenes. Another key connector figure was Benton Quin, an Off-Off-Broadway performer who rented Harry and Stein a loft on the Bowery where the couple lived and the band rehearsed.

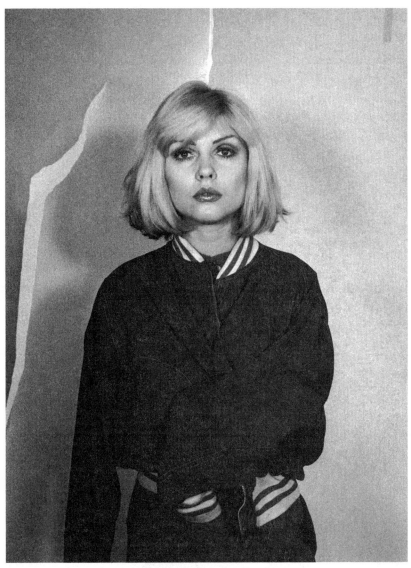
Debbie Harry in the Blondie Loft
© LISA JANE PERSKY

"Benton is the person who gets credit for all that," Lisa Jane Persky said of the way he helped spark many artistic relationships. "He masterminded a lot of the stuff, even though he was a bit cuckoo in many ways." Quin was also a very literal matchmaker for Persky and Gary Valentine. After Quin appeared with her in

Koutoukas's *Grandmother Is in the Strawberry Patch,* they remained close; and when Valentine moved into the loft, he realized the bassist was perfect for Persky and insisted that the two should meet. "Benton must have been persuasive, and so she came over," Valentine said. "We later consummated our first meeting after a *Vain Victory* performance, the one Blondie appeared in. There was a party in the Upper West Side somewhere, and so a lot of people from the theater scene—Divine and all that—were there. That was a special night for Lisa and I." He later wrote the early Blondie hit, "(I'm Always Touched by Your) Presence, Dear," about their relationship.

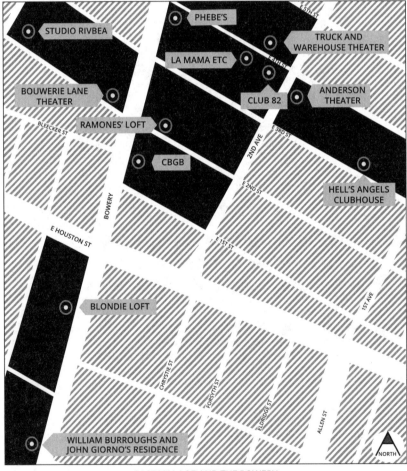

EAST VILLAGE AND THE BOWERY

The close proximity of underground theater venues and punk clubs created other social connections. The Mumps' Kristian Hoffman lived right down the street from CBGB, and the first thing he did every evening was stop by the bar to see what was happening. "Then we'd go to Phebe's and have a blueberry pie and ice cream," he said, "then wait for friends to show up." Located on the corner of Bowery and East Fourth Street, Phebe's was known as the "Sardi's of Off-Off-Broadway" (the Times Square hotspot Sardi's drew an uptown Broadway crowd). "You needed a place to hang out," Machado said, "and Phebe's offered a safe refuge. Not every bar wanted theatrical people, because it was a conservative Eastern European neighborhood."

When CBGB shifted the downtown's center of gravity to the Bowery, the longtime hipster venue Max's Kansas City had to play catchup. "CBGB was definitely in the forefront," Kaye said. "When Max's started booking the local bands, they did it in emulation of CBGB. They borrowed all the bands and the concepts because they knew that's what was happening." Enumerating Max's various cliques in the early 1970s, Zanetta recalled, "I was part of the underground theater freak tribe, and there was also the Warhol people. And there was another group at Max's, which was Danny Fields, Lisa and Richard Robinson—the rock writers, which then led to more of the rock and rollers going there because they were the most influential rock writers in the United States."

Smith recalled that the scene at Max's began shifting by the start of the 1970s. "One could still count on Holly Woodlawn sweeping in, Andrea Feldman dancing on the tabletops, and Jackie and Wayne spewing cavalier brilliance, but increasingly their days of being the focal point of Max's were numbered."[7] Kaye also began hanging out at Max's during this time. "I started going there when the Velvet Underground played upstairs in the summer of '70," he said, "and that's when I was able to establish my 'regular' credentials—so I could just walk in there."

Back when the Warhol crowd dominated Max's back room, future CBGB regulars Joey Ramone and his brother Mickey Leigh didn't really feel welcome there. "It was also not exactly a 'We accept you, you're one of us' kind of thing with my brother and our friends," Leigh said. "They were the beautiful people and we were us, from Forest Hills, Queens." Paul Zone, who traveled with his brothers and friends to Max's from another unhip borough—Brooklyn—had a much better experience. "I was this cute little boy and I was all dressed up in glam regalia," Zone said. "So were my brothers and everyone else we were with that would come in from Brooklyn. Mickey Ruskin, he sat at the front door of Max's every single

night and knew everyone. Every time he would see me he would smile and he'd give me a hug and he'd say, 'Come on in, boys.'"

When Ruskin sold Max's Kansas City in 1974, it was renovated by new owner Tommy Dean, who made it resemble an airport lounge, complete with a bad

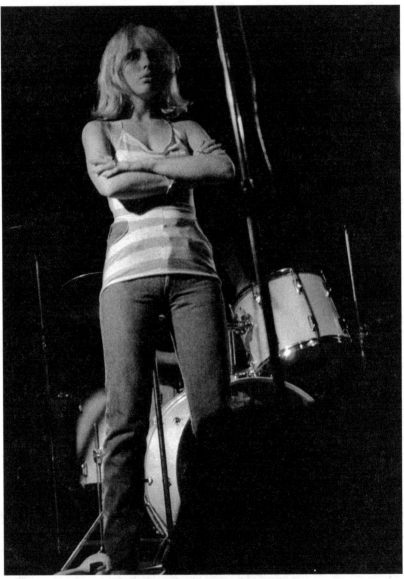

Debbie Harry onstage with Blondie at Mother's
© LISA JANE PERSKY

THE DOWNTOWN POP UNDERGROUND

disco band. "He asked Wayne County, 'What have I done wrong? Why is my club empty?' and Wayne referred him to me," recalled Peter Crowley, who booked bands at Max's from 1974 to 1981, after working at the Living Theatre and managing coffeehouses in the 1960s. "I told him everything he did wrong. At first he gave me Sunday, Monday, and Tuesday, and I started bringing in all the CBGB bands. Basically I just stole all Hilly's acts—Television, Ramones, Talking Heads, Blondie, all the usual suspects."

During this time, Zone became the new house DJ at Max's, along with Wayne County (who changed her name to Jayne in the late 1970s). "Wayne was heavily focused on early British invasion, but also played comparable American records," Crowley recalled, "and the same more or less with Paul." Zone added, "When I was the DJ with Jayne at Max's in '74, '75, '76, the only music we were playing was sixties music and glam music. There was no other music. There were no punk records yet. All we played was sixties girl groups, British Invasion, Beach Boys, and we were playing the Dolls and some other glam, T. Rex and Bowie. Or I would play disco songs I thought were really good, like 'Waterloo' by ABBA and things like that."

Bands bounced back and forth between CBGB and Max's, as well as lesser known venues like Mother's—a gay bar near the Chelsea Hotel where Suicide, the Fast, Ramones, and Blondie played. In the punk scene's early days, well before the genre's loud-hard-fast formula was established, bands were free to pursue their own unique paths. There was no unified sound or style, but by 1977 the music would be widely known as "punk"—a useful catchall term for critics and journalists, but one that flattened the nuances that existed among a diverse range of downtown musicians.

CHAPTER 31

New York Rock Explodes

New York's underground rock scene embraced everything from Patti Smith's boyish androgyny to Debbie Harry's more traditional femininity, with the New York Dolls splitting the difference. Despite their contrasting styles, Smith's and Harry's public personas blurred gender binaries, and these two women shared other commonalities. Both were drawn to New York's downtown after growing up in New Jersey, then followed a similar path through Max's Kansas City, Off-Off-Broadway theater, and onward into music.

Harry moved to New York City first, in the mid-1960s, but it was Smith who hit the ground running—cultivating a presence in the downtown's theater, poetry, and music scenes. Blondie's early career arc, on the other hand, contained none of the early triumphs that the Patti Smith Group achieved. "Blondie were more ramshackle than the Ramones," recalled producer and recording engineer Craig Leon, who recorded their first album. "They didn't sound very good, quite honestly. They weren't taken seriously. If you would have said, 'Who was the band that was least likely to be signed?' it would have been them. Particularly in the earlier incarnations that I'd seen, like the Stilettoes."

"We weren't even really a garage band," Harry said of those early years. "We were so bad we were more like a *garbage* band." Her quip is fitting, given that Blondie emerged from the ashes of a group called Pure Garbage, featuring Warholites Elda Gentile and Holly Woodlawn. During Woodlawn's short tenure in the group, she recalled that she "jiggled my jugs, wiggled my hips, shook my maracas, and played the cymbals between my knees, a rare talent that I had picked up from a battery-operated monkey at FAO Schwarz."[1] After Pure Garbage broke up in early 1973, Harry ran into Gentile and suggested they start a new band. "I had made a deal with Jayne County to allow her PA system to remain in my loft in exchange for free rehearsal time," said Gentile, "and that allowed me to put together the Stilettoes."[2]

The band primarily played makeshift spaces and failing bars, like Bobern Bar & Grill on West Twenty-Eighth Street. Named after its owners, Bob and Ernie,

Bobern was such a low-rent venue that they had to take the legs off a pool table to make a stage, but at least it was conveniently located on the same block where Gentile lived. The Stilettoes played there between October and December 1973, and they developed a following in part because Gentile had connections as a Max's Kansas City waitress who was dating the New York Dolls' Sylvain Sylvain (and had previously had a child with Eric Emerson). "I wasn't sure if anyone would come, but within a week the place was packed," she recalled. "David and Angie Bowie were there, and so were all our friends. . . . Being related to Eric Emerson meant that everyone in downtown New York would know about the gig."[3]

Chris Stein was at the debut show, where he finally saw Debbie Harry for the first time. Stein was roommates with Emerson, who had known Harry since her days as a waitress at Max's, but after all their years downtown Stein and Harry had still never met. "Our paths didn't really cross," she said. "I guess it was just a matter of time until we eventually hooked up, but it definitely was directly related to Eric Emerson." Stein was dazzled by Harry and immediately volunteered himself as the Stilettoes' musical director. "They didn't have permanent members," he said, "just floating musicians, so I became the first permanent member." The two quickly fell in love, and together they eventually formed the creative core of Blondie.

"With the Stilettoes," Stein said, "there was a lot of theatricality. It was tongue in cheek, and very campy." Their embrace of artifice was reflected in the lyrics to one of their earliest numbers, "Platinum Blonde," the only song that made its way into Blondie sets. "I wanna be a platinum blonde / Just like all the sexy stars," Harry sang. "Marilyn and Jean, Jane, Mae and Marlene / Yeah, they really had fun / In luminescent DayGlo shades / Walk into a bar and I'll have it made." (She sometimes ended that couplet with ". . . and I hope I get laid.")

"The Stilettoes were kind of a combination of Elda's idea of creating a campy, kitschy, trashy *True Confessions* image," Harry explained, "and me wanting to emulate the style of girl groups like the Shangri-Las, but with more attitude. We were real sleazy and would dance around the stage in really trashy clothes. In fact, sometimes our clothes actually came from the trash—boots, jackets, lots of stuff could be found in decent condition. That zebra print dress I wore was made from a pillow case that was found in the garbage."

When Stein was younger, he looked down on "all that girl group stuff," but while in the Stilettoes he realized how compelling that music was. "No one was really playing that style of music back in the mid-1970s," Harry added, "that throwback kind of pop style. The Stilettoes wanted to bring dancing back to rock and roll,

which is what I loved about the music in the first place. Dancing is more fun than just sitting there watching a band. It was the idea of bands and audiences interacting, and I think that that's the great tradition of rock and roll."

The Stilettoes played their first gig at CBGB on May 5, 1974, then did a half dozen shows at the club supporting Television. Harry and Stein then formed a new group, Angel and the Snake, which played only once under that name before settling on Blondie for a string of CBGB shows with the Ramones. Between 1973 and 1975, the band was constantly in flux, changing names and reshuffling members (sisters Tish and Snooky were backup singers in another lineup before they cofounded Manic Panic, an East Village boutique that became best known for its brand of hair dye). Sometimes their original drummer Billy O'Connor would lose consciousness during their sets, though not for the typical rock 'n' roll reasons—it was because of anxiety—so Dolls drummer Jerry Nolan occasionally sat in with them. "Everybody liked Blondie," photographer Roberta Bayley said, "and they were definitely a key part of the scene. But their band wasn't totally respected because when it would start to come together, then a member would leave, or they would have a different name."

If Blondie got off to a wobbly start, Patti Smith enjoyed a quite different trajectory between 1973 and 1975. Talent and stage presence are obviously important, but a good manager also goes a long way in building a career. Jane Friedman was a supporter of experimental art within the downtown scene, and she began taking on managerial duties during Smith's solo performances at the Mercer Arts Center, sometimes supporting the New York Dolls. In late 1973, guitarist Lenny Kaye rejoined Smith for a successful show at the West End Bar, then Friedman secured them a gig opening for protest singer Phil Ochs at Max's. It was their first residency, two sets a night for six nights, and it led to other opportunities.[4]

By this point they had added Richard Sohl on keyboards, allowing the group to segue from Smith's poems to some musical numbers played on guitar and piano. "Soon enough we started getting a thing together," Kaye said. "We didn't start out to have a band. What we wanted was to have a musical element in the performance and we let it grow into the band it would become, so it didn't sound generic or get too ahead of itself."

Given that videomaker Paul Dougherty was among the first to document New York's punk scene, it's fitting that he fell for a band named Television. "I pretty religiously read the *Village Voice*, scanning music pages," he said. "There was an ad for Television, where one of the guys is holding a TV, and they all looked really great—completely off the wall." Dougherty finally got to see Television in

THE DOWNTOWN POP UNDERGROUND

August 1974 when the Patti Smith Group opened for them during a residency at Max's. "Richard Hell was acting like sort of a crazy guy at a revival meeting, and Tom Verlaine struck me as a guy who was really wound up and might snap and seemed a little bit psycho," he said. "It all was just kind of nuts, and I loved the way they all looked."

By now, Smith and Hell were doing rock full time, though they still maintained their links to the poetry world, as when Smith staged a series of shows she playfully dubbed "Rock and Rimbaud." On November 10, 1974—the anniversary of the death of her favorite poet, Arthur Rimbaud—the Patti Smith Group kicked off the series at the Le Jardin disco in the Hotel Diplomat. She recalled looking out in the crowd and seeing Susan Sontag and other downtown luminaries, then realizing that something was really starting to happen.[5] Also in attendance at the Le Jardin show was Cockette Pam Tent, who was dating bassist Dee Dee Ramone. "It was so crowded with people," Tent recalled, "and it was so hot and sweaty and filled with energy that Dee Dee and I actually had sex standing up in the crowd." On another night of the series—this time at the Blue Hawaiian Discotheque—the Fast's Paul Zone captured Smith's performance with an unlikely photo that included the raggedy punk singer and a glittering disco ball in the same frame.

"After a while," said Lenny Kaye, "we felt like we needed another instrument because both myself and Richard Sohl, the pianist, were kind of having to do too much work." After placing an ad in the *Village Voice*, they found Ivan Kral, who was currently playing guitar for the scene's ne'er-do-wells, Blondie. After performing as a four piece at CBGB for about seven weeks in early 1975, the Patti Smith Group expanded their lineup to include drummer Jay Dee Daugherty, who jumped ship from Lance Loud's band the Mumps. "It was allowed to grow very organically," said Kaye. "So by the time we had a drummer we sounded like ourselves, instead of like every other band."

With no major labels interested in signing an androgynous poet-singer, Smith decided to do it herself. Kaye had produced an album by the Sidewinders for RCA Records and previously played on a single as a teenager, so he knew his way around the studio. "We recorded our single in June of 1974," he said, "mostly just because I knew that you could make records easily from hanging out in these record stores." Robert Mapplethorpe loaned them the money to press a seven-inch single, which was recorded at Jimi Hendrix's Electric Lady Studios on West Eighth Street. The Patti Smith Group performed the Hendrix staple "Hey Joe," along with one of her original songs, "Piss Factory," to which Verlaine added guitar. The group began distributing the single via mail order, at local bookstores

and record stores, and during Smith's shows—where Jane Friedman sold them out of a large shopping bag.

"The DIY way of working in the poetry world was completely assumed," Hell said, "so that idea leaked into the music world when Patti Smith and Lenny Kaye pressed their single." Hell also pointed out that this independent route was a continuation of what Warhol had done when he produced the first Velvet Underground record. Instead of waiting to sign to a major label, he paid for the sessions himself so as to avoid being constrained by record company executives.

Hell quit Television after falling out with Tom Verlaine, leaving the bass spot open for Fred Smith to join—which spelled more bad news for Blondie. Smith had played with Harry and Stein since their days in the Stilettoes, but Television was his favorite group and he jumped at the chance to play with them. Around that same time, Kral quit Blondie, too. "It was the worst, the absolute worse," Harry said. "It felt like everyone in the scene hated us, and every time we got some momentum, the rug got pulled out from under us." With two key members of Blondie now playing with Television and the Patti Smith Group, Harry and Stein put their fledgling band on hold for a while.

Hell left Television in April 1975, several months before the band released its first single, and the group waited two years before releasing a full-length album, *Marquee Moon*. In the meantime, the only way early punk shows were preserved was through live bootleg recordings. Two avid tapers on the scene were brothers Paul and Peter Dougherty, who grew up in the same Forest Hills neighborhood as the Ramones (Paul recalled seeing Tommy and Johnny Ramone perform in a mid-1960s battle of the bands, when they were in the group Purple Majesty). The Dougherty brothers shared an obsession with rock music, which led them to Max's and CBGB.

"What I remember about CBGB is walking into the bar and I felt like, 'These are music nerds,'" Paul said. "And I thought, 'Ah, I'm home. This is great. I love this.'" Peter had been taping larger concerts and festivals, so when they discovered punk it was natural for him to capture this new scene. One important gig for the Dougherty brothers was the 1975 live debut of the Heartbreakers, an early punk supergroup featuring Television's Richard Hell and the New York Dolls' Johnny Thunders and Jerry Nolan. Every morning when Paul woke up to go to work, Peter blasted a tape of that show.

While working at Manhattan Cable's public access channel, Paul met a woman named Pat Ivers, and they soon began taking their young coworkers to CBGB. "It was our great fortune to see one of the first Talking Heads shows, opening

for the Ramones," Paul said. "So it was a eureka, epiphany moment for myself and everyone else. We began videotaping later that summer, during the CBGB Festival of Unsigned Bands."

"We went to talk to Hilly," Ivers said, "and he said yes, and that's how it started. I was convinced that the scene was a historic shift in music, and was positive that shooting it was essential." Without that video footage of Blondie, the Heartbreakers, Talking Heads, and many other bands shot by the Metropolis Video collective, punk's ephemeral early years would exist only in faded memories. Ivers and Dougherty had the public access department's blessing to take out an entire remote studio, which helped raise the production values. "So instead of just going with a couple of Portapaks, we had the switcher, the mixer, and the cameras," Dougherty said. "The first time we did it, we lit it and got pretty good sound, but it got a lot better."

After Dougherty moved away, Ivers plowed forward with her motley video crew, irregularly showing their live footage in late 1975 as part of a public access show called *Rock from CBGB's*. "A place like CB's was revolutionary and perfect for capturing the energy of this new scene," Ivers said. "The intimacy of getting right up in the faces of these musicians telegraphed the intimacy of the room, where the border between musician and fan was quite porous. Also, the DIY methodology of the scene was in its DNA, so for me, being able to document the scene was an important contribution to the community, which I very much felt a part of. The black-and-white cameras also had a fabulous film noir quality that fit with the smoky late-night, slightly criminal vibe of downtown. Public access was a great fit for its DIY ethos, and no one was going to put these acts on any kind of mainstream media outlet for years."

Lenny Kaye pointed out that the early CBGB scene was quite small. "It was the same twenty-five or thirty-five people in the audience," he said, "and you would get up onstage and play, and then go offstage and hang out and watch your friends play. Everybody had a sense of the destination, but the fact that this destination was so improbable allowed you to develop at your own speed." Roberta Bayley also recalled that CBGB was practically deserted in the beginning, noting that "the only ones that paid were people we didn't know. The cover was two dollars."

"1975 was the best year," said Paul Zone, who would soon join his brothers as the lead singer for the Fast. "It really was, because no one was signed and everyone was there. Every single night you could see the main characters." The bands sounded quite different from one another but were united by a sense of spirit and discovery. "We weren't competing with each other," Chris Stein said. "Television,

Talking Heads, the Ramones—we all shared equipment and had each other's backs for the first year, when everything was starting to come together." Debbie Harry acknowledged that there was certainly some animosity between certain people, "but in a pinch, if you asked nicely, you could borrow an amp."

"Oh, you know her, would you look at that hair / Yeah, you know her, check out those shoes," Harry mock-snarled in "Rip Her to Shreds," an early Blondie song. "Yeah, she's so dull, come on rip her to shreds." Harry explained that her lyrics were poking as much fun at herself as others on the scene, playing around with the idea of being a gossipy bitch, but there actually was some tension between her and Patti Smith, who was dismissive of the Blondie singer in the early CBGB days. "Around this time people came up to me and told me to get out of rock 'n' roll," Harry said in an early 1980s interview with biographer Victor Bockris. "Patti wasn't the only one. I was pretty horrible. I deserved to be told to get out of rock 'n' roll. I was pathetic. Horrible and pathetic. I was very shy and stiff."[6]

Drummer Clem Burke observed that there was a schism between the more cerebral and artsy groups at CBGB, such as Talking Heads, Television, and the Patti Smith Group, and the more poppy and rockin' groups, such as Blondie, the Ramones, and the Heartbreakers. "Blondie never performed with Patti Smith," he said. "We performed with Television. We performed with Talking Heads, shared stages with the Ramones, Johnny Thunders, the Mumps, etc., etc. But we never played on the same stage the same night with Patti Smith. It was just like two camps, and both Patti and Debbie were butting heads a little bit. You could stereotype it as just women being bitchy towards one another, maybe, but really there were two camps."

Lisa Jane Persky, who photographed Harry for Blondie's first cover story, observed that the singer was a more traditional kind of girl. "Patti wasn't even a girl, she was just a person—she looked like a gender-free kind of person. But Debbie, on the other hand, was just like this old-fashioned girl." Clem added, "It's interesting, because they were the photo opposites of each other, black and white. They were both driven, and they both became massive stars, but they were both doing it in a completely individual way." Harry recalled that, in the early years, the music press largely ignored Blondie, and what little attention they got was a result of her looks. "I think that Patti Smith, because of her intellectual nature and her identity as a poet, was taken very seriously and was praised for her work as a writer," Harry said, "and because I approached my work as a pop figure, it was overlooked at first."[7]

Blondie's fortunes began to turn around soon after Burke joined the band. "He definitely was a wannabe rock star," Harry recalled. "He came in looking cool to the audition and he played well. He seemed to know a lot about music, and he was

into the Shangri-Las, the Ronettes, and the Ventures, all the stuff we were into." As for Burke, he said it wasn't really much of an audition. "We just talked, more or less," he said. "I just knew that she was it. I was looking for my Bowie, my Mick Jagger, my Bryan Ferry, and it just turned out to be a woman instead of a guy."

Burke's first Blondie gig was the same night bassist Fred Smith announced he was leaving to play with Television, and the despondent group fell apart again. "I kept in touch with Debbie and Chris, trying to keep the band going," Burke said, "and then I brought Gary in. To me, that was the beginning of Blondie." Roberta Bayley also recalled that the band finally gelled with the addition of bassist Gary Valentine and keyboardist Jimmy Destri. "They were more cohesive," she said, "and they started rehearsing and trying to be a little bit more professional, and writing new songs."

Valentine taught himself how to play bass after seeing Television and other new downtown bands perform around town. "They weren't great musicians," he said, "but they were inventing themselves in front of you. Then you felt like, 'Well, I could do that, too.' And that's what got me going." Valentine moved in with Stein and Harry in their cramped Thompson Street apartment on the edges of Little Italy and SoHo, but the living conditions were not optimal. "The glitter clothes and green eye shadow never endeared them to their neighbors," Valentine recalled, "old Italian men who sat for hours in smoke-filled social clubs over beers and espresso, and moustached Catholic women who crossed themselves when they saw Chris's pentagrams."[8]

The three leapt at the chance to move into what became known as the Blondie Loft—a four-story building on the Bowery with a liquor store on the ground floor, about a block south of CBGB. "We went to CBGB five to seven days a week," Burke said. "It was a place to go, it was the thing to do, it stayed open late. We would rehearse at the loft and just live there, and sleep on the floor. Or sleep with other girls. Things would happen, you know, anything goes. I was a teenager. But it was primarily Chris and Debbie's residence." The building's unofficial landlord was Benton Quin, whom Valentine described as "a good artist, a flamboyant creative fellow, with all the eccentricities that go with that." He rented the bottom loft floor to the bandmates and lived directly above them in a space littered with cans of urine (because there was no bathroom on his level).

"Benton was a real character," Stein said. "He made a lot of cartoon-like cutout things that would get pummeled onstage by Debbie, like during 'Kung Fu Girls.' He also made the leather briefs that Debbie wore with that 'Vultures' T-shirt in *Punk* magazine. Benton had a gay biker aesthetic, he was very thin, and was really

Debbie Harry makes breakfast in the Blondie Loft with Jimmy Destri and Gary Valentine
© LISA JANE PERSKY

into the Hells Angels, but he couldn't get too close to them because they'd murder him." Quin was once attacked by some Hells Angels on the street, but he said he didn't recall much of anything about it because he was punched in the face so hard. "It was a close relationship with Benton and the band," Burke recalled. "It

Gary Valentine snacking in front of occult bric-a-brac, 1975
© LISA JANE PERSKY

was a little micro world of our own in that loft building. Debbie helped Benton bleach his body hair, because he wanted it to be blond, and he had a *lot* of body hair—you know, he had all these different strange goings on."

The loft was cluttered with Quin's large paintings, and Harry and Stein placed occult bric-a-brac on the walls. "Chris and I shared some interests," Valentine said, "like horror films and comic books. He was keen on voodoo and pentagrams. Actually, Chris was kind of a goth in the beginning, wearing eyeliner and silver skulls." By late 1975, Valentine was the first to cut his hair short; then Stein and Burke did the same and adopted a retro 1960s style. "There's a picture of Debbie and me walking down Fourteenth Street," Burke said, "and everyone is looking at us, and I'm wearing what you would call a slim-fit suit. They weren't looking at us because we were famous, because we weren't yet. We just didn't dress like everyone else then."

During the early years of the CBGB scene, no one had Mohawks or any of the other styles that are now punk clichés. The people on the scene mostly took their inspiration from Beatlemania-era fashion: black jeans and skinny ties. It was a pronounced contrast from the prevailing trends of the time, when earth tones, blue denim, and bell-bottoms prevailed. Designers weren't in the habit of making black slim-fit jeans and suits—and even if they were, the members of Blondie didn't have the money to buy new clothes. Instead, Burke purchased thrift store suits, wore them in a tub full of water, and then walked around in the summer so that the clothes would shrink around his body.

"Everybody loved the skinny ties," Persky recalled. "There was a place in New Jersey where they had brand-new 'old stock.' It was all these old peg-leg pants from the early sixties, and they were brand new. We used to go there and get stuff all the time." Burke once bought a bunch of unworn 1960s clothes from that store—such as Levi's Sta-Prest jeans and button-down collar polka dot shirts—then lugged them to the loft. Some of those items ended up on the cover of the band's debut album, because the guys in the band often shared clothes.

Burke went to similar extremes to ensure his hair looked good before Blondie gigs. "I used to stick my head in the oven," he said. "Before I put my head in the oven, I put beer and like sugar-water in my hair—things like that. So you don't put your face in it. You put the back of your head in the oven, kind of leaning back in a chair." Persky recalled how he would also come over to 87 Christopher Street to use her oven for his hair care needs, turning his head gently from side to side.

This interest in fashion intensified when designer Stephen Sprouse moved into the building's top floor. "I invited Stephen to live there sometime after I met him at Reno Sweeney, when Holly Woodlawn was performing there," Quin said.

Debbie Harry and Clem Burke on Fourteenth Street
© CHRIS STEIN

"Stephen began designing and making a few things for Debbie, and also loaned her things. She was just basically wearing a lot of thrift shop stuff, so Stephen ramped up her glamour several notches." Sprouse had a professional background working for Halston, a major designer at the time, and he created clothes for everyone in the band. "He was very much an artist who was aggressive about how he would cut up materials," Stein said. "He was just so far ahead of his time."

"Stephen would find things for me to wear," Harry recalled, "or go through my collection of rags and put them together so that it had a strong visual look. He had all that experience at Halston of creating collections, so he was able to compile things."[9] Bayley added, "Dressing Debbie was probably inspirational for him, and it was great for her because she really developed her look—going from a thrift shop look, because nobody had money, to actually having dresses that were made for her to be onstage." Sprouse did other graphic design work for the group, and in 1976 he was tapped to be the art director on the first two Blondie videos, "X Offender" and "In the Flesh."

From the very beginning, Blondie understood that visuals matter. The group started making music videos five years before MTV debuted in 1981, and photos of Harry circulated widely well before the band ever had an American hit, which undoubtedly laid the foundation for their later success. Although Blondie began as the runts of the CBGB scene, the group became its biggest global export by the end of the decade.

THE DOWNTOWN POP UNDERGROUND

CHAPTER 32

Suburban Subversives

Patti Smith's audience grew throughout her CBGB residency with Television in early 1975, which created more momentum for the scene. "That was the first time when it started to get crowded," doorwoman Roberta Bayley said, "and I think by the end it was sold out." This was followed by CBGB's Festival of Unsigned Bands in the summer of 1975, which drew even more attention. "The Ramones started to get a following," she said, "and I think the Ramones were probably the first band to really build a fan base, and packed the place. Not long before it was just thirty, forty, maybe eighty people on a good night."

The media coverage that CBGB and Smith received benefited both parties, and on May 1, 1975, Arista Records mogul Clive Davis offered her a contract. Later that month, after signing, they celebrated with a live set that aired on the local radio station, WBAI, which she revered for its lack of formatting constraints (a freedom that complemented her approach to music, both aesthetically and ideologically). It was Smith's first, but certainly not last, appearance on radio. The Velvet Underground's John Cale produced the Patti Smith Group's debut, *Horses*, and Robert Mapplethorpe shot the striking cover photo of her in a white men's dress shirt and skinny tie. By this point, Smith's band had outgrown CBGB and started to play larger venues in the city, such as the Palladium (formerly the Academy of Music).

Roberta Bayley, who was there from the start, felt that the club was getting far too crowded for her tastes. "It just wasn't that interesting anymore," she said, "because all the people from the scene stopped going." Some grumbled that CBGB was ruined when all the kids from the suburbs began filling the club, which may be true, but that ignores the fact that several early punk artists came from outside the city. Smith and Harry hailed from New Jersey, and many others fled the New York suburbs for more exciting escapades downtown—like the Ramones. "My mother encouraged our creativity and expression, definitely," Mickey Leigh recalled. "I don't think there would've been a Joey Ramone if not for her urging us always to express ourselves artistically."

Charlotte Lesher, mother of Jeffrey and Mitchel Lee Hyman (the future Joey Ramone and Mickey Leigh), used to hang out in Greenwich Village and pursued her own creative path by making, among other things, quirky collages on metal lunch boxes. She eventually opened a gallery in Forest Hills, despite the lack of an art market in that Queens neighborhood. "But that's how we did things back then," Leigh said. "You just do it and then see what happens, and that's what my brother definitely did later on with his music." By the early 1970s, Joey began playing drums (using the name Jeffrey Starship) for the glam band Sniper, which performed at Mercer's and Max's Kansas City. Meanwhile, Leigh joined a short-lived band with two future Ramones—John Cummings and Tommy Erdelyi—which practiced in the basement of his mother's gallery, Art Garden. "We put the PA down there, so it had already been turned into a rehearsal place," he said. "And when my brother got into the Ramones, of course they were all allowed to rehearse there as well."

Erdelyi encouraged Cummings to start a band, and was more of a manager figure during the Ramones' early days. "Tommy's role became increasingly more important and pivotal in an organizational and artistic way," Leigh said. "Tommy really helped the whole thing gel and kind of helped it define itself." For Craig Leon, who produced the band's first album, the Ramones were like a performance art piece. "Tommy knew how to create this image of what they became," Leon said. "He originally studied to be a film guy, and he saw things in that visual sense. Even though the Ramones were definitely rock 'n' roll, they reminded me a lot of Warhol. The four of them had that deadpan Andy Warhol persona. They were, like, straight out of the New York art scene."

Joey Ramone started out as the band's drummer until it became clear that he was a much better frontman, so Tommy took over on the drum stool. Joey, Johnny, and Tommy expanded to a quartet when another neighbor, Douglas Colvin (later Dee Dee Ramone), joined on bass. Cockette Pam Tent and Dee Dee were already an item, which provided the band with a connection to the various downtown arts scenes. He got his cosmetology license and was working for the Pierre Michel Salon, but as Tent recalled, "Dee Dee wanted to be this nasty rocker around downtown. He and I had a lot of fun. Oh, my god, did we have fun. He was like a little boy and he would giggle at things. He would read comic books, but he used to drive me crazy. I came home from work once, and he let Johnny Thunders babysit my four-year-old son. He took him out on the town—Johnny Thunders, of all hare-brained people!"

After the Cockettes' disastrous New York debut in 1971, Tent resettled in the city because she was already friends with David Johansen, who had just started

out with the New York Dolls. "David was a good friend and he was around," Cockette Lendon Sadler said. "Pam had an East Coast connection to lots of people." She performed in *The Palm Casino Revue* at the Bouwerie Lane Theater with people from the Cockettes, Ridiculous, and Warhol crowds, and also was a member of Savage Voodoo Nuns. That drag group also included Fayette Hauser, John Flowers, and Tomata du Plenty—all from the Cockettes—as well as Arturo Vega, who later became the Ramones' longtime lighting designer and also created their iconic eagle logo.

Tent was staying with Hauser and Flowers in a loft at 6 East Second Street, right around the corner from CBGB, and Vega lived below them. "We introduced Dee Dee to Arturo," she said, "and after I left New York it became the Ramones hangout, that whole place." The Ramones' CBGB debut was on the same bill with Savage Voodoo Nuns and Blondie, a performance that was preserved by a videographer friend who was on the scene. Black Randy's footage captured wobbly versions of "Now I Wanna Sniff Some Glue" and other primordial takes on songs that became punk standards. From the beginning, all the elements of the Ramones' aesthetic were in place.

"They knew exactly what they were going to do," recalled Kristian Hoffman, whose band the Mumps often played with the Ramones. "They already had 'Beat on the Brat,' and a few key songs from the first album were already written." The Ramones' early sets were short, just like their songs, with each intro punctuated by Dee Dee's trademark *"One-two-three-four!"* count-off. "At first the Ramones just had one long twenty-minute song, with different riffs running through," said Leon, who was tasked with transforming the group's live sets into an album. "They were all written as individual songs, but they never thought about it from a recording point of view—you know, 'How is this song gonna end?' They'd just play and then 'One-two-three-four,' they'd start the new one."

Most punk histories maintain that Sire Records paid a paltry $6,400 to record *Ramones*, but Leon said, "We never paid the full studio rate. It was actually cheaper than $6,000." The album cover had similarly modest origins. Sire hired a music biz pro to photograph the band, but they hated the results and instead chose an outtake from a more informal photo shoot with *Punk* magazine contributor Roberta Bayley. "We just went over to Arturo's loft and everybody was there," Bayley recalled. "We went outside, and first we found this playground, and then did a few different setups there against that brick wall."

The Ramones likely sold more T-shirts than records—especially in the 1970s, when mainstream listeners couldn't decode the catchy pop songs that lurked just

below the surface guitar noise. When they opened for blues-boogie arena rocker Edgar Winter, the Ramones were met with a hail of bottles and boos. "There were people who wanted to burn the Ramones records and stuff like that because they were horrible, in their opinion," Leon said. "Ramones songs are now played at sports arenas and on commercials, so it's hard to understand how extreme they sounded at the time."

For every band like the Ramones, there were dozens of CBGB acts that didn't achieve wider acclaim, such as the Fast. Both bands shared a similar pop sensibility and emerged from unhip outer-borough neighborhoods (the Fast's bandmates grew up in Borough Park, Brooklyn, while the Ramones hailed from Forest Hills, Queens). Unlike the Ramones—pretend "bruddahs" who adopted the same surnames—the Fast actually were brothers: Paul, Mandy, and Miki Zone. Together, they became a ubiquitous presence on the downtown scene, spanning the glam, punk, and post-punk eras.

"We were a working-class family," Paul Zone said, "but I can't remember not having enough or not getting anything we wanted or needed. So my family could provide it if we needed an amplifier or a new guitar." The postwar economy of

Paul Zone and Joey Ramone, 1975
COURTESY PAUL ZONE

abundance fueled the growth of both the suburban middle class and underground culture. Bohemians benefited from the trickle-down of the economic boom, which allowed them to live on next to nothing; a part-time job or welfare benefits could subsidize a life in the arts. And out in the suburbs, the Zones' father could buy his kids musical instruments and other gear, even though he was a blue-collar sanitation worker.

Miki played guitar from an early age, middle brother Mandy sang, and Paul tagged along and followed his older siblings' lead. Miki obsessively bought rock magazines and gravitated to the photos of flamboyantly styled musicians, particularly late 1960s British bands like Faces and the Rolling Stones. "I always remember going to record stores with my brothers," Paul recalled, "and picking up the covers where the members looked somewhat different than everyone else." Not having the faintest clue about where to buy the platform shoes they saw in rock magazines, the Zone brothers assembled their own version with a hammer and nails. They sawed wood blocks and nailed them to the bottom of boots, which they painted silver and decorated with fake jewels; after their mother taught the boys how to sew, they began frequenting fabric stores as often as record shops.

Paul wasn't in his brothers' band at this point, but he was still heavily involved with the Fast. "Making costumes was just one of the many things that I had a part in," he said, "along with taking pictures and doing their lights and sound while they were performing, when I was about thirteen. By the time I hit high school, even in seventh and eighth grade, I was already wearing clothes that were just completely not accepted in a Brooklyn suburban neighborhood. I had platform shoes on. I was wearing satin pants."

What was it like growing up looking like that in Borough Park, a largely Italian and Hasidic Jewish working-class area of Brooklyn? "Of course, the people who would see us, slurs would come out of their mouths," Paul said. "They would obviously just think we were some sort of flamboyant homosexual, but that never even dawned on us. It was like, 'This is what British rock and rollers dress like!' It wasn't working out, believe me. The band definitely never won the battle of the bands." But they tried. At one high school dance in 1970, the Fast played in front of a homemade backdrop of cut-out lollipops and stars, and other times they dressed a friend as Alice in Wonderland while other friends outfitted in nun costumes handed out cookies in the audience.

Even though the Zone brothers were oddballs, their family was still very supportive—especially their mother Vita Maria, who was the Fast's biggest fan. "We started growing our hair long," Paul said, "and that was a big thing back then,

when a lot of kids could have been ousted from their family for that. But even aunts and uncles, they just never really thought of us as strange or outcasts." Still, they knew suburban life was not for them. "As long as I can remember," he added, "we wanted to get to that train as quick as we could to get to Manhattan. It was only a few stops away." When they started seeing ads in the *Village Voice* for an odd-looking band that turned out to be the New York Dolls, the brothers began frequenting the Mercer Arts Center, Club 82, and other venues.

The Fast, 1976
COURTESY PAUL ZONE

Peter Crowley began booking bands at Max's Kansas City in 1974, and the Fast were among the first to regularly play there. "I met them hanging out at Max's, a little bit before CBGB's," recalled Chris Stein. "We met Jimmy Destri, our keyboard player, through them, and we did a lot of shows with the Fast at CBGB's." In 1976, Paul Zone debuted as the Fast's new frontman, and Debbie Harry introduced them at CBGB by waving a checkered racing flag. "We had a pretty good start because the name was established," he said, "so people knew who the Fast were." The future looked bright when they recorded a single with 1960s pop producer Richard Gottehrer, who helmed Blondie's first international hit singles, but the Fast were done in by a combination of bad management and bad luck. (Even after Ric Ocasek tapped the Fast to open for the Cars on a 1979

stadium tour, commercial success eluded the brothers until Paul and Miki transformed into an electronic dance duo in the mid-1980s.)

The Mumps also had their fair share of misfortune. After *An American Family* became a hit in 1973, *The Dick Cavett Show* flew singer Lance Loud, keyboardist Kristian Hoffman, and the rest of the band out to New York to perform on the show. The two best friends had already made one attempt at living in the city and returned to Santa Barbara in defeat—"We had our New York experiment," Hoffman recalled, "and we didn't meet the Velvet Underground"—but this time they stayed. After their television debut, various managers and record companies encouraged the band to change their name to Loud in order to cash in on their fleeting fame. "We hated that idea," Kristian recalled, "and Neil Bogart, who ran Casablanca Records, also wanted us to call the band An American Family."

The buzz created by the series brought the Loud family to the attention of millions of people, including Lisa Jane Persky. The year it debuted, her father, Mort Persky, hired Pat Loud to write a piece about the show for *Family Weekly*, a newspaper insert that he edited. Lisa thought Lance's brother was cute, and a couple of months later, Mort introduced her to Grant Loud when he and the other Loud kids visited New York. She took them to see Holly Woodlawn perform at Reno Sweeney, an intimate cabaret located at 126 West Thirteenth Street in Greenwich Village. "Because of Warhol films like *Trash* and Off-Off-Broadway," said Paul Serrato, who often accompanied Woodlawn as a pianist, "everybody wanted to see Holly perform at Reno Sweeney. It attracted everybody from the underground scene."

By this point, Lance Loud and Hoffman had fully immersed themselves in the downtown underground and become regulars at the New York Dolls' gigs at Mercer's. "We went there every single show," he said, "so we quickly met all these wonderful people like Paul Zone, who introduced us to everybody in the Lower East Side rock scene. Everyone happened to live in a one-mile-square neighborhood, and you would just see them every day. So we did everything together—the Mumps, the Fast, Blondie. All of these things intersected, and all of these crazy people hung out together."

Lance Loud was a magnetic frontman, though not necessarily the greatest singer (but this was punk rock, so it didn't really matter). "Lance loved performing, and he would sweat gallons," said Persky, who became a good friend. "He was just so blissed out when he was onstage." The Mumps played CBGB early on because Hoffman was working with Richard Hell at the vintage movie poster and bookstore Cinemabilia, which landed the band a slot opening for Television.

The Mumps at a Park Avenue parking lot
© LISA JANE PERSKY

Because of the hype surrounding *An American Family*, Loud was probably the best-known person in the nascent punk scene. "Lance was a larger-than-life figure," Blondie drummer Clem Burke recalled. "He was probably the first bona fide celebrity I ever met."

Pat Loud took a job in publishing in 1974 and followed her son out to New York, where she opened her small Upper West Side apartment to Lance and his friends. "She's the most marvelous mother," Hoffman said. "I mean, I really think of her as my other mother. She takes care of us all the time, to this day. So when she met Lance's colorful panoply of insane artsy friends, she would just invite them into her house for dinner without prejudice. They had a little kitchen about the size of a California closet, and she made all of this magic happen in that room."

Pat also used to drop by CBGB and other downtown venues to see her son's band play. "The Mumps were on the bill when she went to see Television," Roberta Bayley said, "when Richard Hell was in the band. I remember Richard dedicated a song to her from the stage, which was nice. I also remember Lance's mother invited Richard and I to an Oscar party at her apartment. I think she was just culturally open to different things and seeing what was going on, and really supportive of her son and his friends." Hoffman reminisced with Pat Loud decades later: "When I got sick, you just came down and put me in a cab and took me up to your place. I stayed at your place until I was well. It was good

to have a Pat in your life." She nodded, "We had good times, Kristian. We had really good times."

Despite Pat Loud's initial dislike of the Jackie Curtis play *Vain Victory*, the two eventually became very good friends; Pat even contributed to Curtis's drag wardrobe after taking revenge on her cheating husband. "One of his mistresses owned a clothing shop in Montecito," she said. "I went over to that clothing shop and I bought everything that fit me—which was a lot of stuff. I put it on a bill, and they let me walk out with all of these clothes." Having no desire to keep them, Pat donated the expensive fashions to the Off-Off-Broadway star ("I gave Jackie lots of stuff," she recalled).

Lance was also good friends with Hibiscus, who often came over to Pat's place for dinner. "That's why there's pictures of me there having dinner with Jackie

Jackie Curtis (left) and Kristian Hoffman (right) at Pat Loud's apartment, circa 1974
COURTESY KRISTIAN HOFFMAN

Curtis," Hoffman said. "Holly Woodlawn was there. Hibiscus was there. You would think having all those crazy people there would be kind of like an art salon," Hoffman said, "but it was more like Pat cooking a delicious meal for love birds that had wet wings and they were lost. It was a place to go to get warm and have a good meal with someone who is completely accepting and loving."

Back when Loud and Hoffman played in a high school band with drummer Jay Dee Daugherty, Pat kept them supplied with treats and refreshments during rehearsals. "Jay and I went through lots of similar experiences together," Hoffman said, "and I looked upon him as one of my closest friends. And when he quit the Mumps to step up into the world of Patti Smith, her future wasn't ensured. This is before *Horses*, and she had only done the 'Piss Factory' single. I thought, 'This person who I had all of these adventures with, I played on *Dick Cavett* with, we moved to New York together—we've been through all this stuff—then the minute he gets a better opportunity, he just leaves?"

Daugherty's departure devastated the Mumps, and as a favor Clem Burke filled in on drums and juggled two bands for a while. "My plans were contingent upon the Blondie situation," he said, "as far as working with the Mumps and Lance." Burke stopped playing with them when Blondie's first single was released, so the Mumps cycled through several ill-fitting drummers while playing CBGB and other places. "We probably would have had a record contract if it hadn't been for that," Hoffman said, "because we would have been right there at the peak of the scene exploding. Instead, we were playing with these lousy drummers, though we still had a lot of fun."

"For me it was just sort of obvious who was going to get signed, who wasn't," Persky said of the feeding frenzy that began after Patti Smith, the Ramones, and Blondie inked record deals. "I think Lance was threatening with his sexuality in a way that Debbie Harry wasn't, and I don't think any record company was ready to bankroll a band with a gay singer." The Mumps keyboardist agreed: "The fact that Lance was gay didn't exactly help. Really, how many openly gay men were in a rock band then?" Hoffman went on to play with several other prominent downtown figures—Lydia Lunch, James Chance, Ann Magnuson, Klaus Nomi—but wider recognition eluded the Mumps. "It kind of hurt to see all your friends that you played with over and over and over again going off on this adventure. But I also was very proud of them."

Inventing "Punk"

Before Debbie Harry appeared on the cover of major magazines like *Cosmopolitan* and *Rolling Stone*, her first-ever cover story was in *New York Rocker*. Publisher Alan Betrock launched his DIY paper in early 1976, right around the time *Punk* magazine debuted on the scene. When Lisa Jane Persky joined *New York Rocker* as a founding staff member, she had been dating Blondie bassist Gary Valentine and had already taken several rolls of film at the band's loft on the Bowery. So when Betrock said he wanted to put Harry on the cover of the third issue and was looking for a photo, Persky realized, "Oh, I've got the perfect one."

Cover of *New York Rocker*, issue three
(photograph of Debbie Harry by Lisa Jane Persky)
COURTESY THE ARCHIVES OF LISA JANE PERSKY

Other small-scale zines had already started covering what would become known as punk music—such as *Teenage Wasteland Gazette*, started in 1973 by the Dictators' primary songwriter Andy Shernoff. The same year, Lisa and Richard Robinson launched the photo-heavy magazine *Rock Scene*, which employed Lenny Kaye as an associate editor and Lance Loud as a contributing writer. Loud brought along bandmate Kristian Hoffman to a 1974 interview with Brian Eno, and Hoffman snapped an infamous picture of the cerebral art rocker holding a lewd, goofy tchotchke he found at a Times Square novelty store.

Brian Eno during an interview with Lance Loud
© KRISTIAN HOFFMAN

Several other little publications existed, such as the Anglophile zine *Trans-Oceanic Trouser Press*, but it was *New York Rocker* that struck at the right place and right time. "Alan kind of invented the scene with *New York Rocker*," Hoffman said, "because it made it seem like, 'Oh, all these bands are in the same magazine,' so it all coalesced into a scene." A symbiotic relationship between local indie media and the downtown scenes had deepened since the early days of the *Village Voice* in the mid-1950s, Ed Sanders's *Fuck You* during the 1960s, and a host of smaller mimeo publications.

Betrock embodied the social connections that developed between indie media and the artists they covered, particularly in the way he was involved in Blondie's

early career. He financed the band's first demo, which included the songs "Out in the Streets," "The Thin Line," "Puerto Rico," "Platinum Blonde," and "Once I Had a Love (The Disco Song)," all of which were recorded during the summer of 1975. The ramshackle "Betrock Demos" did little to improve the biz's negative view of punk—or of Blondie, who remained a music industry hot potato. "Alan Betrock was running around with the demos that nobody was interested in," recalled Craig Leon. "The label executives and A&R folks used every excuse in the book: 'Girls can't rock,' 'She's too old,' 'It's too gimmicky.'"

"Alan wanted to manage us," Harry said, "but we were such a mess that I think he lost interest, and then he turned his attention to starting *New York Rocker*." That paper covered a wide variety of bands on the scene, much like the music weeklies *Melody Maker* and *New Musical Express* did in Britain. "*New York Rocker* definitely attempted to look at the personalities a little more deeply and to see how the music was put together," Lenny Kaye said. "Whereas *Punk* magazine was very specific in terms of what they considered 'punk.'"

Many took a rather dim view of that magazine, which Kaye described as a bit "Johnny-come-lately" (*Punk* cofounders Eddie "Legs" McNeil, John Holmstrom, and Ged Dunn Jr. didn't start their publication until the scene was in full swing). "*Punk* magazine, although I was friends with those guys, that never had much appeal to me," Blondie drummer Clem Burke said. "I just really liked the *New York Rocker*. It was like our version of *New Musical Express* or something. They wrote about the music more in-depth, and they covered lots of different bands. *Punk* didn't really deal as much with music. It was more like a lifestyle."

To build buzz for their new magazine, Holmstrom and McNeil plastered PUNK IS COMING! posters all around downtown in early 1976. "When those posters went up around town," Gary Valentine recalled, "everyone thought it was some band from New Jersey coming to play in the city." While *Punk* had its detractors, others—notably Chris Stein and Debbie Harry—became fans. "People went nuts for that first issue," said Holmstrom, who attended the School for Visual Arts in Manhattan with Stein. It also found a supporter in CBGB doorwoman Roberta Bayley, after a lanky man approached her and said, "I'm Legs McNeil from *Punk* magazine. I get in for free."

"No you don't," she shot back. "You pay two dollars."

Bayley had a change of heart and told McNeil that he could get into CBGB for free in exchange for a copy of *Punk*, but he insisted she go to the bar and buy it herself. "I thought he kind of had an obnoxious attitude," Bayley said, "so I let him in for free and I went into the bar and bought the magazine. I went home and

read it, and I thought it was the greatest magazine I'd ever seen. I just thought the whole thing was just so wacky and original. Then I thought, 'Yeah, I got to work for these guys.' We did a couple of photo shoots together. They started asking me to do photos for them, so we collaborated in that way."

"Harvey Kurtzman, the founder of *Mad* magazine, was my teacher at School of Visual Arts," Holmstrom said. "He was really excited about European comics that did wild, crazy things, like draw on photographs, so I thought, 'Why not merge rock 'n' roll photography with a comic story?'" *Punk* developed a hybrid photo-comic-filmstrip aesthetic used in a multipage feature titled "The Legend of Nick Detroit," published in late 1976. It starred Richard Hell as the noir-ish Nick Detroit, with cameos by David Johansen, Lenny Kaye, Debbie Harry, and other scenesters. "Richard Hell, God knows why he agreed to be Nick Detroit," Bayley said. "I think he was kind of friendly with Legs. 'Nick Detroit' turned out really well, and then people were begging to be in *Punk*."

Stein shot several photos for "Nick Detroit" and continued to contribute images that appeared in subsequent issues. "Chris was effectively an uncredited editor for *Punk*," Holmstrom said. "He gave me a ton of photos, and was always so helpful, smart, and professional. A lot of people think he was the best photographer on that scene, and there were a lot of amazing photographers." Blondie had not yet attained A-list punk status, so it took until issue four for the group to make it into the pages of *Punk*, whose coverage often revealed the same chauvinist thinking that dominated mainstream media: "Blondie is the sexiest chick on the New York underground rock scene. What else need I say? Just look at the pictures. Look at the pictures."

The two-page spread—titled *"Punk* Playmate of the Month"—featured sultry images of Harry taken by Stein, who also submitted similar photos to *Creem* and other national magazines. By ironically invoking the iconography of the American blonde bombshell, these 1950s-style pinup homages helped Blondie gain the attention of a larger audience, but their media-savvy tactics also had unintended consequences. "I created my own image," Harry said, "but then I was trapped inside it. It got a little out of hand. At a certain point, journalists just focused on my looks."

The word *punk* had previously been used by a handful of rock writers, such as Lester Bangs, Dave Marsh, and Lenny Kaye, but it hadn't yet circulated widely as a music genre name. "Nobody in New York wanted to be called 'punk,'" said Ramones producer Craig Leon. "There were no real tags except 'New York Rock.'" By early to mid-1976, just after *Punk* began publishing, mass media outlets

located in midtown began taking notice of this subculture that was brewing nearby. "I think punk," Hoffman observed, "the name that got attached to our bands, happened because *Punk* magazine existed." Holmstrom added: "Punk rock didn't really start with *Punk* magazine, but we really put it on the map. We brought media attention."

Peter Crowley recalled that when the first issue of *Punk* came out, a seething Dee Dee Ramone came to his office at Max's Kansas City clutching the magazine. "Peter, they're calling us *punks*," the Ramones bassist said. "Let's go kick their ass." However, they soon realized that *Punk* was helping to publicize the Ramones, which brought in bigger crowds to their shows. "We were selling more tickets and getting more press and all that kind of stuff," Crowley recalled. "So everybody went, 'Okay, we'll be punks.'" Even though some on the scene hated *Punk*—or at least thought it was sexist, knuckle dragging, or just plain clueless—they still hoped the magazine would write about their bands, because media coverage was hard to come by.

Unfortunately, this eventually had the effect of flattening the diversity of New York's underground rock scene, reducing punk to a one-dimensional parody of itself. "I think *Punk* was more about the cartoon aspects of the music," Kaye said. "It was not a lot about the music. It was mostly a caricature of the music, which is somewhat valuable, and somewhat limiting." Gary Valentine also felt that *Punk* projected a very narrow idea of what the scene was about—one that erased, for instance, the gay roots that punk emerged from. "I thought it was part of what turned the scene into a very specific kind of thing," Gary said. "It previously had this openness and embraced lots of different sounds and looks, but *Punk* simplified it in a way that the safety pin did in the UK."

The British punk band the Sex Pistols never had a Top 10 hit in the United States, but their media presence was substantial. US news outlets latched onto the sensationalistic, violent aspects of the British punk scene—which were then projected onto groups like the Ramones, much to their chagrin. This attracted boorish types who thought that being 'punk' was about starting fights, so most American record companies kept their distance from the scene. "Once the Sex Pistols and the British music scene embraced the word *punk*, it was very, very bad to have that word associated with the New York bands," the Fast's Paul Zone recalled. "It was hurting all of the New York artists to be called punk, because it was associated with the whole Sex Pistols fiasco."

The mass media image of punk—think: safety pins holding together ripped clothes—was the result of a transatlantic conversation that developed between

the New York and London scenes. Sex Pistols manager Malcolm McLaren started out running a London clothing store in the early 1970s with designer Vivienne Westwood, and then dipped his toes in band management during the New York Dolls' final days. This pairing happened after McLaren and Westwood began flying to New York for fashion trade shows, where they met Dolls guitarist Sylvain Sylvain—who had his own boutique clothing company, Truth and Soul. "We were making really good money," Sylvain recalled, "I was making $5,000 a time, and that was four times a year."[1]

Roberta Bayley also briefly worked at McLaren and Westwood's clothing store—then called Let It Rock—when she lived in London in 1973. She met the shop owners when they came into Chelsea Nut House, a vegetarian restaurant in London where she was a waitress. "Their store regularly changed names," Bayley recalled, "and during the punk years it was called Sex—which made the band name Sex Pistols essentially a marketing tool for their brand." Many New Yorkers felt that "punk" was manipulated by McLaren, Westwood, and others to fit their own agenda. "They were all about making fashion," Clem Burke said, "not music."

McLaren lived in New York when he was managing the Dolls and often went to CBGB, where he kept his eyes wide open. One person he noticed was Richard Hell, who was then playing bass in Television. "Richard had very distinct way of dressing," Bayley recalled. "He thought it through. He was very clear on how he came to the look, the haircut, and everything." Hell arrived at his chopped, spiky haircut through careful analysis, and was inspired by the crew cuts of his youth, which would grow ragged because kids didn't like to go to barbers. "When that patchy raggedness was exaggerated to the degree that I exaggerated it, it expressed defiance and criminality too," he recalled. "For one thing, a guy with a haircut like that couldn't have an office job."[2]

"Richard had spiky short hair, ripped T-shirt, and looked like a guy who crawled out of the gutter," Bayley said, "but his look was intentional. It wasn't accidental. It's like, 'This is how I look, deal with it.' So Malcolm went back to England and incorporated some of those things into the things Vivienne designed. I don't think Malcolm made any particular bones about copying Richard's look. He was a conceptualist artist, and Malcolm just liked the idea that people looked like street urchins." One day in 1976, Chris Stein was paging through a European rock magazine and said, "Hey Richard, you've got to see this. There are four guys who look exactly like you!" Hell looked and saw the name Malcolm McLaren by a photo of the Sex Pistols.

Malcolm really did like me, he thought.

"I had to laugh," Hell recalled. "Everybody in the band had short, hacked-up hair and torn clothes and there were safety pins and shredded suit jackets and wacked-out T-shirts and contorted defiant facial expressions. The lead singer had changed his name to something ugly. It gave me a kind of giddy feeling. It was flattering. It was funny. They looked great. I thought, 'This thing is really breaking out.'"[3]

Punk's bad boy image was codified by corporate and indie media outlets soon after the rise of the Sex Pistols. The loud-hard-fast music of the Ramones, for example, further solidified the perception of punk as music made by and for angry young men who rejected "girly" prefab pop. The punk explosion supposedly reset the cultural clock to Year Zero, but far from rejecting the musical past, many early New York punks embraced the guilty pleasures of their youth. "Our number one main influence was the sixties," Paul Zone said. "The Ramones, you listen to their songs and they're complete bubblegum pop, without a doubt." Lead singer Joey Ramone readily admitted, "We really liked bubblegum music, and we really liked the Bay City Rollers. Their song 'Saturday Night' had a great chant in it, so we wanted a song with a chant in it: 'Hey! Ho! Let's go!' on 'Blitzkrieg Bop' was our 'Saturday Night.'"[4]

The Ramones wore leather biker jackets and ripped jeans and had tough scowls on their faces, but that pose was also underpinned by a Warholian irony and poppy fizz. Leon noted that they embraced bubblegum and 1960s pop as "a return to the rock 'n' roll roots. Even the manufactured stuff like the Shangri-Las was young people speaking to other young people." That 1960s girl group was one of the common musical denominators that Blondie shared, and Burke explained the Shangri-La's proto-punk appeal: "They had their black leather vests and their tight black leather pants, and they sang 'Give Him a Great Big Kiss.' They sang about dirty fingernails, wavy hair, and leather jackets, and things like that."

The Shangri-Las cast a long shadow over glam and punk rock. The New York Dolls' "Looking for a Kiss" borrowed the spoken word intro from their "Give Him a Great Big Kiss," and another Dolls song, "Trash," copped the campy "How do you call your lover boy?" line from "Love Is Strange," a catchy 1956 hit by Mickey & Sylvia. The group's final album, *Too Much Too Soon*, was produced by Shadow Morton, who had crafted the girl group classics "Leader of the Pack" and "Remember (Walking in the Sand)" for the Shangri-Las. As Burke recalled, "Bubblegum rock was part of the roots of the New York music scene. Some of the old-school

guys like Richard Gottehrer or Marty Thau—who had some money and success in pop music—they understood the music because they were coming from that Brill Building mentality."

Thau was the New York Dolls' first manager before McLaren took the job, and he had previously made a living as a record promoter for late 1960s bubblegum groups the 1910 Fruitgum Company ("Simon Says") and the Ohio Express ("Yummy Yummy Yummy"). Thau recorded the Ramones' first demos and released Suicide's debut album on his independent label Red Star, and also formed the production company Instant Records with the old-school industry hit maker Richard Gottehrer. "Richie was part of that whole Brill Building rock thing," Leon said, "which had a lot of nostalgia for us because we grew up with it on the radio when we were kids."

Gottehrer started Instant Records with Marty Thau after leaving Sire Records, a label he cofounded in 1966 with Seymour Stein ("The name *Sire* is a combination of *S*, first letter of Seymour. *I*, second letter of Richard. *R*, first letter of Richard. *E*, second letter of Seymour"). Gottehrer and Stein originally met in the Brill Building in the mid-1960s and decided to form a production company, then began releasing records on their own imprint—long before Sire signed punk staples like the Ramones, Richard Hell and the Voidoids, the Dead Boys, and Talking Heads.

"Everything runs its course and you move on from time to time," Gottehrer said. "I wanted to get more active in producing again, so I decided that it was time to move on in '76. Seymour kept the Sire name and went on to greater glory." Gottehrer dove headfirst into the punk scene, recording the first two Blondie albums, a single by the Fast, and Richard Hell's full-length debut, *Blank Generation*. Blondie first came to his attention when Gottehrer was recording a 1976 music festival at CBGB. "I was in the truck recording all the bands for a live album for CBGB's," recalled Leon, who was then working for Instant Records. "We did a sound check and Debbie came in the truck and she saw Richie and me sitting there, and she said to Richie, 'I want you to make a record of me.'"

The no-nonsense Gottehrer set up a rehearsal for Blondie to see if they had what it took to be stars—or at least release a catchy single. "I remember grinning from ear to ear throughout the whole rehearsal because the songs were so great," he said. "She was great. You could tell right away they were special." Unfortunately, Gottehrer had no luck convincing any major labels that Blondie was marketable, though he finally persuaded an old friend from his Brill Building years, Larry Uttal, whose label Private Stock Records was home to the 1960s pop singer Frankie Valli. Uttal agreed to release one Blondie single with an option on a full-length album, and Leon was dispatched to record their debut.

The obvious choice for a single was the Valentine-penned "Sex Offender," with "In the Flesh" as the B-side. That single was recorded at Plaza Sound (as were their first two albums), a midtown studio above Radio City Music Hall. Debbie Harry's suburban parents took her to see Christmas shows at Radio City in the 1950s, when CBGB owner Hilly Kristal was in the chorus that backed the Rockettes. It is quite possible that Harry heard Kristal sing during a Radio City holiday show long before either was involved in punk rock.

Plaza Sound Studios was a huge room that had previously been used as a radio studio for the NBC Symphony Orchestra and a rehearsal space for the famed conductor Arturo Toscanini. Blondie paid the night rate, and salsa king Eddie Palmieri recorded his album during the day—an arrangement that rubbed off a bit on Blondie's music. "They left everything all set up for a session the next day with Eddie Palmieri," Leon said of the salsa band's instruments, "and we just grabbed them all and overdubbed every one of them on 'X Offender.' That's why all those shakers and bells and all that other junk was on that record." The single originally had the more punk-sounding name—"Sex Offender"—but Gottehrer changed it because 1970s radio programmers would not play a song with "sex" in the title.

A catchy tune about a prostitute falling in love with a cop, "X Offender" high-lights the ways that Blondie's deceptively upbeat music often obscured bleaker lyrical themes. "I don't think there's a song without a reference to someone getting shot, stabbed, degraded, or insulted. It's prime-time television on record," Harry said of Blondie's debut album, which included "X Offender."[5] The single's flip side, "In the Flesh," had another girl-group link: Brill Building songwriter and performer Ellie Greenwich singing "ooh-ing" backup vocals. " 'In the Flesh' was a huge hit in Australia," Gottehrer recalled, "but it never sold anywhere else in the world. What it did was it showed that there was a market out there for Blondie—for the voice, for the image, for everything about them."

Blondie came across as a fairly conventional pop-rock act, but the band's brand of bleach-blonde pop concealed its much darker roots. "In the end, when the story is written," Leon said, "Blondie were closer to the New York art sensibility than a lot of these people who had pretensions of being that." This outsider orientation was further obscured by the fame they enjoyed soon after the release of *Parallel Lines*, a multiplatinum 1978 album that was the first to drag "punk" into the Top 40. Blondie's rise from the margins to the top of the charts highlights how the social center and its peripheries are often divided by porous boundaries, blurring the lines between underground and pop culture.

Coda

The downtown New York scene paved the way for everything from punk and disco to the gradual acceptance of gay and transgender life. The area's close proximity to the nation's media nerve center helped cross-pollinate underground and popular culture, allowing new kinds of expression to flower. At the height of Blondie's fame, for example, Chris Stein co-hosted an experimental talk show with Warhol associate Glenn O'Brien that aired weekly on public access television. *TV Party*, which ran from 1978 to 1982, also included visual artist Jean-Michel Basquiat and future *Yo! MTV Raps* host Fab 5 Freddy, who operated the cameras and appeared as frequent on-air guests. "Everybody was on that damn show," Stein recalled. "Talking Heads, Klaus Nomi, George Clinton, Iggy Pop, and the guys from the Clash."

Freddy was a graffiti artist who introduced Blondie to hip-hop, directly inspiring their global number one hit "Rapture"; Basquiat played a DJ in the song's music video while Harry rapped, "Fab 5 Freddy tells me everything's fly." When she hosted *Saturday Night Live* in 1981, Harry insisted on booking the Funky 4 + 1 as the show's musical act, exposing this obscure South Bronx crew to millions. Harry and Stein often collapsed the distinctions between mainstream and subculture, much like one of their primary inspirations, Andy Warhol. Straddling the uptown and downtown, he stood at the center of a tightly knit network of artists, musicians, filmmakers, poets, performers, intellectuals, and other eccentrics.

"Everyone I knew was somehow connected to Andy," Stein said. "It felt like the whole city was connected to him. Right up until he died, I knew people who were directly or indirectly involved with him." Harry added, "Andy definitely was a big influence on the downtown scene, and its energy fed back into his own work. He really took me and Chris under his wing, and while we were never that close, we learned so much from him. He taught us to not be bogged down by the past, or nostalgia, and to be open and ready for the next thing that comes along—the

newest music or fashions or technologies." Warhol always moved forward, never looking back as he hurtled from scene to scene, medium to medium. His Pop Art silkscreens and deadpan persona exuded a camp sensibility also found in Off-Off-Broadway, which embraced trashy Hollywood movies and other discarded products of mass culture.

In places like Caffe Cino, people reinvented themselves and stretched the boundaries of theater by staging a series of plays that used comic books as scripts, along with other groundbreaking performances. The Cino's outrageous shows and free-thinking atmosphere also inspired Susan Sontag, who used drag and camp to think through the relationship between performance, artifice, and sexuality. This helped form the basis of many influential academic theories of gender performativity, but they weren't really all that new. Downtown artists had been embracing fragmented sexual identities for decades, literally acting them out onstage. Actors and actresses often performed multiple roles in the same show, fluidly changing their onstage personas or genders.

This blurring of social and aesthetic categories also occurred at the Factory, which became a staging area for many varied ventures: the assembly line–like production of silkscreened prints and films; the Velvet Underground's avant-rock, which provided a soundtrack for multimedia events; and the endless audiotaped conversations that were transcribed as content for Warhol's *Interview* magazine, his Off-Off-Broadway show *Pork*, and his "novel" titled simply *a*.

Like Warhol, who had escaped to New York as a young man, Ed Sanders fled his small Missouri hometown for a life of Beatnik glory. An early Civil Rights and peace activist, Sanders joined his downtown Yippie friends to organize an October 1967 anti–Vietnam War demonstration in Washington, where they tried to levitate the Pentagon. His political prank used magic, though not the kind that could actually lift that structure; it instead utilized the mystical powers of imagination. Ideas can be transformed into action capable of reshaping individual lives and the whole of society, and the people who populate this book are proof positive of this. Their zany levitation plan publicized the protest, which became the largest antiwar demonstration at that point in the nation's history.

This meme continued to resonate within cultural memory a half century later when, in 2015, a New York–based experimental music group named Talibam! tried to levitate the headquarters of Vice Media, a symbol of the hipster gentri-fication of Brooklyn. Talibam! is one of the Fugs' many spiritual stepchildren, Dada- and Fluxus-inspired art-pranksters who operate on the periphery of this

gilded lifestyle metropolis. Because of rising rents, most of the small-scale venues where Talibam! played over the previous two decades have closed. "The late nineties was the last era of commercial enterprises that could exist without the day-to-day stress of economics," observed group member Matthew Mottel, son of underground theater artist and photographer Syeus Mottel.

New York's real estate boom began when the city government strongly encouraged property development in the 1980s, which facilitated Donald Trump's rise to national prominence. Sadly, "wealthfare" tax breaks supplanted social welfare programs for the poor. "I was taught to spit on Donald Trump's buildings since I was ten years old," said Mottel, who witnessed how the mogul's luxury developments ravaged the Upper West Side, where he grew up, displacing many former residents. The real estate gold rush then shifted downtown, which led to the closing of the Knitting Factory, Tonic, and other downtown venues that programmed innovative musical acts. Even the venerable punk club CBGB closed its doors in 2006 and was replaced by a high-end John Varvatos clothing store (the club's interior was preserved, simulacrum-style, to inflate the retailer's cultural capital).

By that point, the underground had already shifted to Brooklyn, which experienced a wave of gentrification that produced similar outcomes. Vice Media's purchase of a building in the Williamsburg neighborhood (aided by a $6.5-million-dollar tax break) resulted in the eviction of several DIY venues that had been staples of the city's experimental performance landscape. Ironically, the "edgy" content produced by Vice's many media platforms feeds off the kind of subcultural activity that used to happen in the company's current headquarters. "To me," Mottel said, "they had a responsibility to assist in creating a diverse and sustainable economic system for the creative culture they cannibalize." This contradiction prompted the Talibam! levitation attempt, a street theater performance that also served as a critique of city government policies that prioritize corporate interests over the communities they displace.

"The money has really changed everything," lamented Chris Stein. "I don't know how anyone who is young and creative can make it here anymore." The downtown's cutting-edge artists were, ironically, at the vanguard of a process that stripped these neighborhoods of their diversity and vitality. Many of those I interviewed for *The Downtown Pop Underground* either have been forced out of their longtime residences or have uprooted themselves for financial reasons. This dynamic was unintentionally set in motion by urban planning theorist

Jane Jacobs and those who followed her lead. In the wake of their activism, city officials became less prone to replace old buildings with large residential developments, and the terms "mixed-use housing" and "adaptive reuse" have now become common buzzwords.

Unfortunately, Jacobs's preservationist instincts did not account for the way that gentrification would burden artists, people of color, and the working poor. Residents in low-rent apartments are often displaced by new owners who rehabilitate buildings to their former architectural glory, thereby increasing property values. These middle-class gentrifiers are then replaced by the upper classes, who attract fancy boutiques to areas that were previously filled with inexpensive ethnic stores (which had been key sites where former residents interacted).[1] Today, downtown New York—like much of the city—is a playground for the rich, rather than a place for artists and other outsiders to thrive, or even survive.

"Spirits of the displaced and dormant creative energies underneath the foundation of Vice Media's HQ will be unleashed," Talibam! declared on social media, "once the building levitates into the East River and a creative re-flowering of the Williamsburg Waterfront Communities will generate." Even though Talibam! and the Yippies did not succeed in raising Vice or the Pentagon, their critiques still reached wide audiences thanks to an independent media network that was seeded by Ed Sanders and many others. Mimeographed zines and the free-form FM radio of the 1960s were supplemented by video and public access television in the 1970s, which evolved into online digital media throughout the 1980s and into the new century.

Shirley Clarke was another downtown artist and indie media pioneer who participated in 1967's March on the Pentagon. She filmed the Fugs' exorcism and levitation rituals with her trusty movie camera, which she soon abandoned for the newfangled Portapak video camera. Clarke and other early video practitioners believed that this medium could expand the democratic potential of mass communication, and they explored how to make this happen. Years before the Internet era's explosion of decentralized user-generated content, Clarke, the Videofreex, and their peers enacted new forms of networked connectivity before it became an everyday reality.

Clarke certainly struggled to be taken seriously as a filmmaker, but La MaMa's Ellen Stewart faced even more obstacles as a black woman in America. Her iron

Ellen Stewart dancing with the audience and cast members at the
1970 premiere of Tokyo Kid Brothers's *Golden Bat*
COURTESY THE LA MAMA ARCHIVE/ELLEN STEWART PRIVATE COLLECTION

will ensured that this experimental theater flourished through the 1960s and 1970s and continues to persist even after her death in 2011 at the age of ninety-one. Jackie Curtis made the most of the freedom that La MaMa's stage offered and, as a result, had a major impact on popular culture—especially for someone who lived in the social margins. In addition to developing a now-ubiquitous pansexual style, Curtis anticipated punk's DIY fashions by wearing ripped thrift store clothes that were safety-pinned together.

Additionally, Curtis was responsible for Patti Smith's New York stage debut when she cast the future punk singer in her play *Femme Fatale* at La MaMa. After Patti's underground theater experience instilled her with confidence, she began mixing poetry and music—which culminated in *Horses*, a classic 1975 album by the Patti Smith Group. The close proximity of CBGB, La MaMa, and other underground theaters ensured a sizable overlap between early punk and Off-Off-Broadway. These two scenes shared similar sensibilities and were open to women and gay men, unlike the mainstream 1970s rock world that eschewed them.

The young George Harris III and the rest of his family also found a welcoming home at La MaMa. While doing avant-garde theater, they appeared in corporate films and commercials—a reminder of the ties that bind mainstream and

underground culture. Another example of this connection was the way that Curtis, Hibiscus, and many others poached from, and subverted, 1930s and 1940s Hollywood studio films. In doing so, they demonstrated how femininity and masculinity are performative acts that are not tied to one's biological sex. Gender can be changed and accessorized—not unlike putting on a costume and acting in a show.

During his time with the Cockettes and Angels of Light, Hibiscus spread his visionary gender-fluid style coast to coast and, eventually, to Europe. This established him as a key member of a downtown diaspora that also included Lance Loud in Santa Barbara, Sylvester in San Francisco, David Bowie in London, and Baltimore's John Waters and Divine. With their enactments of a wide range of sexualities, these unconventional performers set the gay and trans revolutions in motion—and they had many good times.

"I don't wanna talk about things we've gone through," Hibiscus would dramatically sing while standing outside Paul Zone's Greenwich Village apartment, quoting the opening lines of ABBA's 1980 hit "The Winner Takes It All." The glitter angel kept Loud and Zone laughing hysterically as he whirled in like a tornado, screaming the details of his latest exploits as his friends futilely tried to get in a word edgewise.

After the Fast went through a goth and synth-pop phase, Paul and Miki Zone rechristened themselves Man 2 Man and became a gay dance act. The two brothers finally enjoyed commercial success in the mid-1980s after hitting the same club circuit as Divine, who also had an unlikely dance music career. Man 2 Man appeared on the popular British television show *Top of the Pops* in 1985 when "Male Stripper" became a top ten UK smash, followed by two other hit singles in that country. They even had a number one single in Mexico, after which the brothers spent six months south of the border appearing on morning talk shows, lip-syncing double entendres such as, "Your love is like a lubricant / it soothes the soul inside."

George Harris III also reinvented himself, starting the new wave group Hibiscus and the Screaming Violets with his sisters and brother Fred in the early 1980s. They were on an upward trajectory—preparing to record, tour Japan, and shoot an MTV video—until the thirty-two-year-old stage veteran rapidly became ill. Hibiscus was among the first to die of complications from AIDS, when its death toll was still in the hundreds (it has since claimed tens of millions of lives).

On May 6, 1982, the entire Harris family felt as though they had been called to his bedside at Saint Vincent's Hospital, where they were joined by their old

Hibiscus and the Screaming Violets
COURTESY THE FAMILY ARCHIVES OF GEORGE EDGERLY AND ANN MARIE HARRIS

friend Harry Koutoukas. "George, I know it's just too much for you," Fred Harris whispered into his ear. "We're all here and it's okay if you want to leave. We all love you." Hibiscus opened his eyes and looked at each of them, then closed them tightly as the family felt his essence float around the room and fly through the open window. While they sat in silence, Koutoukas looked out at the sky and sincerely asked, "Won't you reconsider?"[2]

Many, many more did not survive the AIDS epidemic—including Lance Loud, Miki and Mandy Zone, and countless others. "I used to keep a list of friends who died," said Chris Kapp, a performer in Hot Peaches and the Play-House of the Ridiculous. "It got up to I think seventy-eight, and then I just couldn't do it anymore," she said. "I became numb. I mean, it was all over—one death after the other. It was awful. In my group, it really tore a huge hole, and it dampened our spirits a lot." Lisa Jane Persky moved away before AIDS hit New York, where she lost many close friends. "It was devastating enough," she said, "but to have been there for for each and every loss, I don't know if I could have dealt with that."

"Sexual diseases, drug addiction, and suicide have always hit the arts community hard," John Waters observed. "But I'm very lucky that I also have friends that are still around. I keep friends. If you're alive, I keep you around. If you're dead, I try to honor you." While AIDS shredded the social fabric of the downtown arts

community, Koutoukas survived—just as he had escaped the fate of 1960s drug casualties like Freddie Herko, who pirouetted from a fourth-story window just down the street from Caffe Cino, or Joe Cino, who stabbed himself to death in a fit of depressive desperation inside his storefront theater.

"Harry was so gorgeous," Agosto Macho recalled. "But as the street community does, they sort of loved him to death. 'Here are some pills. Here's some grass. Here's this and that.' And being so young, his body was able to take it for years, until speed took over." But Koutoukas was like a cockroach, or another one of the immortal subterranean dwellers who populated his plays. He remained in his apartment on 87 Christopher Street for fifty years without getting evicted—no small feat—scraping by and living off the generosity of friends until he died in 2011. Harry's former neighbor Yoko Ono sometimes sent her limo driver down to deliver a stack of Lean Cuisine frozen dinners, the playwright's favorite, and she also bought him a motorized Rascal scooter to help him get around.

Near the end of Koutoukas's life, Machado turned to him and said, "Oh, we could pretend we're at a café in Paris," gesturing to the street scene. "Agosto," he replied, "I'm very happy being in Greenwich Village. It was my salvation when I ran away from home. Life began when I moved to Greenwich Village, and this is where I'm going to die." He regularly attended Alcoholics Anonymous meetings and services at Judson Church, whose community welcomed him as a member of their flock just as it embraced him as a playwright decades earlier. "Harry really was very, very happy at the Judson, during that later period," Machado recalled. "The congregation really respected him."

Koutoukas's favorite actress was Maria Montez, "The Queen of Technicolor," whose excessive eruptions of femininity provided grist for many of his plays. Debbie Harry likewise absorbed more than a few ideas from those trashy Hollywood movies, and from the gay men who loved them. "I learned a lot from drag queens," she said. "That's no joke." Harry presented herself as an over-the-top pastiche of classic female stereotypes, embracing a more fragmented postmodern identity that stood in contrast to the kinds of "honest" self-expressions that defined the 1960s rock era. The appeal of these earlier rock stars was grounded in their displays of emotional pain and ecstasy, but Harry was clearly acting, faking it. Irony and artifice would become the new authenticity.

By the early twenty-first century, the downtown's more expansive conceptions of sexual identity finally began to circulate in mainstream culture. One can draw a straight line (perhaps *straight* isn't the right word) from the glitter-trash look that was developed by Jackie Curtis to contemporary television shows such as

RuPaul's Drag Race. Before entering the mainstream on the coattails of the 1992 dance-pop hit "Supermodel," RuPaul made music on indie labels, appeared in zero-budget movies like the *Star Booty* trilogy, and adored Blondie. Looking at some photos of Harry and RuPaul side by side, they could be drag queen sisters from another mister.

"Drag was a tool—it was the most punk-rock antiestablishment thing we could do," RuPaul said. "It had nothing to do with being gay, nothing to do with wanting to be a woman. It was about challenging ideals of identity and making a political statement against the preppy Reagan eighties and the existing drag community."[3] In 2016, Debbie Harry and Chris Stein appeared as guest judges on *RuPaul's Drag Race*, in an episode titled "New Wave Queens." As I watched Stein gush that he was a huge fan of the show, I recalled how he once offhandedly told me, "The best thing about having some success is getting to meet your heroes—like Bowie, or RuPaul." Most people wouldn't think of Bowie and RuPaul as artistic or cultural equivalents, but he wasn't being snarky or ironic.

Stein's flattening of aesthetic hierarchies is classic Warhol, and his RuPaul fandom is another reminder of Blondie's roots in the LGBTQ community. The band played an early gay pride rally in the West Village during the mid-1970s, and Stein and Harry openly embraced queer fans at a time when the larger culture was overtly hostile toward them. Furthermore, not every young man who worshiped the singer was necessarily heterosexual; as one *Drag Race* contestant told Debbie, "I had a poster that was above my bed, and my parents really thought I was straight. For a minute." Her response: "I was a beard?"[4]

Since the publication of Dick Hebdige's 1979 cultural studies classic *Subculture: The Meaning of Style*, scholars and critics have praised punk for its authenticity, confrontational politics, and lack of sentimentality. Like many books of its type, Hebdige's examination of rebel youth movements located subcultural activity, well, where the boys are.[5] "According to the prevailing cultural history of our times," media historian Susan Douglas observed, "the impact of the boys was serious, lasting, and authentic. They were thoughtful, dedicated rebels, the counterculture leaders, the ones who made history. The impact of the girls was fleeting, superficial, trivial."[6]

The punk movement has often been celebrated as a total break from the past, an aggressive rejection of prefab pop and other products of an insidious (and implicitly feminized) consumer culture. But as *The Downtown Pop Underground* shows, punk was part of a larger historical continuum that was far more diverse than the caricature that it became. Its rise was enabled by the interconnections that

developed between the midtown mainstream and the downtown underground, which crossed paths in many unexpected ways during the 1960s and 1970s.

This book's many lead and supporting characters were unique and influential, but they should also be viewed as part of a collective social dynamic; the whole was greater than the sum of its parts. Many other important scenes have existed elsewhere in the world, but New York's downtown was uniquely positioned very close to the heart of the culture industry—ensuring that its ripple effects could spread far and wide. If, for example, anyone is to be praised or blamed for today's image-obsessed celebrity culture, the rise of reality television, and the oversharing that occurs on social media, it is Andy Warhol. Starting in the mid-1960s, he began recording mundane moments with cassette recorders and video cameras, and famously predicted the day "when everyone will be famous for fifteen minutes."[7]

That aphorism first appeared in a 1967 *Time* magazine article and was repeated ad nauseam throughout the following decade, going viral around the time *An American Family* debuted. One early symptom of the spread of Warholism was the popularity of that show, which documented the minutiae of the Loud family's lives in ways that were not unlike the content of Warhol's *Interview* magazine (which might include a long digression about a salad someone ate). Lance Loud had been a Warhol acolyte since he was thirteen, and his performance on *An American Family* was heavily influenced by Warhol's films. "When the cameras were on me," he recalled, "I was really thinking, you know, *Chelsea Girls*."[8]

Fittingly, the debut of the first reality television series coincided with the rise of David Bowie and glam rock, which overtly embraced theatrical artifice and a queer sensibility. Loud was the first out gay man on television, stirring up passionate (and often vicious) debates about homosexuality back when it was still a verboten subject on broadcast television. He became the poster child of moral decay and camp excess, a divisive lightning rod that helped spark America's culture wars. "The Andy Warhol prophecy of fifteen minutes of fame for any and everyone," the former reality television star said, "blew up on our doorstep."[9]

Lance Loud and other like-minded souls were often supported by unsung mothers such as Pat Loud and Ann Harris, who encouraged them to blaze their own unique paths. The downtown was also bursting with nonbiological extended families that provided support for those who couldn't fit in anywhere else, or who were rejected by their own parents. Just as Ellen Stewart played a maternal role for Off-Off-Broadway's wayward children, many gay men often looked after young women like Debbie Harry, Lisa Jane Persky, and the Harris sisters—showing them

how to apply makeup and carry themselves, as well as providing other forms of emotional support.

After Divine got Persky her first agent, she moved to Los Angeles in 1977 to be a professional actress, taking memorable roles in *When Harry Met Sally*, *The Cotton Club*, and *The Big Easy*. Through her Off-Off-Broadway experiences, she found her calling. "Until I had somebody telling me, 'My God, you do this really well,' I just didn't know. The nurturing part was key," Persky said. "I felt the drag queens and gay men I knew had a genuine interest in me, and maybe it was the same with Debbie. They loved women, and they were the ones who took care of us and who showed us how to look our best, and how to do things."

The inhabitants of downtown not only cultivated alternative familial support systems, they also created new ways of inhabiting their bodies by following the lead of Off-Off-Broadway. Underground theater productions tended to reject naturalism by continually reminding spectators that they were watching a staged performance, a "show." They sometimes contained plays within plays—or broke the fourth wall in other absurd ways—and these performances also emphasized the act of role-playing.[10] Play-House of the Ridiculous satires like *Cock-Strong*, for example, pulled back the curtain to reveal how the gendered roles that people play in everyday life are arbitrary and even ridiculous. On Off-Off-Broadway, men were cast as women, girls played boys, and in *Women Behind Bars*, a rooster was even cast as a chicken named Rosalita.

Underground theater people, filmmakers, visual artists, poets, musicians, activists, and other outsiders developed subversive uses for the mass culture they consumed; and as DIY media makers and performers, they were free to express themselves without constraints. This relatively small group of people connected with each other at shows in makeshift venues and on the street—as well as through new communication technologies like mimeo machines, audio recorders, portable video cameras, and public access television—which further extended their reach. By developing new modes of independent distribution, they anticipated the ways that people now use social media and other online platforms. The denizens of downtown did not wait patiently for a new era to arrive, and instead set about building their own world by making creative uses of the materials they had access to. Through the act of reinventing themselves and remaking their community, they transformed popular culture on a national and global scale.

Author's Note on Research, Interviews, and Acknowledgments

The liberating ripple effects that originated in downtown New York eventually reached Iowa City, where I now live, as well as other cultural peripheries like Virginia Beach, my hometown. I was first introduced to punk via mass media at the age of nine, when Debbie Harry guest starred on *The Muppet Show*, singing "One Way or Another" in 1980. Though this version of "punk" was certainly constrained by the commercial priorities of the CBS network, merely catching a glimpse of Harry's shaggy two-toned hair and sassy snarl signaled to me that a weirder and more wonderful world might be right around the corner.

Like those chronicled in this book, I was transformed by my engagement with the arts, which began in a mid-1980s high school drama club that also included actor Mark Ruffalo. This immersion in theater brought me out of a shy shell, and I have since orchestrated several media pranks with my alter egos Reverend Eleven and RoboProf. The drama coach for Thespian Troupe 3178, Nancy Curtis, staged a Pink Floyd–soundtracked production of *Antigone* and also let me codirect a theatrical version of the cult black comedy *Harold and Maude* (which opened with a student hanging from a noose ten feet above the stage, drawing audible gasps from the unprepared audience). Curtis also introduced me to Sam Shepard and Patti Smith's *Cowboy Mouth*—and the Holy Modal Rounders, which planted an early seed that led to me writing *The Downtown Pop Underground*.

This idea began to flower after a chance encounter with Lou Reed, which left an indelible mark on me. I had prepared for his August 8, 1989, concert in Richmond, Virginia by bringing a few of his albums and my lucky Sharpie, which I surmised was the reason I had been able to meet Iggy Pop and a few other musical heroes as a teen. Sure enough, I scored a backstage pass that night (right place, right time) and was the first person in the green room where Lou Reed was standing. He dutifully signed *The Velvet Underground & Nico* and his other albums while I mined his mind with a volley of questions based on info I had gleaned from books, magazines, and records.

"That crazy one-note guitar solo on 'The Ostrich' sounds a lot like what you later did in the Velvet Underground. Did you always play like that?"

"Yeah," Reed said. "Because it's easier. That's rock 'n' roll. Keep it simple."

"Is the Candy in 'Walk on the Wild Side' and 'Candy Says' the same person?"

"You could say that. Those songs were about the same person, but ya know, Candy had several different personas."

"What was Andy Warhol like?"

"He taught me to work hard. He used to tell me I was lazy, because I said I only wrote ten songs that day," Reed said, echoing a line from *Songs for Drella*—a tribute to Warhol he was making at the time with John Cale, his former Velvet Underground bandmate. I soaked it all up, wide-eyed. Meeting Reed sent me on a three-decade-long mission to learn everything I could about this subterranean world that altered the possibilities of what music, art, and culture could offer.

I had been actively working on various iterations of what became *The Downtown Pop Underground* for more than seventeen years, but it wasn't until I got to know Lisa Jane Persky that everything came into focus. This kindred spirit helped open doors by making introductions and plugging me in to her elaborately woven social networks, while also graciously sharing with me many of her underground theater bills, personal letters, photos, and other ephemera from that period. She also served as a regular sounding board for ideas throughout the course of writing *The Downtown Pop Underground*, and she kindly allowed me to reprint many of her photos in this book.

Thanks to everyone else who lent me their time and memories, and who opened up their archives to me, such as Paul Dougherty, who shared with me his personal experiences and the research he conducted on early video during his coursework at NYU's Moving Image Archiving and Preservation program. I was also able to view many treasures in the Archives of Lisa Jane Persky, the Al Hansen Archive, and the Family Archives of George Edgerly and Ann Marie Harris—all of which enriched my understanding of the downtown scenes. I also benefited from access to the following institutional archives: NYU's Fales Library's John Vaccaro and the Play-House of the Ridiculous Papers 1959–2005, and the Ed Leffingwell Jack Smith Curatorial Files 1962–2010; New York Public Library Lincoln Center branch's Magie Dominic Collection of Caffe Cino Materials, where Magie herself walked me through her donated collection and its associated memories.

This book was written during a leave from teaching enabled by the National Endowment for the Humanities Public Scholar Fellowship and a University of Iowa Career Development Award; the nineteen months of uninterrupted research

and writing provided me with momentum and confidence, allowing me to finish this ambitious project in a timely manner. I also received financial support from University of Iowa's Vice President for Research Office's and the College of Liberal Arts and Sciences' Book Subvention Program, as well as an Arts and Humanities Initiative Award for transcriptions and photo licensing. I also thank my colleagues in the Department of Communication Studies for their ongoing support.

For giving me a place to sleep whenever I am in New York, I offer my deepest gratitude to Kennan Gudjonsson, Nina Nastasia, Jeila Gueramian, and Scott Anderson—who essentially subsidized my many trips to the city for research and pleasure. Early on, Chris Offutt offered advice about organizing this book that proved to be pivotal as the manuscript came together. I am also indebted to Fred Turner and Siva Vaidhyanathan, who wrote letters supporting my NEH project proposal, and John Durham Peters, who gave me critical feedback on my proposal and discussed ideas as my research developed. *The Downtown Pop Underground* also benefited from the custom maps created by Ahnna Nanoski, who worked with me closely over the course of a year on this project and did a beautiful job. I wrote much of this book in the café of Prairie Lights—my favorite bookstore in America—and I also want to acknowledge another Iowa City institution, *Little Village*, which allowed me to develop some of the material for this book in my biweekly column, "Prairie Pop." Viva indie media!

For their assistance licensing images for this book, I also want to thank Lisa Jane Persky, Chris Stein, Kristian Hoffman, Dagmar, Andrew Sherwood, Matthew Mottel, Bibbe Hansen, Sean Carrillo, Dagon James, Wendy Fisher, James D. Gossage, Wendy Clarke, the Harris Family, the Videofreex, Becky Simmons at the The Wallace Center, and Mary Huelsbeck at the Wisconsin Center for Film and Theater Research.

Many, many, many thanks to Abrams and my wonderful editor, David Cashion, whose line edits and more general feedback in multiple drafts greatly improved *The Downtown Pop Underground*. And as always, I want to acknowledge Sarah Lazin for her work as my longtime literary agent and for finding a great home for this book. It could not have been completed on schedule without the hard work of my primary research assistant, Morgan Jones, who greatly impressed me with her professionalism, work ethic, and intelligence; by the end of the project, she became an editorial assistant whose work was indispensable. I also want to thank Lynne Nugent, Alasdair Nugent-McLeod, and Damian Nugent-McLeod, who are a constant source of inspiration and support, and whom I love with all my heart.

I interviewed more than 100 people, totaling more than one million transcribed words (some of the quoted material was lightly edited for clarity or to avoid unnecessary repetition). Most of these interviews were quite lengthy, and several people talked to me on multiple occasions—though a handful were much more brief, such as my encounter with Lou Reed. Although some people I talked to were not directly quoted in this book, they all enriched my understandings of downtown New York and I appreciate their time. Thanks also to those who helped with the transcription process: Jody Beth LaFosse, Gina Smith, Morgan Jones, and Jonathan Hansen.

Lastly, I want to pay respect to the amazing people I spoke with about New York City, without whom this book would not have been possible:

Laurie Anderson

Penny Arcade

Michael Arian

Sharon Barr

Anthony Barsha

Roberta Bayley

Skip Blumberg

Clem Burke

David Byrne

Nancy Cain

Mari-Claire Charba

Rhys Chatham

David Christmas

Hampton Clanton

Wendy Clarke

Andrei Codrescu

Jacque Lynn Colton

Tony Conrad

Jayne County

Marion Cowings

Simeon Coxe

Lowell Cross

Peter Crowley

Demian

Paul Dougherty

Jason Epstein

Bruce Eyster

Bob Fass

Fab 5 Freddy

Lisette Foley

Paul Foster

Jim Fouratt

Richard Frey

Richard Goldstein

Kim Gordon

Richard Gottehrer

Andrew Gurian

James Hall

Bibbe Hansen

Ann Harris

Eloise Harris

Jayne Anne Harris

Mary Lou Harris

Walter Michael Harris

Debbie Harry

Fayette Hauser

Robert Heide

Richard Hell

Kristian Hoffman

William M. Hoffman

John Holmstrom
Pat Ivers
Patricia Jaffe
Nick Johnson
Chris Kapp
Lenny Kaye
Larry Kornfeld
Paul Krassner
Peter Kuttner
Gary Lachman
Jimi LaLumia
Melba LaRose
Mickey Leigh
Craig Leon
Pat Loud
Agosto Machado
Ann Magnuson
Norman Marshall
Michael McGrinder
Jonas Mekas
Thurston Moore
Yoko Ono
Robert Patrick
Sandy Pearlman
Anton Perich
Lisa Jane Persky
Amos Poe
Don Price
Benton Quin

Mary Curtis Ratcliff
Lou Reed
Ruby Lynn Reyner
Will Rigby
Lendon Sadler
Ed Sanders
Paul Serrato
Robert Shields
Michael Smith
Patti Smith
Peter Stampfel
Chris Stein
F. Story Talbot
Pam Tent
Lily Tomlin
Tracy Tynan
John Vaccaro
Steina Vasulka
Woody Vasulka
Alan Vega
Viva
Jane Wagner
John Waters
Joshua White
Jane Wilson
Mary Woronov
Tony Zanetta
Nestor Zarragoitia
Paul Zone

WORKS CITED AND CONSULTED

Albrecht, Donald. 2016. *Gay Gotham: Art and Underground Culture in New York*. New York: Rizzoli.

Ambrose, Joseph G. 2007. *Chelsea Hotel Manhattan*. London: Headpress.

Ammann, Judith. 1987. *Who's Been Sleeping in My Brain?* Frankfurt am Main: Suhrkamp.

Angell, Callie. 2006. *Andy Warhol Screen Tests: The Films of Andy Warhol*. New York: Abrams.

Aronson, Arnold. 2000. *American Avant-Garde Theatre: A History*. New York: Routledge.

Artaud, Antonin. 1958. *The Theater and Its Double*. New York: Grove Weidenfeld.

Astor, Peter. 2014. *Blank Generation*. New York: Bloomsbury.

Auslander, Philip. 2006. *Performing Glam Rock: Gender and Theatricality in Popular Music*. Ann Arbor, MI: University of Michigan Press.

Austen, Jake, ed. 2011. *Flying Saucers Rock 'n' Roll: Conversations with Unjustly Obscure Rock 'n' Soul Eccentrics. Refiguring American Music*. Durham, NC: Duke University Press.

Baker, Roger, and Peter Burton. 1994. *Drag: A History of Female Impersonation in the Performing Arts*. New York: New York University Press.

Banes, Sally. 1983. *Democracy's Body: Judson Dance Theater, 1962–1964. Studies in the Fine Arts*. Ann Arbor: UMI Research Press.

Banes, Sally. 1993. *Greenwich Village 1963: Avant-Garde Performance and the Effervescent Body*. Durham, NC: Duke University Press.

Bangs, Lester. 1980. *Blondie*. New York: Simon & Schuster.

Bar-Lev, Amir. 2017. "Act I: It's Alive." Documentary. *Long Strange Trip*.

Baraka, Amiri. 1997. *The Autobiography of LeRoi Jones*. Chicago: Lawrence Hill Books.

Barnes, Clive. 1968. "Hair: It's Fresh and Frank Likable Rock Musical Moves to Broadway," *New York Times*, April 30, 40.

Bayley, Roberta. 1997. *Blank Generation Revisited: The Early Days of Punk Rock*. New York: Schirmer Books.

Bayley, Roberta. 2007. *Blondie: Unseen, 1976–1980*. London: Plexus.

Beeber, Steven Lee. 2006. *The Heebie Jeebies at CBGB's: A Secret History of Jewish Punk*. Chicago: Chicago Review Press.

Bernard, Kenneth. 1971. *Night Club and Other Plays*. New York: Winter House.

Bessman, Jim. 1993. *Ramones: An American Band*. New York: St. Martin's Press.

Blake, Mark, ed. 2006. *Punk: The Whole Story*. New York: Dorling Kindersley.

Bockris, Victor. 1998. *NYC Babylon: Beat Punks: Notes, Raps, Essays, Secrets, Transcripts, Opinions (Wise and Otherwise), and Pictures of a Gone World and of How the Punk Generation Typhooned Its Way Back through and Harpooned the Beat Generation in Harmonic Collaboration*. New York: Omnibus.

Bockris, Victor. 1999. *Patti Smith: An Unauthorized Biography*. New York: Simon & Schuster.

Bockris, Victor. 2003. *Warhol: The Biography*. New York: Da Capo Press.

Bockris, Victor, and Gerard Malanga. 1983. *Up-Tight: The Velvet Underground Story*. New York: Omnibus Press.

Bodenheim, Maxwell. 1961. *My Life and Loves in Greenwich Village*. New York: Belmont Productions.

Bottoms, Stephen James. 2006. *Playing Underground: A Critical History of the 1960s Off-Off-Broadway Movement*. Ann Arbor: University of Michigan Press.

Bowman, David. 2001. *This Must Be the Place: The Adventures of Talking Heads in the 20th Century*. New York: Harper Entertainment.

Boyle, Deirdre. 1997. *Subject to Change: Guerrilla Television Revisited*. New York: Oxford University Press.

Brazis, Tamar, Hilly Kristal, and David Byrne, eds. 2005. *CBGB & OMFUG: Thirty Years from the Home of Underground Rock*. New York: Abrams.

Brecht, Stefan. 1986. *Queer Theatre: The Original Theatre of the City of New York, from the Mid-60s to the Mid-70s*. New York: Methuen.

Broyard, Anatole. 1993. *Kafka Was the Rage: A Greenwich Village Memoir*. New York: C. Southern Books.

Cagle, Van M. 1995. *Reconstructing Pop/Subculture: Art, Rock, and Andy Warhol*. Thousand Oaks, CA: Sage.

Cain, Nancy. 2011. *Video Days: How Street Video Went from a Deep Underground Phenom to a Zillion-Dollar Business*. Palm Springs, CA: Event Horizon Press.

Calhoun, Ada. 2016. *St. Marks Is Dead: The Many Lives of America's Hippest Street*. New York: W. W. Norton.

Camicia, J. 2013. *My Dear, Sweet Self: A Hot Peach Life*. Silverton, OR: Fast Books.

Carver, Lisa. 2012. *Reaching Out with No Hands: Reconsidering Yoko Ono*. Montclair, NJ: Backbeat Books.

Che, Cathay. 2000. *Deborah Harry*. New York: Fromm International.

Cherry Vanilla. 2010. *Lick Me: How I Became Cherry Vanilla*. Chicago: Chicago Review Press.

Christgau, Robert. 2015. *Going into the City: Portrait of a Critic as a Young Man*. New York: Dey Street Books.

Clayson, Alan, Barb Jungr, and Robb Johnson. 2004. *Woman: The Incredible Life of Yoko Ono*. New Malden: Chrome Dreams.

Colegrave, Stephen, and Chris Sullivan. 2001. *Punk*. New York: Thunder's Mouth Press.

Cooper, Kim, and David Smay. 2001. *Bubblegum Music Is the Naked Truth*. Los Angeles: Feral House.

County, Jayne, and Rupert Smith. 1995. *Man Enough to Be a Woman*. New York: Serpent's Tail.

Crespy, David Allison. 2003. *Off-Off-Broadway Explosion: How Provocative Playwrights of the 1960s Ignited a New American Theater*. New York: Back Stage Books.

Davis, Deborah. 2015. *The Trip: Andy Warhol's Plastic Fantastic Cross-Country Adventure*. New York: Atria Books.

DeCurtis, Anthony. 2017. *Lou Reed: A Life*. New York: Little, Brown and Company.

DeRogatis, Jim, and Bill Bentley. 2009. *The Velvet Underground: An Illustrated History of a Walk on the Wild Side*. Minneapolis: Voyageur Press.

di Prima, Diane. 2001. *Recollections of My Life as a Woman: The New York Years*. New York: Viking.

Doggett, Peter. 2012. *The Man Who Sold the World: David Bowie and the 1970s*. New York: Harper.

Dominic, Magie, and Michael Smith. 2010. *H. M. Koutoukas, 1937–2010, Remembered by His Friends*. Silverton, OR: Fast Books.

Susan Douglas. 1995. *Where the Girls Are: Growing Up Female with the Mass Media*. New York: Three Rivers Press.

Duberman, Martin. 1994. *Stonewall*. New York: Plume.

Dundy, Elaine. 2001. *Life Itself!* London: Virago Press.

Dylan, Bob. 2007. *Chronicles. Vol. 1.* New York: Simon & Schuster.

Edwards, Henry, and Tony Zanetta. 1986. *Stardust: The David Bowie Story.* New York: McGraw-Hill.

Esslin, Martin. 2004. *The Theatre of the Absurd.* New York: Vintage Books.

Evans, Mike. 2003. *N.Y.C. Rock.* London: Sanctuary.

Eyen, Tom, and Michael Feingold. 1971. *Ten Plays.* New York: Samuel French.

Fahs, Breanne. 2014. *Valerie Solanas: A Life of Scum (Or, Why She Shot Andy Warhol and Other Chit Chat).* New York: Feminist Press.

Fensterstock, Ann. 2013. *Art on the Block: Tracking the New York Art World from Soho to the Bowery, Bushwick and Beyond.* New York: Palgrave Macmillan.

Fields, Danny. *My Ramones.* London: Self-published.

Fletcher, Tony. 2009. *All Hopped Up and Ready to Go: Music from the Streets of New York, 1927–1977.* New York: W. W. Norton.

Flint, Anthony. 2011. *Wrestling with Moses: How Jane Jacobs Took On New York's Master Builder and Transformed the American City.* New York: Random House.

Foster, Paul. 1971. *"Balls" and Other Plays: The Recluse, Hurrah for the Bridge, the Hessian Corporal.* London: Calder and Boyars.

Gann, Kyle. 2006. *Music Downtown: Writings from the Village Voice.* Berkeley: University of California Press.

Garr, Gillian G. 1993. *She's a Rebel: The History of Women in Rock and Roll.* Berkeley, CA: Seal Press.

Gendron, Bernard. 2002. *Between Montmartre and the Mudd Club: Popular Music and the Avant-Garde.* Chicago: University of Chicago Press.

Gholson, Craig. 1976. "Blondie's Roots," *New York Rocker*, May 1976, 10–12. http://www.rip -her-to-shreds.com/archive_ press_magazines_nyrockermay76.php.

Glass, Loren. 2013. *Counterculture Colophon: Grove Press, the Evergreen Review, and the Incorporation of the Avant-Garde.* Stanford, CA: Stanford University Press.

Glass, Philip. 2016. *Words without Music: A Memoir.* New York: Liveright.

Glimcher, Mildred, and Robert R. McElroy. 2012. *Happenings: New York, 1958–1963.* New York: Monacelli Press.

Goldberg, Kim. 1990. *The Barefoot Channel: Community Television as a Tool for Social Change.* Vancouver: New Star Books.

Goldstein, Richard. 2015. *Another Little Piece of My Heart: My Life of Rock and Revolution in the '60s.* New York: Bloomsbury.

Gooch, Brad. 1993. *City Poet: The Life and Times of Frank O'Hara.* New York: Knopf.

Goulart, Ron. 1973. *An American Family.* New York: Warner Paperback Library.

Gratz, Roberta Brandes. 2010. *The Battle for Gotham: New York in the Shadow of Robert Moses and Jane Jacobs.* New York: Nation Books.

Gress, Elsa. 1968. *Boxiganga: Teater Som Livsform.* Copenhagen: Spectator.

Grode, Eric, Gerome Ragni, and James Rado. 2010. *Hair: The Story of the Show That Defined a Generation.* Philadelphia: Running Press.

Grossman, Ron. 2014. "Fatal Black Panther Raid in Chicago Set Off Sizable Aftershocks," *Chicago Tribune*, December 4. http://www.chicagotribune.com/news/history/ct-black-panther-raid-flashback-1207-20141206-story.html.

Gruen, Bob, David Johansen, and Sylvain Sylvain. 2008. *New York Dolls: Photographs.* New York: Abrams Image.

Gussow, Mel, and Bruce Weber. 2011. "Ellen Stewart, Off-Off-Broadway Pioneer, Dies at 91." *New York Times*, January 13. http://www.nytimes.com/2011/01/14/theater/ 14stewart.html.

Hajdu, David. 2001. *Positively 4th Street: The Lives and Times of Joan Baez, Bob Dylan, Mimi Baez Fariña, and Richard Fariña*. New York: North Point.

Halleck, DeeDee. 2002. *Hand-Held Visions: The Impossible Possibilities of Community Media*. New York: Fordham University Press.

Hamilton, Ed. 2007. *Legends of the Chelsea Hotel: Living with the Artists and Outlaws of New York's Rebel Mecca*. New York: Thunder's Mouth Press.

Hansen, Al. 1965. *A Primer of Happenings and Time/Space Art*. New York: Something Else Press.

Harding, James Martin, and Cindy Rosenthal, eds. 2007. *Restaging the Sixties: Radical Theaters and Their Legacies*. Ann Arbor: University of Michigan Press.

Harrell, G. T. 2010. *For Member's Only: The Story of the Mob's Secret Judge*. Bloomington, IN: AuthorHouse.

Harris, Ann, Walter Michael Harris, Jayne Anne Harris-Kelley, Eloise Harris-Damone, and Mary Lou Harris-Pietsch. 2014. *Caravan to Oz: A Family Reinvents Itself Off-Off-Broadway*. New York: El Dorado Books.

Harris, Mary Lou, Jayne Anne Harris, and Eloise Harris. 2017. *Flower Power Man*. New York: El Dorado Books.

Harry, Debbie, Chris Stein, and Victor Bockris. 1982. *Making Tracks: The Rise of Blondie*. New York: Dell.

Harvard, Joe. 2004. *The Velvet Underground and Nico*. New York: Continuum.

Hebdige, Dick, 1979. *Subculture: The Meaning of Style*. New York: Routledge.

Hell, Richard. 2014. *I Dreamed I Was a Very Clean Tramp: An Autobiography*. New York: Ecco.

Hell, Richard. 2015. *Massive Pissed Love: Nonfiction 2001–2014*. Berkeley, CA: Soft Skull Press.

Hermes, Will. 2012. *Love Goes to Buildings on Fire: Five Years in New York That Changed Music Forever*. New York: Farrar, Straus & Giroux.

Heylin, Clinton. 1993. *From the Velvets to the Voidoids: A Pre-Punk History for a Post-Punk World*. New York: Penguin Books.

Highberger, Craig B. 2005. *Superstar in a Housedress: The Life and Legend of Jackie Curtis*. New York: Chamberlain Bros.

Hoberman, J., and Jonathan Rosenbaum. 1991. *Midnight Movies*. New York: Da Capo Press.

Hoffman, Abbie, Izak Haber, and Bert Cohen. 1995. *Steal This Book*. New York: Four Walls Eight Windows.

Holmstrom, John, and Bridget Hurd, eds. 2012. *Punk: The Best of Punk Magazine*. New York: HarperCollins.

Hopkins, Jerry. 1986. *Yoko Ono*. New York: Macmillan.

Horn, Barbara Lee. 1993. *Ellen Stewart and La MaMa: A Bio-Bibliography*. Westport, CT: Greenwood Press.

Ingall, Andrew, and Daniel Belasco. 2015. *Videofreex: The Art of Guerrilla Television*. New York: Samuel Dorsky Museum of Art.

Ives, John G., and John Waters. 1992. *John Waters*. New York : Emeryville, CA: Thunder's Mouth Press.

Jacobs, Jane. 2011. *The Death and Life of Great American Cities. 50th anniversary ed*. New York: Modern Library.

Jay, Bernard. 1993. *Not Simply Divine: Beneath the Make-Up, above the Heels, and behind the Scenes with a Cult Superstar*. New York: Simon & Schuster.

Johnson, Nicholas. 1970. *How to Talk Back to Your Television Set*. Boston: Little, Brown.

Johnstone, Nick. 2005. *Yoko Ono "Talking": Yoko Ono in Her Own Words*. London: Omnibus.

Johnstone, Nick. 2012. *Patti Smith: A Biography*. London: Omnibus.

Joseph, Branden Wayne. 2011. *Beyond the Dream Syndicate: Tony Conrad and the Arts after Cage*. New York: Zone Books.

Kane, Arthur. 2009. *I, Doll: Life and Death with the New York Dolls.* Chicago: Chicago Review Press.

Kane, Daniel. 2003. *All Poets Welcome: The Lower East Side Poetry Scene in the 1960s.* Berkeley: University of California Press.

Kane, Daniel. 2017. *"Do You Have a Band?": Poetry and Punk Rock in New York City.* New York: Columbia University Press.

Kaufman, David. 2002. *Ridiculous!: The Theatrical Life and Times of Charles Ludlam.* New York: Applause Theatre & Cinema Books.

Killen, Andreas. 2006. *1973 Nervous Breakdown: Watergate, Warhol, and the Birth of Post-Sixties America.* New York: Bloomsbury.

Kirby, Michael. 1965. *Happenings.* New York: E. P. Dutton.

Koestenbaum, Wayne. 2001. *Andy Warhol.* New York: Viking.

Koutoukas, H. M. 1991. *When Lightning Strikes Twice.* New York: Samuel French.

Kozak, Roman. 1988. *This Ain't No Disco: The Story of CBGB.* Boston: Faber & Faber.

Krassner, Paul. 1993. *Confessions of a Raving, Unconfined Nut: Misadventures in the Counter-Culture.* New York: Simon & Schuster.

Kroll, Jack. 1969. "Ridiculous!" *Newsweek,* November 3.

Lahr, John, and Jonathan Price, eds. 1974. *The Great American Life Show: Nine Plays from the Avant-Garde Theater.* New York: Bantam Books.

Lawrence, Tim. 2009. *Hold On to Your Dreams: Arthur Russell and the Downtown Music Scene, 1973–1992.* Durham, NC: Duke University Press.

Leigh, Mickey, and Legs McNeil. 2009. *I Slept with Joey Ramone: A Punk Rock Family Memoir.* New York: Simon & Schuster.

Leland, John. 2015. "The Prosecution Resets in a 1964 Obscenity Case." October 30, *New York Times.* https://www.nytimes.com/2015/11/01/nyregion/the-prosecution-resets-in-a-1964-obscenity-case.html.

Levy, Aidan. 2016. *Dirty Blvd.: The Life and Music of Lou Reed.* Chicago: Chicago Review Press.

Lewallen, Constance, Steve Seid, and Chip Lord. 2004. *Ant Farm, 1968–1978.* Berkeley: University of California Press.

Light, Alan. "David Johansen: The MOJO Interview," *MOJO,* March 2015, 39–43, 40.

Loud, Pat, and Nora Johnson. 1974. *Pat Loud: A Woman's Story.* New York: Coward, McCann & Geoghegan.

Loud, Pat, and Christopher Makos. 2012. *Lance Out Loud.* New York: Glitterati.

McDonough, Jimmy. 2001. *The Ghastly One: The Sex-Gore Netherworld of Filmmaker Andy Milligan.* Chicago: A Cappella.

McGrath, Garrett. 2013. "The Theater Came Crashing Down," *Narratively,* September 5: http://narrative.ly/stories/the-theater-came-crashing-down.

McLeod, Kembrew. 2016. *Parallel Lines.* New York: Bloomsbury.

McMillian, John Campbell. 2011. *Smoking Typewriters: The Sixties Underground Press and the Rise of Alternative Media in America.* New York: Oxford University Press.

McNeil, Legs, and Gillian McCain, eds. 1996. *Please Kill Me: The Uncensored Oral History of Punk.* New York: Grove Press.

Mekas, Jonas. 2015. *Scrapbook of the Sixties: Writings 1954–2010.* Edited by Anne König. Leipzig: Spector Books.

Miles, Barry. 2012. *In the Seventies: Adventures in the Counterculture.* London: Serpent's Tail.

Moody, Howard. 2009. *A Voice in the Village: A Journey of a Pastor and a People.* New York: Xlibris.

Munroe, Alexandra, with Jon Hendricks. 2000. *Yes Yoko Ono.* New York: Japan Society.

Murphy, J. J. 2012. *The Black Hole of the Camera: The Films of Andy Warhol.* Berkeley: University of California Press.

Name, Billy, John Cale, Glenn O'Brien, Dagon James, and Anastasia Rygle. 2014. *Billy Name: The Silver Age: Black & White Photographs from Andy Warhol's Factory*. London: Reel Art Press.

Needs, Kris, and Dick Porter. 2006. *Trash!: The Complete New York Dolls*. London: Plexus.

"New Wave Queens." 2016. *RuPaul's Drag Race*.

Newton, Esther. 1979. *Mother Camp: Female Impersonators in America*. Chicago: University of Chicago Press.

Nobakht, David. 2005. *Suicide: No Compromise*. London: SAF.

O'Leary, Chris. 2015. *Rebel Rebel*. Winchester, UK: Zero Books.

Olsen, Christopher. 2011. *Off-Off Broadway: The Second Wave, 1968–1980*. CreateSpace Independent Publishing Platform.

Ono, Yoko. 2000. *Grapefruit: A Book of Instruction and Drawings by Yoko Ono*. New York: Simon & Schuster.

Orzel, Nick, and Michael Smith, eds. 1966. *Eight Plays from Off-Off Broadway*. New York: Bobbs-Merrill.

Padilha, Roger, and Mauricio Padilha. 2009. *The Stephen Sprouse Book*. New York: Rizzoli.

Patrick, Robert. 1994. *Temple Slave*. New York: Masquerade Books.

Patrick, Robert, and Michael Feingold. 1972. *Robert Patrick's Cheep Theatricks!* New York: Samuel French.

Piekut, Benjamin. 2011. *Experimentalism Otherwise: The New York Avant-Garde and Its Limits*. Berkeley: University of California Press.

Poland, Albert, and Bruce Mailman. 1972. *The Off-Off-Broadway Book: The Plays, People, Theatre*. Indianapolis: Bobbs-Merrill.

Porter, Dick, and Kris Needs. 2012. *Parallel Lives*. New York: Omnibus.

Powers, Devon. 2013. *Writing the Record: The Village Voice and the Birth of Rock Criticism*. Amherst: University of Massachusetts Press.

Rabinovitz, Lauren. 2003. *Points of Resistance: Women, Power & Politics in the New York Avant-Garde Cinema, 1943–1971*. Urbana: University of Illinois Press.

Ramone, Dee Dee, and Veronica Kaufman. 2000. *Lobotomy: Surviving the Ramones*. New York: Thunder's Mouth Press.

Ramone, Marky, and Rich Herschlag. 2015. *Punk Rock Blitzkrieg: My Life as a Ramone*. New York: Touchstone.

Reed, Lou. 1991. *Between Thought and Expression: Selected Lyrics of Lou Reed*. New York: Hyperion.

Reeves, Richard. 1994. *President Kennedy: Profile of Power*. New York: Touchstone.

Robert J. Schroeder, ed. 1968. *The New Underground Theatre*. New York: Bantam Books.

Robinson, Lisa. 2014. *There Goes Gravity: A Life in Rock and Roll*. New York: Riverhead Books.

Rodenbeck, Judith F. 2011. *Radical Prototypes: Allan Kaprow and the Invention of Happenings*. Cambridge, MA: MIT Press.

Roszak, Theodore. 1969. *The Making of a Counterculture*. New York: Anchor.

Ruoff, Jeffrey. 2002. *An American Family: A Televised Life*. Minneapolis: University of Minnesota Press.

Russell, Donn. 1996. *Avant-Guardian: 1965–1990*. Pittsburgh: Dorrance.

Sanders, Ed. 1970. *Shards of God*. New York: Grove Press.

Sanders, Ed. 2011. *Fug You: An Informal History of the Peace Eye Bookstore, the Fuck You Press, the Fugs, and Counterculture in the Lower East Side*. Cambridge, MA: Da Capo Press.

Sante, Luc. 2003. *Low Life: Lures and Snares of Old New York*. New York: Farrar, Straus & Giroux.

Scherman, Tony, Andy Warhol, and David Dalton. 2009. *Pop: The Genius of Andy Warhol*. New York: HarperCollins.

"Sculpture. Master of the Monumentalists." 1967. *Time*, October 13.

Sewall-Ruskin, Yvonne. 1998. *High on Rebellion: Inside the Underground at Max's Kansas City*. New York: Thunder's Mouth Press.

Shamberg, Michael. 1973. *Guerrilla Television*. New York: Holt, Rinehart, & Winston.

Shaw, Philip. 2008. *Horses*. New York: Continuum.

Shaw, Suzy, Mick Farren, and Greg Shaw. 2007. *Bomp!: Saving the World One Record at a Time*. Los Angeles: AMMO.

Sheffield, Rob. 2016. *On Bowie*. New York: Dey Street Books.

Shepard, Sam. 2006. *Fool for Love and Other Plays*. New York: Dial Press.

Shewey, Don. 1997. *Sam Shepard*. New York: Da Capo Press.

Shkuda, Aaron. 2016. *The Lofts of SoHo: Gentrification, Art, and Industry in New York, 1950–1980*. Chicago: University of Chicago Press.

Simmons, Sylvie. 2013. *I'm Your Man: The Life of Leonard Cohen*. New York: Ecco.

Smith, Michael. 1969. "Theatre: Cock Strong." *The Village Voice*, June 26.

Smith, Michael. 1967. "Theatre Journal." *The Village Voice*, November 30.

Smith, Michael. 1969. *Theatre Trip*. Indianapolis: Bobbs-Merrill.

Smith, Michael, ed. 1972. *More Plays from Off-Off-Broadway*. Indianapolis: Bobbs-Merrill.

Smith, Michael. 2011. *Johnny!* Silverton, OR: Fast Books.

Smith, Neil. 1996. *The New Urban Frontier: Gentrification and the Revanchist City*. New York: Routledge.

Smith, Patti. 1995. *Early Work: 1970–1979*. New York: Norton.

Smith, Patti. 2006. *Patti Smith Complete, 1975–2006: Lyrics, Reflections, and Notes for the Future*. New York: Ecco.

Smith, Patti. 2010. *Just Kids*. New York: Ecco.

Snetiker, Marc. 2017. "From Drags to Riches." *Entertainment Weekly*, June 23.

Sontag, Susan. 1964. "A Feast for the Eyes." *The Nation*, April 13, 1964.

Sontag, Susan. 2001. *Against Interpretation and Other Essays*. New York: Picador.

Stansell, Christine. 2001. *American Moderns: Bohemian New York and the Creation of a New Century*. New York: Holt.

Stein, Chris. 2014. *Chris Stein/Negative: Me, Blondie, and the Advent of Punk*. New York: Rizzoli.

Stein, Jean, and George Plimpton. 1994. *Edie: American Girl*. New York: Grove Press.

Stone, Wendell C. 2005. *Caffe Cino: The Birthplace of Off-Off-Broadway*. Carbondale: Southern Illinois University Press.

Stosuy, Brandon, ed. 2006. *Up Is Up, but So Is Down: New York's Downtown Literary Scene, 1974–1992*. New York: New York University Press.

Suárez, Juan Antonio. 1996. *Bike Boys, Drag Queens, and Superstars: Avant-Garde, Mass Culture, and Gay Identities in the 1960s Underground Cinema*. Bloomington: Indiana University Press.

Sullivan, Dan. 1967. " 'Supreme Comedy' of the End Opens." *New York Times*, November 28, 76.

Susoyev, Steve, and George Birimisa. 2007. *Return to the Caffe Cino*. San Francisco: Moving Finger Press.

Tavel, Ronald. 2015. *Andy Warhol's Ridiculous Screenplays*. Silverton, OR: Fast Books.

Teasdale, Parry D. 1999. *Videofreex: America's First Pirate TV Station and the Catskills Collective That Turned It On*. Hensonville, NY: Black Dome Press.

Tent, Pam. 2004. *Midnight at the Palace: My Life as a Fabulous Cockette*. Los Angeles: Alyson Books.

Thompson, Dave. 1989. *Beyond the Velvet Underground*. New York: Omnibus.

Thompson, Dave. 2011. *Dancing Barefoot: The Patti Smith Story*. Chicago: Chicago Review Press.

Thompson, Mark. 1987. *Gay Spirit: Myth and Meaning*. New York: White Crane Books.

Tippins, Sherill. 2013. *Inside the Dream Palace: The Life and Times of New York's Legendary Chelsea Hotel*. New York: Houghton Mifflin Harcourt.

True, Everett. 2002. *Hey Ho Let's Go: The Story of The Ramones*. London: Omnibus.

Trynka, Paul. 2011. *David Bowie: Starman*. New York: Little, Brown.

Turner, Fred. 2013. *The Democratic Surround: Multimedia and American Liberalism from World War II to the Psychedelic Sixties*. Chicago: University of Chicago Press.

Tyler, Parker. 1969. *Underground Film: A Critical History*. New York: Grove Press.

Tytell, John. 1995. *The Living Theatre: Art, Exile, and Outrage*. New York: Grove Press.

Ultra Violet. 1988. *Famous for 15 Minutes: My Years with Andy Warhol*. San Diego: Harcourt Brace Jovanovich.

Unterberger, Richie. 2009. *White Light/White Heat: The Velvet Underground Day-by-Day*. London: Jawbone Press.

Valentine, Gary. 2006. *New York Rocker: My Life in the Blank Generation, with Blondie, Iggy Pop, and Others, 1974–1981*. New York: Thunder's Mouth Press.

Van Ronk, Dave, and Elijah Wald. 2005. *The Mayor of MacDougal Street: A Memoir*. Cambridge, MA: Da Capo Press.

Ventura, Susana. 2009. *Bad Reputation: Performances, Essays, Interviews*. Cambridge, MA: Semiotext(e), MIT Press.

Wade, Leslie A. 1997. *Sam Shepard and the American Theatre*. Westport, CT: Greenwood Press.

Wanzer-Serrano, Darrel. 2016. *The New York Young Lords and the Struggle for Liberation*. Philadelphia: Temple University Press.

Warhol, Andy. 2006. *The Philosophy of Andy Warhol: From A to B and Back Again*. Orlando: Harcourt.

Warhol, Andy, and Pat Hackett. 2006. *POPism: The Warhol Sixties*. Orlando: Harcourt.

Waters, John. 1995. *Shock Value*. New York: Thunder's Mouth Press.

Watson, Steven. 2003. *Factory Made: Warhol and the Sixties*. New York: Pantheon Books.

Wetzsteon, Ross. 2002. *Republic of Dreams: Greenwich Village, the American Bohemia, 1910–1960*. New York: Simon & Schuster.

White, Edmund. 2009. *City Boy: My Life in New York during the 1960s and '70s*. New York: Bloomsbury.

William M. Hoffman, ed. 1968. *New American Plays. Vol. 2*. New York: Hill & Wang.

Witts, Richard. 2006. *The Velvet Underground: Icons of Pop Music*. Bloomington: Indiana University Press.

Wolf, Reva. 1997. *Andy Warhol, Poetry, and Gossip in the 1960s*. Chicago: University of Chicago Press.

Woodlawn, Holly, and Jeffrey Copeland. 1991. *A Low Life in High Heels: The Holly Woodlawn Story*. New York: St. Martin's Press.

Woronov, Mary. 1995. *Swimming Underground: My Years in the Warhol Factory*. Boston: Journey Editions.

Zone, Paul, and Jake Austen. 2014. *Playground: Growing up in the New York Underground*. Los Angeles: Glitterati.

Zak, Alban. 1997. *The Velvet Underground Companion: Four Decades of Commentary*. New York: Schirmer Books.

Zukin, Sharon. 2011. *Naked City: The Death and Life of Authentic Urban Places*. Oxford: Oxford University Press.

Zukin, Sharon. 2014. *Loft Living: Culture and Capital in Urban Change*. New Brunswick, NJ: Rutgers University Press.

NOTES

Introduction

1. Sharon Zukin, *Naked City: The Death and Life of Authentic Urban Places* (Oxford: Oxford University Press, 2011), 223.
2. Barry Miles, *In the Seventies: Adventures in Counterculture* (London: Serpent's Tail, 2012), 61.

Chapter 1

1. Stephen James Bottoms, *Playing Underground: A Critical History of the 1960s Off-Off-Broadway Movement* (Ann Arbor: University of Michigan Press, 2006), 60.
2. Ed Sanders, *Fug You: An Informal History of the Peace Eye Bookstore, the Fuck You Press, the Fugs, and Counterculture in the Lower East Side* (Cambridge, MA: Da Capo Press, 2011), 10.

Chapter 2

1. Elaine Dundy, *Life Itself!* (London: Virago Press, 2001), 40.
2. Richard Witts, *The Velvet Underground: Icons of Pop Music* (Bloomington: Indiana University Press, 2006), 102.
3. Judith F. Rodenbeck, *Radical Prototypes: Allan Kaprow and the Invention of Happenings* (Cambridge, MA: MIT Press, 2011), 123.
4. Ed Sanders, *Fug You: An Informal History of the Peace Eye Bookstore, the Fuck You Press, the Fugs, and Counterculture in the Lower East Side* (Cambridge, MA: Da Capo Press, 2011), 51.
5. Dundy, *Life Itself!*, 239.
6. Ibid.
7. Ibid.
8. Howard Moody, *A Voice in the Village: A Journey of a Pastor and a People* (New York: Xlibris, 2009), 249.
9. Dundy, *Life Itself!*, 240.
10. Ibid., 242.
11. Lauren Rabinovitz, *Points of Resistance: Women, Power & Politics in the New York Avant-Garde Cinema, 1943–1971* (Urbana: University of Illinois Press, 2003), 123.
12. Sally Banes, *Greenwich Village 1963: Avant-Garde Performance and the Effervescent Body* (Durham, NC: Duke University Press, 1993), 154.
13. Amiri Baraka, *The Autobiography of LeRoi Jones* (Chicago: Lawrence Hill Books, 1997), 184.

Chapter 3

1. Steven Watson, *Factory Made: Warhol and the Sixties* (New York: Pantheon Books, 2003), 25.

2. Sally Banes, *Greenwich Village 1963: Avant-Garde Performance and the Effervescent Body* (Durham, NC: Duke University Press, 1993), 119.
3. Ed Sanders, *Fug You: An Informal History of the Peace Eye Bookstore, the Fuck You Press, the Fugs, and Counterculture in the Lower East Side* (Cambridge, MA: Da Capo Press, 2011), 23.
4. Watson, *Factory Made*, 119.
5. Van M. Cagle, *Reconstructing Pop/Subculture: Art, Rock, and Andy Warhol* (Thousand Oaks, CA: Sage, 1995), 67.
6. Judith F. Rodenbeck, *Radical Prototypes: Allan Kaprow and the Invention of Happenings* (Cambridge, MA: MIT Press, 2011), 99.
7. Andreas Killen, *1973 Nervous Breakdown: Watergate, Warhol, and the Birth of Post-Sixties America* (New York: Bloomsbury, 2006), 148.

Chapter 4

1. Andreas Killen, *1973 Nervous Breakdown: Watergate, Warhol, and the Birth of Post-Sixties America* (New York: Bloomsbury, 2006), 148.
2. Steven Watson, *Factory Made: Warhol and the Sixties* (New York: Pantheon Books, 2003), 212.
3. Philip Shaw, *Horses* (New York: Continuum, 2008), 45–46.
4. Dave Van Ronk and Elijah Wald, *The Mayor of MacDougal Street: A Memoir* (Cambridge, MA: Da Capo Press, 2005), 146.
5. Ibid., 47.
6. Howard Moody, *A Voice in the Village: A Journey of a Pastor and a People* (New York: Xlibris, 2009), 209.
7. Victor Bockris and Gerard Malanga, *Up-Tight: The Velvet Underground Story* (New York: Omnibus Press, 1983), 17.
8. Ed Sanders, *Fug You: An Informal History of the Peace Eye Bookstore, the Fuck You Press, the Fugs, and Counterculture in the Lower East Side* (Cambridge, MA: Da Capo Press, 2011), 68.

Chapter 5

1. Ed Sanders, *Fug You: An Informal History of the Peace Eye Bookstore, the Fuck You Press, the Fugs, and Counterculture in the Lower East Side* (Cambridge, MA: Da Capo Press, 2011), xiii.
2. Ibid., 46.
3. Ibid., 69.
4. Reva Wolf, *Andy Warhol, Poetry, and Gossip in the 1960s* (Chicago: University of Chicago Press, 1997), 38.
5. Ibid., 35.
6. Sanders, *Fug You*, 37.
7. Ibid., 128.
8. Ibid., 136.
9. Ibid., 129.
10. Don Shewey, *Sam Shepard* (New York: Da Capo Press, 1997), 35.
11. Devon Powers, *Writing the Record: The Village Voice and the Birth of Rock Criticism* (Amherst: University of Massachusetts Press, 2013), 36.
12. Paul Krassner, *Confessions of a Raving, Unconfined Nut: Misadventures in the Counter-Culture* (New York: Simon & Schuster, 1993), 46; John Campbell McMillian, *Smoking Typewriters: The Sixties Underground Press and the Rise of Alternative Media in America* (New York: Oxford University Press, 2011), 33–36, 99.
13. McMillian, *Smoking Typewriters*, 80.

Chapter 6

1. Barbara Lee Horn, *Ellen Stewart and La MaMa: A Bio-Bibliography* (Westport, CT: Greenwood Press, 1993), xv.
2. Ibid., 12.
3. Ibid., 12.
4. Ibid., 13.
5. Ibid., 14.
6. Ibid., 14.
7. Ibid., 16–17.
8. Ibid., 14–15.
9. Ed Sanders, *Fug You: An Informal History of the Peace Eye Bookstore, the Fuck You Press, the Fugs, and Counterculture in the Lower East Side* (Cambridge, MA: Da Capo Press, 2011), 99–100.

Chapter 7

1. Ann Harris et al., *Caravan to Oz: A Family Reinvents Itself Off-Off-Broadway* (New York: El Dorado Books, 2004), 29.
2. Darrel Wanzer-Serrano, *The New York Young Lords and the Struggle for Liberation* (Philadelphia: Temple University Press, 2016), 50.

Chapter 8

1. Anthony Flint, *Wrestling with Moses: How Jane Jacobs Took On New York's Master Builder and Transformed the American City* (New York: Random House, 2011), 62.
2. Ibid., 85.
3. Ibid., 86–87.
4. Sharon Zukin, *Naked City: The Death and Life of Authentic Urban Places* (Oxford: Oxford University Press, 2011), 12–13.
5. Flint, *Wrestling with Moses*, 90, 121.
6. Ibid., 110.
7. Aaron Shkuda, *The Lofts of SoHo: Gentrification, Art, and Industry in New York, 1950–1980* (Chicago: University of Chicago Press, 2016), 49, 123.
8. Flint, *Wrestling with Moses*, 177.
9. Sharon Zukin, *Loft Living: Culture and Capital in Urban Change* (New Brunswick, NJ: Rutgers University Press, 2014), 91.
10. Ann Fensterstock, *Art on the Block: Tracking the New York Art World from Soho to the Bowery, Bushwick and Beyond* (New York: Palgrave Macmillan, 2013), 31.
11. Nick Johnstone, *Yoko Ono "Talking": Yoko Ono in Her Own Words* (London: Omnibus, 2005), 24.
12. Lisa Carver, *Reaching Out with No Hands: Reconsidering Yoko Ono* (Montclair, NJ: Backbeat Books, 2012), 9.
13. Johnstone, *Yoko Ono "Talking,"* 20.
14. Zukin, *Loft Living*, 95.
15. Shkuda, *Lofts of SoHo*, 8.
16. Alan Clayson, Barb Jungr, and Robb Johnson, *Woman: The Incredible Life of Yoko Ono* (New Malden: Chrome Dreams, 2004), 42.
17. Carver, *Reaching Out*, 47.
18. Munroe and Hendricks, *Yes Yoko Ono*, 2000, 47; Ono, *Grapefuit*, 2000.
19. Magie Dominic and Michael Smith, *H. M. Koutoukas, 1937–2010, Remembered by His Friends* (Silverton, OR: Fast Books, 2010), 58.

Chapter 9

1. H. M. Koutoukas, *When Lightning Strikes Twice* (New York: Samuel French, 1991), 50.
2. Michael Smith, ed., *More Plays from Off-Off-Broadway* (Indianapolis: Bobbs-Merrill, 1972), 13.
3. Ibid., 15.
4. Nick Orzel and Michael Smith, eds., *Eight Plays from Off-Off Broadway* (New York: Bobbs-Merrill, 1966), 63.
5. Robert Patrick and Michael Feingold, *Robert Patrick's Cheep Theatricks!* (New York: Samuel French, 1972), 299.
6. Richard Witts, *The Velvet Underground: Icons of Pop Music* (Bloomington: Indiana University Press, 2006), 10.
7. Judith F. Rodenbeck, *Radical Prototypes: Allan Kaprow and the Invention of Happenings* (Cambridge, MA: MIT Press, 2011), 4–5.
8. Fred Turner, *The Democratic Surround: Multimedia and American Liberalism from World War II to the Psychedelic Sixties* (Chicago: University of Chicago Press, 2013), 266–67.
9. Sally Banes, *Greenwich Village 1963: Avant-Garde Performance and the Effervescent Body* (Durham, NC: Duke University Press, 1993), 153–54.
10. Orzel and Smith, *Eight Plays from Off-Off-Broadway*, 132.
11. Arnold Aronson, *American Avant-Garde Theatre: A History* (New York: Routledge, 2000), 28–29.

Chapter 10

1. Branden Wayne Joseph, *Beyond the Dream Syndicate: Tony Conrad and the Arts After Cage* (New York: Zone Books, 2011), 229–31.
2. Juan Antonio Suárez, *Bike Boys, Drag Queens, and Superstars: Avant-Garde, Mass Culture, and Gay Identities in the 1960s Underground Cinema* (Bloomington: Indiana University Press, 1996), 181–82.
3. Susan Sontag, "A Feast for the Eyes," *The Nation* (April 13, 1964), 376.
4. J. J. Murphy, *The Black Hole of the Camera: The Films of Andy Warhol* (Berkeley: University of California Press, 2012), 19.
5. Joseph, *Beyond the Dream Syndicate*, 233.
6. Ibid., 239–40.
7. Steven Watson, *Factory Made: Warhol and the Sixties* (New York: Pantheon Books, 2003), 143.
8. John Leland, "The Prosecution Resets in a 1964 Obscenity Case," *New York Times* (October 30, 2015), https://www.nytimes.com/2015/11/01/nyregion/the-prosecution-resets -in-a-1964-obscenity-case.html.
9. Richie Unterberger, *White Light/White Heat: The Velvet Underground Day-by-Day* (London: Jawbone Press, 2009), 28.
10. Aidan Levy, *Dirty Blvd.: The Life and Music of Lou Reed* (Chicago: Chicago Review Press, 2016), 109–110.
11. Suárez, *Bike Boys, Drag Queens, and Superstars*, 239.
12. Reva Wolf, *Andy Warhol, Poetry, and Gossip in the 1960s* (Chicago: University of Chicago Press, 1997), 37–38.
13. Stephen James Bottoms, *Playing Underground: A Critical History of the 1960s Off-Off-Broadway Movement* (Ann Arbor: University of Michigan Press, 2006), 218.
14. Ed Sanders, *Fug You: An Informal History of the Peace Eye Bookstore, the Fuck You Press, the Fugs, and Counterculture in the Lower East Side* (Cambridge, MA: Da Capo Press, 2011), 35.

15. Ibid., 35.
16. Ibid., 54–55.
17. Ibid., 276–77.
18. Elaine Dundy, *Life Itself!* (London: Virago Press, 2001), 241.
19. Ibid., 242.

Chapter 11

1. Callie Angell, *Andy Warhol Screen Tests: The Films of Andy Warhol* (New York: Abrams, 2006), 149.
2. Richard Reeves. *President Kennedy: Profile of Power* (New York: Touchstone, 1994), 243.
3. Angell, *Andy Warhol Screen Tests*, 149.
4. Victor Bockris and Gerard Malanga, *Up-Tight: The Velvet Underground Story* (New York: Omnibus Press, 1983), 11.
5. Clinton Heylin, *From the Velvets to the Voidoids: A Pre-Punk History for a Post-Punk World* (New York: Penguin Books, 1993), 5.
6. Alban Zak, *The Velvet Underground Companion: Four Decades of Commentary* (New York: Schirmer Books, 1997), 111.
7. Ibid., 39.
8. Ibid., 190.
9. Daniel Kane, *"Do You Have a Band?": Poetry and Punk Rock in New York City* (New York: Columbia University Press, 2017), 47.
10. Dave Van Ronk and Elijah Wald, *The Mayor of MacDougal Street: A Memoir* (Cambridge, MA: Da Capo Press, 2005), 54.
11. Dave Thompson, *Beyond the Velvet Underground* (New York: Omnibus, 1989), 17.
12. Andy Warhol and Pat Hackett, *POPism: The Warhol Sixties* (Orlando: Harcourt, 2006), 184.
13. Legs McNeil and Gillian McCain, eds., *Please Kill Me: The Uncensored Oral History of Punk* (New York: Grove Press, 1996), 11.
14. Yvonne Sewall-Ruskin, *High on Rebellion: Inside the Underground at Max's Kansas City* (New York: Thunder's Mouth Press, 1998), 199–200.
15. Steven Watson, *Factory Made: Warhol and the Sixties* (New York: Pantheon Books, 2003), 279.
16. Ibid., 377.
17. Sally Banes, *Democracy's Body: Judson Dance Theater, 1962–1964. Studies in the Fine Arts* (Ann Arbor: UMI Research Press, 1983), 190.

Chapter 12

1. Stephen James Bottoms, *Playing Underground: A Critical History of the 1960s Off-Off-Broadway Movement* (Ann Arbor: University of Michigan Press, 2006), 60.
2. From the archives of Lisa Jane Persky.
3. Bottoms, *Playing Underground*, 284.
4. Diane di Prima, *Recollections of My Life as a Woman: The New York Years* (New York: Viking, 2001), 331.
5. Ibid., 396.

Chapter 13

1. Juan Antonio Suárez, *Bike Boys, Drag Queens, and Superstars: Avant-Garde, Mass Culture, and Gay Identities in the 1960s Underground Cinema* (Bloomington: Indiana University Press, 1996), 123–24.

2. Arnold Aronson, *American Avant-Garde Theatre: A History* (New York: Routledge, 2000), 46.
3. Branden Wayne Joseph, *Beyond the Dream Syndicate: Tony Conrad and the Arts After Cage* (New York: Zone Books, 2011), 240–41.
4. David Allison Crespy, *Off-Off-Broadway Explosion: How Provocative Playwrights of the 1960s Ignited a New American Theater* (New York: Back Stage Books, 2003), 112.
5. Susan Sontag, *Against Interpretation and Other Essays* (New York: Picador, 2001), 280.

Chapter 15

1. Victor Bockris and Gerard Malanga, *Up-Tight: The Velvet Underground Story* (New York: Omnibus Press, 1983), 33.
2. Ibid., 33.
3. Aidan Levy, *Dirty Blvd.: The Life and Music of Lou Reed* (Chicago: Chicago Review Press, 2016), 109–10.
4. Ed Sanders, *Fug You: An Informal History of the Peace Eye Bookstore, the Fuck You Press, the Fugs, and Counterculture in the Lower East Side* (Cambridge, MA: Da Capo Press, 2011), 108.
5. Ibid., 154–55.
6. Andy Warhol and Pat Hackett, *POPism: The Warhol Sixties* (Orlando: Harcourt, 2006), 206.
7. Bockris and Malanga, *Up-Tight*, 77.
8. Dave Thompson, *Beyond the Velvet Underground* (New York: Omnibus, 1989), 32.
9. Warhol and Hackett, *POPism*, 210.
10. Dick Porter and Kris Needs, *Parallel Lives* (New York: Omnibus, 2012), 172.
11. Richie Unterberger, *White Light/White Heat: The Velvet Underground Day-by-Day* (London: Jawbone Press, 2009), 122.
12. Sanders, *Fug You*, 170.
13. Ibid., 206–7.
14. Abbie Hoffman, Izak Haber, and Bert Cohen, *Steal This Book* (New York: Four Walls Eight Windows, 1995), 67.
15. Sanders, *Fug You*, 280–281.
16. Theodore Roszak, *The Making of a Counterculture* (New York: Anchor, 1969), 124.

Chapter 16

1. Barbara Lee Horn, *Ellen Stewart and La MaMa: A Bio-Bibliography* (Westport, CT: Greenwood Press, 1993), 21.
2. Ibid., 18–19.
3. Ibid., 25–26.
4. Diane di Prima, *Recollections of My Life as a Woman: The New York Years* (New York: Viking, 2001), 376.
5. Ibid., 358.
6. Mary Woronov, *Swimming Underground: My Years in the Warhol Factory* (Boston: Journey Editions, 1995), 173.
7. Jayne County and Rupert Smith, *Man Enough to Be a Woman* (New York: Serpent's Tail, 1995), 50.
8. Dan Sullivan, "'Supreme Comedy' of the End Opens," *New York Times* (November 28, 1967), 76.
9. Steven Watson, *Factory Made: Warhol and the Sixties* (New York: Pantheon Books, 2003), 356.

Chapter 17

1. Craig B. Highberger, *Superstar in a Housedress: The Life and Legend of Jackie Curtis* (New York: Chamberlain Bros., 2005), 25.
2. Ibid., unpaginated epigram.
3. Ibid., 19–20.
4. Ibid., 29.
5. Ibid., 189.
6. G. T. Harrell, *For Members Only: The Story of the Mob's Secret Judge* (Bloomington, IN: AuthorHouse, 2010), 381.
7. Andy Warhol and Pat Hackett, *POPism: The Warhol Sixties* (Orlando: Harcourt, 2006), 283.
8. Highberger, *Superstar in a Housedress*, 109.
9. Jack Kroll, "Ridiculous!" *Newsweek* (November 3, 1969).

Chapter 18

1. Yvonne Sewall-Ruskin, *High on Rebellion: Inside the Underground at Max's Kansas City* (New York: Thunder's Mouth Press, 1998), xi.
2. Patti Smith, *Just Kids* (New York: Ecco, 2010), 117.
3. Andy Warhol and Pat Hackett, *POPism: The Warhol Sixties* (Orlando: Harcourt, 2006), 233.
4. Sewall-Ruskin, *High on Rebellion*, 113.
5. Jayne County and Rupert Smith, *Man Enough to Be a Woman* (New York: Serpent's Tail, 1995), 59.
6. Ibid., 59.
7. Breanne Fahs, *Valerie Solanas: A Life of Scum (Or, Why She Shot Andy Warhol and Other Chit Chat)* (New York: Feminist Press, 2014), 91.
8. Mary Lou Harris, Jayne Anne Harris, and Eloise Harris, *Flower Power Man* (New York: El Dorado Books, 2017), 35.
9. Fahs, *Valerie Solanas*, 62–3.
10. Ibid., 51.
11. Ed Sanders, *Fug You: An Informal History of the Peace Eye Bookstore, the Fuck You Press, the Fugs, and Counterculture in the Lower East Side* (Cambridge, MA: Da Capo Press, 2011), 315.
12. Ibid., 315.

Chapter 19

1. Ed Sanders, *Fug You: An Informal History of the Peace Eye Bookstore, the Fuck You Press, the Fugs, and Counterculture in the Lower East Side* (Cambridge, MA: Da Capo Press, 2011), 119.
2. Ibid., 185.
3. Ibid., 253.
4. Ibid., 371–72.
5. Ibid., 372.
6. Ibid., 396.

Chapter 20

1. Stephen James Bottoms, *Playing Underground: A Critical History of the 1960s Off-Off-Broadway Movement* (Ann Arbor: University of Michigan Press, 2006), 193.

2. Barbara Lee Horn, *Ellen Stewart and La MaMa: A Bio-Bibliography* (Westport, CT: Greenwood Press, 1993), 20–21.
3. Clive Barnes, "Hair: It's Fresh and Frank; Likable Rock Musical Moves to Broadway," *New York Times* (April 30, 1968), 40.
4. Robert Patrick and Michael Feingold, *Robert Patrick's Cheep Theatricks!* (New York: Samuel French, 1972), 211.
5. Alan Light, "David Johansen: The MOJO Interview," *MOJO* (March 2015), 40.

Chapter 21

1. Patti Smith, *Just Kids* (New York: Ecco, 2010), 27.
2. Ibid., 48.
3. Ibid., 59.
4. Ibid., 94.
5. Ibid., 99.
6. Ibid., 142.
7. Ibid., 116.
8. Ibid., 130.
9. Jayne County and Rupert Smith, *Man Enough to Be a Woman* (New York: Serpent's Tail, 1995), 59.
10. Ibid., 63.
11. Smith, *Just Kids*, 159–60.
12. Craig B. Highberger, *Superstar in a Housedress: The Life and Legend of Jackie Curtis* (New York: Chamberlain Bros., 2005), 138–39, 152.
13. Sherill Tippins, *Inside the Dream Palace: The Life and Times of New York's Legendary Chelsea Hotel* (New York: Houghton Mifflin Harcourt, 2013), 305.

Chapter 22

1. Ron Grossman, "Fatal Black Panther Raid in Chicago Set Off Sizable Aftershocks," *Chicago Tribune* (December 4, 2014), http://www.chicagotribune.com/news/history/ct-black-panther-raid-flashback-1207-20141206-story.html.

Chapter 23

1. Jeffrey Ruoff, *An American Family: A Televised Life* (Minneapolis: University of Minnesota Press, 2002), xvi.
2. Andreas Killen, *1973 Nervous Breakdown: Watergate, Warhol, and the Birth of Post-Sixties America* (New York: Bloomsbury, 2006), 145.
3. Ibid., 148.
4. Ibid., 57–58.
5. Pat Loud and Christopher Makos, *Lance Out Loud* (New York: Glitterati, 2012).
6. Killen, *1973 Nervous Breakdown*, 73.
7. Pat Loud and Nora Johnson, *Pat Loud: A Woman's Story* (New York: Coward, McCann & Geoghegan, 1974), 96.
8. Ron Goulart, *An American Family* (New York: Warner Paperback Library, 1973), 48.
9. Ibid., 48–49.
10. Killen, *1973 Nervous Breakdown*, 72.
11. Ibid., 71.
12. Loud and Johnson, *Pat Loud*, 146.
13. Ibid., 150.
14. Goulart, *American Family*, 10.

15. Ibid., 12.
16. Loud and Johnson, *Pat Loud*, 162.
17. Loud and Makos, *Lance Out Loud*, 121.
18. Loud and Johnson, *Pat Loud*, 100.

Chapter 24

1. Andreas Killen, *1973 Nervous Breakdown: Watergate, Warhol, and the Birth of Post-Sixties America* (New York: Bloomsbury, 2006), 140.
2. Juan Antonio Suárez, *Bike Boys, Drag Queens, and Superstars: Avant-Garde, Mass Culture, and Gay Identities in the 1960s Underground Cinema* (Bloomington: Indiana University Press, 1996), 137.
3. Legs McNeil and Gillian McCain, eds., *Please Kill Me: The Uncensored Oral History of Punk* (New York: Grove Press, 1996), 95.
4. Auslander, *Performing Glam Rock*, 61.
5. Jayne County and Rupert Smith, *Man Enough to Be a Woman* (New York: Serpent's Tail, 1995), 87–88.

Chapter 25

1. Don Shewey, *Sam Shepard* (New York: Da Capo Press, 1997), 70.
2. Philip Shaw, *Horses* (New York: Continuum, 2008), 60.
3. Shewey, *Sam Shepard*, 76.
4. Ibid., 64.
5. Patti Smith, *Just Kids* (New York: Ecco, 2010), 173–74.
6. Patti Smith, *Patti Smith Complete, 1975–2006: Lyrics, Reflections, and Notes for the Future* (New York: Ecco, 2006), 21.
7. Sam Shepard, *Fool for Love and Other Plays* (New York: Dial Press, 2006), 147.
8. Ibid., 145.
9. Smith, *Just Kids*, 184–85.
10. Shewey, *Sam Shepard*, 73.
11. Bernard Gendron, *Between Montmartre and the Mudd Club: Popular Music and the Avant-Garde* (Chicago: University of Chicago Press, 2002), 243.
12. Ibid., 243.
13. Smith, *Just Kids*, 138.
14. Richard Hell, *I Dreamed I Was a Very Clean Tramp: An Autobiography* (New York: Ecco, 2014), 109–10.
15. Ibid., 101.
16. Ibid., 101.

Chapter 27

1. Barry Miles, *In the Seventies: Adventures in the Counterculture* (London: Serpent's Tail, 2012), 186.
2. Craig Gholson, "Blondie's Roots," *New York Rocker* (May 1976), 10–12. http://www.rip-her-to-shreds.com/archive_press_magazines_nyrockermay76.php.
3. Legs McNeil and Gillian McCain, eds., *Please Kill Me: The Uncensored Oral History of Punk* (New York: Grove Press, 1996), 117.
4. Richard Hell, *I Dreamed I Was a Very Clean Tramp: An Autobiography* (New York: Ecco, 2014), 110.
5. Patti Smith, *Just Kids* (New York: Ecco, 2010), 217–18.

6. Garrett McGrath, 2013. "The Theater Came Crashing Down," *Narratively* (September 5, 2013), http://narrative.ly/stories/the-theater-came-crashing-down.
7. Dick Porter and Kris Needs, *Parallel Lives* (New York: Omnibus, 2012), 44.

Chapter 28

1. Abbie Hoffman, Izak Haber, and Bert Cohen, *Steal This Book* (New York: Four Walls Eight Windows, 1995), 144.

Chapter 29

1. Magie Dominic and Michael Smith, *H. M. Koutoukas, 1937–2010, Remembered by His Friends* (Silverton, OR: Fast Books, 2010), 34.
2. Dick Porter and Kris Needs, *Parallel Lives* (New York: Omnibus, 2012), 255.

Chapter 30

1. Martin Duberman, *Stonewall* (New York: Plume, 1994), 196.
2. Marky Ramone and Rich Herschlag, *Punk Rock Blitzkrieg: My Life as a Ramone* (New York: Touchstone, 2015), 89–90.
3. Patti Smith, *Just Kids* (New York: Ecco, 2010), 239.
4. Richard Hell, *I Dreamed I Was a Very Clean Tramp: An Autobiography* (New York: Ecco, 2014), 111.
5. Ibid., 133.
6. Will Hermes, *Love Goes to Buildings on Fire: Five Years in New York That Changed Music Forever* (New York: Farrar, Straus & Giroux, 2012), 69.
7. Smith, *Just Kids*, 179.

Chapter 31

1. Holly Woodlawn and Jeffrey Copeland, *A Low Life in High Heels: The Holly Woodlawn Story* (New York: St. Martin's Press, 1991), 233.
2. Dick Porter and Kris Needs, *Parallel Lives* (New York: Omnibus, 2012), 46.
3. Ibid., 48.
4. Patti Smith, *Just Kids* (New York: Ecco, 2010), 233.
5. Ibid., 232.
6. Victor Bockris, *NYC Babylon: Beat Punks: Notes, Raps, Essays, Secrets, Transcripts, Opinions (Wise and Otherwise), and Pictures of a Gone World and of How the Punk Generation Typhooned Its Way Back Through and Harpooned the Beat Generation in Harmonic Collaboration* (New York: Omnibus, 1998), 59.
7. Gillian G. Gaar, *She's a Rebel: The History of Women in Rock and Roll* (Berkeley, CA: Seal Press, 1993), 260.
8. Gary Valentine, *New York Rocker: My Life in the Blank Generation, with Blondie, Iggy Pop, and Others, 1974–1981* (New York: Thunder's Mouth Press, 2006), 65.
9. Roger Padilha and Mauricio Padilha, *The Stephen Sprouse Book* (New York: Rizzoli, 2009).

Chapter 33

1. Kris Needs and Dick Porter, *Trash!: The Complete New York Dolls* (London: Plexus, 2006), 29.
2. Richard Hell, *I Dreamed I Was a Very Clean Tramp: An Autobiography* (New York: Ecco, 2014), 117.
3. Ibid., 197.

4. Kim Cooper and David Smay, *Bubblegum Music Is the Naked Truth* (Los Angeles: Feral House, 2001), 38.

5. Debbie Harry, Chris Stein, and Victor Bockris, *Making Tracks: The Rise of Blondie* (New York: Dell, 1982), 49.

Coda

1. Sharon Zukin, *Naked City: The Death and Life of Authentic Urban Places* (Oxford: Oxford University Press, 2011), 229.

2. Mary Lou Harris, Jayne Anne Harris, and Eloise Harris, *Flower Power Man* (New York: El Dorado Books, 2017), 197.

3. Marc Snetiker, "From Drags to Riches," *Entertainment Weekly* (June 23, 2017), 26–27.

4. "New Wave Queens," *RuPaul's Drag Race* (2016).

5. Dick Hebdige, *Subculture: The Meaning of Style* (New York: Routledge, 1979).

6. Susan Douglas, *Where the Girls Are: Growing Up Female with the Mass Media* (New York: Three Rivers Press, 1995), 5.

7. "Sculpture: Master of the Monumentalists," *Time* (October 13, 1967).

8. Andreas Killen, *1973 Nervous Breakdown: Watergate, Warhol, and the Birth of Post-Sixties America* (New York: Bloomsbury, 2006), 71–72.

9. Killen, *1973 Nervous Breakdown*, 138.

10. Stefan Brecht, *Queer Theatre: The Original Theatre of the City of New York, from the Mid-60s to the Mid-70s* (New York: Methuen, 1986), 54.

INDEX

population, 71, 73
Pork (Warhol), 225–31
Pornography and Censorship
 Conference, 167
portraits, 108
posters, *82*, 90, *126*, *152*
 Harry on, 279
 by mimeograph, *263*
Potts, Nancy, 190
poverty, 1, 75, 164
Powers, Devon, 55
Prague Conservatory, 259
preservation, 319
 artists and, 74–83
Preston, Josephine, 205
Price, Don, 127
di Prima, Diane, 52, 121, 154
Project of Living Artists, 252
property development, 318–19
Prospect Park, 98
public access shows, 261–62
 Rock from CBGB's, 291
 TV Party, 316
publishing, 52
 distribution for, 53–54
 Loud, P., in, 304
 zines and, 308
punk, 163, 256, 269. *See also*
 rock
 associations with, 7
 authenticity of, 324
 bands, 26, 253
 development of, 14
 invention of, 307–15
 poetry and, 237–38
 styles and, 295–96
Punk magazine, 299
 Bayley and, 309–10
 Burke on, 309
 subculture and, 311
punk rock. *See also* punk
 roots of, 272–85

queerness, 87
 culture and, 153
 fans and, 324
 Little Richard and, 40
 style and, 96
Quin, Benton, 241, 264
 Harry and, 293–95
 matchmaking by, 280–82
Quintano's School for Young
 Professionals, 161

radicalism, 4, 6
 realism and, 26, 29
 rock and, 137–48
radio, 56–57, 141
Radio City Music Hall, 315

Rado, James, 189, 190, 191, 192
Ragni, Gerome, 189, 190, 191,
 192
 Koutoukas and, *265*
Ramone, Dee Dee (Douglas
 Colvin)
 on *Punk* magazine, 311
 Tent and, 298–99
Ramone, Joey (Jeffrey Hy-
 man), 41–42, 184, 283
 mother of, 298
 Zone, P., and, *300*
the Ramones, 41, 141
 at CBGB, 256
 development of, 297–300,
 313
 the Mumps and, 224, 299
Ratcliff, Mary Curtis, 210–11,
 260
Rauschenberg, Robert, 25,
 92, 253
 Abstract Expressionist, 33,
 89, 174
 Johns, J. and, 32
 realism, 218
 radicalism and, 26, 29
 the *Realist* magazine, 55–56
Redd, Freddie, 27
Ree, Larry, 204, 255
Reed, Lou, 45–47, 110, 160, 164
 on Ruskin, 170
Rev, Marty, 251–53
reviews, 168
Reyner, Ruby Lynn, 151, 153,
 157, 164, 168
 on show songs, 253–54
 on Silver Apples, 174
 Zanetta on, 175–76
Richman, Jonathan, 254
Richter, Hans, 23
Riley, Terry, 256
Rimbaud, Arthur, 148, 199, 289
Rivers, Larry, 200
 Curtis and, 169
 at Film-Makers' Coopera-
 tive, 23
Robbins, Timmy, 243
Robinson, Lisa, 308
Robinson, Richard, 308
rock
 explosion of, 286–96
 glam rock as, 228, 247
 radicalism and, 137–48
 venues for, 181
Rock Scene magazine, 308
Rodenbeck, Judith F., 36
Roiphe, Anne, 223
role-playing, 326
Roller-Arena-Skates, 21

Rolling Stone magazine, 307
Rolling Stones, 218
the Ronettes, 144, 293
 Hansen, B., and, 48
The Room (Pinter), 61
Rosenberger, Ernst, 185
Rosenthal, Charlotte, 48
Rosenthal, Irving, 193
Rothermel, John, 239
Rubin, Barbara, 103, 112
runaways, 134
RuPaul, 324
Ruskin, Mickey, 170–71, 173,
 247
Russell, Arthur, 256

Sadler, Lendon, 193, 268
 activism and, 194
 on the Cockettes, 198,
 239–40, 241
Saks Fifth Avenue, 58, 59
Sanders, Ed, 3, 44
 activism for, 147–48
 arrest of, 185
 film and, 102–3
 independent media and,
 50–57
 Peace Eye Bookstore of, 6,
 54, 139
 on Solanas, 179
 story of, 317
San Francisco, CA
 Avalon Ballroom in, 139
 communes in, 268–69
 Eyster in, 241
 Graham, Bill in, 181–82
 Hibiscus in, *195*
San Remo bar, 34–35
Sartre, Jean-Paul, 10
satire, 165
 censorship and, 92
 male virility and, 176
Saturday Night Live, 316
Sauer, Ralph, 198
Schneemann, Carolee, 91
schools, 70, 243–44
the Screaming Violets, *322*
SCUM Manifesto (1967), 178,
 180
Second City, 210
Sedgwick, Edie, 37–39
 death of, 217
 at the Factory, 102, 109, 115
 in *Vogue* magazine, 40
Seidel, Leon, 76
Serrato, Paul, 179, 204
the Sex Pistols, 311–12
Shangri-Las, 48, 144, 287, 293
 influence of, 313

ABOUT THE AUTHOR

Kembrew McLeod is an award-winning author of several books whose writing has been featured in the *New York Times*, the *Los Angeles Times*, the *Washington Post*, the *Village Voice, Rolling Stone, Slate,* and *Salon.* A professor of communication studies at the University of Iowa, he is the recipient of a recent NEH Public Scholar fellowship to support *The Downtown Pop Underground.* He has also produced three documentaries about popular music that have screened at many festivals including the Toronto International Film Festival and SXSW Film Festival. *Copyright Criminals* debuted on PBS's Emmy Award–winning *Independent Lens* series, and McLeod's documentary *Freedom of Expression*® was a companion to his book of the same name that won the American Library Association's Eli M. Oboler Memorial Award for "best scholarship in the area of intellectual freedom." The American Association of University Presses designated *Pranksters* as one of the "Best of the Best Books You Should Know About" in 2014, and in 2016 Bloomsbury published his book on Blondie's *Parallel Lines* in its 33⅓ series.

Library of Congress Control Number: 2017956862

ISBN: 978-1-4197-3252-2
eISBN: 978-1-68335-345-4

Printed and bound in the United States
10 9 8 7 6 5 4 3 2 1

Abrams books are available at special discounts when purchased in quantity
for premiums and promotions as well as fundraising or educational use. Special
editions can also be created to specification. For details, contact specialsales@
abramsbooks.com or the address below.

Abrams Press® is a registered trademark of Harry N. Abrams, Inc.

ABRAMS The Art of Books
195 Broadway, New York, NY 10007
abramsbooks.com